EPICENTER

EPICENTER

San Francisco Bay Area Art Now

Mark Johnstone AND

Leslie Aboud Holzman

CHRONICLE BOOKS

SAN FRANCISCO

All photographs courtesy of the artist unless otherwise noted.
Page 276 constitutes a continuation of the copyright page.

Library of Congress Cataloging-in-Publication Data available.
ISBN: 0-8118-3541-3

Manufactured in Hong Kong.

Designed by Sara Schneider

Distributed in Canada by Raincoast Books
9050 Shaughnessy Street
Vancouver, British Columbia V6P 6E5

10 9 8 7 6 5 4 3 2 1

Chronicle Books LLC
85 Second Street
San Francisco, California 94105

www.chroniclebooks.com

ACKNOWLEDGMENTS

This book could not have been done without the artists. They supplied their time, information, and artwork. The authors feel fortunate and privileged to have worked with them.

Many other people generously gave their time, energy, thoughts, and materials throughout our research and writing. Among them are: Ellen Mahoney, Connie and Stephen Wirtz at Stephen Wirtz Gallery; Paule Anglim, Ed Gilbert, Ian Alteveer, Annie Lawson, and Barbara Carder at Gallery Paule Anglim; Jeffrey Fraenkel and Frish Brandt at Fraenkel Gallery; Dianne Hoover at Hosfelt Gallery; Calvert Barron and Walter Maciel at Rena Bransten Gallery; Ruth Braunstein, Shannon Tremble, and Jennifer Gately at Braunstein/Quay Gallery; and Nami Dunham, Amy Davila, and Gina Fairley at Haines Gallery. In addition, Jeff Kelley, Phil Linhares, and Mark Pauline made valuable suggestions. At Chronicle Books, Alan Rapp has been the driving force behind this book since the proposal arrived on his desk, and has constantly (almost daily) asked provocative questions, provided great advice, direction, and labored to improve it. Thanks to Steve Mockus for taking charge of many details, and Sara Schneider for the stunning design. Ian and Kitty frequently provided food, transportation, and lodging on my many San Francisco visits. At my regular job, Roella Louie was supportive of this project. Jake and Guy insisted that I get away from the computer—at least into the backyard—and Julia could always be found plopped in the middle of my desk.

Leslie is fantastic—actually unbelievable—as a working partner, writer, and gallery visitor. Neither of us had an inkling that this would be a three-year project when I asked her if she would like to work with me on this book.

My wife Robbi knows me well, and endured more than anyone can imagine with this book. She weathers my mood swings, hours spent at the computer, and the general disruption that often accompany my projects. I am eternally grateful for her support and love.

—Mark Johnstone

I would like to add my utmost thanks to my husband Jeff, for his never-ending patience and support; for assuming the day-to-day tasks so I could have space to work; for readily accepting the intrusion of this project in our lives; and for taking me on long walks when my resolve was waning. He made it possible for me to get to the finish line. To my parents, for their constant and caring concern for my health, happiness, and overall anxiety level; and to Mark, for inviting me to work with him on this book.

—Leslie Aboud Holzman

TABLE OF CONTENTS

SOMEWHERE BETWEEN
ORDER AND CHAOS: SYNTHESIS

GEOMORPHOLOGY
the study of the character and origin of landforms,
such as mountains, valleys, and so on

The groundbreaking ceremony for the new home of the San Francisco Museum of Modern Art took place on April 8, 1992 in the South of Market area, about ten blocks from the Civic Center location that the museum had occupied for fifty-seven years. The site was across the street from the Yerba Buena Center for the Arts and near the future new locations of the Jewish Museum San Francisco and the Mexican Museum. A local artist and a local collaborative were invited to participate in the museum's inaugural ceremony. In retrospect, these elements offered a shrewd summation of Bay Area art—past, present, and future. Taken together, the events could be envisioned as exercises in the cultural opposition and fusion that characterize the region: elegance and dissonance, novel and traditional ideas of artistic production, abstract thought and kinetic action. Slow, silent poetry and raw, roaring technology.

Conceptual artist David Ireland had traced and broken a narrow crescent-shaped gap in the pavement adjacent to where the officials were gathered. Inviting the assembled dignitaries to join him, he spaded earth from the narrow arc. Artist friends and museum patrons lined up to shovel, in a performance that mimicked the customary hard-hat groundbreaking photo op. The V-shaped trench was to be filled with concrete, and after the concrete had set, then removed and deposited in local finance mogul Charles Schwab's backyard.

In stark contrast, the performance by Survival Research Laboratories (SRL) was anything but subdued. Spectators arrived at a converted parking lot filled with large machines, a thirty-by-twenty-foot mural painted with a sexually graphic scene, and cardboard structures. Founder Mark Pauline and his irregular band of volunteers prepared an arsenal featuring an electromagnetic rail gun that vaporized metal bars and shot sparks at two-hundred miles-per-hour, while sonic booms belched from a converted NASA engine that produced noise in excess of one hundred decibels, excruciatingly loud even blocks away. SRL staff operated these two machines, which were augmented with a swiveling, twenty-foot-long lobsterlike machine, crawling this way and that, and a collection of noisy "live garbage cans" spewing paint and flame. As the spectacle progressed, the cheap theatrical trappings caught fire or collapsed, and attending fire department personnel slapped Pauline with a sixty-dollar citation for creating a fire hazard. Local newspaper critics roundly panned the event in the following day's press accounts, observing, ". . . this SRL piece seemed to consist of elaborately turning one kind of mess into another,"[1] and it "needlessly endangered onlookers and polluted the atmosphere, was all sound and fury, signifying little other than the power of hype and nostalgia for a rough-and-ready avant-garde."[2]

[1] Kenneth Baker, "Museum Dedicates Site With a Bang," *San Francisco Chronicle*, 9 April 1992, sec. E, p.1

[2] David Bonetti, "The Day the Ground Broke," *San Francisco Examiner*, 9 April 1992, sec. C, p.1, 5

The two events could not have contrasted more in appearance, and neither seemed fully appreciated by the estimated twenty thousand people in attendance, according to the press accounts. In fact, except for a few people at the front of the crowd, the majority were unable to see what was happening at either event. Eight days later, many audience members gathered with SRL fans at a bar around the corner to watch video of the SRL performance.

Ireland, hewing to his conceptual, site-specific persona, brought into being an arc that was sympathetically drawn from the earth and created a poetic gesture for the place and event; his selection by the museum represented the high intellectual and conceptual framework that would appeal aesthetically to the art cognoscenti. SRL delivered on its maverick reputation, producing a hybrid performance blending art, sport, science, and war, rife with the physical shock and adrenaline rush inherent in the mechanical mayhem that ensues when the engines of their machines begin running. The SRL actions were not void of purpose; the group had performed such events for over a decade. Deemed the Bay Area art emissaries for this event, Ireland and SRL ostensibly represent the poles of calm highbrow intellectualism and spectacular lowbrow chaos. Both poles have historically marked the Bay Area's cultural reputation. And both poles are as mythical as they are real, but myth often outlives fact. With its reputation for dynamic adventurism and cool urbanity, the Bay Area is culturally caught between the forces of order and chaos.

If the breadth of the cultural scene covers art this disparate, how does one neatly summarize everything in between? The Bay Area's most identifiable styles such as figurative and Funk were variations on preexisting ones (Abstract Expressionism and Pop) that flourished in New York and Los Angeles. There were no taste-making power patrons or critics at the level of Peggy Guggenheim or Clement Greenberg or Leo Castelli who could shape an otherwise loose association of artists into a movement. The large local institutions were likewise unable to galvanize artists into nationally or internationally recognized groupings. In the absence of institutional definitions, what Bay Area artists tended to have in common was their individualism. In the context of Northern California—eclectic, multi-ethnic, culturally and technologically progressive—this meant that artists took what they wanted of trends and adapted them to their work. What emerged was a scene less defined by critically or commercially derived labels than a synthetic, multidisciplinary, cross-referential—yet conversely individualist—amalgam.

BASEMENT
harder and usually older igneous and metamorphic rocks that underlie the main sedimentary rock sequences, which are softer and usually younger, of a region

San Francisco matured ahead of other West Coast cities, and the evolved social and cultural infrastructure made it an attractive destination for artists in the 1950s—the postwar period when the population became more mobile and economic prosperity was steadily increasing. The downside to San Francisco—and every other location west of the Hudson—was the void between it and New York, the most direct route to success in the art world. The upside was a temperate climate and unfettered conditions for the creation of work. A decade after it materialized, the prevailing visual style of art at the beginning of the 1950s was still Abstract Expressionism. These were years when many artists consciously chafed against preconceived expectations, perhaps unconsciously manifesting the collective relief and optimism generated in the wake of surviving world conflict. By mid-decade, New York and Los Angeles artists incorporated assemblage or mixed media into their pieces, conceptually and formally separating their works from what had prevailed a few years earlier.

Print media and radio dominated mass communication in the United States in the early 1950s, to be joined by television a decade later. In San Francisco, *Zen and the Art of Archery* (1953) by Eugene Herrigel and *Doors of Perception* (1954) by Aldous Huxley were passed around and discussed among the cognoscenti. Alan Watts, who moved to Berkeley in 1951, popularized Zen Buddhist philosophies through articles, books—*The Way of Zen* (1958), *Beat Zen, Square Zen and Zen* (1959)—and "Way Beyond the West," his regular radio lectures on Berkeley station KPFA from 1953 to 1958. There was a common desire for transcendence in pursuit of self-inquiry and knowledge. Alcohol, marijuana, and psychedelic drugs were routinely used to intensify these existential explorations.

The literary arts, music, and theater formed the backbone of the arts scene in San Francisco. Within several years after it opened in 1953, Lawrence Ferlinghetti's press and bookstore, City Lights, gained a reputation as a "Mecca for madmen and malcontents" in the literary world. The West Coast haunt of poets Kenneth Rexroth, Gregory Corso, and Allen Ginsberg and novelist Jack Kerouac, it was also at the forefront of the important obscenity trial around Ginsberg's *Howl*. A bohemian community gradually established itself in the nearby North Beach Italian neighborhood with coffeehouses and galleries. *Beatnik,* coined in 1957 by writer Herb Caen, after the launch of the Russian satellite *Sputnik,* apportioned a slightly derogatory suffix to the descriptive label describing those who disdained conventional lifestyles or fashion—bohemians—through indirect association with the Red Menace. The slang became common parlance, although the scene and circumstances that spawned it had dissolved by 1956, and Ginsberg, Burroughs, Kerouac, and others moved elsewhere.[3]

[3] Nancy J. Peters, "The Beat Generation and San Francisco's Culture of Dissent," in *Reclaiming San Francisco.* (San Francisco: City Lights, 1998): p. 211.

Bay Area artists, like those in most cities, developed informal networks of friends and colleagues, who congregated in bars or homes and supported each other's exhibitions. Painter Wally Hedrick managed the Six Gallery, where Allen Ginsberg read *Howl,* and he lived with his wife, painter Jay DeFeo, in a building on Fillmore Street. Poet Michael McClure and his wife, Joanna, were among the artist friends who rented apartments in the building. McClure had grown up with visual artist Bruce Conner in Wichita, Kansas. In the late 1950s and early 1960s, there was fluid movement of artists between San Francisco and Los Angeles, some of whom also spent brief periods in Berkeley and Marin. Central among these nomads were artists Wallace Berman and George Herms and poet Robert Alexander from Los Angeles, and poet McClure, ceramist Peter Voulkos, and Conner from the Bay Area. Bruce Conner's primacy to the scene cannot be overstated. Although he was primarily known as a painter when he landed in San Francisco in 1957, he was being recognized by the following year—for the originality, maturity, and challenging content of his assemblages and films. His debut, *A MOVIE,* is a seminal work of found-film collage. Conner and other artists working in assemblage forged connections with their immediate environments through materials, with many producing works that have tantalizing interconnections.

BODY WAVE
a seismic wave that moves through the interior of the earth

Painting was the most exhibited and written-about visual art through the mid-1970s, and the Bay Area was not unlike New York in this regard. Abstract Expressionism was an emulated style in the Bay Area into the mid-1950s, when Richard Diebenkorn (1922–93), David Park (1911–60), and Elmer Bischoff (1916–91) began turning to representation. Their paintings retain the bold gestures characteristic of Abstract Expressionism while incorporating figurative or landscape elements. Diebenkorn lived and taught for extended periods in both Northern and Southern California, and while his work is seminal and strongly identified with the Bay Area, it more broadly reflects West Coast painting from the early 1960s through the 1980s. There are early parallels between Diebenkorn's work and that of Wayne Thiebaud (1920–), but the latter had a greater predilection for the recognizably commonplace, possibly from having worked as a commercial artist in his twenties. In the 1960s, his subject matter frequently included familiar subjects such as sandwiches or commonly encountered products of the consumer world such as toys or gumball machines. Thiebaud is best known for paintings and prints of cakes and desserts, and the light, pale colors that developed in his palette reflect the bleached, bright California sunshine.

The Northern California innovation based on Pop art—Funk— is still arguably the most regionally identifiable Bay Area style. The slick, commercial subjects of Pop were recast in Funk with a healthy dose of wackiness. Funk gained notoriety in ceramics as an irreverent

treatment of a traditionally stoic material, characteristically employing bright colors, commonplace items, and humor. However, an artist whose works bear little relationship to Funk orchestrated the general circumstances that led to its emergence—Peter Voulkos (1924-2002). His work introduced to ceramics a vigorous rough-hewn quality that glorified the fired piece as an object with a physical presence equal to that of sculpture in the traditional materials of metal or wood. Voulkos set up the ceramics studio at the University of California in Berkeley in 1959.[4] The artists most associated with Funk are sculptors Robert Arneson (1930-1992), and painter William Wiley (1937-). Arneson, a student of Voulkos, gave the timid perfection of craft practice an edge through slumping shapes and a free association of seemingly unrelated subjects, which were likely to have sexual overtones. Wiley fills his painting, sculpture, assemblage, and prints with a dense amalgamation of images and colors. An inveterate word punster, he weaves together recognizable, personal, and cryptic images in a consciously naïve style that emulates folk art. Roy De Forest (1930-), a friend and colleague of Wiley's, creates lively paintings, drawings and prints with colorful fantasy landscapes populated by dogs, meandering designs, and imaginary hybrids of humans and animals.

Educational institutions were a primary conduit for an exchange and promulgation of ideas, and offered opportunities for communal activity among students and teachers. The passage of the G.I. bill after World War II and the resulting increased enrollments helped generate an expansion of programs at colleges and universities across the country. Art schools gained stature through the artists on their faculties, and the success of their students. In the Bay Area, the San Francisco Art Institute is the oldest—and after World War II the leading—art school in the region.[5] Clyfford Still taught painting there in 1946, and regular or visiting faculty included Ad Reinhardt, Mark Rothko, Ansel Adams, Edward Weston, and Imogen Cunningham. In the early 1950s, the painting faculty included Bischoff, Diebenkorn, and Park. Then, in the 1960s, the faculty included Bruce Conner, Jay DeFeo, Wally Hedrick, Robert Hudson, Manuel Neri, and William Wiley.

In the 1950s and 1960s, the curriculum of art programs at Bay Area universities reflected the general education mission of the schools, and offered young, talented, financially struggling artists a way to make a living.[6] Among notable artists achieving recognition and

[4] Voulkos organized the "Clay Shop" at the County Art Institute in Los Angeles that was later renamed Otis Art Institute. He returned to the Bay Area after being fired by director Millard Sheets.

[5] In the 1990s, SFAI experienced a substantial turnover of faculty. Reinvigorated staff and programs have led many to consider the California College of Arts and Crafts as the most influential Bay Area art program.

[6] Approximately 70% of the artists in *Epicenter* have teaching as their primary income. "In California, more than in New York and other art centers, schools have been and remain the basis for the creation and maintenance of a viable art culture. An understanding of the development of the art and culture of California in the twentieth century demands a critical look at the nature and extent of the role played by its art schools, colleges, and university departments." Paul J. Karlstrom, "Art School Sketches: Notes on the Central Role of Schools in California Art and Culture," pp. 84–108 in *Reading California: Art, Image, and Identity*, 1900–2000 (Los Angeles: Los Angeles County Museum of Art; Berkeley: University of California Press, 2000): 85.

supporting themselves as teachers were Peter Voulkos (1959–85), Elmer Bischoff (1963–85), and painter Joan Brown (1974–90) at the University of California at Berkeley; and Robert Arneson (1962–91), William Wiley (1962–73), Roy De Forest (1965–82), and Wayne Thiebaud (1960–76) at the University of California at Davis. Other graduate students of Voulkos at UC Berkeley, in addition to Robert Arneson, were Stephen De Staebler (1930–) and Ron Nagle; De Staebler taught at Stanford University in Palo Alto along with painter Nathan Oliveira (1964–96). Nagle continues to teach at Mills College in Oakland along with Catherine Wagner, Anna Valentina Murch, and Hung Liu.

Voulkos, like Conner and other artists, switched media, moving back and forth between clay and painting. Voulkos forcefully challenged the conventional traits of ceramics, creating works that were asymmetrical, or pierced with holes, juxtaposed surface decoration and form, and ranged from tabletop scale to massive towers weighing several hundred pounds. Jay DeFeo (1929–89) moved her painting into a region that reflected a sculptor's affinity for physicality and space. She began the expressive abstract painting *The Rose* in 1958, and when she finally finished in 1964, it weighed twenty-three hundred pounds.

The primacy of painting as a medium steadily eroded throughout the 1960s, and by the end of the decade many artists—teachers and students alike—were exploring new media and technologies that seemed more relevant as avenues of expression. In 1969, artists were

living and thinking differently from the circumstances and environment that existed a mere ten years earlier. By the late 1960s, young people under age thirty comprised the highest proportion of the population since World War II. The effects of this social dynamic ranged from increased enrollments at colleges to more consumer goods being marketed at a younger demographic. The Bay Area seemed to be the crucible of youth-culture events that would have a long-term impact. In 1964, on the University of California campus in Berkeley, student protests and demonstrations spawned the Free Speech Movement, which subsequently encouraged the involvement of students in curriculum, and administrative decision making at schools across the country. In 1966, author Ken Kesey—psychedelic adventurer whose cross-country trip with the Merry Pranksters was immortalized by Tom Wolfe in *The Electric Kool Aid Acid Test*—produced the Trips Festival at the Longshoreman's Hall in San Francisco. It was the first major concert, light, and drug extravaganza, and was promoted through a poster designed by Bruce Conner, using one of his mandala drawings. Bill Graham commercialized this trend, marketing rock-and-roll performances at the Fillmore Auditorium—with the Grateful Dead, Jefferson Airplane, and Big Brother and the Holding Company personifying the "San Francisco Sound"—through posters derivative of Conner's drawings and the underground comics of R. Crumb. The

media-christened "Summer of Love" in 1967 was short-lived, but it branded the Haight-Ashbury district near Golden Gate Park as a hotbed of hippies and drugs. Beyond the realm of the senses, the Esalen Institute (1962) promoted gestalt therapy, massages, and seminars that blended Eastern philosophy with Western science. By 1967, over four thousand people had traveled to Esalen's site overlooking the ocean in a remote area of Northern California, and another twelve thousand had attended seminars at a San Francisco branch.

Musical innovations flourished in the Bay Area. Composer Terry Riley helped move music into the minimalist modes also emerging in visual art with *In C* (1964). Drawing on the improvisational character found in jazz and Indian classical music, Riley explored the rich possibilities of interlocking repetitive musical patterns. This minimalist movement in music was concurrent with the technological advances that created electronic music. A cadre of artists interested in these emerging technologies and their potential applications to music— among them Morton Subotnick, Ramon Sender, Pauline Oliveros, and Riley—founded the San Francisco Tape Music Center in 1961. With the help of a grant from John Cage, the center moved in 1966 to Mills College in Oakland, where it was eventually renamed the Center for Contemporary Music. The presence of these artists and the center has helped groundbreaking electronic music to flourish in the Bay Area for decades.

Artforum magazine, begun in San Francisco in 1962 and briefly published out of Los Angeles before relocating to New York in 1967, helped bring attention to contemporary California art. It was a catalyst for a level of critical discourse in the Bay Area (and the entire West Coast) that was otherwise absent, and made available a broader range of subjects and theoretical approaches than the academically styled writing characterized by New York's Clement Greenberg. *Artweek,* appearing in 1969, provided a weekly discourse that nurtured and sustained conversations. Founded and published by Cecile McCann in Oakland, it was the primary—and often sole—conduit of information for the East Coast (and elsewhere) about what was happening on the West Coast.

During the 1960s and into the early 1970s, art periodicals had limited circulation and books were more widely distributed, especially in paperback. Marshall McLuhan's *Understanding Media* (1964) proposed that new technologies were creating a new environment, and his popular culture philosophy provoked general discussions about television, film, and other forms of communication and expression. Just fifteen years earlier, the multi-disciplinary and cross-disciplinary thinking that proposed new technologies as part of the natural evolution of life in general, and art in particular, would have seemed tangential to many artists.

Theorist and art historian Jack Burnham's *Beyond Modern Sculpture: The Effects of Science and Technology on the Sculpture of This Century* (1968) and *The Structure of Art* (1971) proposed new frameworks for how artists and students might think about the creation and critical evaluation of art. Burnham's argument—that the

concepts in contemporary sculpture were problematic and that traditional aesthetics were limited or flawed—echoed in a different way, what was proposed by Conceptual Art. In 1968, Burnham wrote: "We are in transition from an *object-oriented* to a *systems-oriented culture*. Here change emanates, not from *things*, but from *the way things are done*." [7]

MAINSHOCK
the largest earthquake in a sequence, sometimes preceded by one or more foreshocks, and almost always followed by many aftershocks

By the end of the 1960s, Conceptual Art and Minimal Art were changing the values of traditional aesthetics. Conceptual artists rejected the formal and traditional qualities of the art object as a commodity. The attention given by artists to the essential components of creation progressed naturally to encompass the presentational framework for how work would be seen. Artists became dissatisfied with the traditional austerity of the "white cube"—gallery or museum exhibition space—and moved towards installations that controlled or directed the way that something was perceived. Earth art departed from building interiors altogether, and were direct alterations of the landscape. "Sound art," the creation of acoustical phenomena as an experience in space, also emerged as specialized equipment became more readily accessible.

[7] Burnham, Jack, *Great Western Salt Works*, New York, George Braziller, 1974, page 16. "Systems Esthetics" originally appeared in Artforum 7:1 (September 1968): 30–35, p 31.

New technology and its implications for art were amplified in Gene Youngblood's *Expanded Cinema* (1970). Ursula Meyer's *Conceptual Art* (1972) codified these new art activities and actions that survived only through oral description or were occasionally written about in art periodicals. Installations, as well as conceptual performances and earthworks, were predominantly temporary and often inaccessible. Photographs, text, and, to a minor extent, video and film were commonly used to document these kinds of art. Photographs are optical records that report a secondary level of information, as compared with the primary experience of being in the presence of the art itself. Conceptual Art became known through these secondary experiences, which enhanced its allusive aura and had a subsequent impact on fine art photography. *Art and the Future* (1973), by Douglas Davis, traced artistic exploration of ideas and works outside the studio, and prophetically identified that thought, social involvement, and technology would be integral elements of art at the end of the twentieth-century. These books codified or formed a basis for intellectual discussions about art, and encouraged artists to reference ideas in making their work.

Historically, artists have organized in guilds or associations for purposes of support. The present-day incarnation of public art museums were developed in the nineteenth century, and they fostered a schism between artwork made as craft, and artwork created in pursuit of innovative and avant-garde ideals. At the beginning of the twentieth century in the United States, educational programs directed artists toward the world of galleries, museums, and collectors. There were limited opportunities for the financial survival of fine arts organizations that appeared to be in competition with these structured businesses of art, even after WW II.

The postwar emergence of artist organizations intended to support specific types of art was pioneered in the Bay Area by Tom Marioni, curator at the Richmond Art Center in 1968–71 and founder of the Museum of Conceptual Art (MOCA) in 1970. Marioni organized challenging and startling exhibitions of conceptually based installation artists and performance artists at both locations, even as he continued to make his own artwork. Rather than describe an artist's activity as performance, Marioni and others preferred the term *action,* in part, as delineation from artistic performance motivated by dance or theatrical traditions. This was consistent with his conception of "performance is sculpture evolved into the fourth dimension."[8]

Marioni consistently supported the works of Bay Area conceptualists Howard Fried, Paul Kos, and Terry Fox, and also presented notable artists such as Chris Burden, Linda Montano, Barbara T. Smith, and Bonnie Sherk. In 1969, in an otherwise empty gallery at the Richmond Art Center, Fox shaped one-and-a-half tons of dirt into an eleven-and-a-half-foot square for a piece entitled *Levitation*. He drew a circle in the dirt with his blood, of a diameter equal to his height, and then lay on his back for six hours in the circle, holding four fifty-foot-long tubes, filled with blood, urine, milk and water, while he tried to levitate. Viewers, allowed in the gallery only after Fox left, could see the imprint of his body in the dirt and read Marioni's two-page description. MOCA, located at 75 Third Street above Breen's Bar and Restaurant, which provided dual service as reception center and artist's saloon, was a "specialized sculpture action museum," directing the exhibitions towards conceptual actions and away from static objects. From 1973 until the space closed in 1984, MOCA presented performances by sculptors, situational works, and social activities. The performances by sculptors were based on various themes, including sound, comedy, time, radio, television, and the body. Paul Kos, one of ten artists represented in *Sound Sculpture As,* the inaugural exhibition, created *The Sound of Ice Melting*. Eight microphones were aimed at two twenty-five-pound blocks of ice and electronically recorded the faint sounds of the blocks as they changed from solid to liquid. Marioni presented exhibitions only when there were works or artists he felt compelled to show. MOCA remained dark for periods of time, which were opportunities for socializing with friends and whoever showed up for free beer on Wednesdays.

Exploring psychological states and social interactions in sculpture, performance, installation, and video, Howard Fried founded the San Francisco Art Institute performance and video department in 1977. Developing pieces over long periods of time, he defines a series of problems and conditions and then constructs physical metaphors for psychological attitudes. *Synchromatic Baseball* (1971) took place on his studio rooftop at night, using tomatoes in place of baseballs.

[8] 1979 Manifesto in *Tom Marioni: Sculpture and Installations, 1969–1997.* (San Francisco: self-published, 1997): p.13.

Twenty invited people were divided into the Dommy and Indo teams, with Fried alternating between pitching and catching. He didn't reveal that participants were assigned to a team based on that person's relationship to him and whether they were dominant or indominant (submissive). The Dommies played dynamically, and the Indos displayed a lack of organization and leadership—much as he suspected. The game was suspended when Fried fell through a skylight, badly cutting both arms—but resumed when he returned.

In the early 1970s, studio art programs in West Coast educational institutions embraced new ideas, with discussions about conceptual theory and investigations of "new" genres such as video, photography, and performance. There was a heightened awareness of the environment for presenting art. Conceptual artists in the Bay Area—Fox, Fried, Kos, and Marioni—were creating actions that might engage a particular environment and only produced a symbolic residue of the action, or nothing at all. Confronted with the sterile artificiality of white walls commonly utilized by institutional presentations of art, David Ireland's development of an attitude that balanced the physical activity of a process—an investment of time, energy, thought—with what was produced by that activity, appears quite reasonable. Ireland and other conceptually oriented Bay Area artists were not bound to the traditional exhibition system of gallery and museum venues, and took advantage of many other opportunities for the creation and presentation of artwork.

In the expansive cultural climate that existed across the U.S., the new medium of video was treated seriously through major initiatives in two cities: Boston and in San Francisco.[9] In San Francisco, the Experimental Television Project (1967–69; renamed National Center for Experiments in Television, 1969–75), was housed at KQED-TV studios. An artist-in-residence program provided selected artists access to the television studios, equipment, and press passes. Unconventional experimentation was encouraged from the beginning, and although the NCET was not the sole reason for the growing use of video by Bay Area artists, it was an unusual and stimulating precedent.

In late 1967, artists started to videotape performances. Ant Farm, Video Free America, and performance group T.R. Uthco[10] also began sponsoring multimedia events. Based around playing recorded and live video feeds, these video "happenings" explored synesthetic experiences through the addition of sound, slide projections, light

[9] The initiative was carried out in Boston through television station WGBH, Contemporary Art Fund, and the Massachusetts Institute of Technology Center for Advanced Visual Studies. Boston attracted a group of internationally recognized artists including John Cage, Peter Campus, Allan Kaprow, and William Wegman through more funding, different technical opportunities, and close proximity to New York. By contrast, The TV Lab at WNET in New York City did not begin until 1972. Kathy Rae Huffman, "Video Art: What's TV Got To Do With It," pp. 81–90 in *Illuminating Video, An Essential Guide to Video Art* (San Francisco: Bay Area Video Coalition; New York: Aperture, 1990): 82, 85.

[10] Chip Lord, Doug Michels, and Hudson Marquez, architects and conceptual artists from Texas, were Ant Farm (1968–78), and were active in the Bay Area through the 1970s. Lord (1944–) continued to make videos and video installations through 1993. Since the mid-1990s, he has worked with digital photographic images, text, and video segments, which are exhibited and available as Web-based experiences. He teaches at the University of California at Santa Cruz.

Video Free America (1970 to the present) is Skip Sweeney; he and Arthur Ginsberg worked together in the early 1970s.

T. R. Uthco (1973–78), "truth company," consisted of Doug Hall, Jody Procter, and Diane Andrews Hall. T. R. Uthco and Ant Farm collaborated for *The Eternal Frame* (1976), a film reenactment of President John F. Kennedy's 1963 assassination, which combines archival footage with actors in a docu-drama. Hall (1944–) worked in performance until 1983, and video until 1990. Since 1990, he has made large-format photographs based on conceptual themes. He has taught at SFAI since 1981, and was co-editor with Sally Jo Fifer of *Illuminating Video.*

shows, and spontaneous performances, occasionally using drugs as a catalyst.[11] The inherent transitory qualities of performing arts—being temporal, spatial, experiential, and non-material—were spilling over into the visual arts. As art historian Marita Sturken observed, "Video art was introduced at a time when the art world was undergoing upheaval, as artists questioned the traditional art-object through non-marketable forms such as performance, conceptual art, earthworks, and body art."[12]

Lynn Hershman forged a seminal path in Bay Area art during the 1970s and 1980s, exploring identity and personal empowerment, especially of women, through sculpture, installations, and the extended performance action *Roberta Breitmore* (1975–78), a fictional persona who participated in real-life scenarios. In 1975, she founded The Floating Museum, and through 1979 organized presentations by artists in public spaces. In the late 1970s, Hershman began making videotapes, and created the first interactive videodisk by an artist, *Lorna* (1979–82). Known primarily as a video artist, Hershman works in other media, including photography and feature film, and her investigations of the ways that technology impacts personal experience are unparalleled.

Many of the new types of art produced in the late 1960s and early 1970s did not readily fit into the conceptual and physical capabilities of exhibition programs. The site-specific, often labor-intensive character of installations rendered most of them too massive or complicated for commercial viability. For example, early in the medium's life, most museums lacked a knowledgeable curator or the expensive equipment necessary to present video. New genres were typically not supported by museums, and the resources at educational institutions were limited. Even photography was slow to gain widespread museum acknowledgment as fine art.

In the mid-1970s, the limited exhibition opportunities at museums and commercial galleries, the increasing number of artists graduating from universities and art schools, and the growth of new genres such as installation, performance, and video contributed to the formation of nonprofit alternative art organizations across the country. This development can be traced in part, to the establishment of several national agencies, including the National Endowment for the Arts, which gave fellowships to individual artists, supported catalogue publications and new genre, and made grants to alternative spaces. Artists banded together and set up nonprofit organizations that provided space and opportunities (money, equipment, staff) for performances, exhibitions, installations, lectures, and communal support.

[11] Investigations of sensorial experiences, as contrasted with identifiable social or cultural issues, are typical of initial artistic forays in a new technology or medium. Compared to present-day capabilities, early video equipment was very expensive, heavy, and technically restricted. Tape stock was only black and white, serial (time-based) due to editing limitations, displayed on small monitors or black and white television sets—and rarely broadcast.

[12] Marita Sturken, "Paradox in the Evolution of an Art Form: Great Expectations and the Making of a History," pp. 101–121 in *Illuminating Video, An Essential Guide to Video Art* (San Francisco: Bay Area Video Coalition; New York: Aperture, 1990): 107.

More than ten nonprofit art organizations in the Bay Area have survived for at least twenty years, and over half support film, video, and still photography.[13] This longevity and the relatively high number of nonprofits with overlapping missions suggest mature administrations that have strong boards of trustees, who are able to keep exhibitions and programming relevant for artists and audience, and can successfully cultivate ongoing financial support. This reveals a generally supportive environment, but after twenty-five years, it also indicates that mainstream institutions are not addressing the needs of certain types of work.[14]

[13] The remaining organizations either offer services aimed at a specific community or support for emerging artists. They include: San Francisco Cinemateque (1961), Bay Area Video Coalition (1975), Film Arts Foundation (1976), Pacific Film Archive (1971), Artists Television Access (1982), San Francisco Camerawork (1974), New Langton Arts (1975), Southern Exposure (1976), ProArts (1974), SomArts (1975), Precita Eyes (1975), and Galeria de la Raza (1975).

[14] Nonprofits provide support for minority artists and types of work that might otherwise be ignored by mainstream institutions (galleries, museums, and financial resources). It can be argued that their continued existence helps perpetuate the conditions they are trying to alleviate, by relieving institutions of the obligation or desire to expand the scope of their programs.

From the day that he first landed in San Francisco, Bruce Conner defied categorization through exploring different media, and producing an ongoing series of unconventional conceptual actions; his art exemplifies what confounds traditional art institutions and spurs the need for artist-run alternatives. Crafting an ambiguous artistic identity, while steadfastly maintaining the autonomy of his artwork, he has fashioned fictional biographies, periodically refused to sign pieces, and challenged adoration of the famous artist. In 1964 he produced "I AM BRUCE CONNER" and "I AM NOT BRUCE CONNER" buttons for a proposed convention consisting only of people named Bruce Conner. "Bruce Conner Makes a Sandwich," describing his culinary creation of a peanut butter, bacon, Swiss cheese, banana, and lettuce sandwich with butter and Miracle Whip, appeared in the September 1967 *Artforum. PRINTS* (1974) includes his handprints and fingerprints in a steel lockbox. *ANGELS* (1972–75) are a series of life-size photograms. He photographed the Bay Area punk scene in the late 1970s, and later incorporated the images in mixed-media collages. The 2002 inaugural presentation of his 16-millimeter films transferred to DVD accompanied a gallery exhibition of works by ANON, Anonymouse, Anon. and Anonymous. As James Johnson has written about his engraving collages, "Appropriated imagery, commercial techniques, and commentary concerning social and sexual topics are all benchmarks of Conner's work. They are also defining characteristics of post-modernist art. Bruce Conner is a bridge between the two periods, a product of the earlier and a progenitor of the later."[15]

[15] James W. Johnson, *BRUCE CONNER: ENGRAVING COLLAGES 1961–1995.* (Wichita, Kansas: Wichita Art Museum, 1997): p.4.

CORE
the innermost part of the earth

The multidisciplinary and cross-disciplinary approaches that progressively appeared in art throughout the 1970s were exemplified by an increasing invocation of postmodernism. Originally coined in 1949 to identify a stylistic development in architecture, postmodernism is a philosophically critical reaction to the absolutist claims of modernism, and is a synthesis of traditional styles or techniques. The term was later applied to literature and appeared in critical art discourse during the 1970s, along with ideas that American art critics and theorists derived from contemporary French philosophy. During this period, art theory was increasingly used by artists as the inspiration or rationale for work, which was a plausible progression following the ideation of Conceptual Art. The increasing postmodern approach in art coincided with the growth of various forms of artistic support, not only through nonprofit organizations but also the maturation of exhibition programs at universities and smaller institutions, and unusual opportunities of residencies and art-making collaborations.

Photography has been a distinctive facet of Bay Area history for more than 125 years, and Group f/64 was formed in 1932 by Ansel Adams, Imogen Cunningham, Sonia Noskowiak, Edward Weston, and Willard Van Dyke among others, to advocate modern artistic practice of the medium.[16] Adams organized the San Francisco Art Institute photography department in 1946, and nationally or internationally renowned photographic artists such as Minor White, Edward Weston, and Imogen Cunningham either taught there or at other Bay Area schools. Outside the educational system, two local programs made influential contributions to shaping photography: San Francisco Camerawork and the San Francisco Museum of Modern Art. SF Camerawork (1974) gained national attention in the late 1970s and early 1980s through exhibition lectures and publications emphasizing interrelationships between photography and language, which were largely generated by Lew Thomas conceptual artist and founder of NFS press.[17] Van Deren Coke, director and curator of the San Francisco Museum of Modern Art photography department from 1979 to 1987, organized a stream of exhibitions featuring contemporary work by many California photographers, including Linda Connor, Judy Dater, Richard Misrach, Larry Sultan, Catherine Wagner, and Henry Wessel. Coke also researched and presented seminal, overlooked German photography from the 1930s and these photography

[16] Other members were Consuela Kanega, John Paul Edwards, Henry Swift, Preston Holder, Alma Lavenson, and Brett Weston.

[17] Thomas was on the board of directors from the mid-1970s to early 1980s. He was part of an informal gathering of photographers who irregularly met in Richard Misrach's studio and included Sam Samore, among others. He was responsible for *Photography and Language* (1976), *Eros and Photography* (1976), *Photography and Ideology* (1977), *Gay Semiotics* (1978), *Structuralism and Photography* (1979), and *Still Photography: The Problematic Model* (1981), and revived critical attention for photographer John Gutmann's work. Ref. in Anne Wilkes Tucker, *Crimes and Splendors: The Desert Cantos of Richard Misrach* (Boston, Mass: Bulfinch Press; Houston, Tex.: Museum of Fine Arts, 1996): p. 33, 181. SFCamerawork executive directors have been Craig Morey, June Poster, and Marnie Gillett since 1984.

exhibitions and publications were a major reason for national art periodicals focusing attention on West Coast art in the 1980s.

Strong collections and excellent exhibition programs can be found at Stanford University, Mills College, San Jose State University, University of Santa Clara, and the Berkeley Art Museum (formerly the University Art Museum), among many other educational institutions. The Berkeley Art Museum houses the Pacific Film Archive, which annually screens over six hundred films and videos and has a world-renowned comprehensive film library. The Matrix exhibition program, begun in 1978, presents new or unconventional art, in addition to an ongoing program that brings attention to previously overlooked historic material. The Oakland Museum of California has a notable collection of California art, houses the Dorothea Lange Archive, and exhibits the work of Bay Area artists. The San Jose Museum of Art has a strong record of exhibiting Chicano and emerging and mid-career artists, and in the 1990s aggressively made contemporary acquisitions. The area's economic boom led to the creation of a charter group that sponsored free admission—a major accomplishment for a significant metropolitan museum.

Two other forms of support for artists have flourished—residencies and collaboration. Residencies are supported through a variety of circumstances at nonprofit organizations, in rare instances at corporations, and may offer exceptional opportunities to stimulate creativity. Among these are the Djerassi program in Woodside, and the Villa Montalvo program in Saratoga. Hundreds of exhibits at the Exploratorium, an interactive science museum in San Francisco near the Golden Gate Bridge, demonstrate and explain principles of the natural world. Its residency program for artists encourages research and experimentation and brings them together with scientists and staff, in addition to participating in programs for visitors.

Since 1986, the Headlands Center for the Arts has emphasized interdisciplinary and interdependent study, annually inviting up to thirty artists—painters, writers, sculptors, storytellers, and woodcarvers, among them—for residences, lectures, performances, and exhibitions. The HCA, occupying former military property in a coastal wilderness area of the Marin Headlands, is indicative of major changes in land use that have occurred around the Bay Area, through gradual withdrawal of the military since the early 1980s.[18] HCA actively maintains involvement with environmental artists and community-based projects, which have occurred since the earliest in-house artist residencies including David Ireland (1986) and Mark Thompson (1986).

[18] HCA was conceived through a planning process that transferred the former military property of Fort Barry to the National Park Service. More than a dozen major stations, forts, airfields and bases existed prior and during the twentieth-century, and the closing of many sites has affected the region's demographics, population, economy—and the arts.

PAIR—PARC Artist in Residence Program—is one of the most advanced collaborations between artists and scientists. Located at Xerox PARC (Palo Alto Research Center), PAIR encourages research that will advance technology and art through one-on-one matching of midcareer artists with scientists and researchers. The team of Margaret Crane and Jon Winet worked in the program for several years, refining their web-based artwork. As a requirement intended to foster collaboration, artists must live in the Bay Area in close proximity to the facility. The program is generally limited to fewer than fifteen artists, as the collaborations are allowed to proceed indefinitely.

Collaboration is one way of transcending barriers, and whether the phalanx of artist-engineers commandeered by SRL, marginalized social constituencies addressed by Suzanne Lacy, or the cinema collaborative Silt, Bay Area artists increasingly made use of collaboration as a creative means to achieve more (ideologically, practically) than is possible working alone.

Since the early 1980s, public art has offered a different type of collaboration for artists. Public art can be broadly separated into two categories that are differentiated by the funding source, between the private and public sectors. Civic public art is funded, selected, and administered through civic local or regional government agencies, and at very least is an active urban dialogue that immerses artists in collaboration.[19] The process can be as important as the product, which can involve multiple reviews of proposals by the users of a facility, surrounding community, and from architectural design and construction teams. Commissioned artists explain their project proposals at every stage and experience new forms of collaboration that frequently require negotiation or compromise to adapt their ideas into the practicalities of budget, architectural design, and use of the space. In the process, artists experience interactions with the world-at-large that cannot occur in any other fashion.

Since the mid-1980s, the most vigorous programs in Northern California have been in San Jose and San Francisco. The Public Art Program of the San Francisco Arts Commission has made over one hundred commissions since 1984 and directed millions of dollars to public artwork, including works by Lewis de Soto, Mildred Howard, Ned Kahn, Alice Aycock, Nayland Blake, Ann Chamberlain, and Ann Hamilton. Downtown San Jose—rebuilt during the corporate business frenzy in Silicon Valley in the 1990s, and surpassing San Francisco in population in 1989—and the surrounding landscape was dramatically altered by the building of numerous technology corporate campuses such as Applied Biosystems, Sun Microsystems, Xerox, Cisco Systems, and Fujitsu, among many others. The San Jose Arts Commission has

[19] Public art can be more than extravagant architectural enhancement when services—such as education, dance, music, theater or poetry readings—are eligible expenditures, in addition to physical art. Mandated by civic (local, state, federal) law, and commonly generated by above-ground construction, the underlying premise for this mitigation is that new construction brings new employees and users to an area and places greater burdens on the existing infrastructure. Programs and obligations vary by individual municipalities, and .5 to 1 percent of construction valuation are the typical range and methods of assessment.

funded more than five million dollars toward public art projects, including works at municipal facilities by Mel Chin, Douglas Hollis, Anna Valentina Murch, and Nobuho Nagasawa.[20]

SEISMIC ZONE
an area of seismicity probably sharing a common cause

The South of Market area (SoMa), a few blocks from the active social and economic center around Union Square in downtown San Francisco, was targeted for redevelopment in the early 1950s. The San Francisco Redevelopment Agency declared it a "blighted area" in 1954 after some political wrangling. The subsequent destruction of buildings, along with the displacement of people, was a long, contentious, and painful process that stirred social consciences across the city. Twenty years later it had deteriorated into a skid row of SRO residential hotels. The first major construction project in SoMa was the Moscone Convention Center (1981), but refilling the empty lots in the surrounding blocks with new buildings was largely delayed for the next fifteen years.

Following the Loma Prieta earthquake in 1989, a swarm of new artist-run alternative spaces emerged in SoMa and the Mission district. The Yerba Buena Center for the Arts, across the street from the Moscone Center in Yerba Buena Gardens, opened in 1993 with a 757-seat theater and 6,700-square-foot multi-use event space on a five-and-a-half-acre site with garden and outdoor sculpture. The center, charged with serving the Bay Area's diverse cultural population, offers programming that includes visual arts, performing arts, film, and video.[21] The remaining structures in the complex were completed over the next several years, and by 1999 the landscaped grounds were being used several hundred times a year for events. The San Francisco Museum of Modern Art opened its new building, designed by Mario Botta, on January 18, 1995. The museum's 1992 groundbreaking prompted a frenzy of building and seemed to signal another phase in the city's life—a competition for space. The California College of Arts and Crafts began occupying a renovated SoMa bus depot in 1998. Commercial galleries, most of them clustered downtown north of Market Street, were also drawn to SoMa. By 1999, an institutional nucleus consisted of the Yerba Buena Center, the San Francisco

[20] One of the highest public art percents in the United States, the San Francisco ordinance requires 2 percent of the construction costs of civic buildings, transportation improvement projects, new parks and other above-ground structures, such as bridges, to be allocated for public art. San Jose enacted a public percent for art requirement in the 1980s, and later approved a private percent for art ordinance.

[21] The San Francisco Redevelopment Agency, using funds from private development in the Yerba Buena Gardens district, built the Yerba Buena Center for the Arts. The Agency partially supports maintenance operations, and the Center is responsible for the artistic and educational programming costs.

Museum of Modern Art, California Historical Society, the Ansel Adams Center of the Friends of Photography, and the Cartoon Art Museum,[22] and was surrounded by trendy restaurants, new hotels, businesses—and, of course, coffee bars.

The San Francisco Museum of Modern Art has strong design, photography, and painting departments, and obtains a majority of the major exhibitions traveling to the area. However, it has been wracked by a roller-coaster ride of pivotal administrative staff changes since the early 1990s.[23] Two of the four major museum relocation projects in the City, each headlined by an internationally renowned architect, are planned for SoMa: the Jewish Museum, designed by Daniel Libeskind, and the Mexican Museum, designed by Ricardo Legorreta. The Asian Art Museum-Chong-Moon-Lee Center will be located in the old main public library in the Civic Center, which is being transformed by Gae Aulenti. Jacques Herzog and Pierre de Meuron are designing the new de Young Museum in Golden Gate Park.

The excited anticipation of these new structures masks an underlying weakness in the cultural fabric of the Bay Area. Museum collections have grown intermittently through purchases and donations from private collections.[24] These projects will improve museums already in existence—however, except for the Yerba Buena Center, no major new art institutions have appeared since 1980. New construction has been diverted into technology and entertainment complexes—such as Metreon—which are generally aimed at tourism, San Francisco's number one industry.[25] They also reflect a trend in architecture to reinterpret any kind of public or private space as a theme park on the order of Disneyland or Las Vegas.

[22] The Ansel Adams Center of the Friends of Photography was part of this institutional core. Founded in 1967, the Friends of Photography moved from Carmel to SoMa in 1989. It suddenly closed in October 2001 under $1.5 million debt. Ironically, *Ansel Adams at 100* was simultaneously a blockbuster exhibition at SFMOMA around the corner. The Cartoon Art Museum currently occupies the space that the Ansel Adams Center used to inhabit.

[23] The untimely death of popular and respected curator John Caldwell in 1993 stunned SFMOMA and the art world. Gary Garrels, the lauded replacement, then left in 1999 for MOMA in New York. David Ross arrived as director in 1998, aggressively made acquisitions—and then abruptly resigned in August 2001, to "make some money" as the director of Eyestorm, an online art vendor based in London.

[24] Phyllis Wattis (b. 1905), easily the single greatest philanthropic force for the arts in the Bay Area, has donated more than $150 million since 1970 to area institutions including the SF Opera, SF Symphony, de Young Museum, Berkeley Art Museum, and SFMOMA. She was largely responsible for SFMOMA's purchases of major artworks at auction in the late 1990s. Other notable donors to the visual arts include Donald and Doris Fisher (The Gap) and Levi Strauss heirs, Peter and Mimi Haas. The San Jose Museum of Modern Art received a considerable gift of sixty works from Katherine and James Gentry in 1998.

[25] Metreon, a Sony Entertainment Center, opened in June 1999 and is the only commercial portion of Yerba Buena Gardens. At its inception it housed: fifteen movie theatres, the City's first IMAX theatre, eight restaurants, shops, and three state-of-the-art "playspaces" with interactive games and visuals. Participating sponsors and partners included Microsoft Corporation, Intel, Pepsi, Levi-Strauss & Co., and Citibank, among others.

HYPOCENTER
the point within the earth where an earthquake rupture begins

"... there have always been two kinds of original thinkers, those who upon viewing disorder try to create order, and those who upon encountering order try to protest it by creating disorder. The tension between the two is what drives learning forward." —E. O. Wilson[26]

The San Francisco Museum of Modern Art groundbreaking was a symbolic activity with two participants representing traits of Bay Area art—individual and collaborative, cool and hot, intellectual and visceral, measured order and unpredictable chaos. These descriptive qualities explain each artwork in compelling ways. The use of polarity as a trope conveniently separates everything into complementary opposites. Order implies a structured way of viewing the world, and chaos suggests the opposite, being defined as "without order or apparent connection." However, current scientific chaos theory proposes that patterns will become discernible if the scale of observation is greatly increased or decreased.

[26] Wilson, Edward O. *Consilience: The Unity of Knowledge.* (New York: Vintage, 1998): 47.

Art is both a product and a part of culture, and there is no culture without community. Recent considerations of history, especially since the beginning of the twentieth century, frequently look beyond individual achievements and evaluate the cumulative effect of group interaction. Applied to the art world, this idea suggests that the cultural consequence of contemporary art is not dependent as much on individual objects as on the cumulative effect that such objects and the artists themselves have on a community. The emergence of developments or styles cannot be traced to a single work or artist. Nor can the vernacular distinctions of Bay Area art be conveniently reduced to yin-and-yang polarities. An interconnected web of support embraces educational institutions, commercial galleries, museums, and nonprofit organizations, which move into a community and become part of it—or create a new community.

Synthesis is a combination of diverse elements into a whole. It is not limited to what can be physically verified and may involve transitory or invisible forces—like the performance action of a conceptual artist, or the causes contributing to an event in a seismic zone.

—Mark Johnstone

RAY BELDNER

Ray Beldner investigates how humans manipulate their environment according to their needs, delving into such topics as their relationship with the natural landscape and the impersonal social exchanges of corporate capitalism. Although he is principally trained in painting and printmaking, his work in graduate school became increasingly reductive and dimensional. It became clear to him that his passion was for sculpture and installation, not the two-dimensional world of painting.

Beldner views the late twentieth-century landscape as altered, compromised, and commodified by humans. His work through the mid-1990s depicts, as he describes, "a landscape formed in man's own image: groves of suit trees, mountains of shoes, a dried lake briefcase, an artificial reflecting pool of inorganic chemicals." In a 1992 solo exhibition, "Landscapes and Dark Suits," he explored this uneasy relationship between nature and society, suggesting how humans shape the world to fit their needs. Men's suits were draped over old-fashioned telephone stands to create an eerie grove of trees. This cluster of suited structures indicted both human manipulations of the natural world and the depersonalized corporate environment.

A self-proclaimed dumpster diver and scavenger, Beldner uses recycled and secondhand materials: business suits, ties, glass bottles, aluminum cans, telephones, army boots, Styrofoam peanuts, paper, wood, wax, tar, and twine. He celebrates the aesthetics of their banality, often adding movement or sound to an installation through elaborate mechanical means. In *Crying Hats* (1999), wine circulated through a piping system and slowly dripped from the brims of fedoras arranged across a gallery wall. His choice of wine—rather than water or another clear liquid—made the installation visually striking. It also reinforced a sad, empty feeling about the fedoras, perhaps of regret for humanity lost in a world of power. As with most of his works by the late 1990s, this installation avoided any explicit representation of the landscape and used banal objects and materials rife with symbolism.

Beldner turned to the corporate manipulation of humans in *Untitled (Wax Shirt Installation)* (1998). Twenty-five starched, white business shirts were folded identically, encased in beeswax, and individually placed in a steel framework as if displayed for sale. Evenly spaced on the wall in a grid of five horizontal rows and vertical columns, the shirts created a visual system of conformity. Yet Beldner subtly subverted this system by allowing a bit of the shirts, each in a different way, to show through the wax. The installation poignantly illustrated the struggle for individuality in modern society and implied an innate resistance to being a mere cog in the corporate machine.

Beldner has also turned a critical eye on the art world. In works dating from 1999 (perhaps not coincidentally overlapping with

RAY BELDNER (B. 1961, SAN FRANCISCO, CALIFORNIA) STUDIED PAINTING AND PRINTMAKING AT SAN FRANCISCO ART INSTITUTE (BFA, 1986), THEN ENROLLED IN THE GRADUATE PROGRAM AT MILLS COLLEGE IN OAKLAND (MFA, 1989). IN ADDITION TO HIS GALLERY INSTALLATIONS, BELDNER HAS COMPLETED NUMEROUS PUBLIC ART COMMISSIONS INCLUDING *GARDEN* (1999), A COLLABORATIVE ENDEAVOR WITH LANDSCAPE ARCHITECT LORETTA GARGAN AND TEACHERS AND STUDENTS AT THE FRANCISCO MIDDLE SCHOOL IN SAN FRANCISCO. ANOTHER 1999 PROJECT COMMEMORATED WORLD WAR II SHIPYARD WORKERS IN RICHMOND, CALIFORNIA. IN 1996, HE INSTALLED FIVE STEEL SCULPTURES, TITLED *PLAYLAND REVISITED*, FOR THE SAN FRANCISCO MUNICIPAL RAILWAY. THE SCULPTURE GARDEN PAYS HOMAGE TO THE FORMER AMUSEMENT PARK PLAYLAND AT OCEAN BEACH. BELDNER LIVES IN BRISBANE AND MAINTAINS HIS STUDIO IN SAN FRANCISCO.

his work for an online art retailer), he explores the theme of the long-standing relationship between art and money. On one level, he is critiquing society's tendency to equate the value of an artwork with its monetary worth. Literally giving form to this idea, he meticulously and obsessively cuts and stitches together dollar bills to create works in the image of modern masterpieces. He arranges the colors, patterns, and textures of the dollar bills, in some instances creating three-dimensional understructures, so that the finished works mimic the originals. Beldner further ensures that the pieces will be recognizable by giving them cynical titles. *Three More Flags* (2000) appropriates Jasper John's 1958 *Three Flags*; *For a Song* (2000) is after *Elegy for the Spanish Republic* (1958) by Robert Motherwell; and the basis for *A Cash Gift* (2001) is Man Ray's *Gift* (1921).

The success of these pieces, as in all of his work, derives from a sense of humor, the use of unexpected materials, and the pleasurable resonance that is rewarded through close examination. By appropriating signature artists of the Modern period, he equates the institutional and commercial branding of art with the commercial branding phenomenon that has made tissue into Kleenex, photocopying into Xeroxing, and coffee into Starbucks. He subverts traditional gender roles by employing traditional women's handiwork to comment on the male-dominated world of art and power, and his slow, meticulous hand labor as an artist is carried out almost in defiance of an increasingly fast-paced, technologically enabled world.

Despite its serious undertones, Beldner's work often reveals a wry wit that only occasionally verges toward the cynical. His art is so resonant because it possesses a humor that even the indicted subjects of the pieces can appreciate. His use of humor transforms artistic and social themes that could be cliché into poignant commentary. As writer Bruce Nixon observed, Beldner's work is "like a tune you can't get out of your head."

SELECTED READING

COUNTERFEIT. WITH TEXT BY MARIA PORGES. SANTA MONICA, CALIF.: FRUMKIN/DUVAL GALLERY, 2001.

CHATTOPADHYAY, COLLETTE. "RAY BELDNER AT SHERRY FRUMKIN GALLERY." *ARTWEEK* 29, NO. 6 (JUNE 1998): 21–22.

GOLEY, MARY ANNE. *MONEY MAKING: THE FINE ART OF CURRENCY AT THE MILLENNIUM.* WASHINGTON, D.C.: FEDERAL RESERVE BOARD, 2000.

NIXON, BRUCE. "CORPORATE JESTER." *ARTWEEK* 25, NO. 13 (JULY 7, 1994): 20.

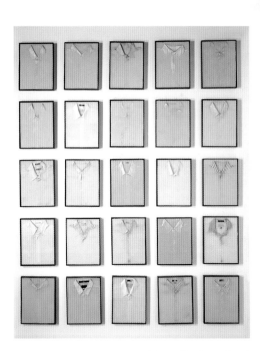

[installation view]

Untitled (Wax Shirt Installation), 1998
WOOD, METAL, SHIRT, WAX;
25 PIECES, 16³/₄" X 12³/₄" EACH

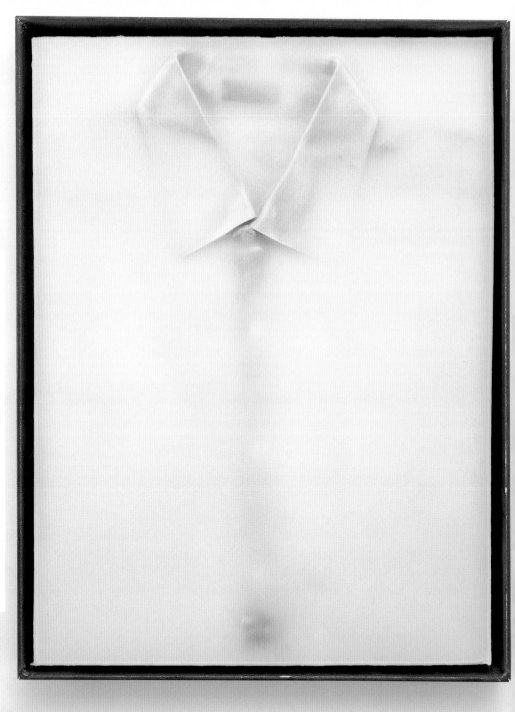

[detail]

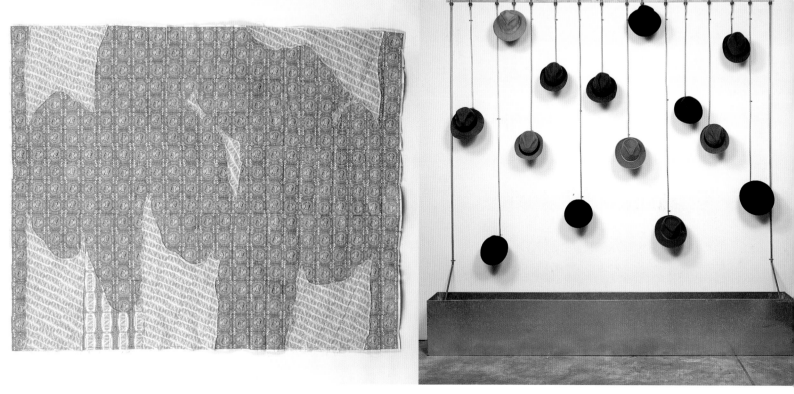

For a Song, 2000
SEWN DOLLAR BILLS; 38" X 48 1/2"

Crying Hats, 1999
METAL, COPPER, WINE, PUMP, MEN'S HATS; 10' X 10' X 18"

CHRISTOPHER BROWN

Primarily known for his figurative painting, Christopher Brown detoured into printmaking early in his career to challenge his sensibilities as a painter and achieve a fresh perspective on his work. He immersed himself in the printmaking process, experimenting, adding, erasing, and making use of the accidental. Printmaking enabled Brown to loosen up his painting process, and now, many years later, he works freely in both media. The desire for experimentation and a heightened awareness of the artistic challenge to continually produce fresh, interesting work led in the late 1990s to a seemingly sudden departure from representation in his painting and into an ongoing experiment with abstraction.

Brown reached the transition to abstraction rather naturally. In his figurative work, he had begun to play with formal abstract techniques; in his paintings by the late 1990s, he had subdued representation to the point of verging on the abstract. He explored rhythms and metaphors of sound and time through repetition of images and creation of patterns. He experimented with transmutation, making one form become another, then another. He established underlying structures to evoke an indeterminate sense of space and a distorted perspective.

Brown's prior work was concerned with history and memory. Moments from collective history, often captured by the camera, were a primary source. He chose potent photographic imagery loaded with historical content, from Abraham Zapruder's Super 8 movie frames of President John F. Kennedy's assassination, to clips from Russian film director Sergei Eisenstein's groundbreaking *Battleship Potemkin* (1925), to photos of President Abraham Lincoln giving the Gettysburg Address. Brown absorbed the visual information recorded in a photograph or stills from videos and films, scrutinizing them often over the course of years, and deconstructing them as the subject in his work. He worked with bits and pieces of a photograph, cropping or enlarging sections, isolating figures, altering perspective, or flattening space. His aim was less about appropriating images, in the postmodern sense, than about demonstrating the partial historical truths revealed, or hidden, in photographs.

In his figurative abstraction, Brown heightens a viewer's awareness of nostalgia through formal constructions. He often elevates the vantage point to suggest the broad, omniscient perspective one has in looking back on history. Objects placed in the foreground both suggest metaphor and create a screen, distancing the pictured historical events. Layered and blurred images suggest memory. Employing these formal strategies in *Odessa* (1993), Brown took inspiration from the film *Battleship Potemkin,* about a battleship crew's onboard rebellion and the subsequent slaughter of sympathetic citizens of Odessa. The film was noteworthy for Eisenstein's innovative editing techniques that established a sense of emotion; Brown echoes

the film's achievements in his painting derived from a famous sequence on the Odessa steps. The slightly elevated perspective shows the backside of a dozen sailors in white uniforms, with an emphasis on the round shape of their caps and the geometry of their bibs, as they move through a space filled with strong, black horizontal stripes suggestive of stairs. The figures, with only subtle differences in their poses, appear anonymous, as if images repeated on the canvas, and a blurred effect enhances the sense of looking back through dim memories.

Brown has always been preoccupied with differences between seeing and knowing. In his figurative work, he consciously sought to separate intellectual knowledge about an object, person, or scene from the literal, essential qualities of its shape, form, or color. Since the late 1990s, he has moved to the other side of this divide, purposefully painting not what he can see, but capturing what he intuitively knows and feels within himself, working without a defined goal or explicit intentionality.

CHRISTOPHER BROWN (B. 1951, CAMP LEJEUNE, NORTH CAROLINA) ATTENDED THE UNIVERSITY OF ILLINOIS AT CHAMPAIGN-URBANA AND STUDIED PAINTING (BA, 1972). HE WENT DIRECTLY TO GRADUATE SCHOOL AT THE UNIVERSITY OF CALIFORNIA AT DAVIS (MFA, 1973). BROWN HAS RECEIVED TWO ART CRITICISM GRANTS FROM THE NATIONAL ENDOWMENT FOR THE ARTS (1979, 1981). IN 1981, HE BEGAN TEACHING STUDIO ART AT THE UNIVERSITY OF CALIFORNIA AT BERKELEY, WHERE HE STAYED UNTIL 1994. OTHER AWARDS INCLUDE A NATIONAL ENDOWMENT FOR THE ARTS FELLOWSHIP IN PAINTING (1987) AND AN AMERICAN ACADEMY AND INSTITUTE OF ARTS AND LETTERS AWARD IN ART (1988). BROWN HAS COLLABORATED WITH PRINTMAKERS AT THE EXPERIMENTAL WORKSHOP AND CROWN POINT PRESS IN SAN FRANCISCO, PAULSON PRESS IN BERKELEY, AND THE TAMARIND INSTITUTE IN ALBUQUERQUE, NEW MEXICO. HE LIVES IN BERKELEY.

In the late 1990s, Brown began painting on individual sheets of paper, allowing color to assume a dominant role for the first time (color had been secondary in his prior work). Willing to accept whatever might develop through experimentation, Brown began almost randomly putting together individual sheets to form diptychs, and then worked with paint to unite the two disparate halves, in some pieces letting the dividing edges play a formal role, in others concealing them entirely. *On the QT* (2000) consists of a brushy blue background with bold oval shapes filled with white, dark blue, and green, and the numbers one through six scribbled in a row at one edge. Two sheets of paper have been visibly joined, and around the periphery of the painting exists a kind of record of its various permutations. Brown pays careful attention to the perimeter of a work. He allows the viewer to see the progression of an artwork in the narrow outside edge, by maintaining traces of the colors, forms, and brushstrokes from the various stages of its development. In *Persian Garden* (2000), Brown paints with thick, evident strokes, delineating swaths of greens, whites, and blues. As implied by the title, the brushstrokes, colors, and shapes come together to suggest an imagined landscape. Brown's foray into abstraction, whether enduring or temporary, reveals an artistic exploration of the pure, basic, formal components of painting.

SELECTED READING

BRENSON, MICHAEL. *HISTORY AND MEMORY: PAINTINGS BY CHRISTOPHER BROWN.* FORT WORTH, TEXAS: MODERN ART MUSEUM OF FORT WORTH, 1995.

CHRISTOPHER BROWN 1989–1990. WITH TEXT BY JOHN YAU. SAN FRANCISCO: GALLERY PAULE ANGLIM, 1990.

CHRISTOPHER BROWN: PAINTINGS ON PAPER. WITH AN INTRODUCTION BY ANDRIA FRIESEN. SEATTLE: FRIESEN GALLERY, 2000.

CHRISTOPHER BROWN: RECENT PAINTINGS. WITH TEXT BY JEFF KELLEY. SAN FRANCISCO: CAMPBELL-THIEBAUD GALLERY, 1993.

MAYFIELD, SIGNE. *CHRISTOPHER BROWN: WORKS ON PAPER.* WITH AN INTRODUCTION BY LINDA CRAIGHEAD AND AN ESSAY BY KARIN BREUER. PALO ALTO, CALIF.: PALO ALTO CULTURAL CENTER, 1995.

Persian Garden, 2001
ACRYLIC AND GOUACHE ON PAPER;
44" X 30"

On the QT, 2001
ACRYLIC AND GOUACHE ON PAPER; 44" X 30"

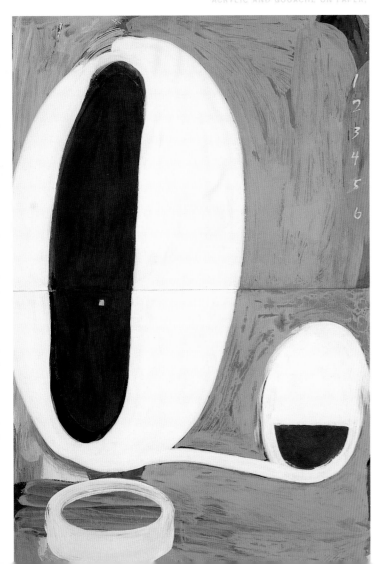

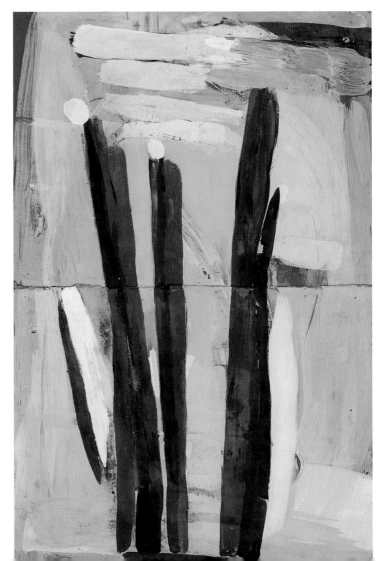

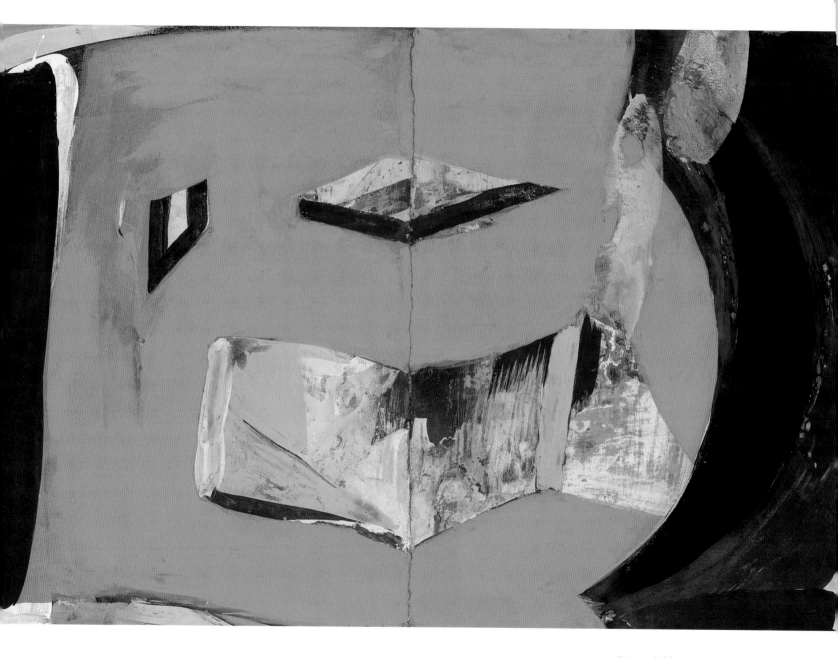

King of Siam, 2001
ACRYLIC AND GOUACHE ON PAPER; 30" X 44"

SQUEAK CARNWATH

One of the most **prolific painters** in the Bay Area, Squeak Carnwath fluidly articulates **universal themes** such as the **passage of time, conflict and tension** in human relationships, **loss, memory, mortality**, and the quest for self-identity or spirituality. An ability to record and express a variety of experiences and emotions, whether genuinely personal or fictitious, allows her work to resonate with the viewer. Carnwath translates this deeply intimate material into a compelling system of symbols and signs, images, and words that are drawn, scratched, and painted onto monumental fields of color. Whimsical touches in the work relieve the ever-present sense of uncertainty and anxiety, but never undermine their import.

Carnwath communicates through a deliberately naive and symbolic language that is scrawled in a childlike graffiti. Her keen choice of words and her expression of seemingly private emotions lend

a diaristic quality to her painting that provides an entry into the content. "It's painting that takes care of me," "By the way I'm fine," and "still searching" are scribbled among the text spread across *Happy Days* (2001). These phrases introduce the viewer to the feelings of someone (perhaps the artist) who is vulnerable and in need of security. Drawn in by these confessional and empathetic phrases, the viewer begins to discover other bits of text that reveal Carnwath's musings on the unknown threats that exist in the world. In a long, fifteen-line section of *Happy Days,* she ponders the discovery in humans of a potentially dangerous virus, possibly introduced through scientific experimentation. The text stands in ironic contrast to the title and, coupled with her diaristic "confessions," suggests anxiety about danger and disease outside of the small, safe microcosm of the studio.

Carnwath's attention to process is evident in the partial concealment of some words or letters by layers of glazes or paint. Under a block of gray, on which is written "Keep Close," is the barely decipherable outline of a house and a word that appears to be "safe." Faintly visible on the right side of the painting is "Sunday 18 February Balthus dead at 92." Other hints of letters or numbers remain illegible. This nebulous, ghostlike quality heightens the sense of uncertainty in her works and provides literal and intellectual depth.

SQUEAK CARNWATH (B. 1947, ABINGTON, PENNSYLVANIA) GREW UP IN VARIOUS LOCATIONS ON THE EAST COAST, MOVING FREQUENTLY WITH HER FAMILY. IN 1968 SHE SPENT A SUMMER AT THE AEGEAN SCHOOL OF FINE ARTS IN PAROS, GREECE. SHE THEN STUDIED AT GODDARD COLLEGE IN VERMONT (1969–70) BEFORE MOVING TO THE BAY AREA TO ATTEND THE CALIFORNIA COLLEGE OF ARTS AND CRAFTS (CCAC). AFTER A YEAR OF CLASSES (1970–71) SHE DECIDED TO PURSUE HER ART FULL-TIME, BUT CONTINUED TO WORK AS A SHOP MASTER IN THE CERAMICS DEPARTMENT. IN 1975, SHE RETURNED TO CCAC FOR GRADUATE STUDIES IN CERAMICS (MFA, 1977). CARNWATH STUDIED EUROPEAN ART AND ARCHITECTURE ON TRIPS TO FRANCE IN 1993 AND 1995. AMONG HER AWARDS ARE FELLOWSHIPS FROM THE NATIONAL ENDOWMENT FOR THE ARTS (1980, 1985) AND THE JOHN SIMON GUGGENHEIM MEMORIAL FOUNDATION (1994). CARNWATH TAUGHT AT THE UNIVERSITY OF CALIFORNIA AT DAVIS (1983–98) AND SINCE 1998 HAS BEEN A PROFESSOR IN RESIDENCE AT THE UNIVERSITY OF CALIFORNIA AT BERKELEY. SHE MAINTAINS HER STUDIO IN OAKLAND.

Commonly recurring images such as handprints, drinking glasses, beds, chairs, Buddhas, houses, and calendars act as visual clues to her private vocabulary. Carnwath also employs repetition as a formal device—numbers, color grids, compartments, bands, boxes, and rows of words—to emulate the rhythms and patterns of time. In *Happy Days,* she includes multiple tally-marks and lists the days of the week, making clear the inevitable passing of time and contributing to a sense of impending doom. Her practice of listing, counting, and naming objects also imbues them with significance, elevating them above the banal (as in "stand up and be counted").

Carnwath's paintings evidence a technical virtuosity, despite the feigned naiveté of some of her strategies. The intricacy and richness of the surfaces and her sophisticated handling of paint are not completely masked by her deliberately primitive images and lettering. The surfaces of the works radiate with light. Combining oil and alkyd, Carnwarth carefully works and reworks the surfaces, which are the products of layers of underpainting, to achieve a luminous, incandescent quality. The surfaces of her paintings betray her extensive background in ceramics and work in glass, as does the inclusion of forms that look like ceramic pieces—such as the rabbit that appears in *Happy Days* and numerous other paintings. She has also worked extensively in printmaking, which may be an inspirational source for her attraction to repetition and multiples.

Carnwath's private visions of contemporary issues take on a mythic significance in her art. Her marks serve to engage viewers intellectually; her gestures move them emotionally.

SELECTED READING

SQUEAK CARNWATH. WITH TEXT BY MARIA PORGES. NEW YORK: DAVID BEITZEL GALLERY, 1998.

CARNWATH, SQUEAK. *SQUEAK CARNWATH: LISTS, OBSERVATIONS AND COUNTING.* SAN FRANCISCO: CHRONICLE BOOKS, 1996.

SQUEAK CARNWATH: RELATIVE. WITH TEXT BY JAMIE BRUNSON. SAN FRANCISCO: JOHN BERGGRUEN GALLERY, 1997.

SQUEAK CARNWATH: SEEING IN THE DARK. WITH TEXT BY GAY SHELTON. SANTA ROSA, CALIF.: LUTHER BURBANK CENTER FOR THE ARTS, 1998.

UNDRAPED HUMAN BEING. WITH TEXT BY PAULINE SHAVER. SAN FRANCISCO: JOHN BERGGRUEN GALLERY, 1998.

Happy Days, 2001
OIL AND ALKYD ON CANVAS OVER PANEL;
70" X 70"

A Little Happy, 2001
OIL AND ALKYD ON CANVAS;
48" X 48"

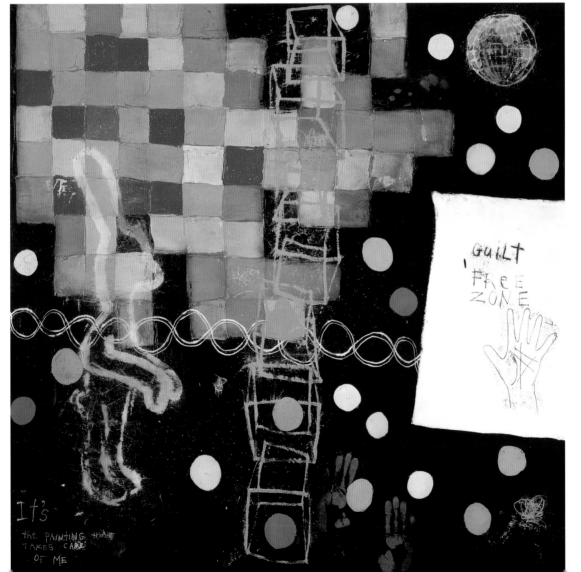

GUILT
FREE
ZONE

It's
the PAINTING THAT
TAKES CARE
OF ME

Calm Pieces, 2000
OIL AND ALKYD ON CANVAS;
10" X 10"

Calm Pieces, 2000
OIL AND ALKYD ON CANVAS;
10" X 10"

All Mysteries, 1999
OIL AND ALKYD ON CANVAS; 10" X 10" EACH PANEL

Numbered Moments, 2001
OIL AND ALKYD OVER PANEL; 24" X 24"

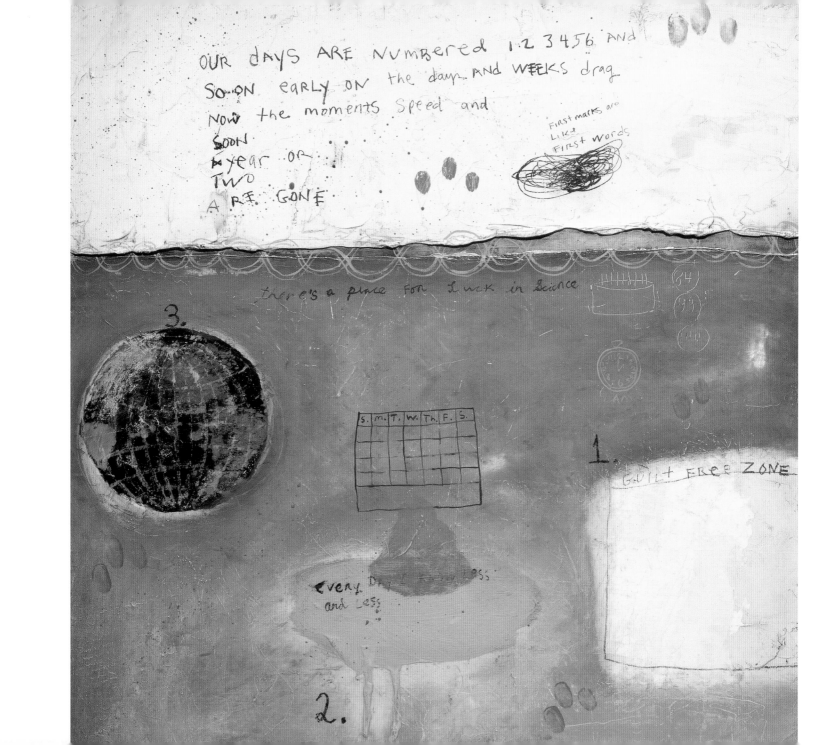

ENRIQUE CHAGOYA

In paintings, prints, and artist's books, Enrique Chagoya blends art and social history to counter Eurocentric political and cultural concepts and to address social inequities. He is a storyteller, a weaver of visual fables, which bring together widely divergent subjects, from cartoon characters to historical artifacts, in a collision of cultures and time periods to provoke viewers into thoughtful reconsideration of their personal values and assumptions about cultural and social history.

Chagoya's work looks at American culture from the outside while also reflecting an insider's intimate knowledge. His point of view on North American culture, and the five-hundred-year history of inter-action between Mexico and the cultures that descended upon it, devel-oped through a combination of personal experience and academic study. Born, raised, and educated in Mexico City, Chagoya moved to the United States in his mid-twenties and has lived here since. The disloca-tion that he has experienced is used to strong advantage.

In works of the 1980s, Chagoya frequently used cartoon characters, inspired by his introduction to North American culture as a child through comic books and movies. For Chagoya, the characters and narratives of cartoons often carried a subtext, such as Superman being a powerful, always triumphant Anglo-American. This theme diminished in emphasis in his work of the 1990s, but continues to appear predominantly in his prints and artist's books. As Chagoya's art has matured and broadened, it has gained complexity in conception and construction, and in the interweaving of political, social, cultural, and art historical themes.

Chagoya combines political commentary, popular culture, and history in *The Governor's Nightmare* (1994), a large acrylic and oil on paper. Seated around the blood-soaked altar-pyramid-throne of an Aztec god, a group of Aztec men eat various bloody organs and limbs. Chagoya created this work in the wake of anti-immigrant sentiment encouraged by the policies of former California Governor Pete Wilson, and was appropriated from surviving Mesoamerican depictions of Aztec life. The Indians eat parts typically offered at a present-day taquería (heart, tongue, brains), along with hands, ears, intestines, and genitals, at a feast in honor of their ruler, Mictlántecuhtli, Aztec Lord of the Dead. A beatific male Anglo face, which could be Governor Wilson, appears in one of the simmering cooking pots. The work is an outrageous fusion of Mexicans as primitives and cannibals. It under-scores fear of them to the point of outrageous absurdity: the Aztec god is preparing to eat Mickey Mouse garnished with two jalapeños. Chagoya satirically links the scenario with the Christian sacrament of Communion by including in the upper left corner a small version of eighteenth-century Mexican painter Juan Correa's *Allegory of the Sacrament,* depicting Christ squeezing a bunch of grapes growing from a vine in his heart and the drops being caught by a Pope in chasuble and miter.

For Chagoya, a dominant culture that borrows concepts from another culture is engaging in cannibalism, such as Modernist art appropriating African masks or Modernist architecture copying Mayan

motifs. He creates visual narratives, either singly or as series, that imagine different outcomes—a process he calls "reverse anthropology." The limited-edition books that he models on ancient Mayan codices are specifically intended to rewrite history. The surviving codices, primarily made before the arrival of Spanish conquistadors, are pictographic chronicles of events, rulers, and religious gods. Horizontally composed on long strips of *amate,* a bark paper, they can be read up and down or right to left. Chagoya's books—*El Regreso del Caníbal Macrobiótico* (1998), *Les Aventures des Cannibales Modernistes* (1999), *utopiancannibal.org* (2000), and *Abenteuer der Kannibalen Bioethicists* (2001)—are in accordion form, illustrated with color lithographs, woodcuts, chine collé, and collage, and also printed on *amate.* The accordion form provides a visual continuity that is not possible with a traditionally bound book and allows Chagoya to convey the passage of time as not precisely linear.

Chagoya's penchant for art history, parody, and satire appears in *Le Cannibale Moderniste,* acrylic and oil on *amate* on linen, painted during Chagoya's 1999 sabbatical in Paris. The lush green scene is immediately recognizable as Monet's Giverny, except for the array of inserted figures and details. Chagoya has painted the image smaller than the dimensions of the forty-eight-by-seventy-two-inch paper. In the border across the bottom, he has inserted figures such as an Aztec couple in a dugout canoe and has developed an interplay between the natural texture of the *amate* and the lily pads floating in the water at Giverny. Among the elements added by Chagoya is the painting's title, scrawled in a red cursive across an upper portion of the garden. On the right side of the landscape, the disembodied head of Monet speaks, a talk bubble containing a detail of a Piet Mondrian painting. In the center of the landscape, a naked African woman stands waist deep in the water, a baby clinging to her back. She clutches a bloody machete in one hand and in the other a human arm, on which she is gnawing. The parallel between the appropriations of Modernism and the woman's cannibalism is unmistakable. Chagoya punishes Monet for Modernism's indiscretion by showing blood streaming from the bottom of his head. *Le Cannibale Moderniste* embodies the dualities in Chagoya's works, between past and present, humor and satire, and beauty and the macabre.

ENRIQUE CHAGOYA (B.1953, MEXICO CITY, MEXICO) STUDIED SOCIOLOGY AND POLITICAL ECONOMY AT THE UNIVERSIDAD NACIONAL AUTÓNOMA DE MÉXICO (1972–75), MARRIED AN AMERICAN IMMIGRANT-LABOR RE-SEARCHER, MOVED TO THE UNITED STATES IN 1977, AND RELOCATED TO SAN FRANCISCO IN 1979. HE RESUMED STUDY OF POLITICAL ECONOMY, THEN CHANGED CAREERS AND STUDIED ART AT THE SAN FRANCISCO ART INSTITUTE (BFA, 1984) AND THE UNIVERSITY OF CALIFORNIA AT BERKELEY (MA, 1986; MFA, 1987). CHAGOYA HAS RECEIVED NUMEROUS AWARDS, INCLUDING A NATIONAL ENDOWMENT FOR THE ARTISTS FELLOWSHIP (1993) AND A BIENNIAL AWARD FROM THE LOUIS COMFORT TIFFANY FOUNDATION (1997). HE HAS TAUGHT AT THE CALIFORNIA STATE UNIVERSITY AT HAYWARD AND THE SAN FRANCISCO ART INSTITUTE, AND SINCE 1995 AT STANFORD UNIVERSITY. HE LIVES IN SAN FRANCISCO.

SELECTED READING

CHAGOYA, ENRIQUE, AND GUILLERMO GÓMEZ-PEÑA. *FRIENDLY CANNIBALS.* SAN FRANCISCO: ARTSPACE BOOKS, 1996.

CHAGOYA, ENRIQUE; GUILLERMO GÓMEZ-PEÑA, AND FELICIA RICE. *CODEX ESPANGLASIS FROM COLUMBUS TO THE BORDER PATROL.* SAN FRANCISCO: CITY LIGHTS BOOKS; SANTA CRUZ, CALIF.: MOVING PARTS PRESS, 2000.

DEMING, DIANE, AND SHIFRA M. GOLDMAN. *ENRIQUE CHAGOYA, LOCKED IN PARADISE.* RENO, NEV.: NEVADA MUSEUM OF ART, 2000.

FISCHER, JACK. "ARTISTS' COLLABORATION ULTIMATELY DENIED FOR SHOW." *SAN JOSE MERCURY NEWS,* 18 MARCH 2001, SEC. E, PP. 1, 18.

OLLMAN, LEAH. "TEARING INTO HISTORY." *LOS ANGELES TIMES,* CALENDAR, 12 JANUARY 2001, SEC. F, P. 41.

PORGES, MARIA. "ENRIQUE CHAGOYA." *ARTFORUM INTERNATIONAL* VOL. 33 (NOVEMBER 1994): 91–92.

This surprised them a little, but the polite white people managed not to smile at his pronunciation of "kodak." They had already learned, as many tourists do, that most Indians are afraid to have their pictures taken.

"We shall not forget you, son," Mr. Davis called. "Perhaps we shall see you soon. Goodbye."

They drove away, and Flame Boy watched the car for a moment. It occurred to him that the white people were returning from the other two...

Flame Boy Did Not Fear the Kodak

Flame Boy, 1997
PAINTING ON AMATE PAPER; 48" X 70"

Le Cannibale Moderniste, 1999
ACRYLIC AND OIL ON AMATE PAPER ON LINEN;
48" X 96"

Pocahontas Gets a New Passport (More Art Faster), 2000
ACRYLIC, WATERBASED OIL, PLASTIC ON AMATE ON LINEN;
48" X 96"

Crossing I, 1994 48" X 72"
ACRYLIC AND OIL ON AMATE PAPER;

The Hand of Power, 1998
COLOR LITHOGRAPH/WOODCUT (EDITION OF 30);
25" X 37"

ANN CHAMBERLAIN

Accomplished in both installation and public art, Ann Chamberlain examines how culture affects individual lives and how individuals in turn change culture, revealing the dynamic interplay between the two.

Her works question the way identity is socially constructed and personally discovered. Many of her projects commemorate local history and often involve multiple collaborators, from artists and architects to local community members.

Chamberlain's artworks reconstruct the history of a place through the stories of the people who have passed through it. She creates archives of personal and collective memories and narratives, and spends a great deal of time with community members to uncover their histories. She may develop events where participants gather to share stories and express their personal relationships with a place or discuss common experiences. Believing in the importance of listening, Chamberlain plays the role of translator, becoming the medium through whom another's story can be told.

This process of sharing, which she calls the "medicine of memory," has included doctors and patients at a cancer center, community members and patrons of a library, women in an alcohol recovery center, residents and tourists in a Mexican town (she spent time in Mexico on a Fulbright Fellowship in 1987–88 and on a Lila A. Wallace–Reader's Digest Fund travel grant in 1992–93), and former convicts engaged in a horticulture program. Chamberlain created a multifaceted public artwork for the outdoor garden of the Mexican Heritage Plaza in San Jose, California (1999), in collaboration with artist Victor Zaballa, local neighbors, business owners, and artisans. Reflective of the months the artists spent learning about community history through talking with residents, the work also portrays the important influence of Mexican immigrants and their customs, beliefs, and histories on the cultural development of San Jose and, conversely, how American society has shaped immigrants. Throughout the garden area, the artists incorporated symbols and images derived from Mesoamerican traditions or influenced by Mexican colonial architecture. Four niches in a wall of the plaza contain tiles with photographic transfers taken from photos contributed by the local neighbors depict-

ANN CHAMBERLAIN ATTENDED SMITH COLLEGE IN NORTHAMPTON, MASSACHUSETTS (BA, 1973) AND LATER COMPLETED GRADUATE WORK AT SAN FRANCISCO STATE UNIVERSITY (MA, CREATIVE ARTS, 1981; MFA, CONCEPT DESIGN, 1987). HER NUMEROUS PUBLIC ART COMMISSIONS IN THE BAY AREA INCLUDE A COLLABORATIVE PROJECT WITH ANN HAMILTON FOR THE SAN FRANCISCO PUBLIC LIBRARY (1995), A HEALING GARDEN AT UNIVERSITY OF CALIFORNIA, SAN FRANCISCO'S MT. ZION CANCER CENTER (1998), AND A PROJECT FOR THE CALIFORNIA SUPREME COURT BUILDING IN SAN FRANCISCO (1999). HER AWARDS INCLUDE TWO NATIONAL ENDOWMENT FOR THE ARTS FELLOWSHIPS, IN INTERARTS (1991–92) AND PHOTOGRAPHY (1994–95). CHAMBERLAIN SERVED AS PROGRAM DIRECTOR FOR THE HEADLANDS CENTER FOR THE ARTS IN SAUSALITO, CALIFORNIA (1989–93), AND HAS TAUGHT AT THE SAN FRANCISCO ART INSTITUTE, CALIFORNIA COLLEGE OF ARTS AND CRAFTS, SAN FRANCISCO STATE UNIVERSITY, AND MILLS COLLEGE. HER STUDIO IS IN SAN FRANCISCO.

ing their friends, families, and relatives, how the neighborhood once looked, and the activities that took place there. Around these niches are handmade terra-cotta tiles, selected from hundreds created by community members in two weekend workshops with the artists and local tilemakers.

Based on her belief that stories emerge from the material of our culture, Chamberlain draws inspiration from small everyday objects, using them as catalysts for storytelling and communicating memory. She is also inspired by the inconsequential actions of daily life and their potential for shaping personal identity. as they accumulate in the background of life. Her work is powerful when viewed in its entirety, and its success relies on the viewer's engagement with the bits of quotidian information uncovered in a studied progression through the space. In the Mexican Heritage Plaza project, the artwork is fluidly integrated with the architecture and succeeds in enhancing the aesthetic experience of the entire space. The viewer who walks along the garden wall and studies the tiles, or examines the intricate mosaics and gate motifs at each entrance, will appreciate the details that allow new discoveries with each visit.

SELECTED READING

BECK, DAVID. "ART IN THE DETAILS: ARTISTS' WORK DRAWS ON NATURE, HISTORY." SAN JOSE MERCURY NEWS. 5 SEPTEMBER 1999, SEC. EN, PP. 18–19.

CHAMBERLAIN, ANN. "ABROAD AND AT HOME: ANN CHAMBERLAIN'S DIARY." HIGH PERFORMANCE 17, NO. 2 (SUMMER 1994): 44–46.

CHAMBERLAIN, ANN. FAMILY STORY/ALBUM FAMILIAR. SAN FRANCISCO: SELF-PUBLISHED, 1991.

CHAMBERLAIN, ANN. STAIN. SAN FRANCISCO: URBAN DIGITAL COLOR, 1996.

COHN, TERRI. "ART IN THE PUBLIC REALM: PLACE, HISTORY AND PUBLIC ART." ARTWEEK 32, NO. 4 (APRIL 2001): 12–13, 32.

MARCUS, CLARE COOPER. "HOSPITAL OASIS." LANDSCAPE ARCHITECTURE 91, NO. 10 (OCTOBER 2001): 36–41, 99.

SCHUMACHER, DONNA. "SAN FRANCISCO: ANN CHAMBERLAIN. SAN FRANCISCO ART COMMISSION GALLERY." SCULPTURE 16, NO. 6 (JULY/AUGUST 1997): 57–58.

[stone well with multimedia component]

[detail showing one of a series of
sequential images of the history of California]

Archive Project, 1999
CALIFORNIA SUPREME COURT, SAN FRANCISCO
MIXED MEDIA; VARIABLE DIMENSIONS

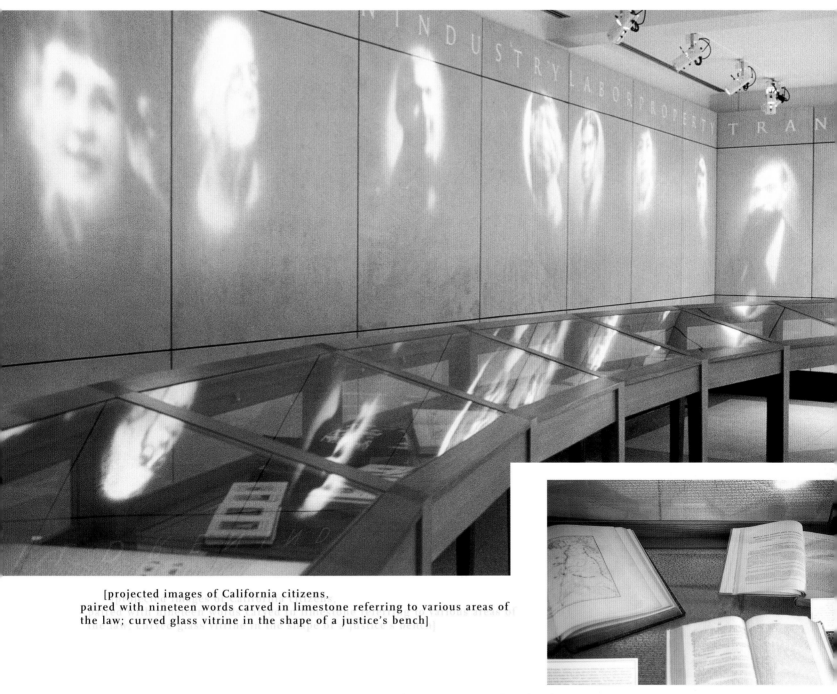

[projected images of California citizens,
paired with nineteen words carved in limestone referring to various areas of
the law; curved glass vitrine in the shape of a justice's bench]

[detail of objects contained in the glass vitrine]

Mexican Heritage Plaza, 1999
MIXED MEDIA; VARIABLE DIMENSIONS, FOUR NICHES WITH HANDMADE
TERRA-COTTA TILES AND PHOTO-TRANSFER TILES

Por Mi Familia
Daria Todo

[detail of photo-transfer tiles]

[one of two tile accent walls with hummingbird imagery derived from Mesoamerican motifs]

[detail of hummingbird imagery]

[one of four cut steel gates and mosaic thresholds, each representing the cardinal directions and their thematic associations in Mesoamerican tradition]

BRUCE CONNER

Theoretical physics currently
postulates that the universe may be defined beyond the visible and measurable
four dimensions (space-time) of our world, and exist in
higher dimensions: h y p e r s p a c e. Bruce Conner is an artistic
explorer of hyperspace; his works throughout various media move back
and forth between substance and concept, physicality and immaterial-
ity, materiality and spirituality. Conner is a distinctly individual artist,
remarkably accomplished, endlessly inventive, and progressively cre-
ative in a wide swath of media. Since the mid-1950s, he has defied
categorization through an ongoing exploration of media, rejected the
status quo of any circumstance, used his being-at-odds as a guiding
muse, and profoundly altered conceptual and philosophical considera-
tions of art.

The duality between physicality and immateriality in *OLD
NOBODADDY* (1951–52), a small, fourteen-by-twelve-inch oil painting
and one of Conner's earliest surviving artworks, begins with five differ-
ent shapes spaced within an orange ground, in which dark blue-black
excised lines create a substructure of geometrical patterns. The five
shapes, clockwise from the lower left corner, are a six-pointed bright
yellow star, small orange oval, large horizontal oval with two horizon-
tal blue dots, vertical white rectangular bar at the right side, and red
square. Another structural level exists in the paint strokes of each
shape. The assembly of shapes has qualities that evoke landscape, a
figure, and geometrical abstraction. The excised lines, revealing a blue
layer behind the thick surface layer of orange, renders both ancient
runic markings and modern graffiti.

Conner moved to San Francisco in 1957, having had a solo
exhibition of his paintings at the Rienzi Gallery in New York the previ-
ous year. Soon fascinated with the abundance of visually intriguing
detritus generated by the Victorian houses being demolished in the
name of urban renewal, he scavenged parts such as wooden architec-
tural details, linoleum fragments, and wallpaper. Adding items of a
more transitory, individual, and social nature such as doll parts, news-
paper clippings, bits of clothing and costume jewelry, he fashioned
dense, layered assemblages with rich colors and textures.

Conner expanded the world of three-dimensional art through
his assemblage sculptures, which address and encompass the themes
of religion, violence, eroticism, sex, and art itself. He displayed materi-
als and items—condoms, girlie calendars, bulging nylon bags, even his
selective service order to report to his local draft board—that were
avoided in abstract expressionist painting, the predominant style dur-
ing the 1950s. Many of the works are swathed with nylon, which was
both a practical means of holding the parts together and a way of
shading, partially obscuring, or revealing what is underneath.

Conner began making films and received wide acclaim for A
MOVIE (1958); his use of found footage, countdown leader, rapid edit-
ing, music, and attention to sex, death, and cultural icons, are seminal
and continue to influence modern film style—even MTV. Conner's cine-
matic techniques introduced a subliminal conveyance of information,
rather than intellectual narrative.

Conner's paintings, assemblages, films, as well as the life-size photograms made with photographer Edmund Shea from 1972–75 are seemingly abrupt shifts in media, but simply belong to a larger artistic trajectory. It is a movement through the space of duality, indeterminacy, and ambiguity, not unlike the performance-type actions throughout his career that focus all attention on a work through not signing it, or raise questions of his identity or presence.

An exploration of physicality and immateriality in Conner's drawings exists between the drawn line and space. His ink drawings, done with felt-tip watercolor or pen and ink, are simultaneously microscopic and telescopic, perceptively shift scale between appearing as molecular structure and far-off galaxies, and explore thresholds of perception and imagination.

Qualities that are present in Conner's assemblages, early drawings, films, and life-size photograms—precision, repetition, symmetry, mysticism, and delicacy of photographic tonalities—are distilled into his complex inkblot drawings. They are formed by Conner folding a sheet of paper into long strips and carefully applying ink, which may be

BRUCE CONNER (B. 1933, MCPHERSON, KANSAS) ATTENDED NEBRASKA UNIVERSITY (BFA, 1956), BROOKLYN MUSEUM ART SCHOOL (1956), AND THE UNIVERSITY OF COLORADO (1957). HE MOVED TO SAN FRANCISCO IN 1957 AND HAS LIVED THERE SINCE, EXCEPT FOR THE YEARS 1962 TO 1965 WHEN HE LIVED IN MEXICO; WICHITA, KANSAS; AND BROOKLINE, MASSACHUSETTS. HE HAS RECEIVED FELLOWSHIPS FROM THE FORD FOUNDATION (1963), THE COPLEY FOUNDATION (1964), AND THE NATIONAL ENDOWMENT FOR THE ARTS (1973). CONNER LIVES AND WORKS IN SAN FRANCISCO.

tiny designs or long undulating lines. As he observes, "I've been watching ink run all my life." Vertical bands of blots that are rendered with the disintegrating wash of a Japanese brush drawing or watercolor seem to contain both order and chaos. They offer metaphysical opportunities for a viewer to discover something unexpected in the infinite contrast of ink on paper.

Although a dimension of order is bounded and imposed on Conner's artwork simply in the framing, one senses that something exists beyond those edges. "Free-moving changing form isn't free," Conner has observed. "It's always contained in something, but every containment is another free-flowing form in another containment.... My role of being an artist, as it might be defined in our society, is to create a dialogue between myself and another person. This is a duality. The process of change in this relationship is what I am interested in."

SELECTED READING

BRUCE CONNER: ASSEMBLAGES, PAINTINGS, DRAWINGS, ENGRAVING COLLAGES 1960–1990. WITH AN INTERVIEW BY ROBERT DEAN AND TEXT BY DENNIS HOPPER. SANTA MONICA, CALIF.: MICHAEL KOHN GALLERY, 1990.

BRUCE CONNER: DRAWINGS, 1965–1972. TEXT BY THOMAS GARVER. SAN FRANCISCO: FINE ARTS MUSEUMS OF SAN FRANCISCO, 1974.

BRUCE CONNER: PHOTOGRAMS. TEXTS BY TERRI COHN AND ANTHONY REVEAUX. SAN FRANCISCO: ART MUSEUM ASSOCIATION OF AMERICA, 1985.

BRUCE CONNER: SCULPTURE, ASSEMBLAGES, COLLAGES, DRAWINGS, FILMS. TEXT BY JOAN C. SIEGFRIED. PHILADELPHIA: INSTITUTE OF CONTEMPORARY ART, UNIVERSITY OF PENNSYLVANIA, 1967.

BRUCE CONNER: SCULPTURE, ASSEMBLAGES, DRAWINGS, FILMS. TEXT BY THOMAS GARVER. WALTHAM, MASS: THE POSES INSTITUTE OF FINE ARTS, BRANDEIS UNIVERSITY, 1965.

2000 BC: THE BRUCE CONNER STORY PART II. TEXTS BY PETER BOSWELL, JOAN ROTHFUSS, AND BRUCE JENKINS. MINNEAPOLIS: WALKER ART CENTER, 2000.

UNTITLED, March 18, 1996
INK ON PAPER ON CLOTH WITH GLUE ON SILK SCROLL;
25³/₄" X 13¹/₂"

OPPOSITE
INKBLOT DRAWING, November 13, 1998
INK ON PAPER; 23¹/₈" X 26³/₈"

MEAT WHEEL, 1960
ASSEMBLAGE; 40" X 25" X 8"
NO LONGER EXTANT

DECEITFISH,
July 30, 1960
ASSEMBLAGE; 20" X 9"
NO LONGER EXTANT

SWEET SIXTEEN CANDY BARS,
February 13, 1963
ASSEMBLAGE/COLLAGE/PAINT; 27 1/2" X 11 1/2"

OLD NOBODADDY, 1951–1952,
OIL PAINT ON CANVAS, 14" X 12"

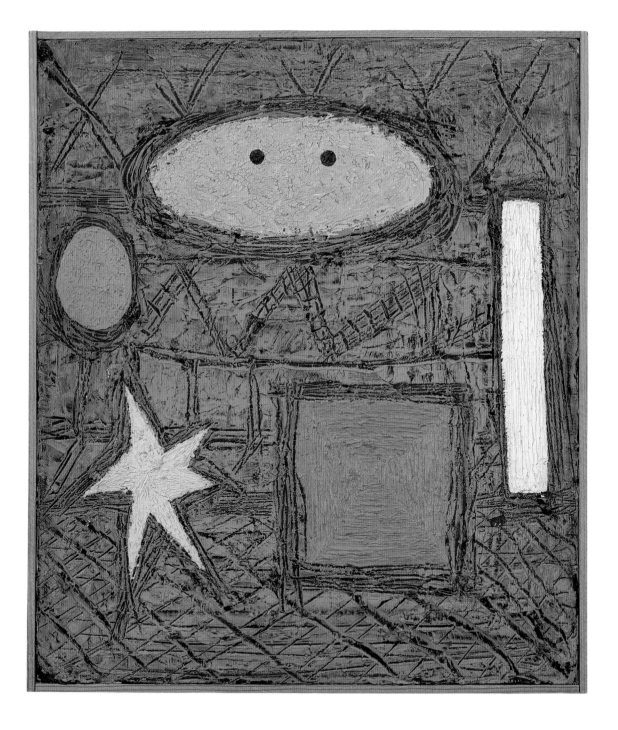

LINDA CONNOR

Seeking manifestations of the spiritual, Linda Connor
photographs ancient non-Western cultures and religious centers; the subjects of
her photographs are about something deeper than who
or what is pictured. A belief that photography can reveal more than
what is visible in the physical world motivates her search for spiritual
sites that have not yet been transformed by contemporary culture. Her
photographs "deal with the inexplicable," she has said. "I want my
work to function at a level not so much of fact, but of knowing. A more
intuitive response rather than an intellectual response . . . I don't want
you to look at my photographs and try to figure them out with your
logic." Connor follows her intuition (even photographing without a
light meter) and her large-format photographs observe—or imply—
connections among people, their activities, and the natural world.

Connor has used a large-format 8x10 camera for much of her
career, which is cumbersome and requires long exposures. She prints
her photographs by placing the negative directly against printing-out-
paper in a glass-front frame, which is then set in the sun and exposed
for several hours until the image is ready to be chemically fixed. The
prints are later immersed in a gold-toning bath, which transforms
them into a rich, deep purplish-brown.

In the late 1960s, Connor made collages of photographs,
some of which she had altered through negative or print manipulation,
and then photographed the result. She also photographed still-life
arrangements of various items such as shells, reproductions of art,
postcards, and later, montages of cut-up photographic images. In 1972
she inherited an 8x10 camera and soft focus lens, which she used for
the next several years. She made contact prints from the large-format
negatives, gold-toned them, and produced a book of the photographs,
Solos. Her exploration of composition, technique and sequential conse-
quences in the book became tools in her working method. This aggre-
gate knowledge coalesces in her work made since 1979, when she
began using a sharp lens with the 8x10 view camera.

Connor has made photographs in Thailand, Bali, India, Tibet,
Egypt, Turkey, Peru, and China, among other exotic locations. Her pho-
tographs depict landscapes with a deep history, expressed in a rich
density of flora, weathering produced by the seasons, or the evident
merger of ancient cultural relics and the natural surroundings. The pre-
dominant subjects of her explorations into other cultures—religious
shrines and temples, carved stone statuary, monks and nuns—are
photographed with scant evidence that might suggest when these
photographs were made.

The entrance in Connor's *Tomb Doorway, Petra, Jordan* (1995)
is in a natural wall of stone, which appears to be part of a mountain-
side and has a swirling and undulating surface of fine lines and irregu-
lar tonalities. The stone lintel of the tomb doorway fits so perfectly
with the surrounding surface that it appears to be carved in place, and
the stone step is deeply worn. A site of indeterminate age, it is a
threshold between exterior light and life and what is unknown in the

LINDA CONNOR (B. 1944, NEW YORK, NEW YORK) STUDIED UNDER HARRY CALLAHAN AT THE RHODE ISLAND SCHOOL OF DESIGN IN PROVIDENCE (BFA, 1967) AND WITH AARON SISKIND AT THE INSTITUTE OF DESIGN, ILLINOIS INSTITUTE OF TECHNOLOGY (MS, 1969) IN CHICAGO. AMONG HER MANY AWARDS ARE TWO NATIONAL ENDOWMENT FOR THE ARTS PHOTOGRAPHY FELLOWSHIPS (1976, 1988) AND A JOHN SIMON GUGGENHEIM MEMORIAL FOUNDATION FELLOWSHIP (1979). THE FRIENDS OF PHOTOGRAPHY HONORED HER AS "PHOTOGRAPHER OF THE YEAR" IN 1986. CONNOR HAS TAUGHT AT THE SAN FRANCISCO ART INSTITUTE SINCE 1969 AND LIVES IN MARIN.

empty blackness of the doorway. The general orchestration of formal qualities and conceptual themes that occur throughout her photographs since 1980—symbolic interplay of light and shadow, patterns, sensual textures, juxtaposition of cultural artifacts with natural landscape, or the sacred and profane—are individually present in various earlier images. As writer Rebecca Solnit has observed, "Connor seeks objects that are symbolically and literally radiant, that shine forth with a sense of meaning, of order, of purpose, in those places where the human is in touch with the natural and the spiritual; and those places whose shadows and darkness hint at the numinous—the cloud of unknowing, the realms of mystery."

A sense of patience or contemplation characteristically appears in all of Connor's photographs; they lack the flux implied in most photographs of contemporary society (particularly if subject matter is moving and the exposure is a fraction of a second). Connor's respect for her subjects is evident both in her successful navigation of uncommon cultures and locations, and the people agreeing to be photographed. They do not display the affected responses that typically appear in Western cultures, which also can be partially attributed to the large imposing camera and long exposure time. Men and women appear as accepting, even collaborating, participants in this enterprise,

helping to create a feeling of peaceful tranquility, as is projected by the calm visage of *Pilgrim, Hemis Monastery, Ladakh, India* (1998).

In 1995, Connor was invited to make interpretive prints from the thousands of glass plates in the Lick Observatory, located at Mount Hamilton just east of San Jose, California. Using the existing glass plate negatives, some over a hundred years old, she made prints that celebrate these astronomical records of the stars. They are maps of the heavens, highly reminiscent of molecular studies at the opposite end of the magnification scale. In her printing, Connor combines the symbolic lights and forms of deep space with the accumulated dust and other flaws, such as cracks, of the old glass plates. The prints combine the minute accretions scattered on glass surfaces over time with the deepest imaginable recesses of the human world and, like her own photographs, provide a palpable continuity to history, suggest connections beyond scientific knowledge, and transform the ordinary into quasi-spiritual dimensions. Paralleling her own explorations, there is an acknowledgment of present or remote secrets and a sense of mystery that does not need to be solved.

SELECTED READING

CONNOR, LINDA. *LUMINANCE.* ESSAY BY REBECCA SOLNIT. CARMEL VALLEY, CALIF.: WOODROSE PUBLISHING, 1994.

CONNOR, LINDA. *ON THE MUSIC OF THE SPHERES.* LIMITED EDITION BOOK WITH CHARLES SIMIC. NEW YORK: WHITNEY MUSEUM OF AMERICAN ART, 1996.

CONNOR, LINDA. *SOLOS: PHOTOGRAPHS BY LINDA CONNOR.* MILLERTON, N.Y.: APEIRON WORKSHOPS, INC., 1979.

CONNOR, LINDA. *SPIRAL JOURNEY.* INTRODUCTION BY DENISE MILLER-CLARK, ESSAY BY REBECCA SOLNIT. CHICAGO: MUSEUM OF CONTEMPORARY PHOTOGRAPHY, 1990.

CONNOR, LINDA. *VISITS, LINDA CONNOR.* INTRODUCTION BY JEFFREY HOONE. SYRACUSE, N.Y.: LIGHT WORK, 1996.

LINDA CONNOR. WITH ESSAY BY JANE LIVINGSTON. WASHINGTON, D.C.: CORCORAN GALLERY OF ART, 1983.

Tomb Doorway, Petra, Jordan, 1995
GOLD-TONED PRINTING-OUT PAPER; 12" X 10"

Stones, Kau Desert, Hawaii, 1991
GOLD-TONED PRINTING-OUT PAPER; 10" X 12"

Hand Prints, Queensland, Australia, 1997
GOLD-TONED PRINTING-OUT PAPER;
10" X 12"

Pilgrim, Hemis Monastery,
Ladakh, India, 1998
GOLD-TONED PRINTING-OUT PAPER; 12" X 10"

MARGARET CRANE JON WINET

Conceptual artists Margaret Crane and Jon Winet
have consistently demonstrated the success and innovation
possible through collaborative
art-making. He is often the photographer, she the writer, and together, since 1985, they have explored new forms for their art as well as new modes of collaboration. Viewer interactivity has been central to their art, whether in gallery work or in community-based public projects.

Mixing art and activism, Crane|Winet create dialogue where they see apathy, comment on the spectacle of American politics, amplify social issues, and plumb the intersection of art and technology. The subjects and sources of their works range from public and political events to the emotional and psychological undercurrents of everyday life.

Crane|Winet have focused public attention on domestic violence and AIDS, through billboards and bus shelter posters in San Francisco, and trading cards distributed though social service agencies and public libraries in Marin County. *The Days of Our Lives* (1993) consisted of a series of thirteen trading cards (approximately ten thousand cards were printed) in both English and Spanish. A photographic image on one side was overlaid with an evocative statement—such as an Egyptian pharaoh with "Knowledge is Power," or a distraught woman covering her face in anguish with "Can we talk?" The other side contained facts about topical social issues, and provided information about local services. This project exemplifies the artists' aptitude for finding a nontraditional medium for their art that is commonly understood by the public and for stimulating the public to give serious consideration to social problems.

The artists have extended their interest in public issues to the Internet. From 1994 to 1998, Crane|Winet worked with Xerox PARC (Palo Alto Research Center) researchers Scott Minneman and Dale MacDonald to explore technological media as the vehicle for their artwork. Through Web-based artworks, they have tackled such issues as mental health, housing, and presidential politics, while pioneering a new model for art making and expanding their vocabulary of interactivity. In these works, Crane|Winet elevate the viewer's role from mere observer to central participant in the creation of art. They combine artistic and social concerns with the strengths of online technology— the ability to create a screen where people can communicate—and in so doing, they are grappling with issues of technology access and how diversity and democracy can exist on the Web.

Participating in the past five presidential election cycles, the artists created works that examine the circus quality of the Republican and Democratic Party conventions and address the state of contemporary electoral politics. The most elaborate and sophisticated of these, which also illustrated their adroit use of the Internet, was *Democracy: The Last Campaign* (2000). During a year-long process involving public forums, discussions, publications, and email exchanges, they followed the events of the presidential primary campaigns and attended the two national party conventions. The outcome was a website hosted by the Walker Art Center in Minneapolis, which has massive visual and

MARGARET CRANE (B. 1955, LONG BEACH, CALIFORNIA) AND JON WINET (B. 1951, PASADENA, CALIFORNIA) MET WHILE AT SAN FRANCISCO STATE UNIVERSITY, WHERE CRANE STUDIED CREATIVE WRITING (BA, 1979) AND WINET CONCENTRATED ON INTERDISCIPLINARY ARTS (MA, 1979). WINET HAD PREVIOUSLY STUDIED SOCIOLOGY AT THE UNIVERSITY OF CALIFORNIA AT BERKELEY (BA, 1973). CRANE LATER COMPLETED GRADUATE STUDIES IN ART AT STANFORD UNIVERSITY (MFA, 1997). THEIR COLLABORATION GREW OUT OF CORRESPONDENCE IN THE EARLY 1980S WHILE WINET WAS AN ARTIST IN RESIDENCE IN NEVADA. ALTHOUGH THEY OFTEN MEET TO DISCUSS IDEAS AND INSTALLATIONS, MUCH OF THEIR COLLABORATION CONTINUES THROUGH CORRESPONDENCE (MOSTLY ELECTRONIC), AS THEY MAINTAIN SEPARATE STUDIOS (CRANE IN SAN FRANCISCO, WINET IN BERKELEY). CRANE|WINET WERE VISITING ARTISTS AT THE CENTER FOR DIGITAL MEDIA AT THE SAN FRANCISCO ART INSTITUTE IN 1997–98 AND RECEIVED A 2000 MCKNIGHT FOUNDATION INTERDISCIPLINARY ARTS RESIDENCY FOR *DEMOCRACY: THE LAST CAMPAIGN*.

textual information that seems to allow endless navigation. Interview transcripts with various players in the political process, press releases, and news from the campaign trail are available online, along with experimental fiction by the artists. Photographs of typical American scenes such as train tracks, city skylines, and neon signs are juxtaposed with sections of the artists' text such as: "The myth of genius is our own special version of the Cinderella story. Walking down the glass encased walkway, he gestures at the glittering cityscape. Competitive free market economy is the destiny of the entire Galaxy, he tells the camera."

Crane|Winet developed the project into four gallery installations shown at the Walker Art Center and Intermedia Arts in Minneapolis; Hallwalls Contemporary Art Center in Buffalo, New York; and SF Camerawork in San Francisco. At SF Camerawork, the project website was accessible at a computer in the gallery. Crane|Winet designed an installation with a video projection of campaign trail images and mock photo opportunities using backdrops of banners with slogans such as "Economic Justice" and "Collective Prosperity." Photographic mural prints of images culled from the project mixed celebrity politicians such as Jesse Jackson with scenic views and behind-the-scenes glimpses from the campaign trail.

Not all their interactive, technology-based works exist on the Internet. In 1997, Crane|Winet created an interactive "soap opera" on the outdoor Jumbotron screens of the nightclub Billboard Live in Los Angeles (in collaboration with Minneman and MacDonald). Billboard Live (now defunct) was one of the few commercial sites in Los Angeles that had an outdoor video screen, facing Sunset Boulevard, which could broadcast live. Crane|Winet photographed a cast of characters, digitally enhanced the images, and added text. The images appeared three times an hour, along with a soundtrack on a low-frequency radio station. Passing motorists were asked to click their electronic garage door openers or automatic car-door key fobs. Receivers collected these signals and sent them to computers controlling the images, enabling the car-bound viewers to affect the plot of the soap opera by changing the sequence of images. Taking cues from the Hollywood setting, the artists created a drama that ordinary people could participate in while engaging them in an experiment of mass interactivity.

SELECTED READING

BONETTI, DAVID. "TIMELY ART ON POLITICS." *SAN FRANCISCO EXAMINER*, 1 NOVEMBER 2000. SEC. B, PP. 1, 7.

BORRUP, TOM. *INTRODUCTION TO 1999 MCKNIGHT ARTIST FELLOWSHIP FOR INTERDISCIPLINARY ARTISTS.* MINNEAPOLIS: INTERMEDIA ARTS, 2000.

CRANE, MARGARET, AND JON WINET. "DEMOCRACY—THE LAST CAMPAIGN." *CAMERAWORK: A JOURNAL OF PHOTOGRAPHIC ARTS* 27, NO. 2 (FALL/WINTER 2000): 17–25.

CRANE, MARGARET; DALE MACDONALD; SCOTT MINNEMAN; AND JON WINET. VARIOUS PROJECTS AVAILABLE AT *www.pair.xerox.com/cw/.*

CRANE, MARGARET, AND JON WINET. "DEMOCRACY: THE LAST CAMPAIGN," 2000. AVAILABLE AT *http://dttc.walkerart.org.*

CRANE, MARGARET, AND JON WINET. VARIOUS PROJECTS AVAILABLE AT *www.misspearlproductions.com.*

HARRIS, CRAIG, ED. *ART AND INNOVATION: THE XEROX PARC ARTIST-IN-RESIDENCE PROGRAM.* CAMBRIDGE, MASS.: MIT PRESS, 1999.

Democracy: The Last Campaign, 2000
PHOTOGRAPHIC MURAL PRINT INCLUDED IN SF CAMERAWORK
INSTALLATION, SAN FRANCISCO; APPROXIMATELY 24" X 60"

[laminated digital photographic print on aluminum, included in SF Camerawork Installation, San Francisco; **APPROXIMATELY 5¹/₄" X 15"**]

[laminated digital photographic print on aluminum, included in Installation, Gallery Paule Anglim, San Francisco; **APPROXIMATELY 5¹/₄" X 15"**]

Democracy: The Last Campaign
DETAIL FROM SF CAMERAWORK INSTALLATION, SAN FRANCISCO,
WITH OFFSET SHOWPRINTS, IKEA CHAIRS, "PRESIDENTIAL BLUE" WALL,
COMPUTER WITH INTERNET CONNECTION FEATURING WEB SITE
AND THEATRICAL LIGHTING; APPROXIMATELY 10' X 20' X 15'

Sunset, 1997
PRODUCED WITH SCOTT MINNEMAN AND DALE MACDONALD;
SIGGRAPH 97, LOS ANGELES AND BILLBOARD LIVE, WEST HOLLYWOOD;
MACROMEDIA DIRECTOR FILES, AUDIO, TEXT,
DIGITAL PHOTOGRAPHY AND GRAPHICS

JUDY DATER

Since the 1960s, Judy Dater has produced photographic portraits that are bold, unabashedly honest, and rendered with equanimity, regardless of her subject's gender, age, or ethnicity. She has mapped the territory of the human face and body, photographing a rich diversity of people and depicting them as individuals, rather than portraying them on the basis of their place within society or culture. Dater seeks to photographically depict her subjects with fresh vision, and convey understated aspects of individuality in her photographs; her images awaken viewers to the subtle beauty that is present in every person.

Dater has created an unparalleled chronicle of women in American society over the course of her career, ranging from the portraits made in 1968–71 that reflect emerging personalities in a rapidly changing social milieu to the extended stories portraying ten individuals made in 1985–88. The earlier series was published as *Women and Other Visions* (1974), and the later photographs as *Body and Soul: Ten American Women* (1988), which were specifically made for a book. The book format is one of many different presentational forms that Dater has explored during her career.

Additionally, frequent subjects are artists and art world personages, including Bay Area painter Wayne Thiebaud and photographers John Gutmann, Minor White, and Imogen Cunningham. Her well-known 1974 portrait of Cunningham and model Twinka Thiebaud in Yosemite National Park is a timeless study of the female dynamic of artist and model, youth and age, beauty and wisdom. Working predominantly with a 4x5 view camera and using available natural light, which preserves a sense of immediacy about her subjects without romanticizing them, the photographs often display telling postures or a playfulness, as when art historian Peter Bunnell solemnly looks into the camera, his tuxedo coat unbuttoned, and hooks a thumb around a suspender strap decorated with naked women.

Dater has periodically expanded her oeuvre by exploring new directions, frequently using herself as subject. She embarked on a vigorously dramatic series of black-and-white self-portrait nudes in the middle to late 1970s, employing different regions of the American West as both subject and foil in her photographs. Dater pictures herself as puny within the natural grandeur, at a distance reclining in the stark space of salt flats, lying atop the geological striations of Badlands, or as a blurred body with a zig-zag petroglyph emerging from beneath her crotch. In a series of color self-portraits in the early 1980s, Dater caricatures the stereotypical social expectations of women, paralleling an emergent interest in staging and self-portraiture among other artists at the time. She plays various roles as tough, sexy, or exasperated, personified in the titles *Death by Ironing* or *Queen of the Night,* with deadpan seriousness, creating characters through materials (satin, velvet), props (feathers, dumbbells), makeup, and costumes (wigs, a leopard-print body suit).

In the 1980s and 1990s, she temporarily shifted to the 35mm format for its mobility and speed, worked with photographs in multiples and installations, and experimented with digital processes and

printmaking. Her grouping of twenty-by-twenty-four-inch black-and-white photographs, made from about 1983 to 1990, are at once the most generic and fantasy-like pieces. Dater explores various arrangements in these composite works—rectangular grids of six or nine images, horizontal and vertical triptychs, five photographs laid out in a cross—and juxtapositions of objects (an empty chair), details of natural landscapes (tree branches, clouds) and art (statuary, painting), facial close-ups, and images of children playing in a lawn sprinkler. The works generate poetic and fluidly evocative interpretations, as declared by titles such as *Memory II* (1988), which is composed of six black-and-white photographs, vertically oriented, arranged in two rows of three stacked on each other. Three close-ups of an elderly woman are juxtaposed with two images of mountainous snow-covered terrain and a photograph of a delicate china teacup and saucer. The uncertainty and thoughtfulness expressed in the woman's portraits balanced against the harsh brilliance of wind-swept snowscapes and tranquil, empty teacup suggest a lifetime of memories and experiences that the viewer can only imagine.

SELECTED READING

DATER, JUDY. *CYCLES: JUDY DATER.* WITH AN INTERVIEW BY DONNA STEIN AND AN ESSAY BY MICHIKO KASAHARA. TOKYO, JAPAN: KODANSHA, 1992.

DATER, JUDY. *IMOGEN CUNNINGHAM: A PORTRAIT.* BOSTON, MASS.: NEW YORK GRAPHIC SOCIETY, 1979.

DATER, JUDY. *JUDY DATER: TWENTY YEARS.* WITH AN ESSAY BY JAMES ENYEART. TUCSON, ARIZ.: UNIVERSITY OF ARIZONA PRESS, 1986.

DATER, JUDY, AND CAROLYN COMAN. *BODY AND SOUL: TEN AMERICAN WOMEN.* BOSTON, MASS.: HILL & CO., 1988.

DATER, JUDY, AND JACK WELPOTT. *WOMEN AND OTHER VISIONS.* WITH AN INTRODUCTION BY HENRY HOLMES SMITH. MORGAN'S FERRY, N.Y.: MORGAN & MORGAN, 1975.

JUDY DATER (B. 1941, HOLLYWOOD) HAD A FATHER WHO OWNED A MOVIE THEATER. SHE SPECULATES THAT SPENDING MANY HOURS PLAYING IN THE DARKENED THEATER INFLUENCED HER DESIRE TO BECOME A PHOTOGRAPHER. SHE STUDIED AT THE UNIVERSITY OF CALIFORNIA IN LOS ANGELES (1959–62) AND THEN WITH JACK WELPOTT AT SAN FRANCISCO STATE UNIVERSITY (BA, 1963; MA, 1966). DATER WAS A FOUNDING MEMBER OF THE VISUAL DIALOGUE FOUNDATION (1968–73), A GROUP OF BAY AREA PHOTOGRAPHERS WHO REGULARLY MET FOR PURPOSES OF CAMARADERIE AND PROFESSIONAL SUPPORT. AMONG AN EXTENSIVE LIST OF HONORS, SHE HAS RECEIVED TWO NATIONAL ENDOWMENT FOR THE ARTS PHOTOGRAPHY FELLOWSHIPS (1976, 1988) AND A JOHN SIMON GUGGENHEIM MEMORIAL FOUNDATION FELLOWSHIP (1978). DATER LIVES IN BERKELEY.

Since 1999, Dater has been photographing the cultural and ethnic diversity of the Bay Area, ranging from the black-and-white fierce intensity of *Ian MacKey* (1999) to the three Polacolor prints of *Yellow Man #1, #2, and #3* (1999). In this trio of images a young man is variously displayed in street clothes (#2), in yellow mask, gloves, and tunic (#3), and partially dressed in the yellow gear (#1). He is an enigma—almost threatening—when fully suited in what appears to be a performance bodysuit and head covering, or in a leather jacket and wearing glasses. In between, he appears at ease, the mask rolled up on his forehead exposing the yellow dusting on his lips and underneath his eye sockets, gazing directly into the camera with almond-shaped eyes projecting trust, even vulnerability.

These explorations, as in all Dater's work, seek to discover how appearance can be a reflection of identity. It is a desire to conjoin the outward projections of individuals—and how they view themselves—with her photographic interpretations of them. "Stylistically, my work has changed over thirty years, mainly because that's a very long time to do the same thing over and over," she observed in 1996. "But in a sense, the concerns of my work are always the same. My work is about the dignity of people and the human condition."

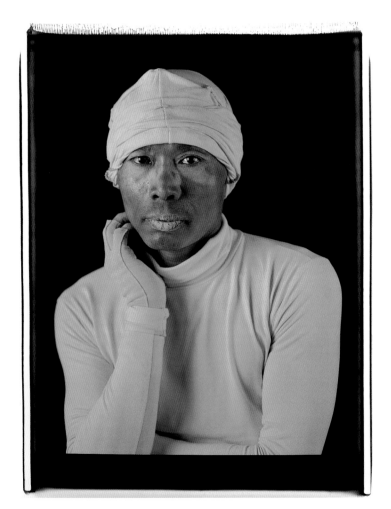

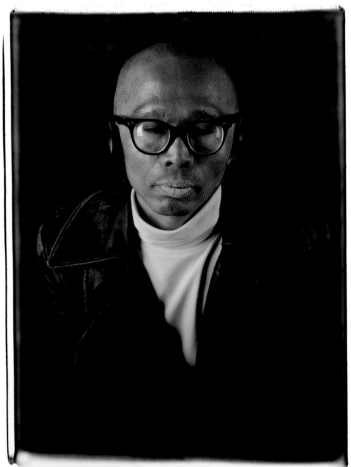

Yellow Man #2, 1999
POLACOLOR; 24" X 20"

Yellow Man #1, 1999
POLACOLOR; 24" X 20"

Yellow Man #3, 1999
POLACOLOR; 24" X 20"

Ian MacKey, 1999
GELATIN SILVER PRINT; 24" X 20"

Daniel Castor, 1999
GELATIN SILVER PRINT; 24" X 20"

LEWIS DE SOTO

Lewis de Soto's works can be broadly described as cross-disciplinary installations, although he also creates stand-alone sculpture and, until the late 1980s, was working predominantly in photography. Initially attracted to photography for how it allowed him to interact with the world outside the studio, he turned to installations as a means to bring the exterior physical world into the studio and to more completely convey his ideas to viewers. His installations can be described as either site-specific—where the form and content are developed in response to characteristics of the site—or culturally specific—where the form and content are derived from de Soto's perception and understanding of cultural politics and heritage.

In the development of site-specific work, de Soto adeptly draws on the idiosyncrasies and peculiarities of a place; he becomes a keen investigator, a kind of anthropologist, observing the sights, smells, and features of a locale, studying its cultural context and social uses. Whether the site is the heavily traversed concourse of an international airport, the secluded space of a jury assembly room, or a parking structure at a naval air station, the resulting work is wholly intertwined in form and content with the nature and function of the site.

In collaboration with the architecture firm of Skidmore, Owings and Merrill, de Soto developed a design for twelve thousand square feet of floor space in the arrivals section of the international terminal building at the San Francisco International Airport. The floor design, inspired by the location, consists of three elements. Undulating curvilinear areas represent zones of high and low pressure in the atmosphere and are made of terrazzo and zinc divider strips. Inset bronze strips outline the shapes of the Earth's landmasses, and 182 bronze plaques are situated where cities with major airports are located in the scheme and are derived from reference charts used by pilots for landing and taking off from these major airports. As de Soto has observed, "The visitor walking on top of the floor first encounters the pattern of the isobars, then sees the touch-down points for airplanes around the world. One can literally traverse the earth, walking on the air, and trace one's path from destination to destination." De Soto carefully studied the physical design of the terminal so that the piece fluidly integrates with the look and feel of the surrounding space.

In contrast, his culturally specific artworks, most often realized in a museum or gallery exhibition, are not driven by the features or uses of a place, but instead reflect a deep awareness of how physical places and events have abstract, spiritual dimensions. He has undertaken explorations on the themes of cosmology, Buddhism, Catholicism, and his Native American ancestry in works such as *Crossing/Cruzandose* (1993–94), *Tahquitz* (1994–96), and *Paranirvana* (1999–2000). *Recital* (1998–2001) is based on a nonfiction book in which a brain pathologist seeks a biological correlation between his deceased wife's creative talents as a pianist and composer and the structure of her brain. In de Soto's dramatic installation, the wife's musical compositions are played on a player piano, as an automatic

page turner slowly flips through the husband's book, which is presented as if it is the musical score. The room is darkened, with a spotlight on the piano, and rows of seats are provided for the audience—much like a musical recital. In de Soto's engagement with this particular story, he also comments on the need to find concrete explanations for the intangible mysteries of human nature. The installation evokes in the viewer a visceral recognition of the mystical, spiritual operatives in the larger world. De Soto undertakes investigation of the spiritual when such notions are often greeted with suspicion. As curator Dan Cameron wrote, "his greatest artistic challenge seems to come from discovering the human aspiration toward the divine in places and situations where one might have reason to believe it had been cancelled out."

De Soto's elaborately constructed installations provide a multisensory experience, and reflect a dexterity with technology and an awareness of how light, sound, and motion can affect a viewer. De Soto has a keen appreciation for how to compose and stage his work for his audience. He strives for, as Cameron describes, the "creation of a purely contemplative state of being which offers a fairly sensitive person the appropriate conditions for reflecting upon whatever deeper meanings can be extracted from both the immediate situation and the broader, unchanging continuity of existence."

LEWIS DE SOTO (B. 1954, SAN BERNARDINO, CALIFORNIA) HAS PATERNAL ROOTS IN THE CAHUILLA TRIBE OF SOUTHERN CALIFORNIA. BY THE TIME HE ATTENDED THE UNIVERSITY OF CALIFORNIA AT RIVERSIDE, HE HAD BECOME INTERESTED IN INVESTIGATING VARIOUS RELIGIONS, WHICH FUELED HIS DOUBLE MAJOR IN RELIGIOUS STUDIES AND STUDIO ART (BA, 1978). AFTER GRADUATING FROM THE CLAREMONT GRADUATE SCHOOL (MFA, 1981), HE MOVED FROM SOUTHERN CALIFORNIA TO SEATTLE IN 1985 TO TEACH AT THE CORNISH COLLEGE OF ARTS. IN 1988, HE CAME TO THE BAY AREA TO TEACH AT SAN FRANCISCO STATE UNIVERSITY, WHERE HE CONTINUES TO TEACH TODAY.

HE HAS BEEN AN ARTIST IN RESIDENCE AT THE LIST VISUAL ARTS CENTER AT MIT IN CAMBRIDGE, MASSACHUSETTS (1997–98), ARTPACE IN SAN ANTONIO, TEXAS (1996), AND THE HEADLANDS CENTER FOR THE ARTS IN MARIN, CALIFORNIA (1990). AMONG HIS AWARDS IS A FELLOWSHIP FROM THE NATIONAL ENDOWMENT FOR THE ARTS (1996–97). DE SOTO MAINTAINS STUDIOS IN NAPA VALLEY AND NEW YORK CITY.

Dervish (1997) was created for Metrònom in Barcelona, Spain. Intrigued by the music of Muslim Spain, and in particular the compositions of Al-Farabi (active in the tenth century), who introduced the Spanish to Sufi tradition, de Soto designed an installation where European and Muslim traditions blend in a technologically sophisticated, yet contemplative, environment. In a large, spare room, six speakers with spot lamps were suspended from aircraft cables. The cables were attached to a rotating disk on the bottom of control boxes. Inside the boxes were computer chips that sent audio signals to the speakers and electricity to the lamps as they rotated, throwing light around the room and shifting the sound with the motion. As the speakers played various rhythms from the recorded music written by Al-Farabi, the sounds combined to create what de Soto calls "accidental melodies" reminiscent of both Arabic music and Spanish folk music. A viewer encountered a space of undulating light and rhythm, designed to inspire meditation on the complex cultural traditions of Spain.

SELECTED READING

CAMERON, DAN. *LEWIS DE SOTO: SHIP.* SANTA MONICA, CALIF.: SMART ART PRESS 4, NO. 39 (1998).

CASTRO, JAN GARDEN. "LEWIS DE SOTO." *SCULPTURE* 19, NO. 10 (DECEMBER 2000): 70–71.

PÉ TÚKMIYAT, PÉ TÚKMIYAT: LEWIS DE SOTO. WITH ESSAYS BY PATRICK J. MAHAFFEY AND REBECCA SOLNIT. SAN JOSE, CALIF.: SAN JOSE MUSEUM OF ART, 1991.

RIDDELL, JENNIFER. *RECITAL.* CAMBRIDGE, MASS.: LIST VISUAL ARTS CENTER, MIT, 1998.

WILLIS, HOLLY. "LEWIS DE SOTO AT CHRISTOPHER GRIMES GALLERY." *ARTWEEK* 29, NO. 5 (MAY 1998): 25.

[detail of brain pathologist's book]

Dervish, 1997
METRÒNOM, BARCELONA, SPAIN; SIX ELECTRONICALLY CONTROLLED
MOTORS, SPEAKERS, SPOTLIGHTS, SIX CHANNEL AMPLIFIERS, AND SIX
DISCRETE AUDIO CHANNELS PLAYED THROUGH SIX MINIDISC PLAYERS.
VARIABLE DIMENSIONS.

Recital, 1998–2001
LIST VISUAL ARTS CENTER, MIT, CAMBRIDGE, MA. YAMAHA DISKLAVIER PIANO,
MECHANIZED ELECTRONIC PAGE-TURNER, BOOK, MUSICAL SCORE. VARIABLE DIMENSIONS.

[detail showing a silvered bronze plaque]

On the Air, 2000, San Francisco International Airport.
12,000 SQUARE FEET OF FLOOR; TERAZZO, SILVER, ZINC, BRONZE, AND YELLOW
BRASS DIVIDER STRIPS; 182 SILVERED BRONZE PLAQUES; FLOORPLAN

[installation view]

VIOLA FREY

Viola Frey is best known for the representational ceramic sculptures she has been creating since the mid-1970s, which depict anonymous individuals on a monumental scale, enlivened with an expressive application of color.

In the 1970s, Frey made slip-casts of small kitschy figurines she had begun obsessively collecting at local flea markets and used them to compose tabletop tableaux, small-scale assemblages, and life-size figures. In 1975, she moved from San Francisco to a large house in Oakland and took a five-year hiatus from exhibiting and selling her work to focus her energies on creating her art. It was during this time that she became influenced by the notion of bricolage—objects made of junk. Already an avid scavenger of flea market treasures, and having grown up in a household of junk collectors, Frey pursued a natural inclination that was sparked by her readings of anthropologist Claude Lévi-Strauss. A *bricoleur,* as he described, is someone who is interested in ordinary, everyday things and makes unique creations from unexpected items. Her collection of secondhand figurines inspired her move toward figurative work, and her *bricoleur*'s sensibility is evident in her persistent interest in the everyday man and woman.

Not only did her Oakland house afford her space for her collections, it also provided her an interior painting studio and, in the backyard, an open-air ceramics studio, giving her space to dramatically enlarge the scale of her sculpture. Frey's outdoor studio exposed her sculpture to changing natural light, which was markedly different from the static conditions of her indoor studio. Applying her knowledge as a painter, she manipulated the clay surfaces with color to reflect an interplay of light and form.

Frey initially applied color to her sculptures naturalistically (brown for hair, red for lips) with a quasi-pictorial effect. As the work evolved, she moved toward a bolder, brushy application that brought forth the symbolic or emotional aspects of color. She takes a painterly approach, not striving for a sense of complete realism but adding gestural lines, marks, and blocks of color that are often unrelated to the underlying form. At every stage throughout her career, Frey has exploited color to infuse her sculpture with a dynamic intensity, ultimately achieving in each piece a balance between naturalistic and symbolic application of color.

Frey's monumental figures, which she has been producing since 1976, are an innovation in technique and style in the contemporary ceramics field. She creates them in sections, first firing the legs as structural support. The towering works—up to ten feet high—typically depict an anonymous man or woman in an awkward, tense pose. The figures are solid and almost clunky, but a sense of emotion comes through, and this makes them seem approachable and fragile. Frey employs formal tricks to make her figures more endearing, such as intentionally enlarging the heads and hands. She often presents her figures in isolation, which lends a sense of insecurity and caution. *Standing Man II* (2000) depicts a man dressed in suit and tie, clumsily tilting forward. As viewers engage the leaning figure, they become

VIOLA FREY (B. 1933, LODI, CALIFORNIA) ENROLLED AT STOCKTON DELTA COLLEGE IN 1952, WHERE SHE HAD HER FIRST FORMAL ART TRAINING. SHE THEN ATTENDED THE CALIFORNIA COLLEGE OF ARTS AND CRAFTS (CCAC) IN 1953 AND BEGAN STUDYING PAINTING UNDER RICHARD DIEBENKORN. AT THAT TIME, CCAC DID NOT OFFER A MAJOR IN CE-RAMICS, BUT SHE DEVELOPED HER INTEREST IN CLAY THROUGH ELECTIVE COURSES. SHE RECEIVED HER DEGREE IN PAINTING (BA, 1956) AND MOVED TO NEW ORLEANS TO STUDY UNDER MARK ROTHKO AT TULANE UNIVERSITY (MFA, 1958). FREY MOVED TO SAN FRANCISCO IN 1960 AND IN 1970 BECAME A FULL PROFESSOR AT CCAC. THIS WAS THE BEGINNING OF HER LONG AND INFLUEN-TIAL TENURE THERE. FREY HAS TWICE BEEN THE RECIPIENT OF FELLOWSHIPS FROM THE NATIONAL ENDOWMENT FOR THE ARTS (1978, 1986). SHE LIVES IN OAKLAND.

aware of its precariousness and fragility. Frey highlights the hair, facial features, clothes, and shoes with black lines and reduces the skin and clothes to blocks of expressive color, adding a liveliness to the static form. In some cases, she has developed a group of figures that share a structural base, as in *Family Portrait* (1995). Although the figures are physically close, their togetherness seems forced and suggests discomfort and unease. The larger, central male figure is visually dominant, inviting speculation that his strong physical and perhaps psychological presence engenders the apprehension in the group.

As she did with monumental sculpture, Frey brought stylistic innovation to the traditional form of the display plate. Her work evolved from pictorial pieces involving paint applied to flat surfaces to volumetric plates overflowing with slip-cast figures and objects. Her plates are more intimate than the monumental sculptures in their small scale and in the kind and number of figures presented. There is also a sense that Frey is showing the viewer something of herself, whether through the inclusion of her personal treasures or the appearance of hands that seem to be hers. *Untitled Plate (Roman Nose/Blue Pegasus)* (2000), which is twenty-five inches in diameter and eight inches deep, features angels, a horse, and a blue Pegasus that could have come from her living-room shelves. A pair of hands tries to contain the pieces in the space, establishing a sense of vitality that is heightened by the bold colors. Frey's plates are in keeping with her interest in bricolage, her exploration of the figure, and her dramatic sense of color, and also reveal her penchant for expanding the possibilities of the clay medium.

SELECTED READING

VIOLA FREY. WITH ESSAY BY GARTH CLARK. SACRAMENTO, CALIF.: CROCKER ART MUSEUM, 1981.

VIOLA FREY. WITH ESSAYS BY REENA JANA AND PATTERSON SIMS. SAN FRANCISCO: RENA BRANSTEN GALLERY, 1998.

VIOLA FREY: MONUMENTAL FIGURES, 1978–1987. WITH TEXT BY SUSAN LARSON. LOS ANGELES: ASHER-FAURE; SAN FRANCISCO: RENA BRANSTEN GALLERY, 1988.

VIOLA FREY: PLATES 1968–1994. WITH TEXT BY DONALD KUSPIT. NEW YORK: NANCY HOFFMAN GALLERY, 1994.

HIRSCH, FAYE. "CERAMIC INVENTIONS." *ART IN AMERICA* 84, NO. 3, (MARCH 1996): 84–87, 125.

Untitled Plate
(Roman Nose/Woody Woodpecker/Cow), 2000
CERAMIC; 25" DIAMETER X 9"

Untitled Plate
(Roman Nose/Blue Pegasus), 2000
CERAMIC; 25" DIAMETER X 8"

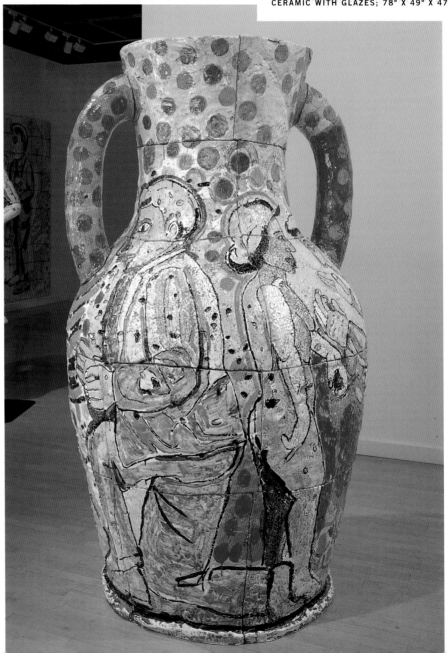

Urn II (After Portland Vase), 2000
CERAMIC WITH GLAZES; 78" X 49" X 47"

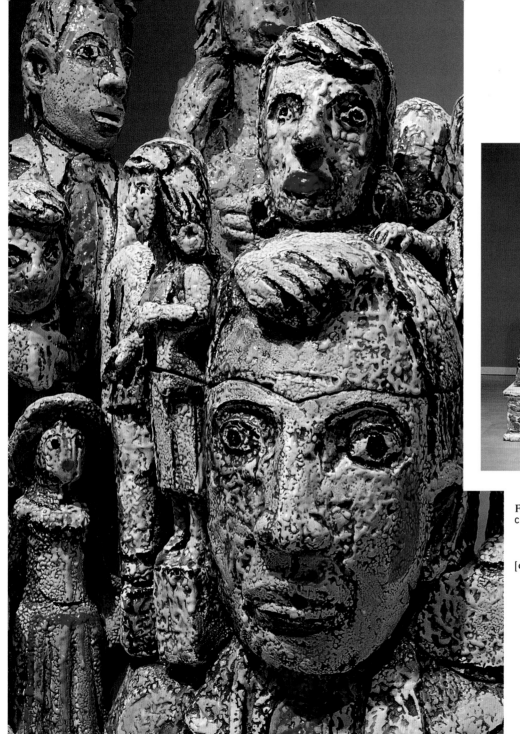

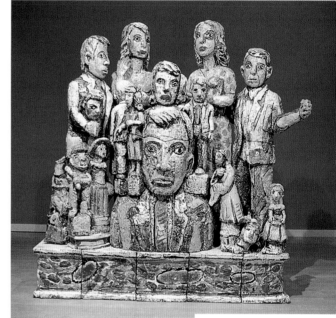

[installation view]

Family Portrait, 1995
CERAMIC; 84" X 79" X 29¹/₂"

[detail]

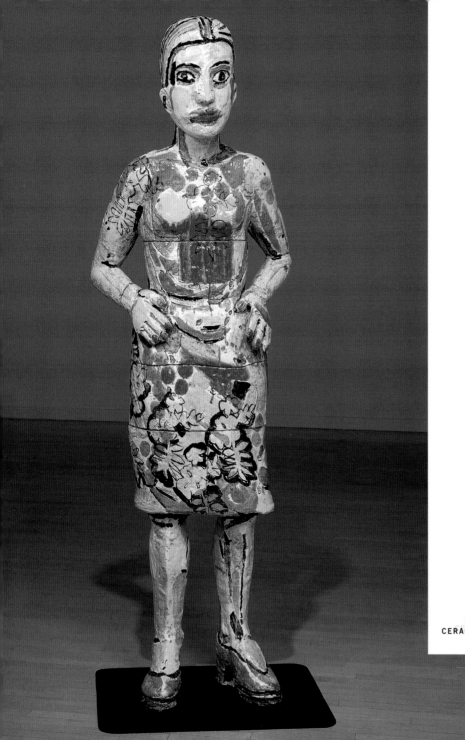

Standing Woman I, 2000
CERAMIC WITH GLAZES; 85" X 30" X 24"

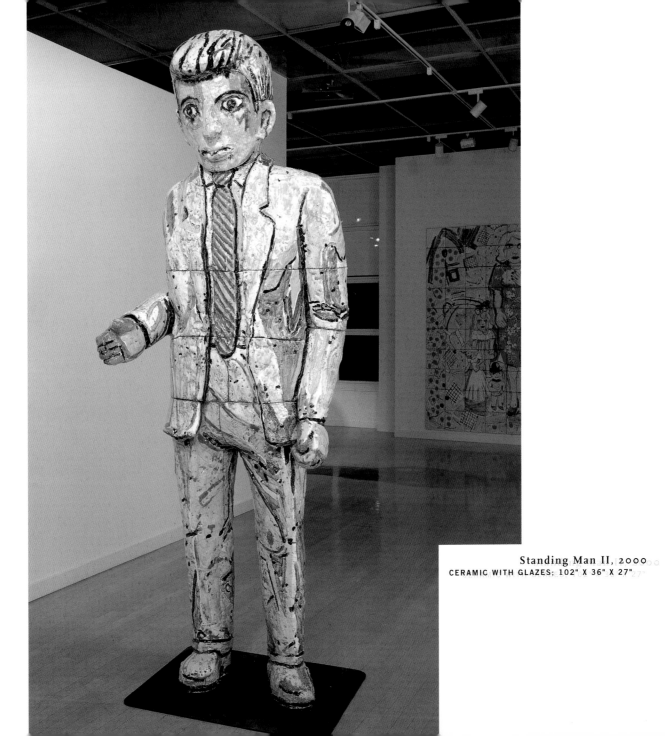

Standing Man II, 2000
CERAMIC WITH GLAZES; 102" X 36" X 27"

RUPERT
GARCIA

While a student in the late 1960s, Rupert Garcia began to create posters with explicit political messages, which continues in a lesser degree to the present. His earliest silkscreened posters protested the Vietnam War, promoted the Third World struggle for economic and political liberation, criticized the mass media as a producer and perpetuator of cultural stereotypes, and supported the Chicano cultural movement. Drawing on his childhood activity of copying from magazines and comic books, Garcia appropriated images from American pop culture, historical events, mass media, Christianity, and Mexican folk tradition. In *Ceylon Tea...* (1972), the Lipton Tea logo of a smiling, white-mustached, Anglo ship captain, dressed in cap, jacket, and bowtie and raising a cup of tea, is juxtaposed with the exclamation "Ceylon Tea: Product of European Exploitation!" *Calavera Crystal Ball* (1992) is a hopeful prophecy that shows a portrait of Christopher Columbus—his face obliterated by a handprint—floating above the hollow eyes of the traditional Mexican *calavera* (skull). Garcia found the poster an ideal medium for the communication and distribution of messages, and he was attracted to the bright, bold color and graphic characteristics of the silkscreen process.

In the late 1970s, Garcia began using pastel and since then has worked in oils, pencil, and printmaking. The political posters garnered him a reputation as a radical, yet his works in all media reflect a balance between activist ideology and aesthetic integrity. Garcia brings a deep understanding of cultural and historical sources to his art, informed by his personal experiences and crystallized though his extensive education. In 1970, Garcia was one of the founding members of Galeria de la Raza in San Francisco's Mission District. During the 1970s, he taught part-time, worked as a freelance writer and graphic artist for the bilingual publications *La Prensa* and *El Tecolote,* designed cover artwork for publications, created animation art for TV and film, and was art editor of an anthology produced by Third World Communications, a Bay Area collective of writers, dancers, musicians, filmmakers, and visual artists. In 1972, he made the first of several trips to Mexico, visited historical sites and museums, and learned about the Mexican artists who would become important influences on his work. His later training in art history has also been incorporated into his art and is readily apparent through a consistent use of references to important figures in the history of art.

Throughout his career, in works that the late critic Thomas Albright called "radical political portraits," Garcia has depicted artists or other inspirational figures. In a later example, *Frida Kahlo* (1990), Garcia

monumentalizes the artist through a tightly cropped, close-up view. In this bold depiction, he pays homage to her and commemorates her life, while bringing her to the attention of a Euro-American culture that has only a superficial understanding of her significant contributions. As he stated in a 1994 interview with artist Guillermo Gómez-Peña, "Kahlo seems to represent to many Americans the ultimate Other. Miss Exotica, a Mexican trinket, something reified to be consumed. For me, Frida represents artistic and social commitment. Her intense and beautiful paintings and the will to make them are inspiring. Her dedication to things Mexican and to social justice are empowering." In each of his portraits, whether of José Clemente Orozco, Emiliano Zapata, or Julius and Ethel Rosenberg, Garcia strives to create an icon that is both personal homage and public commemoration.

Photographs are frequently the basis for Garcia's pastels and paintings. His pastel *After Manuel Alvarez Bravo* (1997) is based on the Mexican photographer's 1937 *Worker on Strike, Murdered*. The original black-and-white photograph depicts a slain worker, arms by his side, lying on the street pavement. Taken at a slight angle, no more than a few feet from the subject, who is pictured from the waist up, it

RUPERT GARCIA (B. 1941, FRENCH CAMP, CALIFORNIA) GREW UP IN THE SAN JOAQUIN VALLEY. HE STUDIED ART AT STOCKTON JUNIOR COLLEGE (AA, 1962) AND IN 1962 MOVED TO SAN FRANCISCO. HE ENLISTED IN THE U.S. AIR FORCE AND VOLUNTEERED FOR SERVICE IN VIETNAM. UPON DISCHARGE IN 1966, HE BRIEFLY WORKED IN A CANNING FACTORY IN STOCKTON AND THEN ENROLLED AT SAN FRANCISCO STATE UNIVERSITY THROUGH THE GI BILL (BA, 1968; MA, 1970). GARCIA SPENT TWO YEARS IN THE DOCTORAL PROGRAM IN ART EDUCATION AT UNIVERSITY OF CALIFORNIA AT BERKELEY (1973–75) AND LATER STUDIED ART HISTORY (MA, 1981). AMONG HIS MANY HONORS ARE LIFETIME ACHIEVEMENT AWARDS FROM THE COLLEGE ART ASSOCIATION (1992) AND THE NATIONAL HISPANIC ACADEMY OF MEDIA ARTS AND SCIENCES (1995). GARCIA HAS TAUGHT AT SAN JOSE STATE UNIVERSITY SINCE 1988 AND LIVES IN OAKLAND.

creates a chilling interplay between the matter-of-fact description of a gruesome reality and the large abstract pool of blood that has poured from the man's head. Garcia crops the composition even more tightly, translates the original black-and-white into saturated colors, and magnifies it to an overwhelming scale (seventy-two-and-three-quarters inches by seventy-three-and-a-half inches). The saturated blocks of colors accentuate the graphic profile, throwing emphasis on the small, staring eye of the man and the thick flow of blood that is reminiscent of a cloth binding the mouth. Garcia has returned to this image in several works, in each instance imbuing the victim with a poignant sense of quiet heroism.

Garcia has used the diptych or triptych format to enhance collisions of meaning. In *The Reds Against the Black Shirts* (1996), a naturalistic rendering of flowers, in vibrant red, blue, green, and yellow on a white ground, is juxtaposed with a dark, indistinct combat scene of soldiers portrayed in red, black, and white. Although color formally links the two halves—the red and green of the flowers ties into the red sky of the combat scene, and the white smoke plays off the background of the flowers—the overall effect is of startling contrast, between peace and violence, between the beauty of nature and the crass ugliness that puts humans in military uniforms. The disparity heightens the viewer's feeling of repulsion about the violence of war.

SELECTED READING

FAVELA, RAMON. *THE ART OF RUPERT GARCIA: A SURVEY EXHIBITION.* SAN FRANCISCO: CHRONICLE BOOKS AND MEXICAN MUSEUM, 1986.

GARCIA, RUPERT. *FRIDA KAHLO: A BIBLIOGRAPHY AND BIOGRAPHICAL INTRODUCTION.* BERKELEY, CALIF.: CHICANO STUDIES LIBRARY PUBLICATIONS UNIT, UNIVERSITY OF CALIFORNIA AT BERKELEY, 1983.

RUPERT GARCIA: SEPTEMBER 4– OCTOBER 4, 1997. WITH TEXT BY LINDA NOCHLIN. SAN FRANCISCO: RENA BRANSTEN GALLERY, 1997.

LIPPARD, LUCY. *RUPERT GARCIA: PRINTS AND POSTERS, 1967–1990.* SAN FRANCISCO: FINE ARTS MUSEUM OF SAN FRANCISCO, 1990.

ASPECTS OF RESISTANCE: RUPERT GARCIA. WITH AN INTRODUCTION BY GENO RODRIGUEZ AND ANDREW PERCHUK, AN INTERVIEW BY GUILLERMO GÓMEZ-PEÑA, AND TEXT BY CARLA STELLWEG. NEW YORK: ALTERNATIVE MUSEUM, 1994.

After Manuel Alvarez Bravo, 1997
PASTEL ON PAPER; 72 3/4" X 73 1/2"

The Reds Against the Black Shirts, 1996
PASTEL ON TWO SHEETS OF MUSEUM BOARD;
80" X 32"

. . . . for Eyellende, 2000
INKJET PIGMENT ON FABRIC (EDITION OF 5);
35" X 57"

CARMEN LOMAS GARZA

Over the course of her career, Carmen Lomas Garza has created paintings, etchings, lithographs, sculpture, cut-paper art *(papel picado),* altars, and installations, in addition to several children's books. She is most widely known for paintings of stylized figures in specific social environments—figures that she calls *monitos* ("little dolls" or "little people"). These brightly colored narratives are scrupulously constructed and filled with exacting details. Garza was academically trained, yet purposefully uses a naive style, incorporating elements from such Mexican folk art traditions as *papel picado,* domestic altars, *capillas* (outdoor yard altars), and the flat-ground compositions of *lotería tablas* (playing cards). Each work contains small vignettes that could exist as separate stories but are carefully woven into the whole.

Barbacoa para Cumpleaños (1993) portrays a backyard barbecue birthday celebration, replete with traditional Mexican customs such as hanging *papel picado* banners and a game of piñata involving a large ring of eager participants. In depicting this gathering of relatives and neighbors, drawn from memories of childhood in south Texas, Garza captures multiple stories within the larger scene: three adults tend to the barbecue while others sit at the cake table conversing among themselves; a boy plays with a dog in the far yard; two sweethearts talk closely behind a tree; a grandfather points out something to his young grandchild; two women stand chatting in the ring of piñata players; boys poke sticks into an open fire. Garza heightens the air of festivity with vibrant colors, while betraying no brush strokes with her precise, smooth execution. She paints in a naive style, with simply rendered figures in stiff poses and a seemingly amateurish representation of a house and yard trees. She gives the viewer a privileged perspective on the scene—the space is compressed and flattened, as the ground is tilted up to enable a full, bird's-eye view. In this backyard scene, as in her other works, Garza establishes a sense of nostalgic timelessness, and among her characters there is a feeling of affection, jubilation, respect, and contentedness.

Garza's artworks are more than a mechanism for relating a story; they are acts of resistance to institutional history and the discrimination felt in her life and experienced collectively in the Chicano community. Rather than call attention directly to this oppression and discrimination, as many of her Chicano contemporaries have done, Garza developed a different artistic ideology, believing in the power of the positive, vibrant, loving, collective nature of her heritage. "My art is a way of healing these wounds, like the sávila plant [aloe vera] heals burns and scrapes when applied by a loving parent or grandparent." *Baile en 1958* (1995) shows a summertime Saturday night dance with young and old alike dancing to a traditional Mexican band. *Empanados: Tio Beto y Tia Paz* (1991) re-creates the annual family tradition of making turnovers at her aunt and uncle's house, and *La Llorana*

CARMEN LOMAS GARZA (B. 1948, KINGSVILLE, TEXAS) GREW UP IN A SMALL RURAL COMMUNITY NEAR THE MEXICAN BORDER. GARZA ATTENDED THE TEXAS ARTS AND INDUSTRY UNIVERSITY (NOW TEXAS A&M UNIVERSITY) IN KINGSVILLE (BS, 1972). SHE WENT ON TO THE JUAREZ-LINCOLN/ANTIOCH GRADUATE SCHOOL IN AUSTIN (ME, 1973) AND CAME TO SAN FRANCISCO TO WORK AS A CURATOR FOR THE GALERIA DE LA RAZA IN THE CITY'S MISSION DISTRICT (1976–1981). SHE LATER STUDIED AT SAN FRANCISCO STATE UNIVERSITY (MA, 1980). SHE HAS WIDELY EXHIBITED HER PAINTINGS, PRINTS, INSTALLATIONS, AND CUT-PAPER WORKS. SHE HAS ALSO TRANS-LATED *PAPEL PICADO* INTO STEEL: FOR THE SAN FRANCISCO INTERNATIONAL AIRPORT, SHE DESIGNED A SIXTEEN-FOOT-BY-TWENTY-FOUR-FOOT CAST COPPER CUTOUT ON STEEL TITLED *BAILE* (1999). GARZA HAS BEEN THE RECIPIENT OF TWO FELLOWSHIPS FROM THE NATIONAL ENDOWMENT FOR THE ARTS (1981, 1987), A LIFETIME ACHIEVEMENT IN ART AWARD FROM THE NATIONAL HISPANIC ACADEMY OF MEDIA ARTS AND SCIENCES (1995), AND AN INTERNATIONAL ARTIST IN RESIDENCE GRANT FROM THE FONDO NACIONAL PARA CULTURA Y LAS ARTES (1996). GARZA LIVES AND WORKS IN SAN FRANCISCO.

(1989) depicts her grandmother telling stories on the back porch to her captivated grandchildren. Through stories, Garza records her memories and celebrates her past, while affirming a specific cultural and social identity.

Garza also offers alternatives to traditional Western art narratives, which often marginalize women by presenting them as passive, sexual objects. The women in her paintings have active roles, as initiators with purpose and integrity, with dimension and character. In *Earache Treatment* (1989), a wife uses a home remedy to cure her husband's earache; the woman is presented not only as a loving caretaker but also as a dependable, confident healer. *Blessing on the*

Wedding Day (1993) offers a private glimpse of bridal preparations; Garza fills the scene with women, highlighting their multidimensionality by displaying a range of traits, including vanity, femininity, wisdom, nurturing, fastidiousness, and reverence. The women in her paintings represent power, productivity, and protection, and are centrally important to the perpetuation of custom and cultural traditions.

SELECTED READING

GARZA, CARMEN LOMAS. *FAMILY PICTURES/CUADROS DE FAMILIA.* SAN FRANCISCO: CHILDREN'S BOOK PRESS, 1990.

GARZA, CARMEN LOMAS. *IN MY FAMILY/EN MI FAMILIA.* SAN FRANCISCO: CHILDREN'S BOOK PRESS, 1996.

GARZA, CARMEN LOMAS. *MAKING MAGIC WINDOWS: CREATING PAPEL PICADO/CUT-PAPER ART WITH CARMEN LOMAS GARZA.* SAN FRANCISCO: CHILDREN'S BOOK PRESS, 1999.

MESA-BAINS, AMALIA. *PEDACITO DE MI CORAZÓN.* AUSTIN, TEXAS: LAGUNA GLORIA ART MUSEUM, 1991.

SNOW, K. MITCHELL. "CARMEN LOMAS GARZA." *ART NEXUS,* NO. 20 (APRIL/JUNE 1996): 124–25.

YBARRA-FRAUSTO, TOMÁS. *LO REAL MARAVILLOSO, THE MARVELOUS/THE REAL.* SAN FRANCISCO: MEXICAN MUSEUM, 1987.

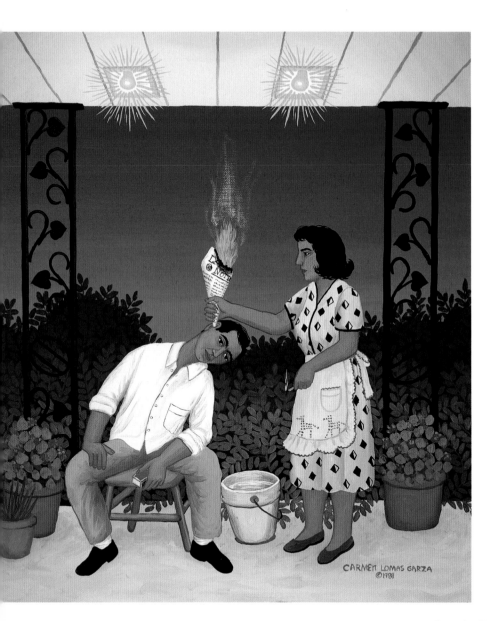

Earache Treatment, 1989
OIL ON CANVAS; 17" X 15"

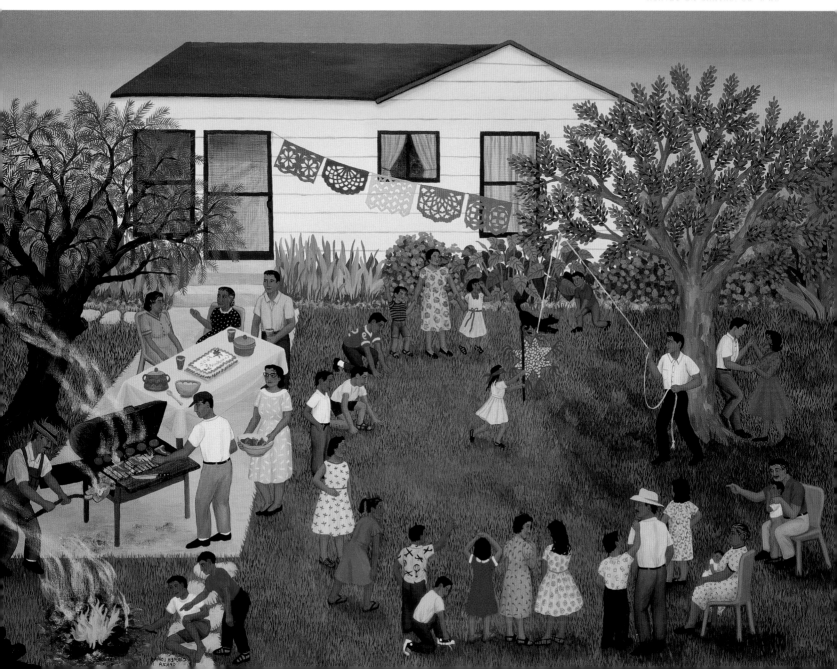

KEN GOLDBERG

The concepts and physical designs of Ken Goldberg's artworks are integrally embedded in the structures of the abstract, participatory, and anonymous nature of computers and the Internet. He creates opportunities for viewers to become involved with sophisticated computer technology whose more lucrative applications have outpaced its humanistic potential. It is this interaction between viewers and technology, a phenomenological exploitation, that shapes his work.

A vocabulary has evolved to describe systems that combine digital communication technology such as the Internet and remotely controlled mechanisms. *Telepresence* is defined simply as experience at a distance; real-time, personal, audio-visual linked webcam feeds via the Internet. *Telerobotics* refers to mechanical actions controlled through remote commands. Goldberg has coined the term *telepistemology,* which he explains as the investigation of knowledge disseminated through the Internet.

Telegarden, begun in 1995 and still ongoing, is a real-world, living flower and vegetable garden that is tended through the Internet. An industrial robotic arm, directed by online viewers, plants, waters, and monitors a small plot of marigolds, peppers, and petunias. A live video feed transmits the progress of the remote garden. The online community formed around the garden is sustained through a chat room and bulletin board. In 1996, *Telegarden* was moved to the Ars Electronica Center in Linz, Austria, where it continues to be on exhibit.

The Internet poses an inherent difficulty in the distinction between what is virtual and what is real. "Technologies for viewing continue to evolve," Goldberg notes, "from the camera obscura to the telescope to the atomic force microscope; each new technology raises questions about what is real versus what is an artifact of the viewing process. . . . Media technology generally facilitates the suspension of disbelief; I'm trying to facilitate the resumption of belief."

Goldberg's work allows, and even depends upon, viewers to question the premises of his works and the technology that delivers them. Goldberg capitalizes on the implied veracity of claims in the new medium and the tendency to doubt what cannot be seen firsthand in *Legal Tender* (1996–97). Online, an introductory text explained that a visitor could perform remote-controlled authentication tests on a pair of hundred-dollar bills, one genuine and the other counterfeit, in an unidentified Washington, D.C., office. Participation required visitor identification and registration, and the penalty for inadvertent destruction of the genuine bill was implicitly severe. Viewers performing these remote authentication tests were prompted to consider the credence of the artwork itself. Was there actually an office? Were these tests being conducted as stated? Were both bills genuine? Or counterfeit? Similarly, *Dislocation of Intimacy* (1998), which Goldberg describes as "a telerobotic camera obscura," was a powder-coated black steel box, thirty-eight inches high, forty-eight inches long, and fifty-eight inches wide, which sat on a gallery floor with an Internet connection cable running out of it. Rather than seeing into the box, viewers had to take home a URL (Web site address) and virtually visit it online in order to view the contents. On the website's interface, six

buttons were presented as options. When selected, each remotely produced different combinations of lighting inside the box in the gallery. A digital still of the selected illumination appeared onscreen and provided an indistinct, colorless image of the assembled objects inside the box. However, nothing was offered to convince viewers that these views were actually taking place inside the box. In both artworks, online visitors were confronted with similar, unverifiable scenarios.

Goldberg further expanded on the question of credibility in *Ouija* (2000). An online computer terminal, housed in a curtain-shrouded gallery installation, displayed a Ouija board. Programmed questions were randomly offered to a viewer, and a robotic arm moved the planchette to provide answers. What the viewer did not know was that the robotic movements were determined by the average of motion commands comprising the mouse movements of up to twenty multiple users. The appearance of the answers mimed playing the game on a traditional board as no single viewer could control the robotic arm, except that online viewers were unaware of one another. Once again,

SELECTED READING

ANDERSON, MAXWELL L., ET AL. *2000 BIENNIAL EXHIBITION.* NEW YORK: WHITNEY MUSEUM OF AMERICAN ART, 2000.

GOLDBERG, KEN, ED. *THE ROBOT IN THE GARDEN: TELEROBOTICS AND TELEPISTEMOLOGY ON THE INTERNET.* CAMBRIDGE, MASS.: MIT PRESS, 2000.

GOLDBERG, KEN, AND ROLAND SIEGWART, EDS. *BEYOND WEBCAMS: AN INTRODUCTION TO ONLINE ROBOTS.* CAMBRIDGE, MASS.: MIT PRESS, 2001.

JACOBSEN, HEIDI ZUCKERMAN. *KEN GOLDBERG.* BERKELEY, CALIF.: BERKELEY ART MUSEUM, 2000.

NUSSBAUM, EMILY. "THE WAY WE LIVE NOW: SALIENT FACTS—EXTREME GARDENING; THE GREEN REAPER." *NEW YORK TIMES SUNDAY MAGAZINE,* 1 JULY 2001, SEC. 6, P. 21.

PESCOVITZ, DAVID. "CYBER VIEW: ACCOUNTING FOR TASTE." *SCIENTIFIC AMERICAN* 282, NO. 6 (JUNE 2000): 44.

KEN GOLDBERG (B. 1961, IBADAN, NIGERIA) BECAME FASCINATED WITH GADGETRY THROUGH HIS FATHER, AN ENGINEER WHOM HE HELPED BUILD A ROBOT. GOLDBERG GREW UP IN BETHLEHEM, PENNSYLVANIA, ATTENDED THE UNIVERSITY OF PENNSYLVANIA, AND EARNED TWO DEGREES (BSE, ELECTRICAL ENGINEERING; BSE, SCHOOL OF ENGINEERING; BSE, WHARTON SCHOOL OF BUSINESS, 1984). IN 1986 HE SPENT A YEAR ABROAD AS A VISITING RESEARCHER AT THE CENTER FOR MANUFACTURING SYSTEMS AND ROBOTICS AT THE ISRAEL INSTITUTE OF TECHNOLOGY (TECHNION) IN HAIFA, ISRAEL. HE THEN PURSUED A DOCTORATE IN ROBOTICS AT CARNEGIE-MELLON UNIVERSITY IN PITTSBURGH (MS, PHD, 1990) AND BECAME INTERESTED IN ART. GOLDBERG TAUGHT AT THE UNIVERSITY OF SOUTHERN CALIFORNIA AND SINCE 1997 HAS BEEN ON THE FACULTY OF THE UNIVERSITY OF CALIFORNIA IN BERKELEY. HE IS A PROLIFIC AUTHOR OF TECHNICAL PAPERS AND IS THE HOLDER OF FOUR U.S. PATENTS. HIS WEB SITE ADDRESS IS www.ken.goldberg.net; THE ADDRESS FOR *TELEGARDEN* IS www.telegarden.aec.at. HE MAINTAINS A LABORATORY IN BERKELEY.

the underlying assertions of the piece's principles—in this case the democratic group process—could not be verified.

In *The Tele-Actor* (2001), online viewers were presented with the opportunity to direct a purported robot. In this piece, Goldberg, with a collaborative team, crossed from the mediums of installation and online technology to performance, and even self-reflexively punctured engineering expertise, for the robot subject was revealed to be a woman equipped with wireless audio and video, taking directions from a community of remote controllers. The online participants could watch the environment of the robot through a webcam and could vote on goals that supposedly directed its actions. Could the ultimate product of state-of-the-art robotics be a human? Here, as in much of his work, Goldberg probes the alleged claims of technology and questions them, without answering, but allowing participants in his art to come to their own conclusions.

While his engineering knowledge provides the technical capability to conceive the work, Goldberg's conceptual investigation does not proceed from strictly scientific or artistic concerns, but also from an interest in human behavior and perception. Collaboration is both the subject and the methodology of much of Goldberg's work, from his project teams of engineers and artists to the presence and participation of viewers interacting with a piece. Perhaps the central question is what constitutes the artwork itself, as the answer vacillates between the sureties of physical presence and the mysteries of immaterial, mutable experience.

Ouija 2000, 1999
INTERNET INSTALLATION AT MATRIX,
BERKELEY ART MUSEUM,
UNIVERSITY OF CALIFORNIA, BERKELEY

Telegarden, 1995 – present
INTERNET INSTALLATION/SCREEN SHOT

[internet installation/robot arm; 6' x 6' x 6']

GUILLERMO
GÓMEZ-PEÑA

Guillermo Gómez-Peña uses language as a living, malleable tool of communication and expression. An extremely prolific artist, he creates poetry, radio commentary, videos, installations, CD-ROMs, and Web-based works as well as politically charged, highly theatrical performances. Gómez-Peña makes observations about numerous social, political, and cultural attitudes, and creates works that promote greater understanding and tolerance through critical self-inquiry.

Collaboration has played a pivotal role in his career. Gómez-Peña was co-founder, writer, and performer for two politically active groups in San Diego, California: Poyesis Genetica (1981–85) and the Border Art Workshop/Taller de Arte Fronterizo (BAW/TAF) (1985–89). Poyesis Genetica created heavily theoretical, multicultural, interdisciplinary performances about immigrant experiences such as displacement, exile, and identity. BAW/TAF fostered art as a social act involving community and communication, and organized interdisciplinary performances, installations, and exhibitions about ethnic stereotyping and borders (still ongoing). Performances were enacted at a US/Mexico border checkpoint, in galleries, and on San Diego streets. Following his participation in BAW/TAF, Gómez-Peña began working with other collaborators including artists Coco Fusco (1992–95), James Luna (1995), and Roberto Sifuentes (since 1993).

Gómez-Peña's text-heavy performances have a searing energy and urgency. He interchanges languages, dialects, and hybrid idioms: Spanish, English, Spanglish, Ingleñol, and Nahuatl, and employs accents and slang. His use of parody, satire, irony, and humor exposes and examines racist stereotypes. Sentences assembled for their sound contain puns and multiple meanings, and Gómez-Peña delivers them with a deliberate, resonant drama.

For Gómez-Peña, national borders work on a metaphorical level as separations between cultures, especially where the separation involves an imbalance of power. The *Border Brujo* (*brujo* is a warlock or shaman) appeared in a 1988 performance of the same name. In character, Gómez-Peña sported a pigtail and wore a straw hat, a border-guard jacket covered with buttons (brandishing political slogans and images of pop stars) and toy sheriff badges, and necklaces of beads, shells, and plastic bananas. He sat at a small table filled with Day of the Dead figurines, incense, votive candles, and a kitsch assortment of puppets, masks, and Indian dolls. As Gómez-Peña read the monologue, he slipped in and out of several languages and accents. In the process, ten different personae emerged, a mix of characters and caricatures, including a border guard, an obnoxious gringo, an undocumented Chicano, and other stereotypes such as the seedy bandito of Saturday morning cartoons, the wetback, and the sleepy Mexican. Scenarios in his performances ask an audience to imagine the perspective on the opposite side of a border. At one point in the performance, the border guard created a scenario in which the audience were treated as visitors to his "performance country," authoritatively addressing them through a bullhorn.

GUILLERMO GÓMEZ-PEÑA (B. 1955, MEXICO CITY) STUDIED LINGUISTICS AND LATIN AMERICAN LITERATURE AT THE UNIVERSIDAD NACIONAL AUTÓNOMA DE MÉXICO (BA, 1976). IN 1978, HE MOVED TO THE UNITED STATES AND STUDIED AT THE CALIFORNIA INSTITUTE FOR THE ARTS IN VALENCIA (MFA, 1982). AMONG NUMEROUS FELLOWSHIPS AND AWARDS, HE BECAME THE FIRST CHICANO/MEXICAN ARTIST TO RECEIVE A MACARTHUR FOUNDATION FELLOWSHIP (1991–96). HE DIVIDES HIS TIME BETWEEN MEXICO CITY AND SAN FRANCISCO.

After the performance, some members of the audience reportedly expressed feelings of alienation during this experience, and annoyance with his use of language that they couldn't understand. The misunderstandings and intertwined relationship between Mexican and American cultures is depicted from both points of view in *Border Brujo,* which was later recorded on videotape (1990, fifty-two minutes, Isaac Artenstein, director).

Gómez-Peña uses the opportunities in different geographical and social circumstances to examine separation between cultural groups and evolve his characters, who reappear in different pieces. In 1998, El Mad Mex (Gómez-Peña), CyberVato (Sifuentes), and LaCultural Transvestite (Sara Shelton-Mann) performed in *Meet Mexterminator, 2 Mexicans on Safari in Manhattan,* and *Temple of Confessions* in New York, sponsored by Creative Time, Circuit Network, and El Museo del Barrio. They were described as ". . . undocumented 'specimens' on display exhibit a variety of cultural characteristics: hybridity, hypersexuality, infectiousness, and unnecessarily violent behavior. They deal drugs and jalapeño peppers, speak Spanglish and gringoñol, practice experimental performance and witchcraft . . . ," and promised impromptu public appearances, conceptual ads, posters, radio PSAs, a radio call-in talk show, and Internet chat.

Gómez-Peña describes the improvisational performance-exhibitions that he and Sifuentes have developed as "living dioramas that parody and subvert traditional representations such as the tableaux vivant, the freak show, the Indian trading post, the border 'curio shop,' and the porn window display. We exhibit ourselves as highly decorated and exoticized 'human artifacts or specimens' and as living avatars or holy saints on an unknown, dying border religion. Our Web site acts as a 'virtual confessional.'"

Early in his career, Gómez-Peña wrote about himself as fated for the role of *chilango* (slang for a Mexico City native) who flees the social and ecological problems of Mexico City and migrates to "el norte." He adapts this role to changing social and political circumstances to catalyze critical thinking about the world. "I like to see myself as a professional troublemaker," he says. "As a builder of ephemeral communities, as someone who shapes someone else's rebellion or anger. I'm always looking for ways to create total experiences that are really exciting and playful, but at the same time hopefully politically enlightening and critical."

SELECTED READING

BRESLAUER, JAN. "THE QUEEN GETS A MAKEOVER." *LOS ANGELES TIMES* CALENDAR, 14 JUNE 1998: PP. 3, 82.

GÓMEZ-PEÑA, GUILLERMO. *DANGEROUS BORDER CROSSERS: THE ARTISTS TALK BACK.* NEW YORK: ROUTLEDGE, 2000.

GÓMEZ-PEÑA, GUILLERMO. *THE NEW WORLD BORDER: PROPHECIES, POEMS & LOQUERAS FOR THE END OF THE CENTURY.* SAN FRANCISCO: CITY LIGHTS, 1996.

GÓMEZ-PEÑA, GUILLERMO. *WARRIOR FOR GRINGOSTROIKA: ESSAYS, PERFORMANCE TEXTS, AND POETRY.* ST. PAUL, MINN.: GRAYWOLF PRESS, 1993.

GÓMEZ-PEÑA, GUILLERMO, PHILIP BROOKMAN, ED., ET AL. *TEMPLE OF CONFESSIONS: MEXICAN BEASTS AND LIVING SANTOS.* NEW YORK: POWERHOUSE, 1996.

SHERLOCK, MAUREEN. "THE YEAR OF THE WHITE BEAR." *ART PAPERS* (MAY–JUNE, 1994): 31–37.

WALD, ELIJAH. "IN KRESGE EXHIBITS, A GLOBAL ASSAULT." *THE BOSTON GLOBE* (3 FEBRUARY 2000): SEC. C, P. 6.

Guillermo Gómez-Peña, Califas 2000, 2000
PERFORMED AT THE LAB, SAN FRANCISCO, CA

Guillermo Gómez-Peña as El Mad Mex and
Roberto Sifuentes as CyberVato, 1997

The Temple of Confessions, 1994
DETRIOT INSTITUTE FOR THE ARTS

IAN
GREEN

Intimate, interior, personal space is balanced against the vastness of the world in Ian Green's mixed-media works. Not limited to what they describe photographically, they instead evoke particular emotional states and explore existential questions of personal identity, spiritual renewal, and the cultural conditions created by society.

In the mid-1980s, Green moved away from traditional photography and began to both manipulate the photograph and combine it with other materials. The photographs were typically simple, straightforward, and small, and were altered through a direct application of subtle colors or through chemical processing, such as toning or blueprinting. The photograph of a steer skull is affixed to a seventeen-by-ten-inch rusted steel plate in *Untitled #100,* a mixed-media piece from his "Cultural Landscape" series (1988). The photograph, approximately five by two-and-a-half inches, has the warm brown of sepia toning and the torn edges of rag paper, and is surrounded by a one-and-a-half-inch faint field of chalk or pastel, which is primarily white with slight additions of red and blue. Below the image, two smaller photographs—each approximately one-quarter by one inch and depicting industrial landscapes, with charred edges suggesting they are fragments—flank a piece of barbed-wire. Ostensibly a work whose substance is described by the combination of images (cattle, western landscape, factories), object (barbed-wire), and patriotic colors (red, white, and blue), its subtext considers the cultural and spiritual attitudes toward the natural landscape. The subjects of all three images are rendered with an elusive light, which ironically projects qualities that are beautiful, thoughtful, and slightly terrifying.

Throughout the 1990s, Green's works reflect an investigation of imagery as a vehicle of emotional states. He typically applies paint or text to create a state of conceptual incongruity, and subjects are selected as metaphors, which are further indicated through costumes (a court jester, a nurse) or title *(The Caregiver).* The individuality of any human subject is deliberately obliterated, with facial features being obscured by masks or hands, or simply turned away from view. Pieces are physically larger (up to eighty-four inches in height), composed of multiple frames, or sculptural, standing on the floor, several with substantial weight. The photographic subjects of these works vacillate between being ultra-contemporary and referring to the mythically ancient, as the pieces themselves became more introspective.

In a diptych from this period, two stacked images, in color so subdued that it is nearly monochromatic, comprise *In Which Tongue Doth She Speak?* (1991). The images are spaced slightly apart, and each is surrounded by an irregular black border. In the upper image, a billboard proclaims "The Virgin Mary Speaks to America Today, toll free message 800-232-MARY," with a high-contrast iconic portrait of

the Blessed Mother. The lower image is a close-up of a tongue depressor being inserted into a female mouth, physically twice the size of the upper frame, and is covered with large block ink printing: "Which Tongue Doth She Speak?" The oral supplication suggests both the act of communion and a medical examination, while the combination of images and text indicts both religion and media.

Green adopts a heavier application of oil paint, which is repetitively brushed until the underlying photographic information is buried in some places, barely visible in others, and seemingly untouched in still other spots in *The Philosopher's Stone* (1996). A human brain is propped inside a framed window, as if displayed for sale. Behind it and slightly to the right, a hooded figure faces the window, at such an oblique angle that only a nose, mouth, and chin are visible. Reds, greens, and grays faintly activate the areas that are not obscured by heavy shadows. The clash of colors is unsettling, a further gesture toward the emotional and away from the representational imagery.

Green began to use water as a subject about 1995. Water has symbolic meaning throughout history in myth, science, and religious practice: being the source of all life, harboring the unknown, and representing renewal and sustenance of religious faith. Bodies of water are without inherent form, except at their surfaces and edges. In his works, Green promotes and admires this physical state of nature and directs viewers towards a consideration of solitude. This solitude blends two kinds of space, the personal, interior space of intimacy and the undefined expanse of an immense world. Entering water's undefined vast space is to philosophically enter another dimension, an immensity that changes preexisting relationships.

IAN GREEN (B. 1963, POUGHKEEPSIE, NEW YORK) WAS RAISED PRINCIPALLY IN DENVER, COLORADO (1965–70), AND AUSTIN, TEXAS (1971–81). HE STUDIED PHOTOGRAPHY WITH NATHAN LYONS, KENDA NORTH, BEN BENSCHNEIDER, JOHN UPTON, AND OTHERS AT THE COLORADO COLLEGE, COLORADO SPRINGS (1981), AND ATTENDED THE UNIVERSITY OF TEXAS IN AUSTIN (1982–84) AND THE BROOKS INSTITUTE OF PHOTOGRAPHY IN SANTA BARBARA, CALIFORNIA (BA, 1987). HE HAS LIVED IN SAN FRANCISCO SINCE 1988.

Green's works from 1997 on are black-and-white photographs painted with oils and affixed to thick wood panels. The images are dark with subdued ochres and greenish blacks; many are so dark that an image is barely perceptible, without an illusion of depth, causing image and art object to be indistinguishable. Each photograph displays a single subject—a life preserver, a boat propeller, a pier, or water—and the same subjects repeatedly appear in various forms. A life preserver, the subject of *Life Ring* (No. 1, 1997), is lying on paper as if cast aside, certainly unprepared to save anyone. The image is divided into quadrants that are not aligned with each other, which creates a spatial and temporal disconnection among the parts. This disjointedness elicits emotions at odds with the presumed safety of the subject depicted. Similarly, in *Untitled (bridge)* (1999), what appears to be part of a pier lies across an expanse of water. The rhythms and texture of the water's surface are barely visible, obliterated by the deep-brown, lifeless coloration, which muffles the hope of spiritual salvation.

SELECTED READING

GREEN, IAN. "TREADING WATER," *IDENTITIES*. HOUSTON: HOUSTON CENTER FOR PHOTOGRAPHY, 2000.

JOHNSTONE, MARK. *MYSTICAL OBJECTS, SACRED PLACES*. WITH AN ESSAY BY AMY GERSTLER. LOS ANGELES: SECURITY PACIFIC CORPORATION, 1989.

MILLER, TRESSA R. *CARNATION COMPANY ART COLLECTION*. GLENDALE, CALIF.: CARNATION COMPANY, 1990.

Life Ring, 1997
OIL ON GELATIN SILVER PRINT,
WOOD PANELS (EDITION OF 2); 46" X 37"

Untitled (bridge), 1999
OIL ON GELATIN SILVER PRINT,
WOOD PANELS (EDITION OF 2); 18" X 57"

Floaters, 1999
OIL ON GELATIN SILVER PRINT, WOOD PANELS (EDITION OF 2); 34" X 18"

LYNN HERSHMAN

Lynn Hershman investigates identity and its peculiarities through photographs, installations, videotapes, and feature films. The narratives in her works since 1970 are essentially psychological explorations accomplished through the establishment of different identities in fabricated persona. She has pursued this search of what constitutes an individual by delving into masks and themes of doubles, replication, and multiple identities. These experiences, in turn, led to her awareness of observation, and to corollary themes of surveillance, empowerment, control, and the roles played by technology in all these interactions.

Hershman's earliest works were designed for viewer interaction, from the wax self-portrait masks that talked to viewers through tape-recorded monologues to a nine-month installation at *The Dante Hotel* (1973–74) in the North Beach section of San Francisco. For the latter, she rented a cheap room, filled it with objects such as books, cosmetics, and clothing to suggest the identities of occupants, lit the space with pink and yellow light, and played tape recordings of breathing, along with live radio. Viewers could sign in at the front desk of the hotel, receive a key, and visit the room. The installation abruptly ended when a hotel guest glimpsed two unmoving female figures in bed and called the police.

Soon after *The Dante Hotel,* Hershman began to construct the identity of a fictional person, *Roberta Breitmore* (1975–78). Her first action was to place an ad in a local newspaper for a roommate. People who answered the ad became participants in the performance, with

both Hershman and accomplices playing the role. She acquired identification papers, a curriculum vitae, rented an apartment, and filled the closet with new clothes. Roberta performed real-life activities in the real world, recorded in photographs, such as opening a checking account, seeing a psychiatrist, and attending a gallery opening and Weight Watchers. Hershman developed the ambitions, needs, and moods of Roberta, who was a blend of artificiality and reality. *Roberta Breitmore* was the beginning of Hershman's exploration of women as figures of power, their identity and representation. She "exorcised" Roberta in 1978 by burning a photograph of her at Lucrezia Borgia's crypt in Ferrara, Italy. As art historian Kristin Stiles has observed, "When the smoke cleared, Lynn picked up a video camera."

Hershman's awareness of identity, especially that of women and their places or roles in society, and how society in turn has shaped those roles, is variously explored in over fifty videotapes that she has made since the late 1970s. She divides her work into two categories—B.C. and A.D. (Before Computers and After Digital). In *Lorna* (1979–83), the first interactive videodisk by an artist, viewers can access information about a woman so traumatized by media reportage of the outside world that she stays in her apartment. Viewers pursue different avenues that elaborate on issues from women's rights to the threat of nuclear war, and direct Lorna's life to several possible endings. While *Lorna* directly addresses feminist issues, it is ironic that her fate is determined electronically by someone else. As Hershman has

observed, "I am concerned with how individuals mirror the society they participate in and internalize the throwaway articles, images, and experiences of everyday life. I use digital tools to create insights into new technologies and to suggest metaphors for related themes, such as surveillance, voyeurism, and capture. An aim of my work, which is often interactive in form, is to push preconceived boundaries between media and 'real' life."

Hershman's dual interest in identity and technology is evident in *Deep Contact: The First Interactive Sexual Fantasy Video Disc* (1984–89), in which viewers may choreograph the story and select their sex, identity, and personality by means of a touch screen. Viewers are instructed to touch their guide Marion on any part of her body and, in so doing, develop different storylines. The layers of truth or representation generated by this experience are an ongoing fascination for Hershman. She participates in a similar fashion through *The Electronic Diaries of Lynn Hershman—First Person Plural, 1984–1996,* where she interweaves personal confession, her professional persona as an artist, and vintage film clips, and tells stories of childhood abuse, being pregnant and deserted by a husband, and her subsequent struggles with weight. The video vacillates between functioning as self-therapy and offering stories that reflect more general experiences of age, gender, and culture. She reconstructs and touches on an array of common experiences that many people are unable to articulate, such as why a relationship failed, and tells her own stories with honesty and elegance.

Hershman's first feature film, *Conceiving ADA* (Fox Lorber, 1999), which she co-wrote, produced, and directed (under her married name, Hershman-Leeson), is the story of Ada Lovelace, a nineteenth-century genius and free-spirited woman who developed the mathematical and theoretical designs for what is now considered an early prototype of the computer. Ada is accidentally channeled by Emmy, a contemporary genetics scientist, virtual-reality researcher, and computer expert, who manages to communicate with her. Emmy finds herself pregnant when she channels Ada and agonizes over the potential effects her untested experiments might have on her pregnancy. Ada is also pregnant and fears that the voice she hears is driving her mad. Patterns of trust emerge, and their spirits overlap as they communicate and form a bond. Gender stereotypes are switched in the film: men are portrayed as being sensitive while women are self-centered, emotionally insensitive, and driven. Hershman used virtual sets to create all the nineteenth-century scenes and based every set, frame, and page of dialogue on the double helix structure of DNA. Artificial life, fantasy, and history are woven together through a dazzling blend of digital video and film techniques in a story about identity, empowerment, and self-expression.

LYNN HERSHMAN (B. 1941, CLEVELAND, OHIO) STUDIED AT CASE WESTERN RESERVE UNIVERSITY, CLEVELAND (BS, 1962), AND SAN FRANCISCO STATE UNIVERSITY (MA, 1972). SHE HAS RECEIVED MANY AWARDS FOR HER WORK, INCLUDING A SEIMENS MEDIA ARTS AWARD, ZENTRUM FÜR KUNST UND MEDIENTECHNOLOGIE, KARLSRUHE, GERMANY (1995); A FLINTRIDGE FOUNDATION VISUAL ARTS AWARD (1998); AND AN IOMEGA AWARD FOR INNOVATIVE TECHNOLOGY AT THE SUNDANCE FILM FESTIVAL (1998). HERSHMAN HAS TAUGHT AT MANY INSTITUTIONS AND SINCE 1993 AT THE UNIVERSITY OF CALIFORNIA, DAVIS. SHE MAINTAINS A WEBSITE AT: HTTP://WWW.LYNNHERSHMAN.COM AND LIVES IN SAN FRANCISCO.

SELECTED READING

DRUCKERY, TIMOTHY, ED. *ITERATIONS: THE NEW IMAGE.* CAMBRIDGE, MASS., AND LONDON: MIT PRESS, 1994.

HALL, DOUG, AND SALLY JO FIFER, EDS. *ILLUMINATING VIDEO: AN ESSENTIAL GUIDE TO VIDEO ART.* NEW YORK: APERTURE; SAN FRANCISCO: BAY AREA VIDEO COALITION, 1990.

HERSHMAN, LYNN. *CHIMAERA MONOGRAPHIE.* MONTBÉLLIARD, FRANCE: CENTRE INTERNATIONAL DE CRÉATION VIDEO, 1992.

HERSHMAN, LYNN, ED. *CLICKING IN: HOT LINKS TO A DIGITAL CULTURE.* SEATTLE, WASH.: BAY PRESS, 1996.

STACK, PETER. "VIRTUALLY REAL 'SETS' FOR NEW MOVIE." *SAN FRANCISCO CHRONICLE,* 15 AUGUST 1996, SEC. D, PP. 1, 5.

STILL FROM Difference Engine 3, 1999
INTERACTIVE NET INSTALLATION

Are Our Eyes Targets
STILL FROM A Room of One's Own, 1994
DIGITAL PRINT; 30" X 40"

Conceiving Ada, 1998
DIGITAL PRINT, 16" X 20"

Phantom Limb 2 Seduction, 1985
GELATIN SILVER PRINT, 24" X 30"

Roberta Construction Chart, 1976
DYE TRANSFER PRINT,
24" X 30"

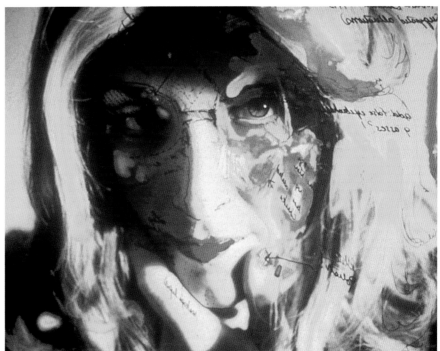

TODD HIDO

Enhanced by the absence of people, a feeling of isolation characterizes Todd Hido's color photographs of the interiors and exteriors of houses that he has made since the late 1990s. His interior photographs depict the empty rooms of low-income apartments or houses in foreclosure, revealing only minimal evidence of the former inhabitants. A sense of loneliness also permeates his exterior photographs of middle-class houses, which he makes from vantage points that convey a sense of illicit lurking. Hido sustains these unsettling emotions through the unexpected colors produced by his extended nocturnal exposures or by photographing in inclement weather.

Home ownership is a social and cultural promise and opportunity in the United States, and the inability to initiate or maintain that contract can imply personal or economic failure. Feelings of abandonment run throughout Hido's photographs of bleak interiors of houses in foreclosure, and viewers are left to speculate about the lives and identities of the former owners. Because Hido works only with available light and light coming through the windows, the colors in the photographs are subdued. An emotional emptiness haunts rooms that are bare except for stained or worn carpeting, dirty walls and cheap paneling, and the occasional discarded household item. The neglect and desertion in the locations where many of these photographs were made—Fresno, Stockton—reflect California cities with a high dependency on rural work, and indirectly suggest the fragility and tough existence in this economic sector.

Hido photographs single-family homes and apartment buildings outdoors at night, and the pathos of his interior photographs is also present in the exterior views. The glow from a single window is usually the only evidence of occupation. Space is a barrier in these photographs in both a physical and psychological sense, as Hido observes his subjects from the opposite side of the street, across an intersection, or from an alley alongside or at the rear of a building. Rather than approach the front of a house, as visitors would, he moves around a building to locate a lit window or follows a pathway to a back door, as can be seen in the trodden path left in freshly fallen snow. Though they feel covert, these images are not voyeuristic, for the occupants of the dwellings never appear in his photographs.

Hido selects a frontal viewpoint on the edge of the narrow space between, and slightly below, two houses in *Untitled #2736* (2000). A single unlit window with drapes closed is visible in the house on the left. The house on the right has a closed garage door, occupies a lot that is considerably lower, and has a brightly lit window in a second story above the garage. The sharp rise under the house on the left occupies almost half of the vertical composition, and the long grasses covering the ground look dry and brittle and are bathed in a warm reddish light that makes them appear on the verge of bursting into flame. This unsettling feeling inflates the disparity in the ground levels, creating a fleeting fantasy that the house on the left may be unstable and crash into the other house; however, the impression passes and one can only ascribe the hallucinatory vision to the unnatural colors and odd angles that Hido constructs.

TODD HIDO (B. 1968, KENT, OHIO) ATTENDED A COMBINED PROGRAM AT THE SCHOOL OF THE MUSEUM OF FINE ARTS, BOSTON, MASSACHUSETTS, AND TUFTS UNIVERSITY, MEDFORD, MASSACHUSETTS (BFA, 1991). THEREAFTER HE STUDIED AT THE RHODE ISLAND SCHOOL OF DESIGN, PROVIDENCE (1991–92), AND THEN TRANSFERRED TO THE CALIFORNIA COLLEGE OF ARTS AND CRAFTS, OAKLAND (MFA, 1996). HE WORKS AS A COMMERCIAL PHOTOGRAPHER AND LIVES IN SAN FRANCISCO.

Whatever might be melancholy about a particular building and its condition is extended and deepened by an inescapable realization that no matter where these views take us, the photographs are disconnected from whatever happens inside these places. Like the photographer, the viewer is also an outsider.

Hido's titles only parenthetically reveal the locations where the photographs were made, and an air of vagabond cross-country travel is supported by the many different site cities. The solitude of being the outsider is reinforced by the autumn or winter seasons depicted, with many of the views—Detroit, Pittsburgh, Colorado Springs, Salt Lake City—showing snow on the ground.

Hido provides revelations in the details of his photographs, which suggest generalities about the people living in these locations, as in *Untitled #2676* (2000), Reno, Nevada. A large pick-up truck is parked alongside a low-slung concrete-block single-story building, pictured across an expanse of asphalt. A single small window punctures two walls of the building, which might be a garage, except for the closed garage door of another building at the rear of the truck. Light blasts out of this solitary window, conveying a sense of desperation that is deepened by the dented side of the truck and wide, deep erosions in the asphalt.

The houses that Hido photographs are not homes in the sense of offering comfort, but are simply shelters, refuges—containers for lives. His photographs gather the minimal visual signs and textures reflecting the inhabitants of these houses, who have disappeared, as if something essential from them has sunk into the houses themselves. The odd colors he creates through extended exposures, coupled with a sense of something forbidden about his points of view, elicit unseen and imaginary associations. In Hido's photographs there is the inescapable fact that a house without inhabitants is not a home.

SELECTED READING

BONETTI, DAVID. "TODD HIDO: NEW PHOTOGRAPHS." *SAN FRANCISCO CHRONICLE*, 21 JULY 2001, SEC. B, P. 10.

GRUNDBERG, ANDY. "HOUSE SITTING, THE PHOTOGRAPHY OF TODD HIDO." *ARTFORUM* 36, NO. 9 (MAY 1998): 128–29.

HELFAND, GLEN. "TODD HIDO: STEPHEN WIRTZ GALLERY." *ARTFORUM* 40, NO. 2 (OCTOBER 2001): 163.

HIDO, TODD. *HOUSE HUNTING.* WITH AN ESSAY BY A.M. HOMES. TUCSON, ARIZ.: NAZRAELI PRESS, 2001.

JOHNSON, DREW HEATH, ED. *CAPTURING LIGHT, MASTERPIECES OF CALIFORNIA PHOTOGRAPHY, 1850 TO THE PRESENT.* NEW YORK: W.W. NORTON, 2001.

SANTE, LUC. "MAKING A HOME A HOUSE." *NEW YORK TIMES MAGAZINE*, 7 MARCH 1999, PP. 74–75.

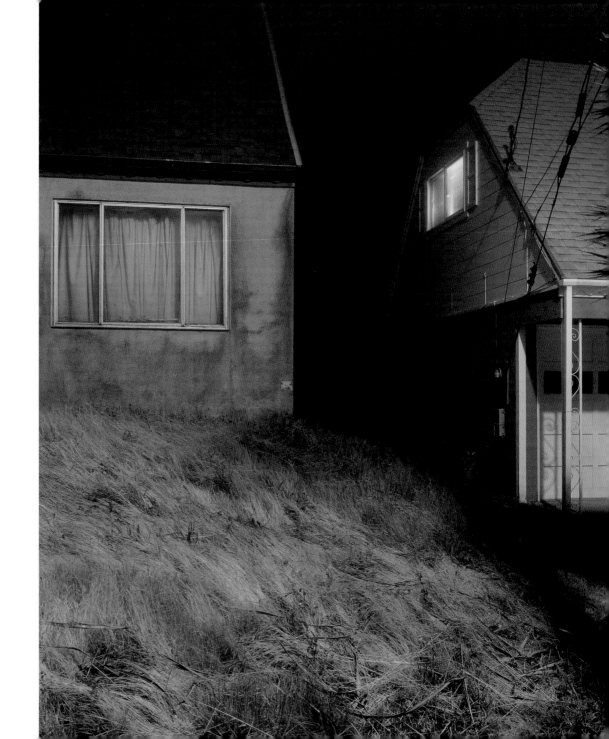

#2736, 2000
CHROMOGENIC PRINT; 38" X 30"

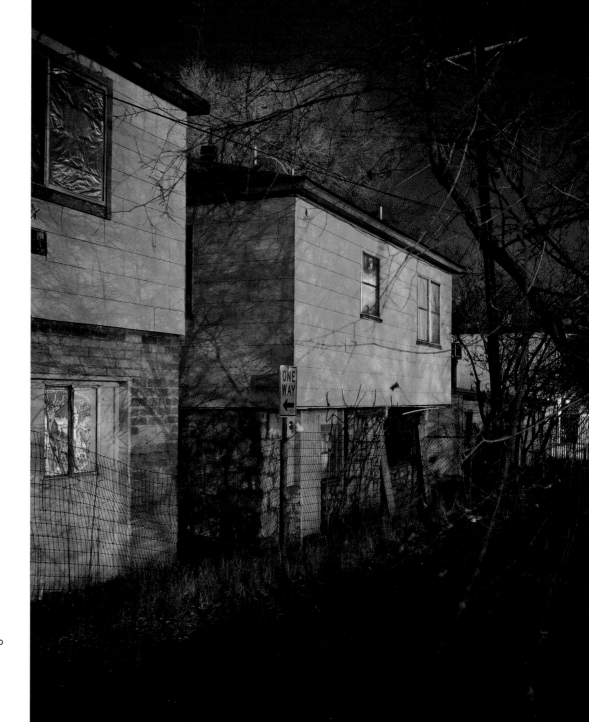

#2611-A, 2000
CHROMOGENIC PRINT; 38" X 30"

DOUGLAS HOLLIS

Douglas Hollis collaborates with the natural forces of wind, water, and light. His sculptures, landscapes, and site-specific public art projects rely on the capacity of viewers to perceive and interact with natural phenomena. His art teaches people to extend their ability to listen and learn to look in new ways, and ultimately understand themselves as part of a greater natural scheme.

Hollis's interest in perception and natural phenomena is based on a fascination with waves and sound as vehicles for communication. During a residency at the San Francisco Exploratorium in the mid-1970s, he created his first aeolian harp, installed on the roof at the Exploratorium, and since then he has built other wind harps and organs. In many works he uses sound generated from wind and water in a way that creates the feeling of architectural space, physically encompassing the viewer and inviting meditation and contemplation. Beyond the phenomenological aspects in his work, Hollis has developed a compelling visual vocabulary that gives sound an expressive physical form.

In *Singing Beachchairs* (1987), located on the beach in Santa Monica, California, Hollis created two oversized (eighteen feet tall), stainless-steel armchairs painted in soft, pastel green and blue; on the backs of the chairs are aluminum wind-organ pipes. The chairs are each large enough to seat two people. When the wind is blowing sufficiently, the participants are enveloped in sound generated from the pipes. Even in the absence of wind, the chairs offer a welcome opportunity to meditate on the ocean extending westward to the horizon and on the quality of light. At the same time, the chairs are a playful enhancement to a heavily used beach.

Through the 1980s and 1990s, Hollis became progressively more attuned to creating, as he described, "places which have an oasis-like quality, where people can pause to catch their spiritual breath in the midst of their everyday lives." The works build on the cultural and physical qualities of their location. For each project, Hollis begins with a blank slate, to be filled with experiential information from the site, as well as information about how the place will be used and who will use it. He conducts extensive research, talks with people who are or will be the community of users, and tries to unearth what he calls the "sensed and remembered properties" of the place.

Oionos (1997) was commissioned through the San Jose Public Art Program for the San Jose Repertory Theater in downtown. Hollis designed a sixteen-foot-tall stainless-steel mast that supports a twenty-four-foot-long steel quill and a circular arbor with a perforated steel screen. Cut out of the screen is text, taken from Act IV of *The Tempest* by William Shakespeare: "We are such stuff as dreams are made on." The sunlight shining down through the screen casts shadows on the plaza, allowing viewers to read the quote, and the quill moves like a vane in the wind. In conceiving his design, Hollis drew on the austere metal skin of the adjacent theater facility and references the tools and traditions of the theater, as well as the natural elements of wind and light.

SELECTED READING

FREY, SUSAN RADEMACHER. "A NEW THEATER OF COLLABORATION." *LANDSCAPE ARCHITECTURE 77* (MAY/JUNE 1987): NO. 3, 52–59, 108.

HOLLIS, DOUGLAS. "DOUGLAS HOLLIS." IN *SCULPTING WITH THE ENVIRONMENT—A NATURAL DIALOGUE,* EDITED BY BAILE OAKES. NEW YORK: VAN NOSTRAND REINHOLD, 1995.

HOLLIS, DOUGLAS, AND JEFF KELLEY. *SCULPTURE AT THE POINT.* PITTSBURGH, PENN.: THREE RIVERS ARTS FESTIVAL, 1991.

TROMBLE, MEREDITH. "A CONVERSATION WITH DOUGLAS HOLLIS, ARTIST." *ARTWEEK 24 NO. 18 (23 SEPTEMBER 1993): 15–6.

DOUGLAS HOLLIS (B. 1948, ANN ARBOR, MICHIGAN) ACQUIRED AN INTEREST IN NATIVE AMERICAN CULTURE AS EARLY AS AGE TWELVE, LEAVING HOME FOR PERIODS OF TIME TO LIVE WITH INDIAN FAMILIES IN OKLAHOMA. THROUGH THESE EXPERIENCES, HE ESTABLISHED A BELIEF THAT HUMANS ARE NEITHER IN CONTROL OF NOR REMOVED FROM NATURE BUT ARE INTEGRALLY CONNECTED TO IT. IN THE LATE 1960S, HOLLIS BEGAN COLLABORATING WITH INDIVIDUALS FROM FILM, DANCE, MUSIC, ENGINEERING, AND SCIENCE ON PERFORMANCE AND INSTALLATION WORKS. HOLLIS HAS CREATED NUMEROUS TEMPORARY INSTALLATIONS AND SCULPTURES SINCE THE 1970S IN ADDITION TO HIS PERMANENT WORKS, MANY OF WHICH WERE COLLABORATIONS WITH ARCHITECTS AND OTHER ARTISTS. HE LIVES IN SAN FRANCISCO.

In designing landscapes and creating artwork that shapes public places, Hollis intends the places to grow over time and in meaning for the people who use them. *Watersongs* (1996), a multifaceted, site-specific project for the U.S. Geological Survey in Menlo Park, California, includes a streambed with river rocks and rapidly moving water, a source pool, water cascading down a vertical wall, and a semicircle of perforated metal chairs positioned around a central, mature tree—all integrated into landscape design. The contemplative space, enhanced by the meditative quality of the running water, changes as the flora develops, as the light shifts, and as the seasons pass, and draws the awareness of people who work there to these subtle transformations.

Hollis once wrote of the world, "I believe we need to shift our attitude from one of imposition and dominance to one of regard, interdependence, and conversation." His career has centered on creating the means to achieve this vision.

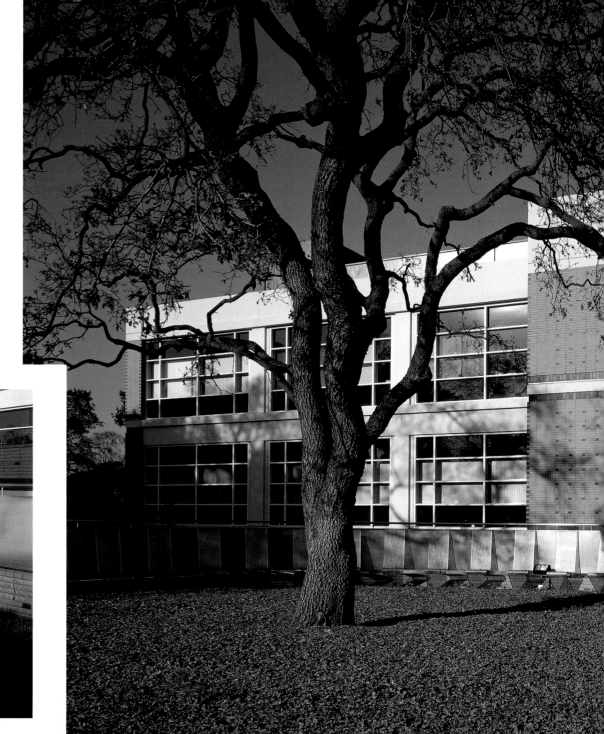

[vortex pool]

[aerial view]

Watersongs, 1996
U.S. GEOLOGICAL SURVEY, MENLO PARK, CALIFORNIA,
VARIABLE DIMENSIONS

[seating detail]

Unspecific Gravity, 1998

UNIVERSITY OF SOUTH FLORIDA, TAMPA. WATER ELEMENTS, SEATING AND PLANTING; VARIABLE DIMENSIONS.

[water element]

[seating detail]

Oionos, 1997 SAN JOSE REPERTORY THEATER, SAN JOSE.
STAINLESS STEEL; 26' X 16' DIAMETER (THE TYPE IS REVERSED OUT OF THE SCULPTURE;
AS SUNLIGHT FILTERS THROUGH THE LETTERFORMS, THE WORDS READ CORRECTLY
ON THE GROUND.)

MILDRED HOWARD

Too young to be part of the racial struggles experienced by her parents and older siblings, Mildred Howard absorbed their tales of survival and endurance in the face of social and economic hardships. The South Berkeley Congregational Church, two doors from the Howard family home, was an influential presence in her formative years. There she studied European classical ballet, took her first art lessons, and heard performances by Aretha Franklin, Leontyne Price, and the Tuskeegee Institute choir. These memories and experiences became the impetus and inspiration for much of her work.

Howard has made installations since 1979, and may evolve ideas in several versions, as she did with *Memory Garden*. Bottles, common to all versions, were used as metaphoric transmitters of dreams or memories. In the first presentation at the Headlands Center for the Arts in Marin County in 1990, bottles were laid and stacked to form the walls and roof of a small house framed out of wood, and others were strewn nearby on the gallery floor. In the second version later in 1990 at the California Afro-American Museum in Los Angeles, Howard did not include the house, and the bottles were upended and scattered throughout a sea of sand. Viewers were invited to walk on gravel pathways, sit on a bench among birch trees, and contemplate text lettered in gray on a white back wall. In the third version at the Transamerica Pyramid in San Francisco in 1991, she rebuilt the bottle house and placed the bench inside it.

The text that appeared in the second version was Howard's original inspiration for the piece, an excerpt from James Weldon Johnson's 1912 novel *Autobiography of An Ex-Colored Man*. Johnson, a prominent African American composer and civil rights leader in the early twentieth century, wrote about an African American man who passes for white and his perceptions of a dominant white society. A passage about the protagonist's nostalgic memories of a family garden ringed with upended bottles reminded Howard of stories about bottles in African American communities—how bottles were placed in front of houses to ward off evil spirits, trees filled with hanging bottles, and the bottles ringing her own family's gardens.

For the permanent installation, Howard used four thousand green, yellow, and clear bottles to form the walls and the peaked-roof house, sitting in a field of the di Rosa Preserve in Napa Valley, California. Placed on the interior gravel floor, four stone slabs, each engraved with Johnson's phrase ". . . I have only a faint recollection of the place of my birth," lead from the entranceway to a wood bench against the opposite wall. Each phase of *Memory Garden* is about the construction of space—what defines or constitutes home, community, culture, or personal identity. The bottles filter the illumination of the chapel-like structure, providing interior ornamental delight. They also fragment an exterior view of the world from within, just as Johnson's story ironically places a man between conflicting worlds.

Howard makes assemblage sculpture, and selects objects for their relationship to her personal life, rather than using them solely as formal devices. The memorabilia, photographic images, and items such as doorknobs, toys, and buttons may evoke nostalgic or sentimental recollections of simple pleasures. A deeper examination often reveals

MILDRED HOWARD (B. 1945, SAN FRANCISCO, CALIFORNIA) ATTENDED THE COLLEGE OF ALAMEDA (AA, CERTIFICATE IN FASHION, 1977) AND JOHN F. KENNEDY UNIVERSITY IN ORINDA, CALIFORNIA (MFA, 1985). SHE HAS RECEIVED PUBLIC ART COMMISSIONS FROM THE WASHINGTON STATE ARTS COMMISSION (1991), SAN FRANCISCO ARTS COMMISSION (1990, 1997), AND SAN FRANCISCO INTERNATIONAL AIRPORT (1997). AMONG HER MANY GRANTS AND AWARDS ARE A LILA A. WALLACE–READER'S DIGEST INTERNATIONAL TRAVELING FELLOWSHIP (1992–93), AND A ROCKEFELLER FOUNDATION GRANT AT THE BELLAGIO STUDY AND CONFERENCE CENTER IN BELLAGIO, ITALY (1996). SHE HAS A LONG-STANDING HISTORY OF COMMUNITY INVOLVEMENT INCLUDING TEACHING ART AT PRO ARTS IN OAKLAND (1981–84), THE SAN FRANCISCO EXPLORATORIUM (1989–99), EAST OAKLAND YOUTH DEVELOPMENT CENTER (1981–87), AND THE EDIBLE SCHOOLYARD PROJECT IN BERKELEY (1999–2000). SHE HAS ALSO TAUGHT AT STANFORD UNIVERSITY, THE SAN FRANCISCO ART INSTITUTE, AND THE CALIFORNIA COLLEGE OF ARTS AND CRAFTS. SHE LIVES AND MAINTAINS A STUDIO IN BERKELEY.

thought-provoking issues of racial and cultural history, as in her selection of Billie Holiday 78-rpm records and cast-glass Aunt Jemimas. Howard's family album is a source for many photographs that appear in the works. Her father and brothers are the quartet of African American men in *Jitterbug John,* her grandmother appears in *Blue Rose,* and the thirty identically uniformed World War I soldiers standing at attention, photosilkscreened and mounted life-size on plywood in the installation *In the Line of Fire,* are one person—her cousin Ickles Rageley.

Windows are a recurring element. She scavenges old frames and alters them minimally to preserve their history and association with home. Howard uses the frames as apertures by adding glass windows, possibly with the translucent silkscreened images of relatives. "Windows are about remembering, about opening and closing," she says. "Both the windows and the buttons that decorate the window frames open and close things. They're metaphors for things that are past and things that you hold on to."

Howard's installation *Ten Little Children Standing in a Line (one got shot, and then there were nine),* 1991, commemorated the 1976 march of fifteen thousand in the poor South African Township of Soweto, which was initiated by youth protesting the teaching of Afrikaans, rather than English, in overcrowded, inadequate schools. Police opened fire on the unarmed marchers, wounding 439 and killing

172. The horrific slaughter of children brought worldwide attention to the struggle against apartheid and was a catalyst for violent resistance to the Afrikaaner minority rule. Seventy-eight copper gloves, individually attached to wooden stakes approximately four feet high and planted in gravel, filled the gallery space. One side wall carried screen-printed text and photographs from Associated Press transmissions about the Soweto massacre. An enlarged photomural of a young girl who had been hit in the mouth by a tear-gas canister was on the opposite wall. The dirt path down the center of this garden of outstretched hands opened to form a cross in front of the back wall, which was covered in a rectangular pattern of bullets.

Howard's assemblage sculpture and installations are reminders of objects and events that may have been forgotten and offer viewers deep emotional experiences by personalizing familial and cultural history.

SELECTED READING

CHAMBERS, EDDIE. *MILDRED HOWARD.* BRISTOL, ENGLAND: EDDIE CHAMBERS, 1998.

HENDERSON, ROBIN, AND LIZZETTA LAFALLE-COLLINS. *CROSSINGS, THE INSTALLATION ART OF MILDRED HOWARD.* BERKELEY, CALIF.: BERKELEY ART CENTER, 1997.

HEWITT, MARY JANE. *MILDRED HOWARD. TAP: INVESTIGATION OF MEMORY.* NEW YORK: INTAR GALLERY, 1992.

HOWARD, MILDRED. *MILDRED HOWARD: TEN LITTLE CHILDREN STANDING IN A LINE (ONE GOT SHOT, AND THEN THERE WERE NINE).* WITH ESSAYS BY JUDITH BETTLEHEIM AND AMALIA MESA-BAINS. SAN FRANCISCO: SAN FRANCISCO ART INSTITUTE, 1991.

LACY, SUZANNE, ED. *MAPPING THE TERRAIN: NEW GENRE PUBLIC ART.* SEATTLE, WASH.: BAY PRESS, 1995.

Post-Traumatic Slave Syndrome:
Don't Get It Twisted, This Is Not My Real Life, 2001
HAND-SEWN SILK WITH PHOTO TRANSFERS IN HAND-MADE BOX; 8" X 9" X 2"

Crossings, 1997
INSTALLATION AT THE BERKELEY ART CENTER, BERKELEY, CA;
MIXED MEDIA: CERAMIC EGGS, INDIGO BLUE WALLS,
ANTIQUE MIRROR, AMBIENT LIGHT;
OVERALL DIMENSIONS APPROXIMATELY 14' X 40' X 50'

From Cotton to Coal . . . The Last Train, 1994
INSTALLATION, OLD SANTA FE TRAIN STATION;
COTTON, COAL, ANTIQUE LUGGAGE CART, AMBIENT LIGHT; 20' X 27'

Caged Bird Series:
Figure Ground/Figure Flight/Figure That, 2001
MIXED MEDIA; 74" X 48" X 32"

One for All and All for One: It's Fun, 2001
PLASTER, METAL; 14" X 8" X 5"

DAVID IRELAND

Perhaps because he is a late bloomer, committing to art as a profession in his forties, David Ireland believes that art and life are inseparable, and that close scrutiny should be given to every part of an artistic process as it unfolds— the end is no more or less important than any part of the journey. Sometimes there is no "end." He creates sculpture, performs "actions" so subtle that scant physical evidence remains, and develops site-specific installations that involve his intellectual and visceral responses to a place and its history. What someone else might consider insignificant debris produced as a by-product of an activity signifies to Ireland the interaction and energy expended with materials in space over time; sometimes it is the art itself. The honesty of any artistic decision or action and a willingness to accept the beauty in mundane materials or circumstances are fundamental principles that guide Ireland in the creation of art.

The variety and depth of this conceptual attitude are exemplified by two separate acts from 1976, which though not performances, are transitory physical activities nonetheless. In the first, he had artist Tom Marioni videotape him repairing a sidewalk in front of his house. The videotape itself is not meant to be the artwork, but simply a record of physical activity in the real world that Ireland conceptually designated as being done with artistic intent. The other activity occurred at the Museum of Conceptual Art (MOCA) building that same year. The MOCA Collection consisted of the accumulated evidence left by the printing business formerly housed there, along with the remnants of various artists' performances. In violation of MOCA policy, a performing artist had painted a back wall of the building white. Ireland repainted this wall to re-create the original stained, faded condition, using photographs as guides. *Restoration of a Portion of the Back Wall and the Floor of the Main Gallery of the Museum of Conceptual Art* (1976) is considered neither an "action" by Ireland nor part of the MOCA program, and both refer to it as a photorealistic painting. The difference between this act and that of repairing the sidewalk exists in his conceptual intent, as the painting was directed towards a specific, final product.

The "Dumbball" has been a frequent object in Ireland's art. A concrete sphere about the size of a croquet ball, it embodies Ireland's attraction to concrete as a material with liquid to solid properties and the verisimilitude produced from a simple action. To create a dumbball, he takes a handful of wet concrete and tosses it from one hand to the other, back and forth, hour after hour, up to twelve hours until it has set enough to not change shape when set down. He explains, "the Dumbball is the result of a process work. It demonstrates a commitment to the realization of an idea . . . You call it the Dumbball because it has no will or design imposed on it. It finds its way by the shape of your hand and dedication to the process." Ireland exhibits the dumbballs in various ways, ranging from several arranged on a shelf or fifteen loaded on a silver tray to a number of them scattered on the floor throughout an installation.

Ireland will reuse ideas in new ways, and his work frequently has a dry humor. A wooden cabinet with two glass doors has been entirely filled with alder logs in *Ego* (1992), and each end of the logs has been branded with his initials "D.I." There is irony in the title, which complements the artist's psychological identity (id) and "official" identity ("ID"), and in the potential erasure of authorship if and when the logs are used as fuel. Logs branded with his initials appear again in *Duchamp's Tree* (1996), where they are affixed to a steel bottle rack in an ironic homage to Marcel Duchamp's ReadyMade *Bottle Rack* (1914).

Ireland's site-specific works are particularly renowned, such as the actions performed in a Victorian house on Capp Street in San Francisco (1975–78), where he lives, and in Building 944 at the Headlands Center for the Arts (HCA) in Marin. For example, Ireland, collaborating with artist Mark Thompson and HCA staff and volunteers in 1986–87, directed the sandblasting, stripping, repairing, polishing, and varnishing of the stairwell and second-floor rooms of a 1907 military barracks. In all locations, the accumulated history in and around edges of the original surfaces is a reminder of the past, in the present. As he explains, "I see myself stripping away intelligence from things so they're not overpowered. Time—its passage and our marking of it—has been a leitmotif. Ideally, my work has a visual presence that makes it seem like part of a usual, everyday situation. I like the feeling that nothing's been designed, that you can't tell where the art stops and starts."

DAVID IRELAND (B. 1930, BELLINGHAM, WASHINGTON) ATTENDED THE CALIFORNIA COLLEGE OF ARTS AND CRAFTS (BA, 1953) AND TWENTY YEARS LATER, THE SAN FRANCISCO ART INSTITUTE (MFA, 1974). HE HAS COMPLETED NUMEROUS PRIVATE AND PUBLIC COMMISSIONS AND RECEIVED MANY HONORS INCLUDING THE LOUIS COMFORT TIFFANY FOUNDATION AWARD (1987), A VISUAL ARTS AWARD FROM THE FLINTRIDGE FOUNDATION (1998), AND TWO NATIONAL ENDOWMENT FOR THE ARTS FELLOWSHIPS (1978, 1983). IRELAND HAS TAUGHT AT VARIOUS INSTITUTIONS. HE MAINTAINS A STUDIO IN OAKLAND AND LIVES IN SAN FRANCISCO.

Ireland spends considerable time observing how ordinary objects occupy space and makes work that connects to the surrounding architecture or environment. He conceptually devises propositions that ride an edge between adding things to the world and existing purely as ideas. *School of Chairs,* installed at the University Art Museum at Berkeley (later renamed the Berkeley Art Museum) in 1988, consisted of fourteen gray industrial chairs arranged in a gallery. The chairs functioned as symbols of home, learning, authority—and conformity. He designed the space for an installation at the Institute of Contemporary Art in 1997 to reveal architectural details of the historic department store building, and create a dialogue between newly constructed drywall and surviving columns, display cabinets, and the marked terrazzo floor.

Ireland's persistent attention to and investigation of the world as part of everyday living consistently provides fresh ways of seeing what is otherwise taken for granted.

SELECTED READING

ANANIA, MICHAEL. *D.I.: DAVID IRELAND.* CHICAGO: ARTS CLUB OF CHICAGO, 1996.

ATKINS, ROBERT. *CURRENTS: DAVID IRELAND.* NEW YORK: NEW MUSEUM OF CONTEMPORARY ART, 1984.

BERKSON, BILL. "DAVID IRELAND'S ACCOMMODATIONS." *ART IN AMERICA* 77 (SEPTEMBER 1989): 177–86, 225.

DAVID IRELAND: GALLERY AS PLACE. SAN FRANCISCO: SAN FRANCISCO ART INSTITUTE, 1987.

IRELAND, DAVID. *DAVID IRELAND.* WITH ESSAYS BY ROBERT STORR AND JENNIFER R. GROSS. PORTLAND: INSTITUTE OF CONTEMPORARY ART AT MAINE COLLEGE OF ART, 1997.

IRELAND, DAVID. *DAVID IRELAND: A DECADE DOCUMENTED, 1978–1988.* WITH ESSAY BY KAREN TSUJIMOTO. SANTA CRUZ: MARY PORTER SESNON ART GALLERY, UNIVERSITY OF CALIFORNIA, 1988.

Tray of Dumbballs, 1992 5" X 21" X 12"
SILVER TRAY, 15 CEMENT DUMBBALLS;

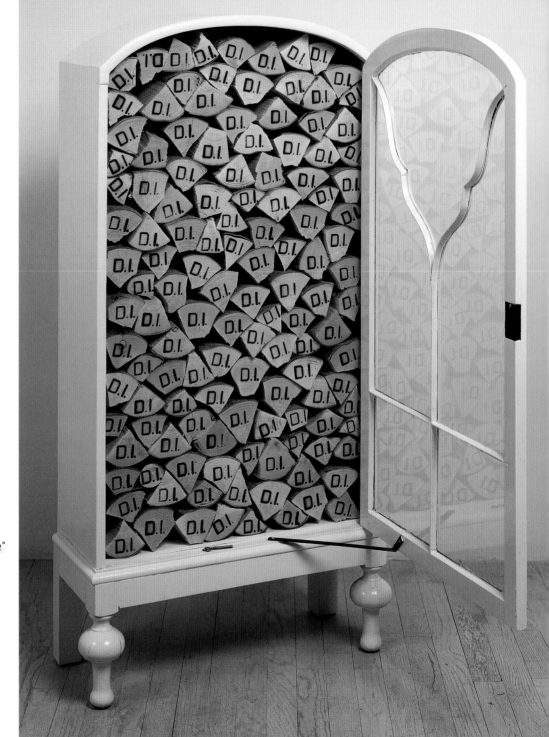

Big Chair, 1997
INSTALLATION, ICA AT MAINE COLLEGE OF ART

Other, Other Ego with Open Door, 1993
ALDERWOOD, ENAMELED WOOD AND GLASS CABINET;
50" X 24" X 32"

Box of Angels, 1996
FROM BEDLAM, ARTS CLUB OF CHICAGO
VITRINE, CAST FIGURES; 78" X 52" X 52"

Metal and Wire Drawing on Pedestal, 1998–2000
METAL, WIRE, MDF, ACRYLIC ON ENAMELED WOOD PEDESTAL;
76" X 43" X 38"

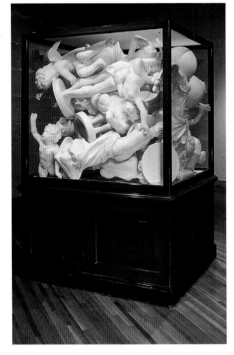

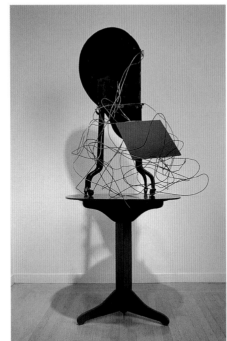

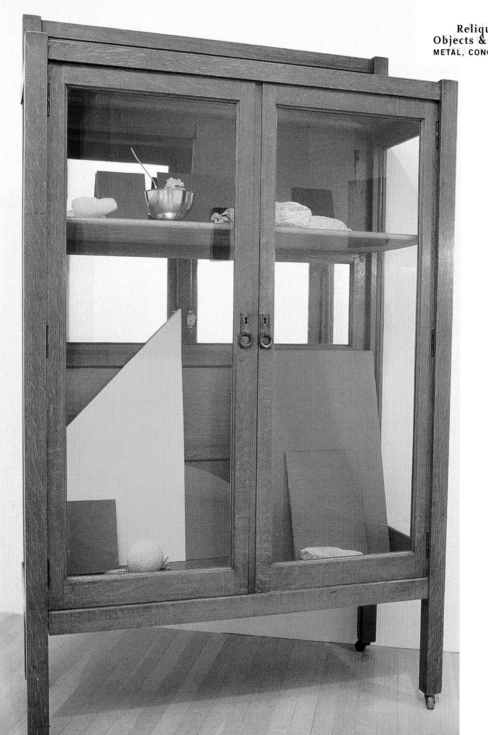

**Reliquary Cabinet with Selection of
Objects & Lamp,** 2000
METAL, CONCRETE, WAX, MDF, SARDINE CAN, DUMBBALL;
64" X 37³/₄" X 15¹/₂"

PAUL KOS

Paul Kos works in video, for which he is perhaps best known, as well as in sculpture, performance, and installation art. His work is easily associated with the humor and irreverence of much Bay Area art, but at the same time it is set apart by a formal beauty and an elegant simplicity. At every turn, he questions the common assumptions about the making, viewing, and exhibiting of art, believing that a viewer should be actively engaged in the work and that his choice of materials is critically relevant to the subject and meaning of his art.

Kos has consistently explored multiple themes and metaphors in his artwork: mortality and the passage of time, Catholicism, the human need for freedom and the simultaneous urge to control, the individual's quest for a personal voice, and the relationship between nature and culture. He has employed various techniques to reveal these themes: establishing visual metaphors and playing with visual perception; introducing sound to signify the passage of time; using elements of chance while prescribing the viewer's participation; and transposing elements from nature into art world settings to unite the natural with the cultural, and art with life.

Tunnel/Chapel for Chartres Bleu (1997), created with Isabelle Sorrell at the di Rosa Preserve in California's Napa Valley, is a sanctuary created around the multichannel video installation *Chartres Bleu,* originally commissioned by the Walker Art Center in Minneapolis in 1986. Consisting of twenty-seven video monitors, the installation convincingly re-creates the original thirteenth-century stained glass window from Chartres Cathedral (although it is not nearly as big). Stacked three across and fifteen feet high, the monitors replicate the patterns of light streaming through a single pane of glass over a twenty-four-hour period that has been compressed into a twelve-minute video loop (Kos spent a week photographing the window from a scaffolding and then transferred the images to video). A visitor enters the dimly lit space, which is built into a hillside, through large doors and first encounters "Stations of the Cross," a concrete tunnel with wooden Roman numerals that extend from floor to ceiling, representing the Stations of the Cross. Running on either side along the base of the tunnel walls are thin, shallow troughs, with a source at the far end that slowly drips water, rhythmically breaking the silence of the space. The video component is visible at the end of the tunnel, where it is installed in a chapel outfitted with rows of chairs. Leading out of the chapel is a small set of stairs, above which Kos has painted "Noah's Ark." Referring to the Napa Valley floods of 1997 as well as the biblical story, Kos derived the dimensions of the painted ark from an engineer's interpretation of its description in Genesis.

Kos, believing any material can be employed in the making of art, has used over the years bells, cheese, sand, ice, cuckoo clocks, brooms, furniture, lightbulbs, pétanque balls, boulders, and water. In *Tunnel/Chapel for Chartres Bleu,* as well as other projects, Kos used the bell as a metaphor, icon, and monument. As visitors leave the chapel, they encounter two bells suspended from wooden beams in two shallow alcoves, the adjacent wall painted a striking ocher in contrast

PAUL KOS (B. 1942, ROCK SPRINGS, WYOMING) GREW UP A FEW HOURS' DRIVE FROM THE WIND RIVER AND TETON RANGES, WHERE HE DEVELOPED AN EARLY AND INTIMATE RELATIONSHIP WITH NATURE. IN 1961, HE ENROLLED AT GEORGETOWN UNIVERSITY IN WASHINGTON, D.C., TO STUDY LANGUAGES AND INTERNATIONAL RELATIONS, AND AFTER A YEAR REALIZED HIS LOVE WAS NOT POLITICS BUT ART. HE THEN ENROLLED AT THE SAN FRANCISCO INSTITUTE OF ART (BFA, 1965; MFA, 1967), WHERE HE CONCENTRATED ON PAINTING. HIS AWARDS HAVE INCLUDED FELLOWSHIPS FROM THE NATIONAL ENDOWMENT FOR THE ARTS (1974, 1976, 1982, 1986, 1993, 1997), THE ROCKEFELLER FOUNDATION (1987), THE WESTERN STATES ARTS FOUNDATION (1983, 1987), THE JOHN SIMON GUGGENHEIM MEMORIAL FOUNDATION (1990). KOS TAUGHT AT THE UNIVERSITY OF SANTA CLARA (1969–77) BEFORE JOINING THE SAN FRANCISCO ART INSTITUTE IN 1978, WHERE HE STILL TEACHES. KOS LIVES IN SAN FRANCISCO.

to the darkened sanctuary. The bell is rich with worldly associations—religious, ritualistic, political, cultural. It announces time, notifies of emergencies, publicizes weddings, proclaims births and deaths, and beckons to gatherings and services; the bell rouses people to their senses.

Kos focused on the forms and processes of the natural landscape early in his career. He brought natural elements, such as sand and ice, into the context of a gallery or museum space to create installations. Through video, he was able to create his art on-site in the landscape. Kos gradually moved away from thematic explorations about nature, toward artwork that was socially based and carried political overtones. In a project completed in 2001, Kos collaborated with poet Robert Hass to develop an outdoor poetry garden in an urban plaza in the South of Market district of San Francisco (199 Fremont Street). Central features include an immense granite boulder transported from the Sierra Nevada, a pair of brass faucets that drip water into a small reflecting pool, and a poem by Hass on the expanse of the 130-foot-by-22-foot plaza walls. Some words are carved into the wall; others are in relief. On the longer wall are the 20-foot-tall words "DAISY LAPS," over which run four lines: "an echo wandered through here what? an echo wandered through hear it? there was morning and later/ there was evening days elapse what? a reck oh! wan where are we going in this city of stone and/ hills and sudden vistas and people rushing to their various appointments what points the way? it's/ raining as it was foggy as the sun was out it was windy spring what? an echo wandered through here."

Turning the corner is the 20-foot-tall word "NOW," and the lines "rock and water/light and air/the sound is a quiet thing." Landscape architect Antonio Bava designed stone seating, walls, and plantings that reflect the Sierra Nevada region. The plantings slightly obscure the poem as they change throughout the seasons, and the sunlight plays with the visibility of the letters depending on the time of day. The installation is about time, the rhythms of nature, and the tricks of visual perception. As Hass described, "[it] manages to convey something of the life of the city, something of the regional roots of its building materials, the post-modern playfulness of its early twenty-first century artists, and to provide a warm escape into an idea of the back country in the middle of the busy city."

Viewers are drawn to immerse themselves in Kos's spaces, to engage themselves in all the aspects of his work—time, space, sound, concept. As he said early in his career, "I, YOU, and the OBJECT are irrelevant, but our combination is art."

SELECTED READING

COPPOLA, REGINA. IN SITE: FIVE CONCEPTUAL ARTISTS FROM THE BAY AREA. AMHERST: UNIVERSITY GALLERY, FINE ARTS CENTER, UNIVERSITY OF MASSACHUSETTS, 1990.

GOLONU, BERIN. "LOOKING BACK." ARTWEEK 31, NO. 1 (JANUARY 2000): 12, 41

JENKINS, BRUCE. VIEWPOINTS: PAUL KOS, MARY LUCIER. MINNEAPOLIS: WALKER ART CENTER, 1987.

LOCAL COLOR: THE DI ROSA COLLECTION OF CONTEMPORARY CALIFORNIA ART. WITH TEXT BY RENE DI ROSA [ET AL.]. SAN FRANCISCO: CHRONICLE BOOKS, 1999.

MOSS, STACEY. PAUL KOS AT THE WIEGAND GALLERY. WITH A PREFACE BY HUGH M. DAVIES. BELMONT, CALIF.: WIEGAND GALLERY, COLLEGE OF NOTRE DAME, 1994.

Tunnel/Chapel for Chartres Bleu, 1997,
in collaboration with Isabelle Sorrell.
WOOD, CONCRETE, STEEL, LIGHTING, WATER;
VARIABLE DIMENSIONS; IN THE COLLECTION OF THE
DI ROSA PRESERVE, NAPA, CALIFORNIA

Chartres Bleu, 1986–1996
27 CHANNEL MONITORS, LASER DISCS, PLAYERS
AND ELECTRONICS; 180" X 57" X 19"

[bell room exit]

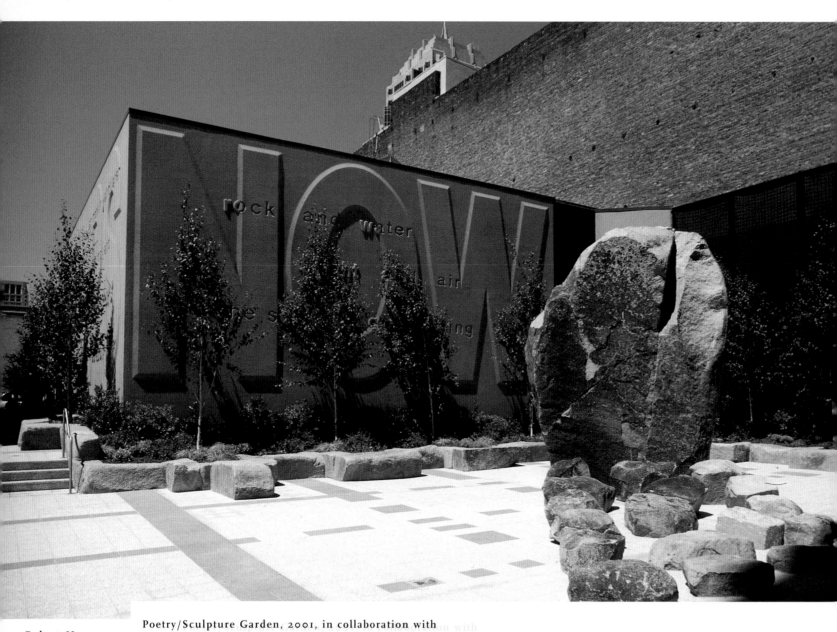

rock and water air

Poetry/Sculpture Garden, 2001, in collaboration with
Robert Hass.
199 FREMONT STREET, SAN FRANCISCO, MIXED MEDIA, VARIABLE DIMENSIONS

[detail of reflecting pool with brass faucets]

SUZANNE
LACY

Since the 1970s, Suzanne Lacy has created performances through orchestrating teams of participants, community organizing, and a savvy appropriation of commercial media to disseminate her artistic and political messages on a variety of issues.

A seminal figure in the women's movement since the 1970s, Lacy was among the first artists to use performance as an exposé of violence against women. Her early, small-scale performances addressed issues of economic, age, and gender discrimination against women. The performances took place primarily in art spaces and feminist communes, although some works, such as *Bag Lady* (1977), were performed in ordinary public settings such as a city street.

In the late 1970s, Lacy began developing the large-scale performances for which she is most known—projects that focused attention on women's issues and other social themes including violence against women, international peace, immigration, racism, teen pregnancy, and the tensions between inner-city youth and police. Lacy continued over the next twenty-five years to create works that required a sophisticated ability to direct large projects, recruit and empower ordinary citizens, and use mass media for promoting her political message.

In her performances, Lacy's goal is to provoke a conscious shift of awareness about a specific social issue. *Code 33: Emergency! Clear the Air* (a project of Teens + Education + Art + Media, or T.E.A.M.) brought together community activists and teachers, along with artist collaborators including Julio Morales and Unique Holland. The piece, presented in 1999 atop the City Center West Garage in downtown Oakland, aimed to "clear the air" between youth and police

officers. For this and other pieces, Lacy begins with traditional community organizing—identifying a situation, in this instance the adversarial relationship between youth and police in Oakland, and becoming a part of the community. Through collaborative workshops and long-term involvement with the community and other participants, she develops a structure for the public performance event. *Code 33,* a title taken from the police radio code that requires officers to stay off the air except in an emergency, was the culmination of a two-year process of working with local youth to express their concerns about neighborhood safety through art workshops; televised, five-week police and youth training sessions; and extensive organizing that garnered the support of local city government, police officers, and residents, leading up to the rooftop performance with 100 police officers and 150 youth. The extensive dialogue generated in this process—among artists, youth, and police—provided a forum where each could develop a better understanding of one another's issues and formulate ways to express their feelings and opinions. In the staged, one-night event (intended to begin with a procession of low-riders and police cars, which was canceled due to an unrelated street protest), small groups of youths and police sat among parked cars, in the glare of the headlights, and openly discussed crime, power, and safety, while audience members eavesdropped on the often heated conversations. Playing on TV monitors were videos created by the youth during the art workshops.

SUZANNE LACY STARTED COLLEGE STUDYING A PREMEDICAL CURRICULUM, WITH AN INTEREST IN PSYCHOSOMATIC ILLNESS. SHE THEN ENROLLED AT CALIFORNIA STATE UNIVERSITY AT FRESNO IN 1969, WHERE SHE WAS INTRODUCED TO ART THROUGH JUDY CHICAGO'S FEMINIST ART PROGRAM. SHE THEN ENTERED CALIFORNIA INSTITUTE OF THE ARTS (MFA, SOCIAL DESIGN, 1973). WHILE IN LOS ANGELES, LACY COFOUNDED THE WOMEN'S BUILDING IN 1973 AND TAUGHT AT ITS FEMINIST ART WORKSHOP (1974–79). IN 1987 SHE JOINED THE CALIFORNIA COLLEGE OF ARTS AND CRAFTS IN OAKLAND, WHERE SHE CONTINUES TO TEACH. LACY ALSO SERVES AS THE ARTISTIC DIRECTOR FOR T.E.A.M. (TEENS + EDUCATION + ART + MEDIA), WHICH SHE COFOUNDED IN 1991 WITH PHOTOGRAPHER CHRIS JOHNSON AND ARTIST-PRODUCER ANNICE JACOBY. SHE HAS RECEIVED NUMEROUS AWARDS, INCLUDING SIX FELLOWSHIPS AND GRANTS FROM THE NATIONAL ENDOWMENT FOR THE ARTS, AND FELLOWSHIPS FROM THE JOHN SIMON GUGGENHEIM MEMORIAL FOUNDATION (1992) AND THE LILA WALLACE–READER'S DIGEST FUND (1992). LACY LIVES AND WORKS IN OAKLAND.

An underlying premise in Lacy's work is that the experiences of the participants will provoke a shift in consciousness—that doing for oneself means *knowing*. Consciousness and self-awareness are fostered throughout the work's process, with the hope that if the process is successful, some participants will be moved to action. In *Code 33*, not only were police and youth heavily involved throughout the project's cycle, but the thousand audience members were able to participate in their own dialogue. Following a dance performance by a troupe of adult and youth dancers from a local company, community members were invited to another area to discuss their response to the issues raised by the youth and police conversations. Art historian Moira Roth's account of the evening tells of a man from Arkansas who flew to Oakland just for the event, hoping to use *Code 33* as a model for action in his town, and of how other community members pledged to attend future neighborhood meetings on police and youth issues.

Lacy has also created installations, typically dealing with the disenfranchised members of society. Her artworks are designed to initiate a process of recovery, healing, and political empowerment. *Underground* (1993), focusing on domestic violence, was installed in a downtown Pittsburgh park for the Three Rivers Art Festival. Three wrecked cars were placed alongside three hundred feet of railroad track across the lawn of the park. The cars were labeled with domestic violence statistics and statements from victims and perpetrators of violence. The vehicles were variously filled with keys—a symbol of control—and lists of what women took with them when they escaped home to go underground. Lacy's works provide the opportunity for compassionate and empathic connections among people. In *Underground,* she facilitated these connections by providing a phone booth that linked abused women to social service agencies. Making the invisible visible and the absent present, Lacy uses her artwork to restore voice to the underrepresented factions of society.

SELECTED READING

BROUDE, NORMA, AND MARY GARRARD. *THE POWER OF FEMINIST ART.* WITH AN ESSAY BY SUZANNE LACY, "AFFINITIES: THOUGHTS ON AN INCOMPLETE HISTORY." NEW YORK: HARRY N. ABRAMS, 1994.

HEARTNEY, ELEANOR. *SCULPTURE AT THE POINT.* PITTSBURGH: THREE RIVERS ART FESTIVAL, 1994.

JACOB, MARY JANE. "FULL CIRCLE: SUZANNE LACY AND A COALITION OF CHICAGO WOMEN." *CULTURE IN ACTION.* SEATTLE, WASH.: BAY PRESS, 1995.

KELLEY, JEFF. "THE BODY POLITICS OF SUZANNE LACY." IN *BUT IS IT ART?,* EDITED BY NINA FELSHIN. SEATTLE, WASH.: BAY PRESS, 1995.

LACY, SUZANNE, ED. *MAPPING THE TERRAIN: NEW GENRE PUBLIC ART.* SEATTLE, WASH.: BAY PRESS, 1995.

LACY, SUZANNE. "PROSTITUTION NOTES." IN *VEILED HISTORIES: THE BODY, PLACE AND PUBLIC ART,* EDITED BY ANNA NOVAKOV. NEW YORK: CRITICAL PRESS, 1997.

ROTH, MOIRA. "MAKING & PERFORMING CODE 33: A PUBLIC ART PROJECT WITH SUZANNE LACY, JULIO MORALES, AND UNIQUE HOLLAND." *PERFORMING ARTS JOURNAL* 23, NO. 3 (SEPTEMBER 2001): 47–62.

Code 33: Emergency! Clear the Air, 1999
CITY CENTER WEST GARAGE, OAKLAND, CALIFORNIA

Code 33: Emergency! Clear the Air, 1999
CITY CENTER WEST GARAGE, OAKLAND, CALIFORNIA

[detail showing the inside of one car]

Underground, 1993
THREE RIVERS ART FESTIVAL; PITTSBURGH, PENNSYLVANIA;
ONE OF THREE WRECKED CARS PLACED ALONGSIDE RAILROAD
TRACK IN A DOWNTOWN PARK

HUNG LIU

Hung Liu's paintings are a rediscovery or recovery of particular qualities of Chinese culture, history, and people. The conflicting ideologies she has experienced throughout her life—a traditional, middle-class upbringing in China, reeducation under the Cultural Revolution, training as an artist to serve the people, and finally graduate study in the United States—have shaped her artistic exploration. Lifestyles and roles in Chinese society, primarily from recent history, constitute the exploratory ground for her paintings, and these subjects are evocatively measured by how identities change through the perspectives of history and different cultures.

Liu studies and re-presents photographs of Chinese subjects as the basis for her oil paintings. Committed to building a solid base of information to support her artwork, she digs through archive documents and seeks out old photographs and books. Her sources include a historic book of photos of Chinese prostitutes, old and contemporary magazine photos, historic pictures taken of Chinese people by foreign tourists, and images of family members. She does not simply copy the material, but may alter the perspective, flatten an image, and remove or embellish the contextual surroundings. As she stated, "between dissolving and preserving is the rich middle-ground where the meaning of an image is found."

Three standing women, one with her arm around the shoulder of her companion, while the third stands closely beside, stare somewhere off the canvas in *Comrade-in-Arms* (2000). Their gaze appears defiant and resolute and yet also exhausted and resigned. Liu depicts these women in plain, rumpled clothes, with hair askew and a sense of weariness evident in their serious faces; their nondescript clothing makes it difficult to situate the women in a particular time. The women stand insistently together, physically and emotionally, as if bound by experience and circumstance. Liu fills almost the entire canvas with the women and provides no contextual information about the scene, opening interpretation to the viewer and also creating the impression of suspended time. These comrades in arms might represent followers of an eclipsed ideological movement, victims of oppression or injustice, or survivors of a battle. The scene is emotionally engaging and arouses empathy for whatever the women have endured and respect for their clear solidarity. She creates a compelling sense of intimacy and connectivity that is alluring.

Liu commonly employs a technique of drizzling linseed oil over a thinly applied layer of paint, which creates a screen between the viewer and the subject. This screen or filter physically and metaphorically represents memory, emotion, or the differing perspective of another culture or time. She employs this to dramatic effect in her works, including *Millstone* (1999). Here, the striations formed by the linseed oil suggest a scene happening on the other side of a divide, in a faraway time or place. This sense of otherworldliness is reinforced

with the fanciful scattering of birds, flowers, and foliage across the canvas. The three women millworkers, two using their entire bodies to push the long wooden handle of a millstone, are dressed in plain tunics and could be a daughter, mother, and grandmother. What the viewer knows intellectually must be difficult work is not presented as such; rather, Liu seems to be representing a romanticization of the labor of the working class.

SELECTED READING

ARIEFF, ALLISON. "CULTURAL COLLISIONS: IDENTITY AND HISTORY IN THE WORK OF HUNG LIU." *WOMEN'S ART JOURNAL* 17 (SPRING/SUMMER 1996): 35–40.

GOUMA-PETERSON, THALIA. *HUNG LIU: A TEN YEAR SURVEY 1988–1998.* WOOSTER, OHIO: COLLEGE OF WOOSTER ART MUSEUM, 1998.

HUNG LIU: CHINESE TYPES. WITH TEXT BY BILL BERKSON. SAN FRANCISCO: RENA BRANSTEN GALLERY, 1998.

HUNG LIU: THE YEAR OF THE DOG, 1994. WITH TEXT BY ROBERT ATKINS, ROSALYN BERNSTEIN, ELEANOR HEARTNEY, BERNICE STEINBAUM, AND PHILIP VERRE. NEW YORK: STEINBAUM KRAUSS GALLERY, 1994.

FROM THE FIFTH GRADE FORWARD, HUNG LIU (BORN IN CHANGCHUN, NORTHEASTERN CHINA, IN 1948, THE YEAR OF THE RAT) WAS EDUCATED IN BEIJING. HER INTENTION TO PURSUE A MEDICAL DEGREE WAS INTERRUPTED BY THE CULTURAL REVOLUTION, AND SHE WAS SENT TO THE COUNTRYSIDE TO BE RE-EDUCATED IN THE FIELDS IN 1966. IN 1972, LIU ENROLLED AT THE BEIJING TEACHERS COLLEGE IN THE REVOLUTIONARY ENTERTAINMENT DEPARTMENT, WHERE SHE WAS PERMITTED TO CREATE ONLY ARTWORK THAT SUPPORTED THE COMMUNIST PARTY MESSAGE. SHE TAUGHT ART IN AN EXPERIMENTAL SCHOOL AFTER GRADUATION IN 1975 AND IN 1979, AT THE END OF THE CULTURAL REVOLUTION, ENTERED GRADUATE SCHOOL AT THE CENTRAL ACADEMY OF FINE ARTS IN BEIJING. IN 1981, SHE WAS ACCEPTED AT THE UNIVERSITY OF CALIFORNIA AT SAN DIEGO—BEING THE FIRST MAINLAND CHINESE STUDENT TO APPLY. AFTER GRADUATION (MFA, 1986), LIU TAUGHT AT THE UNIVERSITY OF TEXAS IN ARLINGTON AND THE UNIVERSITY OF NORTH TEXAS IN DENTON AND THEN MOVED TO OAKLAND WHERE SHE HAS TAUGHT AT MILLS COLLEGE SINCE 1990. HER STUDIO IS IN OAKLAND.

In *Brotherhood* (1998), Liu depicts a young boy grasping a smaller, barefoot boy in his arms. Their expressions show surprise, fear, or pain. Liu balances subdued tonalities with yellows, blues, and greens, and bold, expressive strokes of red, bringing forth both naturalistic and symbolic qualities of color. Red can connote danger, alarm, and blood, but it is also the color used in Chinese weddings and festivities and in the Chinese flag. More immediately, the red amplifies the sense of fear or pain in the boys' faces. From this almost abstracted background of color emerge images of foliage and alert, watchful deer. *Brotherhood* exemplifies Liu's strong rendering ability and what critic Bill Berkson describes as "a renegade taste for the unencumbered pleasures of painterliness." She develops artwork that is engaging, and encourages careful looking and thoughtful reflection.

Liu's work builds bridges between people and cultures, and fosters understanding of difference rather than reinforcing or re-creating divisiveness. Her paintings establish a sense of something personal, experienced, or remembered. Although specific in subject to the Chinese people and Chinese history, her work opens itself to more universal musings on history, identity, and memory.

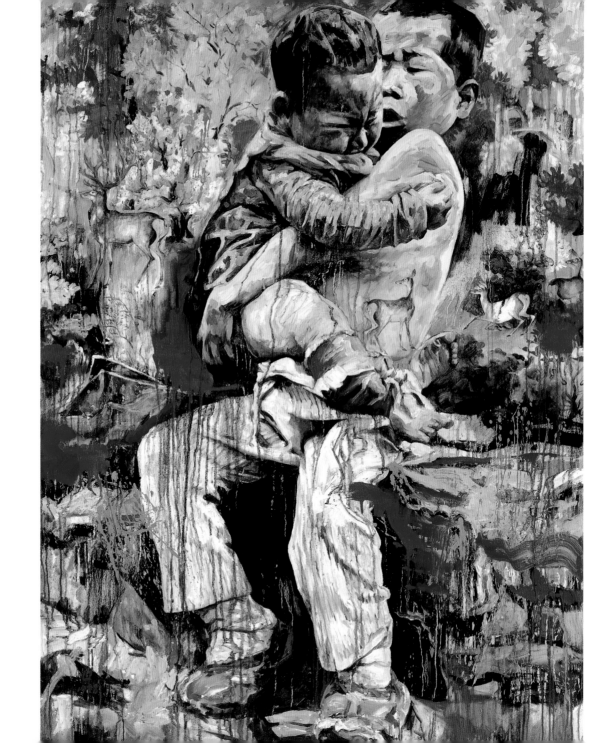

Brotherhood, 1998
OIL ON CANVAS; 64" X 48"

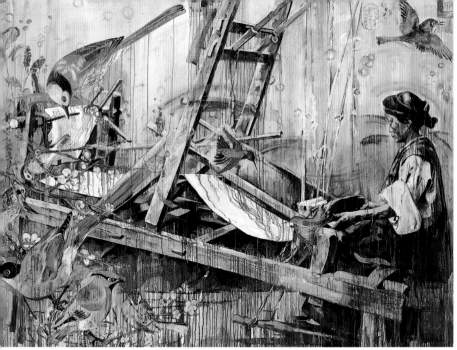

Loom, 1999
OIL ON CANVAS; 80" X 110"

Still Point, 1998
OIL ON CANVAS; 84" X 60"

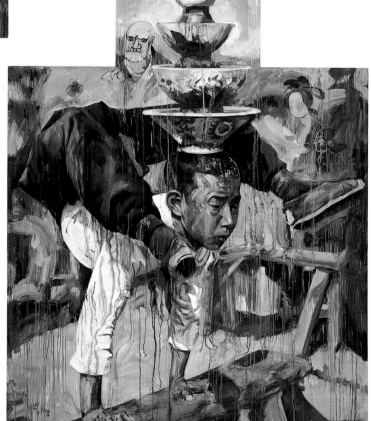

Millstone, 1999
 OIL ON CANVAS; 80" X 110"

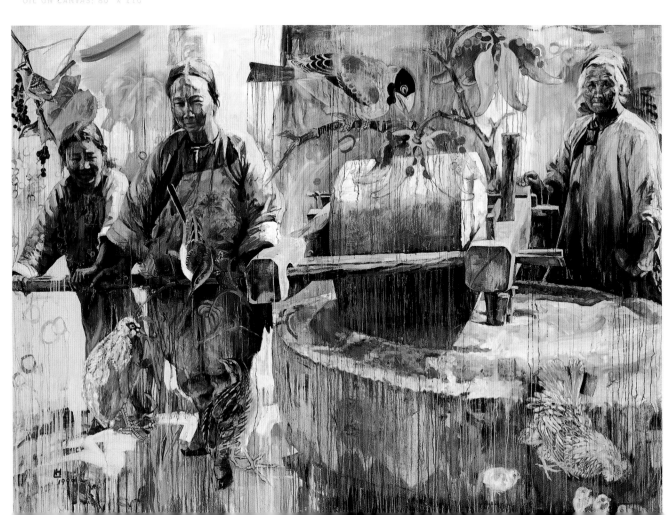

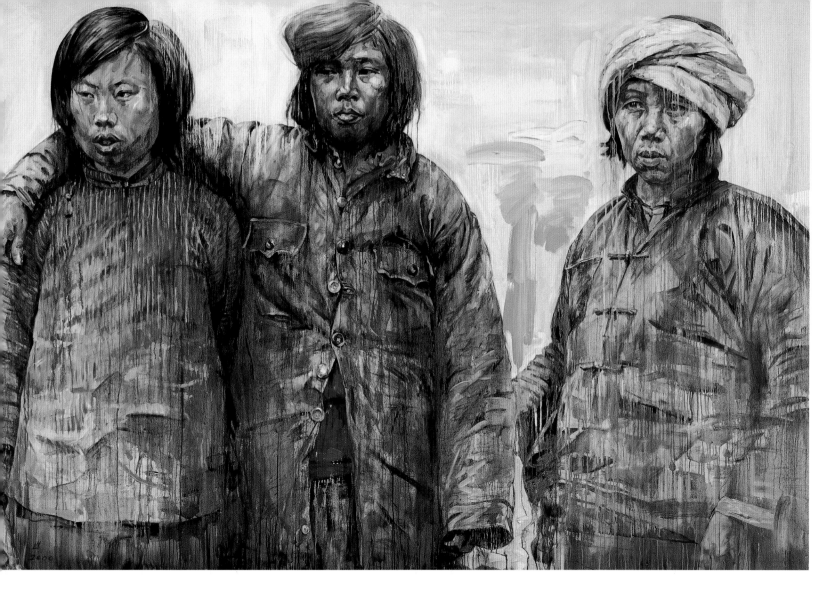

Comrade-in-Arms, 2000
OIL ON CANVAS; 78" X 114"

TOM MARIONI

Tom Marioni's work since the late 1960s redefines traditional sculpture in concept, act, and object. Marioni broadly delineates the differences among his works by separating them into two categories: "social art," such as installations, actions, or performances that take place in a public context, and "private investigations," including drawings, sculpture, or prints created in a studio. Working to synthesize concept and practice from different artistic disciplines—for example, combining drawing and musical performance—he pays deliberate attention to the passage of time and the concept of art as a process that unfolds, from beginning to end. Recurring throughout his career is an exploration of sound, color, light, shadow, and movement.

Marioni initially created sculpture and sound works. Interested in the deeper relationship between sculptor and object, in a manner similar to the symbiotic relationship between a dancer and the dance, he developed a conception of sculpture as a fixed set of elements in space. He envisaged movement, or an "action," as the corollary addition of time to sculpture. An action was not intended to have a preconceived outcome, like a dance, but would be open-ended and shaped by the unfolding action. From this conceptual basis he created "actions," as well as performances and installations.

This social art of performances, installations, and organized gatherings takes advantage of a public context in which Marioni plays separate roles as performer and impresario. His conceptual framework extends to his work both as an artist and as a curator. In some events those roles are blurred. Marioni's own actions or performances in the late 1960s and early 1970s were predominantly solo, such as the work he performed as Allan Fish, a pseudonym he used while curator at the Richmond Art Center (1968–71), for "Sound Sculpture As . . . ," a 1973 Museum of Conceptual Art group exhibition of performance/installation works. For the piece titled *Pissing,* he drank beer all night and periodically climbed a short ladder to urinate into a metal tub, which produced a changing musical pitch as the tub filled.

From 1975 to 1984 at MOCA, Marioni presented works that explored social situations as content and material, an area of particular interest. In 1970, he created *Drinking Beer with Friends is the Highest Form of Art* for an exhibition at the Oakland Museum of Art. Marioni and a group of friends met at the museum on a Monday when it was closed, sat, conversed, and drank beer. The remaining detritus (empty bottles, cigarette butts, and so on) comprised the artwork on display. Marioni continued this work at MOCA as *Free Beer* (1973–94), a weekly interactive piece, involving artists, friends, and any other visitors sitting in the space, drinking beer, and conversing as they would in a similar social setting. The circumstances Marioni provided consistently included a refrigerator full of cold beer, shelves for empty bottles, a table, chairs, and framed cards explaining this "social art." This work has also been called *Wednesdays, Café Society, Academy of MOCA Café, Archives of MOCA,* and *Café Wednesdays.*

Throughout his career, Marioni has also created studio works that overlap the conceptual strategies of his social art and also explore different ideas. His approach to drawing is cross-disciplinary and process-oriented, as in the *Drum Brush* drawings that he has made since 1972. Marioni rhythmically beats two silverplated wire drum brushes against a sheet of sandpaper over a period of hours, which wear through the top layer to create a pattern of silver marks. Marioni envisions these pieces as an amalgamation of drawing, painting, writing, music, and sculpture. He considers drumming as both communication and music, and observes, "I see the world as a sculptor, sound as material and my brushes as tools that create conditions demonstrating basic sculpture principles: the relationship of elements in time and space. . . . I have held onto my notion of the sculpture action where the action is directed at the material I'm manipulating instead of at the audience."

Marioni carefully considers each decision in the creation of art. The care that characterizes his decisions is present in sculptural works begun in the early 1980s, which utilize simple, common objects

TOM MARIONI (B. 1937, CINCINNATI, OHIO) STUDIED VIOLIN AT THE CINCINNATI CONSERVANCY OF MUSIC (1954–55) AND COMMERCIAL AND FINE ART AT THE CINCINNATI ART ACADEMY (1955–59). HE MOVED TO SAN FRANCISCO IN 1959, AND EXCEPT WHILE STATIONED IN GERMANY WITH THE U.S. ARMY (1960–63) HAS LIVED THERE SINCE. AMONG MANY AWARDS, HE HAS RECEIVED FELLOWSHIPS FROM THE JOHN SIMON GUGGENHEIM MEMORIAL FOUNDATION (1981), THE NATIONAL ENDOWMENT FOR THE ARTS (1976, 1980, 1984), AND THE FLINTRIDGE FOUNDATION (1998). HE LIVES AND MAINTAINS A STUDIO IN SAN FRANCISCO.

and place them in precise ways to function in an evocative manner. A wood bowl, tipped ninety degrees and attached to the edge of a rusted steel plate, is poised like a wood antenna dish in *The Listener (San Francisco)* (1997), which is approximately twenty-four inches high. The top of the steel plate has been curved and fixed to a flat steel circular base, and it cants away from the wood bowl at a slight angle. Half an oyster shell, centered inside the bowl and mounted slightly away from the surface, is poised like a crustacean ear inside this wood receiver. The various parts echo each other and progressively change in color and texture, from delicately hued nacre interior to rough exterior of the oyster shell, from shell to lathe-turned bowl and from curved, deep brown, smooth wood to rusted steel plate. These parts have a startling formal diversity of materials, surfaces, and found or constructed elements. There is an equally layered complexity in the conceptual interpretations: shell, wood, and steel were used as tools by humans in progressive evolutionary stages, and they represent natural, constructed, and manufactured worlds. The aggregate is an artwork that is a model for science and the auditory systems of living organisms. When the sculpture is lit from the side, it casts a shadow in the image of a satellite dish read to detect any vibrations or signs of life, just as Marioni is a receptor for sounds, sights, and ideas.

SELECTED READING

CAGE, JOHN. *ROLYWHOLYOVER: A CIRCUS.* LOS ANGELES: MUSEUM OF CONTEMPORARY ART; NEW YORK: RIZZOLI, 1993.

FORTY YEARS OF CALIFORNIA ASSEMBLAGE. LOS ANGELES: WIGHT ART GALLERY, UNIVERSITY OF CALIFORNIA, LOS ANGELES, 1989.

MARIONI, TOM. *SCULPTURE AND INSTALLATIONS, 1969–1997.* SAN FRANCISCO: SELF-PUBLISHED, 1997.

SCHIMMEL, PAUL, ET AL. *OUT OF ACTIONS, BETWEEN PERFORMANCE AND THE OBJECT, 1949–1979.* LOS ANGELES: MUSEUM OF CONTEMPORARY ART, 1998.

Café Wednesday (in studio) 1992
ONGOING ACTION IN ARTIST'S STUDIO

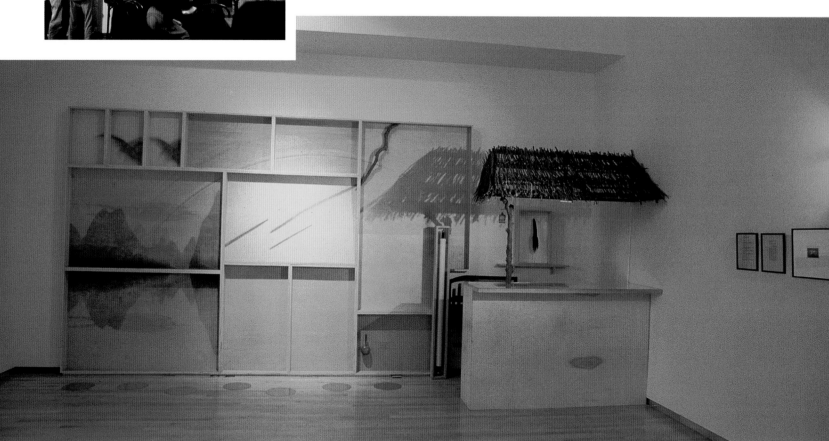

By the Sea (The Pacific Rim), 1992–93
INSTALLATION 9' X 21' X 5'; OBJECTS, LIGHT AND SHADOW WITH DRAWINGS ON WOOD; INCLUDES A
FUNCTIONING BAR OPEN ON WEDNESDAYS WITH AN INTERACTIVE ELEMENT

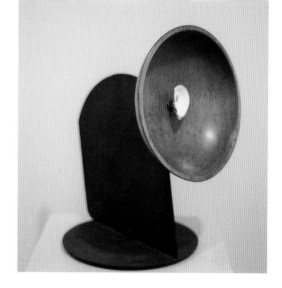

The Listener, 1997
STEEL, WOOL, BRASS; 24" X 15" X 15"

Drum Brush Drawing, 1975
STEEL ON SANDPAPER; 22" X 28"

RICHARD MISRACH

Consistently making photographs
that are beautiful and often inherently political, Richard Misrach
is best known for color
landscapes of the West. Underlying all his work is a desire to
engage viewers in complex issues of politics, beauty, morality, and spirituality, which Misrach accomplishes not only through traditional photographic print displays and exhibitions, but also through the medium and form of books.

The substantive conceptual explorations by Misrach during the 1970s were fostered through friendships with artists such as Sam Samore and Lew Thomas, who shared interests in photography and language. Misrach's first book, self-published in 1974, consists of black-and-white portraits of people on the streets of Berkeley, California, made with electronic flash at night. His second book, also comprising nocturnal flash-lit photographs, depicts desert foliage such as Boojum trees and saguaro cactus. He accentuated the alien appearance of the cacti and foliage through split toning, a process that imbues black-and-white prints with a combination of warm reddish-brown hues and cold, silvery tones.

He was so resolute that the images be viewed only for their own merits that no text appears anywhere in the book, with printing only on the spine. (It reads: ©Richard Misrach 1979 Library of Congress 78—71568 ISBN 0-917986-13-X Grapestake Gallery San Francisco $12.95.) From this early work he learned how perceptions are altered through extended observation, and how assembling photographs in series can develop concepts that are not immediately evident in a single image.

Misrach began making daylight, large-format color photographs of the desert in 1979, initially working in Southern California's San Jacinto Mountains region, where ocean and desert environments converge. In 1983, he learned about the structure of Ezra Pound's fifty-year epic poem *Cantos,* and adopted it as a model for the desert photographs. A canto is a division in a long poem or song, and the "Desert Cantos" became his vast open-ended project (still ongoing). This framework conceptually expanded the subjects of his photographs, for as a canto is part of an aggregate, no single site could be expected to convey the whole.

The "Desert Cantos" begins with a prologue of photographs that set the stage for an exploration of culture, civilization, resplendent beauty, and ruin in the desert environment. Individual images have meaning, but like poetry there is a symbolic meaning and cumulative effect beyond what they depict. The aesthetic and spiritual qualities of these subjects, which range from people to skies and various desert areas throughout the American West (and a few in Israel), create a provocative social document that delves into morality and politics. The hundreds of images mark a journey that is not directed towards a single-minded goal, but the willingness to embrace the unforeseen directions provided by the photographs.

Misrach continued to work with books as an informal vehicle to convey these suite-based ideas. The photographs that comprise

Canto V: The War (Bravo 20) and Canto VI: The Pit were separately published as Bravo 20 (1990), and along with some from Canto XI: The playboys were published as Violent Legacies (1992). In the former, Misrach vividly depicts the grim vestiges and unlikely beauty of illegal bombing exercises in Nevada, and in the latter adds the tightly composed bullet-riddled pages of two found Playboy magazines. "Probably the strongest criticism leveled at my work is that I'm making 'poetry of the holocaust,'" Misrach observed in 1992. "But I've come to believe that beauty can be a very powerful conveyor of difficult ideas. It engages people when they might otherwise look away."

He continues to explore the romanticism of large-format color landscapes, and the results of the interaction between humans and nature. It may be a chimerical marriage, as demonstrated in his photographs made along Cancer Alley (1998), a fifty-mile stretch of Mississippi River between Baton Rouge and New Orleans that has been used as a biochemical dumping ground. In these images a pendulum swings between nature and industry, ravishing beauty and toxic realism.

In the 1990s, he has primarily pursued two separate projects. In his photographs of skies, the landscapes are gone and the frame is emptied of content. The skies, made with exposures that extend several hours, are treated as meditative windows of fantastic color, as in Mars and Air Traffic over Las Vegas, 3.12.97, 3.13.97, 10:26 pm–2:14 am (from Desert Cantos XXI—Heavenly Bodies, 1997). The graceful arcing lines of stars, created by the earth's rotation during the extended exposure, are abstract marks in a colored field that can only be seen through photographic processes. In The Sky Book, each grouping of

stars or area underneath a depicted sky is captioned, and the accompanying text explores the cultural history of the names associated with these places or sky phenomena.

Returning to a minimal inclusion of landscape, his photographs of the San Francisco Bay and Golden Gate Bridge, made from his front porch, are unapologetic observations of the sublime colors that daily sweep across the coastline, and arranged together in Golden Gate. Boundless sky space is seemingly filled with every visible color, and is grounded by patches of water, the Golden Gate Bridge, and Alcatraz Island. Initially, these photographs do not seem to carry the same searing political or social indictments as other images; however, they represent the privileged view accompanying expensive real estate, and the beautiful colors are indicative of environmental disregard, for like the most resplendent sunsets they are in part a product of pollution.

RICHARD MISRACH (B. 1949, LOS ANGELES, CA) GREW UP IN LOS ANGELES AND ATTENDED THE UNIVERSITY OF CALIFORNIA AT BERKELEY (BA, 1971) AND THEN BEGAN A DOCUMENTARY PROJECT FOR WHICH HE WAS AWARDED A NATIONAL ENDOWMENT FOR THE ARTS PHOTOGRAPHY FELLOWSHIP (1973). HE SELF-PUBLISHED THE PROJECT AS TELEGRAPH 3 A.M: THE STREET PEOPLE OF TELEGRAPH AVENUE, BERKELEY. MISRACH HAS RECEIVED NUMEROUS OTHER AWARDS AND COMMISSIONS, INCLUDING A JOHN SIMON GUGGENHEIM MEMORIAL FOUNDATION FELLOWSHIP (1979), AND THREE ADDITIONAL NATIONAL ENDOWMENT FOR THE ARTS PHOTOGRAPHY FELLOWSHIPS (1977, 1984, 1992). HE MAINTAINS A STUDIO IN EMERYVILLE, AND LIVES IN BERKELEY.

SELECTED READING

MISRACH, RICHARD. CANTOS DEL DESIERTO 1979–1999. GRANADA, SPAIN: DIPUTACIÓN DE GRANADA, 1999.

MISRACH, RICHARD; T. J. CLARK, AND RICHARD WALKER. GOLDEN GATE. SANTA FE, N.M.: ARENA EDITIONS, 2001.

MISRACH, RICHARD. TELEGRAPH 3 A.M: THE STREET PEOPLE OF TELEGRAPH AVENUE, BERKELEY. BERKELEY, CALIF.: CORNUCOPIA PRESS, 1974.

MISRACH, RICHARD. VIOLENT LEGACIES: THREE CANTOS. WITH FICTION BY SUSAN SONTAG. NEW YORK: APERTURE, 1992.

MISRACH, RICHARD. THE SKY BOOK. WITH TEXT BY REBECCA SOLNIT. SANTA FE, N.M.: ARENA EDITIONS, 2000.

MISRACH, RICHARD, AND MYRIAM WEISANG MISRACH. BRAVO 20: THE BOMBING OF THE AMERICAN WEST. BALTIMORE, MD.: JOHNS HOPKINS UNIVERSITY PRESS, 1990.

TUCKER, ANNE. CRIMES AND SPLENDORS: THE DESERT CANTOS OF RICHARD MISRACH. BOSTON AND HOUSTON: BULFINCH PRESS IN ASSOCIATION WITH THE MUSEUM OF FINE ARTS, 1996.

3.20.00, 4:05 – 5:00 am
DYE COUPLER PRINT

Battleground Point #14, 1999
DYE COUPLER PRINT

Swamp and Pipeline,
Geismar, Louisiana, 1998
DYE COUPLER PRINT

Paradise Valley 10-5-97 6:37 pm
DYE COUPLER PRINT

Clouds (Stratus Nebulosus), Cholla Mountains
11-2-96 10:10 – 10:54 pm
DYE COUPLER PRINT

ANNA VALENTINA MURCH

VALENTINA MURCH

When Anna Murch arrived in the American West from the United Kingdom in the late 1970s, the vast landscape and open expanses of sky impressed her: the environment, as she described, gave her "room to breathe mentally as well as physically." Inspired by her surroundings, Murch has worked with light, and reflective materials such as glass, metal, or aluminum, which she applies to the constructed, industrial, and natural landscape in the creation of her artwork.

Since the late 1980s, Murch has created installation art, focusing on permanent, site-specific commissions. Experienced as a collaborative team member, she works closely with architects, engineers, and other artists on a variety of projects including public artworks, landscape and architectural designs, and cultural master plans. From 1994 to 1998, she worked with Sasaki & Associates landscape architects to design and install transit shelters at four stops on a stretch of the San Francisco Municipal Railway along South Embarcadero and King Streets, from the Ferry Building, past the baseball stadium, and to the train station. After holding a series of workshops with local residents, port and transit officials, and landowners, the team identified the desired goal of the project: to preserve views of the San Francisco Bay while providing functional shelters that would protect transit riders from sun, wind, and rain. The solution was to develop a series of curving metal and glass windscreens, covered overhead by glass and steel canopies, which elegantly echo the waves in the bay and the hills of the East Bay visible in the distance.

Dualities recur in Murch's work. Manufactured materials such as metal or glass are often used to bring about fleeting perceptual or psychological experiences. For *Cycles* (1997), a permanent installation for the Queens Civic Court in New York, Murch selected as her site an interior public courtyard that cannot be entered but is visible through windows in the lobby. She uses a combination of manufactured and natural materials in the space to harness and draw attention to the natural rhythms of time and light. Murch brings these elements together into a sophisticated, contemplative landscape that encourages and catalyzes introspection to relieve the anxiety and tension experienced by litigants, jurors, and witnesses in court.

The multifaceted project uses the sunlight and breeze coming into the open-air, limestone courtyard (outdoor floor lights projecting skyward visually activate the space at night). On one wall, a nine-foot-diameter polished aluminum wheel with fan blades slowly rotates with the wind, which creates shadows and reflects light. Nearby, a highly polished stainless steel form, about three feet high and shaped like a

ANNA VALENTINA MURCH (B. 1948, DUMBARTON, SCOTLAND) STUDIED SCULPTURE AT THE ROYAL COLLEGE OF ART IN LONDON (MA, 1973) AND DID FURTHER GRADUATE WORK IN RESPONSIVE ENVIRONMENT STUDIES AT THE ARCHITECTURAL ASSOCIATION IN LONDON (1973–74). MURCH CAME TO THE UNITED STATES IN 1976 AND OBTAINED PERMANENT RESIDENT STATUS A YEAR LATER. FROM 1983 THROUGH 1992, SHE TAUGHT AT VARIOUS INSTITUTIONS, AND SINCE 1992 HAS BEEN AN ASSOCIATE PROFESSOR OF ART AT MILLS COLLEGE IN OAKLAND. AMONG HER HONORS ARE A PRESIDENTIAL DESIGN AWARD (1995) AND A NATIONAL DESIGN FOR TRANSPORTATION AWARD FROM THE NATIONAL ENDOWMENT FOR THE ARTS (1996). MURCH LIVES IN SAN FRANCISCO.

toy top, revolves on a barely noticeable turntable. As it slowly spins, it reflects the sky and other parts of the courtyard. The motion of these elements engages viewers' awareness of the steady, inevitable passage of time. Four round, black granite vessels are arranged in a row in a long, narrow space in the courtyard. The first vessel, almost flush with the ground, is over seven feet in diameter; the others are progressively taller and narrower. The water in the vessels reflects the sky, bringing it into the constructed space of the courtyard. Along the limestone courtyard walls are shallow reliefs in the form of circular labyrinths.

In her art, Murch gives time a materiality through the slow changes that are revealed through extended viewing. *Skytones* (1998), a light project for the Benaroya Symphony Hall in Seattle, is located in the Third Avenue Arcade, an enclosed public passageway that serves as an extended lobby for the symphony hall. The passageway is characterized by a soaring wall at street side, the upper two-thirds formed of

glass. Within this voluminous architectural space, Murch installed fluorescent lights, placing warm and cool hues in different locations and programming them through a dimming panel. As the lights change in intensity, different colors fill the space. The slow transformation of colors moves from blues through magenta to deep yellows, giving a corporeal sense of the passage of time. *Skytones,* a visually poetic performance, enables viewers, either passing by outside or through the interior, to be mindfully connected to their perceptions of space, time, and the beauty of light.

SELECTED READING

BLANKSTEIN, AMY. "COMMISSIONS: ANNA VALENTINA MURCH." *SCULPTURE* 17, NO. 6 (JULY/AUGUST 1998): 19.

CHANDLER, MARY VOELZ. "DIA'S 'SKYDANCE' MOVES SIGHT AND SUBCONSCIOUS." *ROCKY MOUNTAIN NEWS,* 6 AUGUST 1995, SEC. A, P. 70.

"MEMORIAL UNION NORTH COURTYARD" (IN ENGLISH AND JAPANESE). *PROCESS ARCHITECTURE* 128 (JANUARY 1996): 120–23.

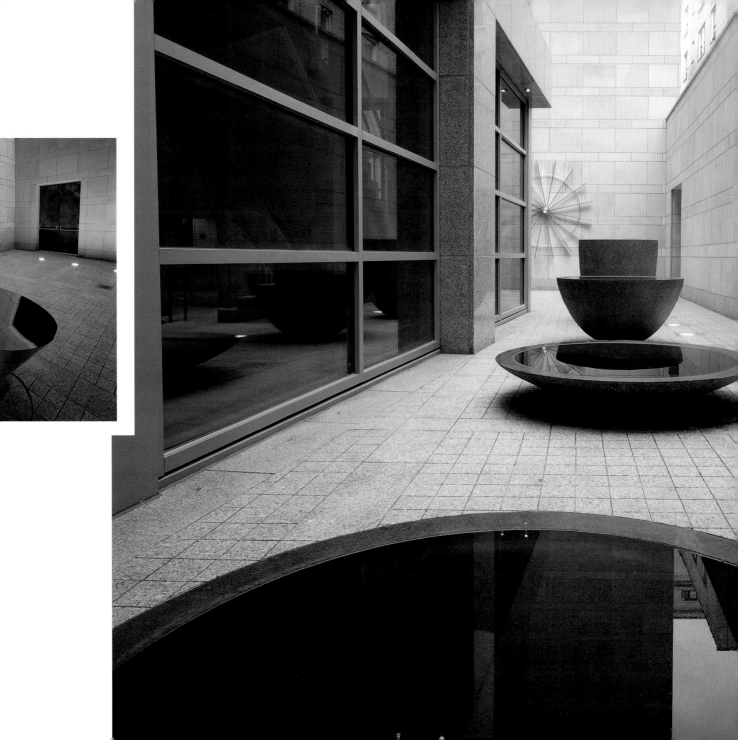

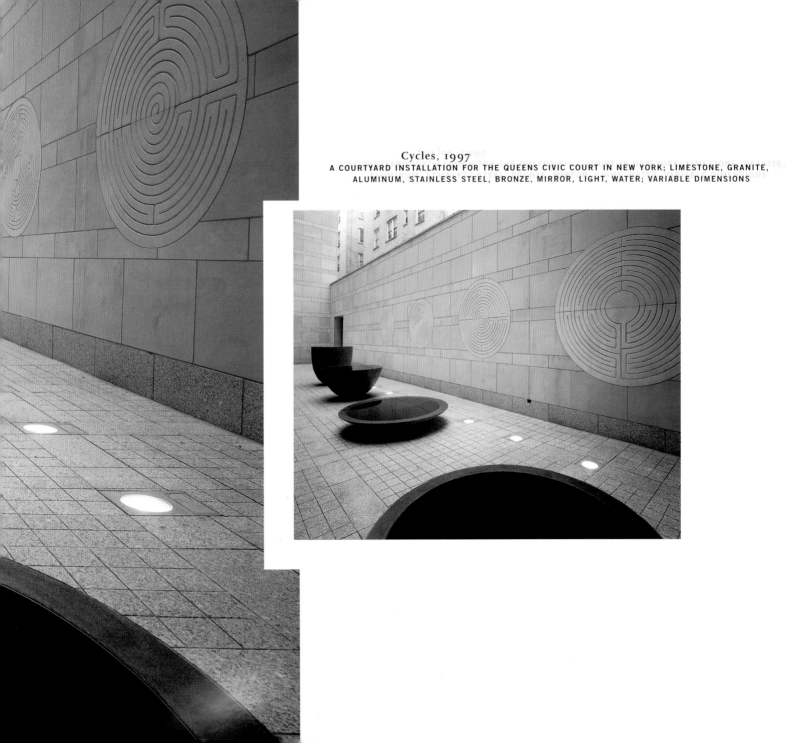

Cycles, 1997
A COURTYARD INSTALLATION FOR THE QUEENS CIVIC COURT IN NEW YORK; LIMESTONE, GRANITE, ALUMINUM, STAINLESS STEEL, BRONZE, MIRROR, LIGHT, WATER; VARIABLE DIMENSIONS

Embarcadero MUNI Metro Station shelters and
wind screens, 1998, San Francisco
IN COLLABORATION WITH SASAKI ASSOCIATES;
FROSTED GLASS, GREEN-TINTED GLASS, STEEL, STAINLESS STEEL

Skytones, 1998
THIRD STREET ARCADE FOR THE BENAROYA SYMPHONY HALL
IN SEATTLE; FLUORESCENT LIGHT, DIMMER SYSTEM,
CURVED PLASTER-BOARD NICHES

NOBUHO NAGASAWA

Since the early 1990s, Nobuho Nagasawa has created artworks that actively engage others in her explorations of history, memory, identity, and time. She displays an equal fluency working in gallery and museum spaces and in public settings and the outdoors. Her complex, large-scale public commissions and installations are significant for the interactions between people that occur during the course of each project. She also creates compelling sculptures and installations that stem from her personal interests and research.

Ring of Time, created in 1999 for the Paradise Wood Sculpture Grove in Santa Rosa, California, is a personal meditation on the passage of time and the human desire to measure it. Four steel rings are hung around branches of an oak tree. Glass globes within the rings reflect the surrounding environment. The diameter of each ring approximates the projected growth of the tree over the next one hundred years. In a contrast of scale and approach, Nagasawa collaborated with project architects to create *Tsukuyomi* (2000) for the exterior plaza of the National Government Buildings in Saitama, Japan, through which as many as fifty thousand people pass each day. This large-scale work is named after the ancient Japanese word that roughly translates to "moon-night viewing" or "moon-reading" and refers to ancient traditions using water and the moon to measure time. Specially manufactured phosphor and granite tiles, which store solar energy and glow in the dark, are placed within a geometric grid in the plaza. The grid consists of columns and rows of squares, and within each is an image representing one phase of the lunar cycle. The entire paving design represents the twenty-eight phases of the lunar cycle for the month when the plaza opened to the public. Fountains periodically spray mist across the space, creating a luminescent interplay between the natural light, the glow of the tiles, and the water. Both *Ring of Time* and *Tsukuyomi* reflect Nagasawa's interest in time and the processes of nature—one on the intimate scale of a discrete sculpture, the other on the public scale that communicates to thousands of people each day.

For Nagasawa, the process of discovery provides the basis for a work. Scholarly research is the first stage of this process, leading to an exploration and investigation into the history, stories, and memories of the place where the artwork will be created. *Far East/Far West,* a temporary installation at the Paradise Wood Sculpture Grove (1999–2000), is about Kanaye Nagasawa (no relation), a master vintner in the Santa Rosa region during the late 1800s, whom she discovered through her research on the site. A large hourglass, mounted on a steel tripod, was filled with sand from both Sonoma County and his hometown of Kagoshima, Japan. The sounds of classical music emanated from a nearby wine barrel, reflecting a Japanese belief that plant growth is positively impacted by music. The piece was Nagasawa's personal commemoration of the vintner and the care that he gave his vineyard, and it was also a meditation on cultural identity and the bridging of differences.

Collaboration is often part of Nagasawa's artistic process, whether she is working with architects to design a transit station or with the children of a local community to create components of an artwork. Collaboration and social exchange are as much a part of the art as the resulting product. Her installations may be physically large and complicated and require the coordination of dozens of people. *Bunker Motel/Emergency Womb* (1995), created in Denmark, is typical of her work with a community. The piece involved hundreds of children making plaster casts of five hundred ostrich eggs and the organization of a town processional to install them at the site. The project, part of "Peace Sculpture 95," commemorating the fiftieth anniversary of the end of World War II, was located in several military bunkers used by the Nazi army. Nagasawa transformed the bunkers into motels for lovers, to counteract the destruction of war with the positive act of procreation, and to suggest the completion of the cycle of life and death. Military cots were installed in the bunkers, along with the five hundred ostrich eggs, which represented the total eggs produced by a woman during her reproductive years. Sandbags filled with sugar and sand were placed on the cots as blankets. The choice of materials derived from a story about how local fishermen attempted to sabotage the bunker construction by mixing sugar into the cement.

Many works are labor and time intensive, and require significant physical effort and the skillful management of complex building processes. For the international exhibition "Invisible Nature" (1993–94), Nagasawa built large structures out of sandbags in the shape of locally significant architectural features in three cities— an eighth-century cathedral in Aachen, Germany; the Chain Bridge over the Danube River in Budapest, Hungary; and the twelfth-century Charles Bridge in Prague. The structures appear precarious in their unusual construction and yet somehow solid and elegant. The choice of material refers to a tenuous, war-torn past. An hourglass placed nearby marked the passage of time. When viewers turned it, they symbolically acknowledged their participation in the historical evolution of postwar Eastern Europe.

Whether viewers are invited to touch, turn, or move components in an installation or are involved in the making of an artwork, audience participation is a significant aspect of Nagasawa's artistic process. Without this involvement, the meaning of her work would be incomplete.

NOBUHO NAGASAWA (B. 1959, TOKYO, JAPAN) HAS LIVED IN CALIFORNIA SINCE 1987, WHEN SHE RECEIVED AN EXCHANGE GRANT TO STUDY AT THE CALIFORNIA INSTITUTE OF ARTS IN VALENCIA. IN 1996 SHE MOVED TO SANTA CRUZ TO TEACH AT THE UNIVERSITY OF CALIFORNIA. WHEN SHE WAS A CHILD, HER FAMILY LIVED IN THE NETHERLANDS, WHERE HER FATHER WAS ON DIPLOMATIC ASSIGNMENT. AFTER HIS DEATH IN 1970, SHE RETURNED TO TOKYO, BUT IN 1978, NAGASAWA WENT BACK TO THE NETHERLANDS TO STUDY AT THE STATE ACADEMY OF FINE ARTS IN MAASTRICHT (BA, 1982). SHE THEN STUDIED IN BERLIN AT THE HOCHSCHULE DER KUNSTE (MFA, 1985). NAGASAWA'S AWARDS INCLUDE AN INTERNATIONAL ARCHITECTURE ASSOCIATION AWARD IN BERLIN (1985), TWO ROCKEFELLER FOUNDATION TRAVEL GRANTS (1993, 1995), AN URBAN PLANNING DESIGN PRIZE IN TACHIKAWA, JAPAN (1994), AND TWO EXHIBITION GRANTS FROM THE JAPAN FOUNDATION (1995, 1996). SHE WAS SELECTED BY JAPAN AS THE COUNTRY'S REPRESENTATIVE FOR THE 2002 BANGLADESH BIENNALE. NAGASAWA LIVES IN SANTA CRUZ.

SELECTED READING

ARRIOLA, MAGALI; ANDREA DI CASTRO, AND KAZUO YAMAWAKI. BETWEEN EARTH AND THE HEAVENS—ASPECTS OF CONTEMPORARY JAPANESE ART II. MEXICO CITY: RUFINO TAMAYO MUSEUM, 1996.

COHN, TERRI. "ART IN THE PUBLIC REALM: PLACE, HISTORY AND PUBLIC ART." ARTWEEK 32, NO. 4 (APRIL 2001): 12–13, 32.

LEE, CANDACE, ET AL. A GATHERING PLACE: ARTMAKING BY ASIAN/PACIFIC WOMEN IN TRADITIONAL AND CONTEMPORARY DIRECTIONS. PASADENA, CALIF.: PACIFIC ASIA MUSEUM, 1995.

MCKENNA, BARBARA. "SITE SPECIFIC: THE HIGHLY VISIBLE ART OF NOBUHO NAGASAWA." UC SANTA CRUZ REVIEW (SUMMER 1998): 16–19.

NAGASAWA, NOBUHO. TOH-NOBUHO NAGASAWA, PROCESS 1984–1990. JAPAN: KYOTO SHOIN, 1992.

WALLACE, LORI. "NOBUHO NAGASAWA: TSUKUYOMI, SAITAMA, JAPAN." SCULPTURE 20, NO. 7 (SEPTEMBER 2001): 20–21.

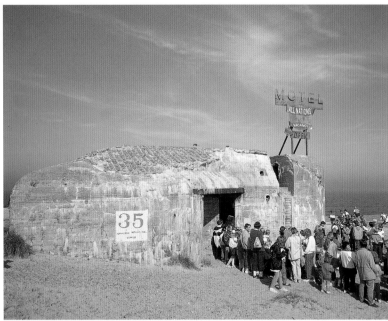

Bunker Motel: Emergency Womb, 1995
INSTALLATION IN THYBORØN, DENMARK; STEEL, SAND, SUGAR,
MILITARY BAGS, ARMY COTS, PLASTER, LIGHT, CANDLES; VARIABLE DIMENSIONS;
EXTERIOR VIEW OF BUNKER WITH PART OF THE TOWN PROCESSIONAL

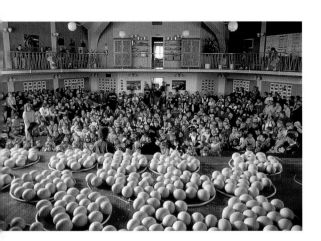

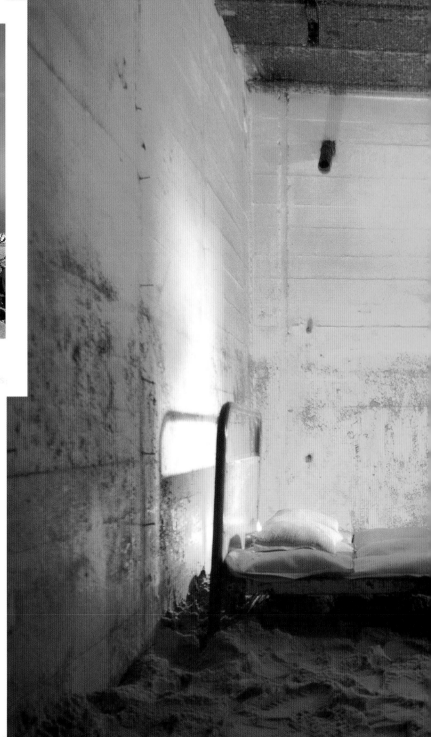

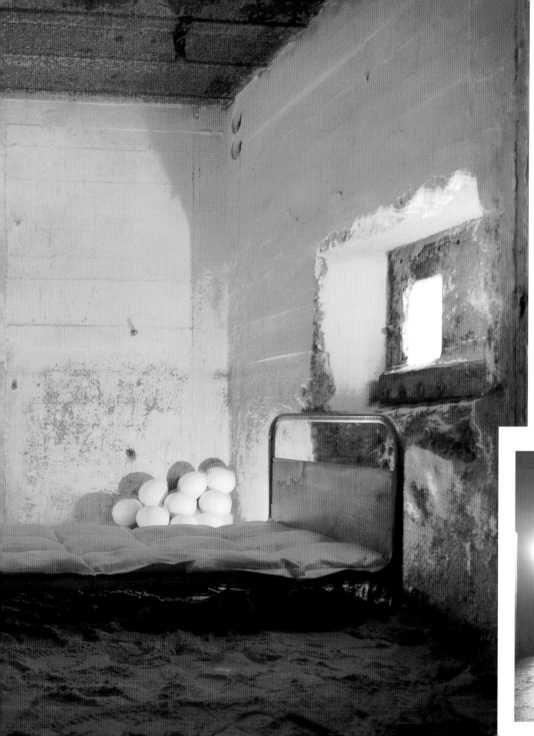

[interior views of the bunkers]

Passage of Time, 2000
INSTALLATION IN DARKENED FREIGHT
ELEVATOR AT THE POST GALLERY, LOS ANGELES;
HOURGLASS, PHOSPHER, STEEL, FABRIC, LIGHT, SOUND

Tsukuyomi, 2000
SAITAMA, JAPAN; PAVEMENT PATTERN
DEPICTING THE 28 CYCLES OF THE MOON:
PHOSPHOR, GRANITE, CONCRETE, MIST FOUNTAINS

RON NAGLE

Ron Nagle's cups are compelling sculptures that occupy an important place in the advancement of ceramics as a fine art since the early 1960s. He invigorates this traditional ceramic form through a dazzling technical virtuosity and use of color. "It is the potential for intimacy inherent to the small object," he once said, "and the ability of color to convey emotion that motivate me."

Nagle's work has always been based on the prescribed cup form. Typically no taller than five or six inches (on occasion reaching thirty inches), the cups are sometimes easily identifiable as such, with clearly delineated containers and usable handles. At other times they barely resemble anything utilitarian. In *Barbra of Hungary* (2001), the red, purple, and black handle protrudes like an ear from the smooth, multicolored container. The handle is clearly functional, but the bowl of the container is reduced to a narrow opening. In *Zoot* (2001), utility is further challenged. What would be the handle is no more than a short, thin, pointed yellow protrusion that seems likely to break if grasped and incapable of supporting the weight of the piece. Nagle has created various handle designs that intentionally undermine their function. Handles, sometimes with phallic or vaginal forms, or even rodent tails, invite or repel a desire to touch them.

Nagle has honed a command of color and worked with techniques of casting on a small scale. Early in his career, he moved from using the traditional pottery wheel to hand-building and slip-casting his clay pieces, and simultaneously developed a unique multiple-glazing technique. Nagle typically applies twenty to thirty layers of low-fire glazes to each piece. He often overglazes with layers of finely applied china paint or airbrushes color in a technique adapted from custom car painting. *Hollowwinnner* (2001) and *Garth's Girth* (2000) have his characteristic smooth, shiny surfaces and saturated colors such as red, yellow, purple, and black.

In the 1970s, inspired by the architecture and design of the 1950s, Nagle began to replicate the bumpy surfaces of stucco exteriors common to houses of the period, and often mimicked the pinks and turquoises of their decor. Nagle continues to use this stuccolike texture in many of his sculptures and has further developed a keen understanding of the emotional and associative qualities of color. In works such as *Trick Tracy* (1998) and *Blue Sabu Too Two* (1999), the orange highlights on the edges of otherwise saturated blue and mint green surfaces make the rough surfaces appear deeply translucent and glowing. The alluring colors offer a counterpoint to the uninviting texture.

RON NAGLE (B. 1939, SAN FRANCISCO) WAS INTRODUCED TO CERAMICS BY A CHILDHOOD FRIEND AND IMMEDIATELY BECAME ENAMORED WITH THE MEDIUM. WHILE STUDYING AT SAN FRANCISCO STATE COLLEGE (BA, 1961), HE TOOK A SUMMER CERAMICS COURSE AT THE CALIFORNIA SCHOOL OF FINE ARTS (NOW THE SAN FRANCISCO ART INSTITUTE), WHERE HE WAS EXPOSED TO THE WORK OF CERAMIC ARTISTS PETER VOULKOS, JIM MELCHERT, KENNETH PRICE, AND MICHAEL FRIMKISS. IN THE EARLY 1960s, NAGLE DEVELOPED A PARALLEL CAREER AS A MUSICIAN AND SONG-WRITER. AMONG THE AWARDS HE HAS RECEIVED ARE THREE FELLOWSHIPS FROM THE NATIONAL ENDOWMENT FOR THE ARTS (1974, 1979, 1986), TWO ANDREW W. MELLON FOUNDATION GRANTS (1981, 1983), AND A VISUAL ARTIST AWARD FROM THE FLINTRIDGE FOUNDATION (1998). NAGLE HAS TAUGHT AT MILLS COLLEGE IN OAKLAND, CALIFORNIA, SINCE 1978 AND LIVES IN SAN FRANCISCO.

The early and ongoing influence of Japanese Momoyama pottery is often evident in Nagle's choice of colors and in the deliberate thick drips of glaze derived from Japanese tea bowls on pieces such as *Knucklehead, Jr.* (2000). Nagle controls how a work is seen by the viewer and, in some instances, creates presentation boxes, much like those of Japanese tea ceremonies. He has always understood that negative space, as much as the form itself, influences the way a sculpture is perceived, especially on the diminutive scale of his cups, and he therefore strives for a brilliant graphic profile.

In the late 1950s, and again in the 1990s, Nagle added decals to the sides of his cups. Some are commercial decals; others are derived from drawings. The decal on *Untitled (Skunk Cup in Box)* (1996) depicts the tail of a skunk poking out from a picnic basket that it has invaded. A series of cups created with painter Hung Liu in the early 1990s has decals with Chinese-language characters, his daughter's youthful drawings of UFOs, and images of a pair of hands creating shadow puppets on a wall.

A multiplicity of influences have come together with Nagle's innovative techniques and sense of color into a signature style aptly described by Sylvia Brown in 1978: "The turquoise of swimming pools, the salmon glow of sunsets, waxed enamel surfboards, candy-apple custom cars, stucco walls and sun-ripened oranges are all reflected in the lush glazes of these small sculptures. Through Nagle's sophisticated humor, the 50s pink-and-black décor of naugahyde and speckled linoleum co-exists with the 50s splattered drip paintings of the Abstract Expressionists; the thick, creamy glazes of Japanese ceramics seem to come in thirty-one flavours, and the structures of moderne architecture can be held in the palm of your hand."

SELECTED READING

BERKSON, BILL. "NAGLE WARES." *AMERICAN CRAFT* 57, NO. 4 (AUGUST/SEPTEMBER 1997): 37–41.

RON NAGLE: A SURVEY EXHIBITION 1958–1993. WITH ESSAY BY MICHAEL MCTWIGAN. OAKLAND, CALIF.: MILLS COLLEGE ART GALLERY, 1993.

MOSER, CHARLOTTE. "RON NAGLE: RECENT WORK." *CERAMICS MONTHLY* 42, NO. 6 (JUNE/JULY/AUGUST 1994): 41–47.

RON NAGLE: 1978 ADALINE KENT AWARD EXHIBITION. WITH TEXT BY SYLVIA BROWN. SAN FRANCISCO: SAN FRANCISCO ART INSTITUTE, 1978.

TROMBLE, MEREDITH. "A CONVERSATION WITH RON NAGLE, ART DEPARTMENT CHAIR, MILLS COLLEGE." *ARTWEEK* 27, NO. 3 (MARCH 1996): 15–16.

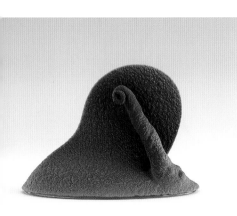

Blue Sabu Too Two, 1999
EARTHENWARE AND OVERGLAZE;
4" X 5³/₄" X 2¹/₂"

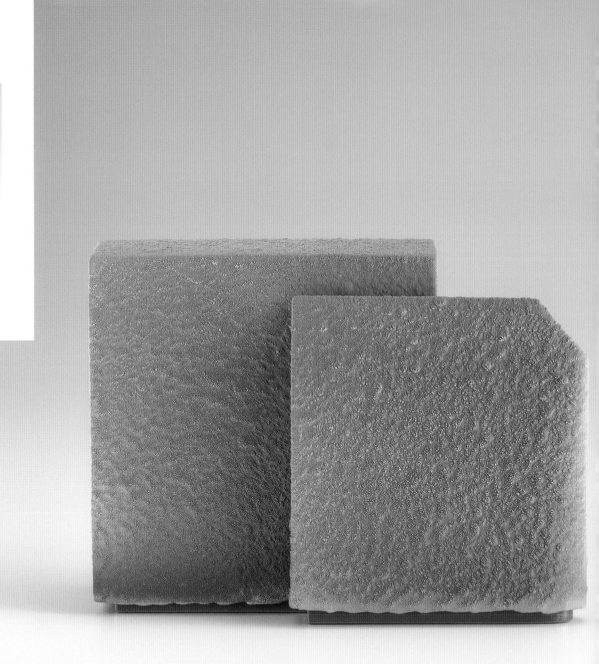

Lobster Boy, 1999
EARTHENWARE AND OVERGLAZE;
3⁵/8" X 4¹/4" X 2¹/8"

Trick Tracy, 1998
EARTHENWARE AND OVERGLAZE; 3³/4" X 5¹/2" X 2³/4"

Remarkable Mark, 2000
EARTHENWARE AND OVERGLAZE;
4³/4" X 5⁵/8" X 4¹/8"

Garth's Girth, 2000
EARTHENWARE AND OVERGLAZE; 5$^{1}/_{8}$" X 3$^{1}/_{8}$" X 2$^{1}/_{4}$"

Hollowwinner, 2001
EARTHENWARE AND OVERGLAZE; 4$^{7}/_{8}$" X 5" X 4$^{1}/_{4}$"

Barbra of Hungary, 2001
EARTHENWARE AND OVERGLAZE;
5 1/4" X 5 3/8" X 3 3/4"

DEBORAH
OROPALLO

Deborah Oropallo's paintings explore everyday, familiar objects and their meanings. Her layering of paint, silkscreen images, and collaged prints represents the accretion of visual and intellectual information. An exquisite technical virtuosity, strong rendering abilities, and a skillful use of paint and color have earned Oropallo high regard; she pushes the formal limits of what a painter can be, making paint a powerful vehicle for expression.

Oropallo does not paint objects merely to represent them. Her works explore the balance between representation and abstraction. As critic Jeff Kelley describes, she seeks "a kind of magical middle distance, an imaginative horizon, where things become images, where objects slip into subjects and paintings flatten into visual fields." She imbues these objects with meaning, both personal and social, and touches on themes such as home and domesticity, the passage of time, and an appreciation of the mundane things in life. Her selection of commonplace items suggests how many things in our lives are overlooked or taken for granted.

Oropallo creates physical layers in her art. Images of objects are silkscreened directly onto the canvases, and then reworked with painting and wiping, and finally the surfaces are varnished. In *Fencing* (1999), Oropallo silkscreens images of used automobile tires onto a 108-by-76-inch canvas. Over this she layers a grid of yellow mesh, which creates a visual barrier between the viewer and the discarded tires. Another barrier is created by the blue pine-tree air fresheners silkscreened in a scattered fashion across the canvas. Formally, the tires, mesh, and Christmas tree deodorizers each define a spatial plane within the painting, although, typical of Oropallo's work, the overall effect is of flattened, compressed space.

The sheer size and scale of Oropallo's work and her monumentalization and repetition of simple, common objects are important strategies. Images repeated on a canvas create a visual rhythm, a push and pull between horizontal and vertical elements, positive and negative space, and representation and abstraction. *BBQ with Lawn Chair* (1999), a geometric pattern of red, yellow, blue, and green stripes, is derived from objects of suburban life—the patterns found in a barbecue grill and plastic lawn chairs. Blown up in scale and repeated in an overlapping pattern, these ordinary backyard accessories become a strikingly elegant formal composition.

DEBORAH OROPALLO (B. 1954, HACKENSACK, NEW JERSEY) STUDIED AT ALFRED UNIVERSITY IN ALFRED, NEW YORK (BA, 1979), THEN MOVED TO THE BAY AREA FOR GRADUATE STUDY AT THE UNIVERSITY OF CALIFORNIA AT BERKELEY (MA, 1982; MFA, 1983). AMONG HER AWARDS IS A FELLOWSHIP FROM THE NATIONAL ENDOWMENT FOR THE ARTS (1991). SHE HAS TAUGHT AT SEVERAL BAY AREA ART SCHOOLS, INCLUDING THE SAN FRANCISCO ART INSTITUTE AND THE SAN FRANCISCO ART ACADEMY COLLEGE. OROPALLO LIVES AND WORKS IN BERKELEY.

Unleashed (1999) is an arrangement of various-sized coils of rope rendered in overlapping circles, to create an undulating rhythm across the canvas. Scattered among the red-and-white- and yellow-and-white-striped rope are small black-and-white images of dogs. Her title refers literally to the unleashed dogs but also conjures the idea of unleashed fury or wrath. Oropallo suggests a state of tenuous or limited freedom—the dogs seem liberated but are still confined and trapped by the rope coils.

In work since 2000, Oropallo uses digital photographs of drums, pipes, and other industrial materials, manipulates the photographs, and then creates large Iris prints. She affixes these in pieces to a canvas, over which she silkscreens images of daisies, lace, or doilies, domestic items that contrast with the potentially dangerous industrial materials. In *Stretch* (2000), stacked blue hazardous-waste containers are encased in stretched plastic wrapping. The close-up, monumental depiction of the drums fills the 94-by-76-inch canvas, the containers' latent hazard lurking as a danger that cannot be ignored. The tight plastic wrapping is a deceptive safeguard, for there are gaps where the plastic has been pulled away and hangs slackly without purpose. Oropallo's formal techniques mirror the way she intends her paintings to be understood—intellectual, physical, and visual layers to be taken in slowly and questioned.

SELECTED READING

BAKER, KENNETH. "NATIONAL REVIEWS: DEBORAH OROPALLO, STEPHEN WIRTZ." *ARTNEWS* 100, NO. 3 (MARCH 2001): 161.

FALKENBERG, MERRILL, AND JEFF KELLEY. *HOW TO: THE ART OF DEBORAH OROPALLO.* SAN JOSE, CALIF.: SAN JOSE MUSEUM OF ART, 2001.

HAMLIN, JESSE. "OROPALLO FINDS PLAYFULNESS, DANGER IN FACTORY IMAGES." *SAN FRANCISCO CHRONICLE,* 31 JANUARY 2001, SEC. D, PP. 1, 8.

OROPALLO, DEBORAH. *DEBORAH OROPALLO.* WITH TEXT BY BILL BERKSON AND MARIA PORGES. SAN FRANCISCO: STEPHEN WIRTZ GALLERY, 1993.

OROPALLO, DEBORAH. *DEBORAH OROPALLO: FLAT PICTURES.* WITH TEXT BY DONALD KUSPIT. SAN FRANCISCO: STEPHEN WIRTZ GALLERY, 1997.

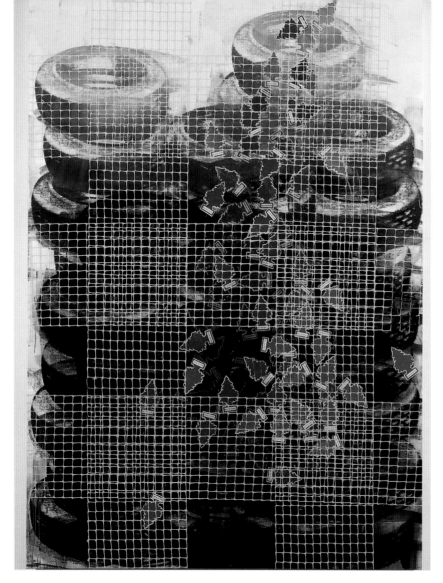

Fencing, 1998
OIL ON CANVAS; 108" X 76"

BBQ with Lawn Chair, 1999
OIL ON CANVAS; 30" X 27"

Unleashed, 1999
OIL ON CANVAS; 100" X 76"

Stretch, 2000
IRIS PRINT, OIL ON CANVAS; 94" X 76"

Pink Noise, 2001
IRIS PRINT, OIL ON CANVAS; 68" X 47"

GAY
OUTLAW

The movement in Gay Outlaw's s c u l p t u r e e x i s t s as one idea

shifting to another. It may be a startling realization about materials as in *Dark Matter Redux* (1998), a snaking wall of fruitcakes, whose individual variations in color and texture create an illusion of stone blocks. The wall, forty inches high, twenty-four inches wide, and thirty-four feet long, emerges from a trench in a field at the Djerassi Foundation near Woodside, California, in the Santa Cruz Mountains and is highly reminiscent of the rock walls that have been built for hundreds of years.

Movement or a shift between two different states is also produced through optical illusions, as with the organic flowing waves and flat industrial patterns that alternately emerge when the different sides of *Black Hose Mountain* (1998) are experienced. This imposing floor sculpture, ten feet wide, fifteen feet high, and ten feet deep, is composed of sections of black rubber hose whose ends are filled with white plaster. When the piece is viewed from one side, a flattening occurs through the optical illusion and visual vibration created by the field of white dots within the black mass. As viewers move around the piece, the graphic contrast between black and white is replaced by the gentle upward movement of dozens, possibly hundreds, of short pieces of black rubber hose, all of which have been diagonally cut on their ends and obsessively lined and stacked in a single direction. Outlaw has said, "part of what drives my art making is a desire to articulate form in an exquisite language."

Outlaw's sculpture emits a considered and thoughtful presence. An initial impression of simplicity in a work is transformed by the discovery of many artistic strategies. Exploration of her sculpture moves beyond the materials, mass, and physical muscularity of a work to its unanticipated optical effects and spatial illusions. The illusion of flattened space produced through one-point perspective is frequently translated into physical materials, such as clusters of white-painted dowels set at an angle in a blue background, which create the impression of an ephemeral scattering of clouds in *Expanded Cloud Study (for Arthur)* (2001).

Impermanence is inherent in her choice of other sculptural materials, such as caramelized sugar, which changes shape over time in response to the effects of humidity, temperature, and gravity. Outlaw's sculptures are not edible culinary creations, although they bring to mind the purpose of food for sustenance and pleasure and have a temporality intrinsic to the biological cycle of life and decay, which may even provide some surprises. *Tinned Wall/Dark Matter* (1995–97), commissioned for the exterior plaza at the Center for the Arts in Yerba Buena Gardens, in San Francisco, was a wall of seven hundred baked fruitcakes. The structural core of the fruitcakes, which could be seen only at the open ends of a serpentine aluminum shell, was so perfectly preserved that when the work was disassembled after two years, she could remake it, minus the aluminum shell, as *Dark Matter Redux*.

Since the mid-1990s, the vocabulary and materials of architecture have been frequently explored by Outlaw, such as in a series of caramel sculptures from 1998, each individually small enough to fit on top of a sculpture pedestal, made from one-half-inch-thick caramel planks. A single plank on edge forms a spine, with the remaining planks shaped and interlocked with it at a ninety-degree angle to make the shapes suggested in titles such as *Caramel Model #3 (Dinghy)* or *Caramel Model #2 (Cathedral)*. The caramel sparkles with a warm, jewel-like translucency inviting touch. Outlaw reverses the scaling down of these models in *Honeycomber* (1999), a floor piece that is eight inches high, seventy-two inches wide, and ninety-eight inches long. A series of short caramel planks, curved on top, on edge, and interlocked, crisscross approximately every twelve inches, forming a large grid. There is a Zen-like peacefulness in the warm, yellowish wave shapes. Still, these sculptures are subordinate to the impermanence of the material, which looks to be on the verge of becoming liquid—a reminder of the inescapable temporality of all things.

SELECTED READING

HUNT, DAVID. "GAY OUTLAW AT REFUSALON." *SCULPTURE* 17, NO. 6 (JULY–AUGUST 1998): 66–67.

KLAUSNER, BETTY. "GAY OUTLAW AT REFUSALON." *ART IN AMERICA* 86, NO. 7 (JULY 1998):103–4.

LOMBINO, MARY-KAY. *GAY OUTLAW—CENTRIC 61.* LONG BEACH: UNIVERSITY ART MUSEUM, CALIFORNIA STATE UNIVERSITY, 2001.

PAGEL, DAVID. "EVERYDAY OBJECTS, CONCISELY." *LOS ANGELES TIMES,* 5 DECEMBER 2001, SEC. F, P. 2.

SCHUMACHER, DONNA LEIGH. "GAY OUTLAW, PUBLIC SCULPTURE AT CENTER FOR THE ARTS THEATER PLAZA, SAN FRANCISCO." *ART PAPERS* 20, NO. 6 (NOVEMBER–DECEMBER 1996): 44.

VAN PROYEN, MARK. "SAN FRANCISCO: E-MAIL." *ART ISSUES,* NO. 57 (MARCH–APRIL 1999): 32–33.

GAY OUTLAW (B. 1959, MOBILE, ALABAMA) HAS NEVER USED HER FULL BIRTH NAME, MARY GAYE OUTLAW (THE E WAS DROPPED EARLY). SHE STUDIED FRENCH AT THE UNIVERSITY OF VIRGINIA, CHARLOTTESVILLE (BA, 1981), TRAINED IN FRENCH PASTRY AND CUISINE AT THE ÉCOLE DE CUISINE LA VARENNE IN PARIS (1981–82), AND ATTENDED THE GENERAL STUDIES PROGRAM AT THE INTERNATIONAL CENTER OF PHOTOGRAPHY, NEW YORK CITY (1987–88). IN 1988 SHE RELOCATED TO SAN FRANCISCO, WHERE SHE STILL LIVES. IN 1998, SHE RECEIVED AN AWARD FROM THE SOCIETY FOR ENCOURAGEMENT OF CONTEMPORARY ART, AN AUXILIARY OF THE SAN FRANCISCO MUSEUM OF MODERN ART.

Other small works pack materials into a dense mass and play with perception. Outlaw glued together chalk sticks, then sanded and shaped the mass into a hemisphere for *Chalk Hill* (1997), a floor piece approximately twelve inches in diameter. An overall pattern created by the addition of dots or ovals to the center of each exposed stick produces illusions of flattened perspective or depth as viewers circle the work. Outlaw has also shaped masses of pencils into sculptures of balls, oblong nests, and a wavy rug. Lively animations of color or form are created when the masses of identical units are shaped or sanded in a particular way, and the cores of the pencils are exposed. Outlaw has similarly made a series of perforated cubes, differing in material and scale, which refer to Op Art—and Swiss cheese. The most successful of these is perforated with so many drilled holes that negative space and material are equally balanced.

Outlaw's sculptures exemplify her strong affinities for craft and process, whether she is baking fruitcake blocks or assembling hundreds of pencils. Whimsy and surprise enliven the interplay of line, mass, and color in her tight packing and repetition of materials. Outlaw's sculpture interprets time as both compressed and expansive. Does the sculpture belong to a particular moment and shape or to an undefined period of time that ends when it has been reduced to a puddle? It is this disruption—and suspension—of expectations that imbues her work with playful, elusive intrigue.

Dark Matter Redux, 1998
FRUITCAKE, TRENCH;
40" X 24" X 408"

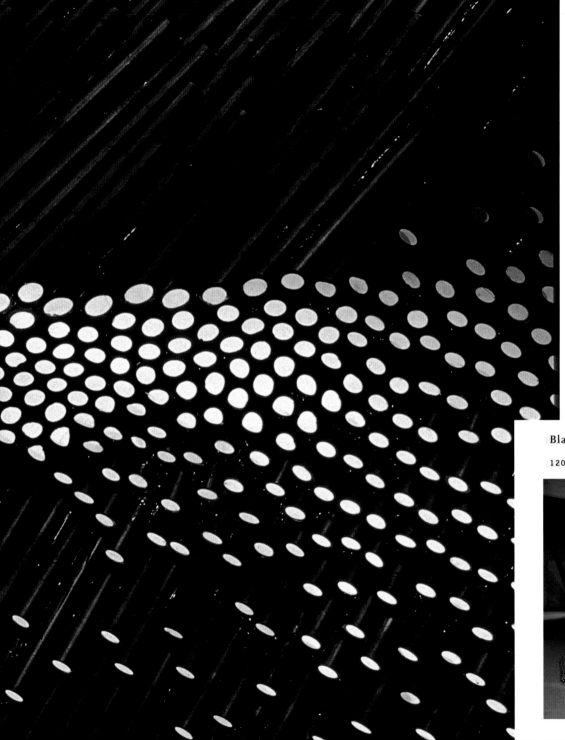

[detail]

Black Hose Mountain, 1998
RUBBER HOSE, PLASTER, SILICONE;
120" X 180" X 120"

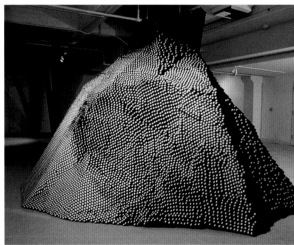

IRÈNE PIJOAN

Describing the motivation for her artistic direction, Irène Pijoan has stated, "We go on the assumption that if we do what's truthful to us, we'll succeed in touching others." Although she avoids a signature style and is comfortable working in a range of media, including painting, sculpture, installation, and works on paper, a common thread in her work is an exploration of physical correlatives of personal experiences. Pijoan may draw on literary references or philosophical theories, but the primary focus of her art is close examination of moment-to-moment experience. Her work serves as a bridge between the world and the individual and between the brain and the body. As she describes, "You have to use both your head and your heart, think and be intuitive at the same time."

Through the mid-1980s, Pijoan created narrative paintings, primarily using encaustic on wood, concrete, or plaster. She experimented with a range of styles including expressionist, neoprimitive, and trompe l'oeil approaches. She worked on small-scale pieces with figures in high relief set against abstracted landscapes and larger-scale paintings, sculpture, drawings, and installations. In the late 1980s, she began to investigate awareness and perception, and migrated solidly into a language closer to abstraction. *3 Into 3* (1991) at the Contemporary Arts Forum in Santa Barbara was an installation aimed at creating a contemplative space, much like a shrine, that allowed for an exploration of the senses. Four walls were covered with plywood that was painted and coated with encaustic, into which she scraped and incised indistinct markings. A series of small holes drilled into the plywood allowed light to pass from outside the gallery into the space. Metal sculptures were carefully positioned on the floor, one reminiscent of a leaf and another of a basket.

In cut-paper constructions from the late 1990s, Pijoan focuses on the activity of seeing, employing an exquisite use of color, radiant surfaces, and intricate cutout shapes and words. Using cutouts allows her to juxtapose the two- and three-dimensional and to create relationships between the form of the artwork and its surrounding space. She begins with gouache sketches on paper of various images, from swirls and amorphous shapes to a thumbprint, DNA strands, columns, and stairwells. Over selected images, Pijoan inscribes text from her introspective poems and writings. She then cuts away spaces around the words, while retaining the overall shape of the original sketched image, and then applies acrylic paint. These tactile works appear as intertwining ribbonlike patterns containing word fragments and numbers. By intention, they are not entirely readable and seem more like transparent, permeable mesh. A viewer has the sense that the words relate to something specific, but with closer investigation, sees that the works are more about the very process of looking. Pijoan hangs the works several inches from the wall, creating an interplay between the paper and its shadow to evoke an additional sense of transparency. She has painted the backside of the paper, which creates a reflection of color on the wall.

IRÈNE PIJOAN (B. 1953, LAUSANNE, SWITZERLAND) WAS BORN TO A SWISS MOTHER AND A CATALAN FATHER, AN ART HISTORIAN FROM WHOM SHE INHERITED HER LOVE OF ART. ON A JOURNEY IN MOROCCO AT AGE EIGHTEEN, PIJOAN MET A FRIEND FROM SACRAMENTO WHO INFLUENCED HER DECISION TO COME TO THE UNITED STATES IN 1974 TO ATTEND ART SCHOOL. PIJOAN ENROLLED AT THE AMERICAN RIVER COLLEGE, SACRAMENTO, AND THEN STUDIED AT CALIFORNIA STATE UNIVERSITY, SACRAMENTO, BEFORE ATTENDING THE UNIVERSITY OF CALIFORNIA, DAVIS (BA, 1978; MFA, 1980). PIJOAN HAS BEEN AN ARTIST IN RESIDENCE AT THE UNIVERSITY OF GEORGIA, ATHENS (1980–81), AND THE ROSWELL MUSEUM AND ART CENTER, NEW MEXICO (1981–82). HER AWARDS INCLUDE A FELLOWSHIP FROM THE NATIONAL ENDOWMENT FOR THE ARTS (1982) AND A GRANT FROM ART MATTERS IN NEW YORK (1996). SINCE 1983, SHE HAS TAUGHT AT THE SAN FRANCISCO ART INSTITUTE. SHE LIVES IN BERKELEY.

Address (1998) is a cutout that was displayed in an exhibition dedicated to the memory of her mother. Pijoan's words and numbers are devoted to her mother's life. Painted in red and pink, they chronicle specific names, events, and dates from her life, and are juxtaposed with pale green, blue, and gray words that reference parallel world events. As critic Maria Porges describes, Pijoan "simultaneously suggests the richness of a lifetime's experience and the impossibility of ever perceiving the true nature or meaning of that experience."

Wannabe (2000), a room-sized mixed-media installation at the San Jose Institute of Contemporary Art, combined a number of cut-paper works. Taking advantage of every surface—walls, floor, and ceiling—Pijoan played with two- and three-dimensional forms in a highly organic, visual game. On the gallery surfaces, she painted large, playful areas of color, arrows, and ribbonlike swirls that are misleading navigational devices through the space. Suspended from the walls and ceilings were six cut-paper works with words hidden among the weblike patterns that spilled onto the floor into an indecipherable puddle, as if too full to be contained. In one corner, a cascading curtain of white cutout paper, resembling a heavy net, was peeled back to reveal saturated blue paint on its backside and on the wall behind. In some areas of the gallery, blocks of painted color seemed to become a flat extension of the cut paper; in other areas, the color appeared as a shadow.

Experienced without accompanying text, *Wannabe* is about the act of seeing and the physical process of discovery. With the guidance of the exhibition catalogue—which provides the viewer with substantial portions of the original texts that are the basis of the cut-paper works—*Wannabe* is revealed as an exploration of a personal inner conflict—the ambition and desire for success and recognition tugging at the artist's unyielding commitment to her art. Each of the six cutout constructions contains poetry composed by the artist as an act of catharsis. The poems are rendered visually unnavigable in the artwork as a cohesive writing; a viewer can pick out words or short phrases, but any attempt to follow the text is thwarted. The text in the white, curtainlike cutout delves into the anguish of the conflict, with phrases such as "None must see this, verso of the middle class mantra" and "walk around, smile to all, and well-guarded against the nemesis of this rancor!" Another cutout, based on the form of an ancient ziggurat turned upside down, has text that confesses anger and frustration with art collectors. A teardrop-shaped construction sprawling across the floor is filled with the repeated words, "please, but just PLEASE but please . . ." The six cutouts create a visual embodiment of the artist's conflicted, highly personal experience and allow a viewer to feel the dilemmas of ambition.

SELECTED READING

IRÈNE PIJOAN. SAN FRANCISCO: RENA BRANSTEN GALLERY, 1990.

KIMBALL, CATHY. *IRÈNE PIJOAN: NON-SPACE ELEMENTS.* SAN JOSE, CALIF.: SAN JOSE INSTITUTE OF CONTEMPORARY ART, 2001.

PORGES, MARIA. "IRÈNE PIJOAN AT RENA BRANSTEN." *ART IN AMERICA* 86, NO. 9 (SEPTEMBER 1998): 136.

TROMBLE, MEREDITH. "A CONVERSATION WITH IRÈNE PIJOAN, ARTIST." *ARTWEEK* 27, NO. 9 (SEPTEMBER 1996): 15–16.

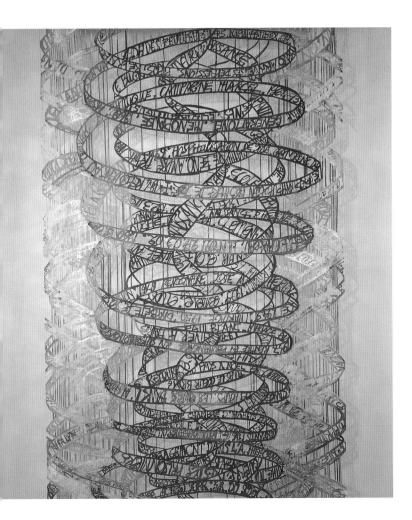

Address, 1998
ACRYLIC ON CUTOUT PAPER;
130" X 80"

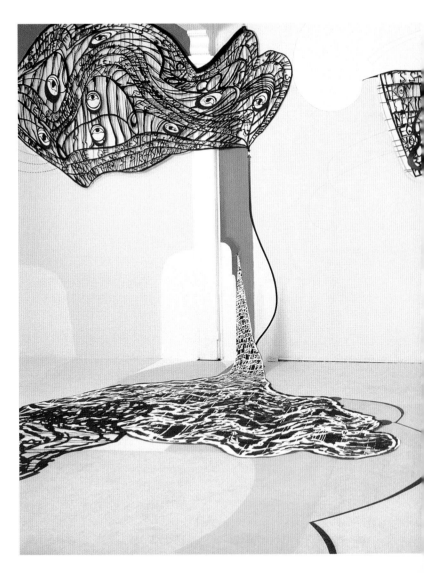

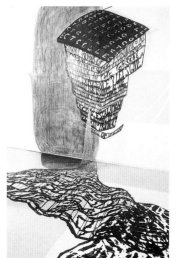

[details of cut-paper works]

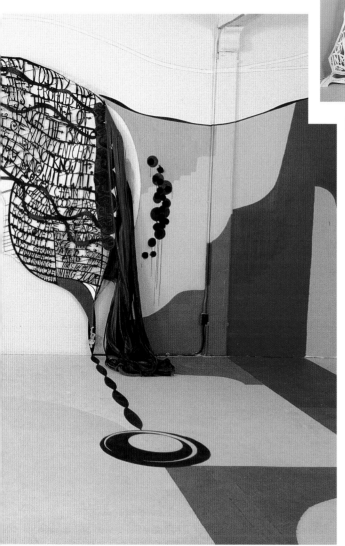

Wannabe, 2000
[installation view]

LUCY PULS

Carefully selecting consumer items that have specific significance in American society, Lucy Puls deploys formal and conceptual strategies to force a reconsideration of them. In her sculptures, she chooses commonplace objects that have been eclipsed in the mercurial, rapidly changing universe of popular taste, and repositions these objects both physically and conceptually. The physical forms (tactility, weight, volume, appearance) of the sculptures contrast or complement the conceptual framework of her pieces, which she conceives with studied care and a liberal dose of wit. Puls works with various materials and forms to create a rhythmic interrogation of concept, process, and object.

Words, books, and the power of knowledge they represent figure prominently in Puls's sculptures. Just as words are the units of Western literature and tradition, Puls deploys them as the building blocks that constitute much of her sculpture. A deference to words is evident in her titles, which about 1990 were Latin phrases followed by rough English translations in parentheses. Around 1994, she shifted the titling to approximate the work's content (consumer items that serve as the basis for the work), and the Latin and English now complement each other. Puls cobbles together the Latin from several dictionaries, forming phrases that intentionally appear naïve and relishing how the approximate and inconclusive meaning can influence viewers' perceptions of the works. As curator Marcia Tanner has observed, ". . . Puls's deadpan use of Latin—the elevated, 'universal' language of scholarship, scientific classification, and the Catholic Church—adds yet another layer of parody and subversion to her project."

Puls has used books in her work since about 1990 for their corporeal presence as general containers (objects) of knowledge and as specific references through the preservation of titles or use of book pages. In the early 1990s, Puls also encased objects such as shoes, toys, doll parts, or stuffed animals in resin blocks or cubes. She found these and other items at thrift stores, but selected only those objects that had almost become valueless, preferring items due to be thrown out. Her interest lies in the meaning (and implied worth) of each object and its significance in modern American culture.

These sculptures are composed of multiple blocks and are arranged or stacked in different combinations. They are displayed on stands, directly on the floor, or on shelves. Puls reconstitutes these items, casting them into a new reality through "repackaging" them in resin blocks, and alluding to retail displays in their exhibition arrangements. The distinguishing details of the objects are frequently subdued in the murky, yellowish or reddish resin blocks, and Puls sands some surfaces to further obscure parts of the immersed items. About 1997, she subsequently casts concrete around the stuffed animals, erasing any vestiges of their precious or cuddly aspects (a quality that is still evoked in the earlier resin pieces, when the head of a button-eyed

teddy is close to the surface of a translucent block). Their dearness is frozen and obscured when set into this common building material, and any associative nostalgia is even more removed than in the resin pieces. The block form, industrial material, repetition, and systematic organization refer to the cool, formal strategies of minimalist sculpture of the 1960s and 1970s, which Puls subverts by placing soft fabric toys and consumer items at their centers; in addition, her fascination and application of language draws on strategies of conceptual art.

The impact and timbre of the cast resin (1999/2000) pieces is heightened in Puls's solo exhibition *White Elephant* (2000) at Stephen Wirtz Gallery in San Francisco. Household appliances such as coffeemakers or toasters are encased in amber resin blocks, and arranged on carpentry tables and the floor as if part of a yard sale. These are discards from a past of fifteen to twenty-five years ago—and also a more recent past, such as compact disks, computer file disks, and computer parts from the last several years. Her earlier works with toys recover and preserve the past, while these resin works preserve a past that is peripheral to the present, ice blocks from a glacier of the modern age.

LUCY PULS (B. 1955, MILWAUKEE, WISC.) ATTENDED THE UNIVERSITY OF WISCONSIN, MADISON (BS, 1977) AND PURSUED GRADUATE STUDIES AT TYLER SCHOOL OF ART, TEMPLE UNIVERSITY, IN PHILADELPHIA (1977–78) AND THE RHODE ISLAND SCHOOL OF DESIGN (RISD) IN PROVIDENCE (MFA, 1980). SHE TAUGHT AT RISD (1980–82) AND AT WESTERN CAROLINA UNIVERSITY IN CULLOWHEE, NORTH CAROLINA (1982–85). SINCE 1985 PULS HAS BEEN ON THE ART DEPARTMENT FACULTY AT THE UNIVERSITY OF CALIFORNIA IN DAVIS. SHE LIVES IN BERKELEY.

The implied meaning of objects is even more layered in works begun in 2001, which contain digital prints that are reproduced the exact same size as the original object and are indistinguishable from the originals—particularly when either is encased in resin. *Multipliciter coniunctio (45 rpm's)* (2001), consisting of sixteen life-size digitally scanned prints of 45 rpm records, are separated equally along two stacked forty-eight-inch-long shelves. The record companies (Atlantic, ATCO, Warner Bros. Records, Columbia, Dial), song titles and groups ("Good Vibrations" by The Beach Boys, "You've Got a Friend" by James Taylor, "My World" by The Rascals, "Can't Get You Out of My Mind" by Paul Anka) represent the cultural and social currency of teenagers in the late 1960s. "In many ways connecting" is an approximate translation of *multipliciter coniunctio,* and within the work exists the potential multiplicity inherent with digitized information, and the reminder that these are now collectible items with a different social and cultural currency. The apparent formality and restraint in Puls's sculpture belies the evocative and emotional individuality of the original objects. Their place in society at-large may have eroded, but they are elevated anew to a new and different place of value as art.

SELECTED READING

DUNYE, CHERYL; LINDA GOOD BRYANT, AND MARCIA TANNER. *BAD GIRLS.* NEW YORK: NEW MUSEUM OF CONTEMPORARY ART, 1994.

KELLEY, JEFF, AND REESEY SHAW. *WILDLIFE.* ESCONDIDO: CALIFORNIA CENTER OF THE ARTS, 1994.

LUCY PULS. ESSAYS BY JEFF KELLEY AND MARCIA TANNER. SAN FRANCISCO: STEPHEN WIRTZ GALLERY, 1995.

SULTAN, TERRY. *THE PERVASIVENESS OF MEMORY.* WASHINGTON, D.C.: CORCORAN GALLERY OF ART, 1995.

TSUJIMOTO, KAREN. *IMAGES TRANSFORMED.* OAKLAND: OAKLAND MUSEUM OF CALIFORNIA, 1992.

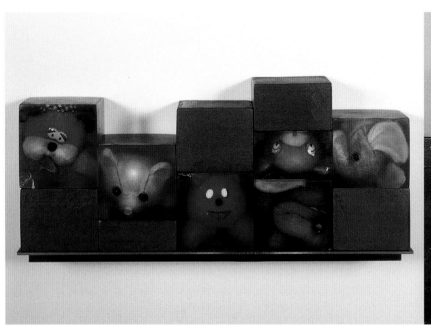

Brown Doggy, Blue Teddy, and Friends, 1997
CEMENT, STUFFED ANIMALS;
18" X 30" X 12" (19" X 12" X 12" EACH)

Sex Bestiolae et Quinque Massae
(Six Animals and Five Blocks), 1994
RESIN, WOOD, STEEL, FABRIC TOYS; 9" X 19½" X 4"

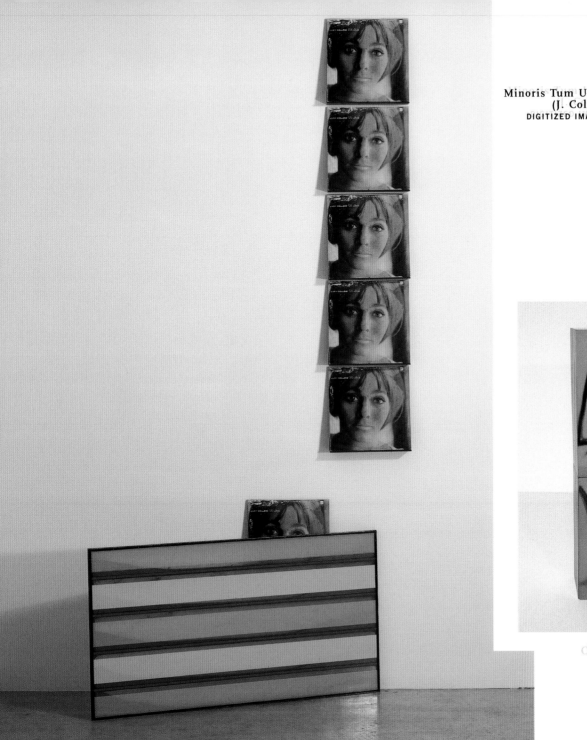

**Minoris Tum Unum Punctum Temporis
(J. Collins), 2001**
DIGITIZED IMAGES WITH MIXED MEDIA; 100" X 49" X 14¹/₂"

Coquere Duo (Edison/Coffematic), 1999
ELECTRIC PERCOLATORS, RESIN;
32³/₈" X 8³/₄" X 5"

Automatus (Fast Cars), 1999
POLYESTER RESIN, TOY CARS;
14" X 8¹/₂" X 4¹/₄"

Multipliciter Coniunctio (45 rpm's), 2001
DIGITIZED IMAGES WITH MIXED MEDIA; 18$^{1}/_{2}$" X 48" X 1$^{1}/_{2}$"

ALAN RATH

Alan Rath is an inventor who builds the components of his technological sculpture, from circuit boards and memory chips to the housing and final framework. He shoots his own video, digitizes it, creates the software, and constructs the electrical circuits. His sculpture is filled with electronic components—CRTs (cathode-ray tubes), LCDs (liquid crystal displays), and LEDs (light-emitting diodes)—and incorporates industrial materials such as metal rods or aluminum panels. He occasionally uses found objects such as boxes, crates, and suitcases to house electronic components, along with other commercially produced items that can conceptually support the piece. Every sculpture displays or broadcasts a message, either visually or through sound. The works reflect the directions of technology, question its usefulness to humans, and inherently demonstrate the human desire to exploit technology. "You know, the Mars Lander is a beautiful piece of sculpture," Rath says. "The people who built it identified with it, so it has a lot of soul. I want power from art on that level of commitment and mastery."

Rath anthropomorphizes technology by having it mirror the human body and mimic human behavior. Images of tongues, chattering mouths, and waving hands appear on CRTs. The wires, tubes, and gangly metal armatures of the pieces are reminders of veins or nerves, internal organs, and limbs. Audio speakers provide a beat that mimics heart rhythms or audible breathing, in addition to generating other types of audio. Rath predominantly uses images of eyes or hands on the CRTs, animating them to invoke sensory/receptive modes of communication—sight, taste, touch, sound—as well as forms of expressive/active ones such as speech or sign language.

The oversize anatomical features on the CRTs of eyeballs or mouths direct viewers to interpret the movements or images as attributes of human behavior or sensations. Rath shoots, sequences, and digitizes all the video images, which can comprise more than thirty thousand video frames, and the presence of particular movements is intentional. The absence of accompanying body language or context for these gestures—broadcast signals—contributes to the associations viewers make between these movements and Rath's sculpture. Rath's sculpture poses a paradox for viewers between the beautiful animation of technology and the human fear of sentient machine intelligence.

The stripped-down tech aesthetic of Rath's work is reminiscent of the 1950s science-fiction visions of robots. In *I Like To Watch* (2001) two large eyes appear on separate CRTs that swivel, extend, and retract. The eyes occasionally blink, but otherwise stare. A plastic-coated electrical cable, coiling around two vertical support bars, suggests a sheathed bundle of nerves. Combined with the oversized eyes, it gives the work an appearance of being equally inspired by stick-figure folk art and Steven Spielberg's cinematic creation of an extraterrestrial in *E.T.* When viewers trip an electric eye, the sculpture is activated, and quickly turns and moves the CRT eyes in the viewers' direction. These movements are separated by indeterminate pauses, imbuing the sculpture with an aura of intelligence. Though displaying only a modicum of human attributes, the sculpture's abrupt and unpredictable movement of the flat screen eyes is unnerving in its verisimilitude.

A sense of play and humor is present throughout Rath's sculpture, ranging from titles such as *Hound, Cyclops,* and *Bumper* to the more poetic aspirations of *Soar Eyes, Electric Asparagus,* and *Magic Mushrooms.* Some CRT images with wagging tongues and provocatively pursed lips have sensual or sexual overtones. Found objects theatrically support or expand the narrative of a work, ranging from wooden crates for housing the electronics to parts of a sculpture being connected by links of chain or handcuffs.

Rath has consistently expanded his work by capitalizing on the latest technology, as he did when LCDs and LEDs first debuted. The effects of his pieces can be quite ominous, as in *Challenger* (1991), consisting of three very large pieces—ranging in height from ninety-one by thirty-three by fifteen inches to eighty-four by forty-three by twenty-four inches to seventy-five by forty-nine by twenty-one inches—arranged in a slight arc. In the left piece, flaming spectacles of electricity periodically flash through the empty interior of a large cage of heavy metal screen. In the middle rack of electronic components, a U.S. flag hangs behind seven CRTs, matching the number of astronauts

ALAN RATH (B. 1959, OHIO) INITIALLY STUDIED PHYSICS AT THE MASSACHUSETTS INSTITUTE OF TECHNOLOGY, THEN MOVED THROUGH MIT'S VISUAL LANGUAGE WORKSHOP, ARCHITECTURE MACHINE GROUP, AND CENTER FOR ADVANCED VISUAL STUDIES. HE ULTIMATELY MAJORED IN ELECTRICAL ENGINEERING (BS, 1982). RATH MOVED TO CALIFORNIA IN 1984 AND BUILT HIS FIRST DIGITAL VIDEO SCULPTURE IN 1985. HIS AWARDS INCLUDE FELLOWSHIPS FROM THE NATIONAL ENDOWMENT FOR THE ARTS (1988) AND THE JOHN SIMON GUGGENHEIM MEMORIAL FOUNDATION (1994). HE LIVES IN OAKLAND.

who perished in the *Challenger* space shuttle explosion; the screens play differing accounts of the tragedy and of space exploration more generally. In the right piece, a giant grid of LEDs runs red digital numbers and cryptic displays of lines, punctuating the electrical flashes and CRT images with an alternately slow or frenzied sense of time. *Challenger* is about the faith in technology encouraged by the government and the media pressure on NASA's beleaguered space program that led to an unprepared launch and the disastrous spectacle on live television.

Message in a Bottle (1994) is a large glass jar, approximately twelve inches high and ten inches in diameter, which is packed with wires and a small CRT and is capped with a plate of electronics. On the CRT, the image of a signing hand spells out two phrases—"What hath God wrought," the first sentence sent telegraphically by Samuel F. B. Morse, and "Mr. Watson come here, I need you," the first sentence spoken telephonically by Alexander Graham Bell. Humans may be mediated by technology, but they are also integrally intertwined with it in Rath's sculpture, as it is a product of their own creation. For Rath, technology needs humans, just as humans also need technology. His sculpture is a reflection of its maker, and technology for him is both a description of the real and an evocation of the imaginary.

SELECTED READING

EBONY, DAVID. "ALAN RATH AT DORFMAN PROJECTS," *ART IN AMERICA* 87, NO .1 (JANUARY 1999): 98.

FRIIS-HANSEN, DANA. *ALAN RATH: BIO MECHANICS.* HOUSTON, TEX.: HOUSTON CONTEMPORARY ARTS MUSEUM, 1995.

RATH, ALAN. *ALAN RATH: PLANTS, ANIMALS, PEOPLE, MACHINES.* SANTA MONICA, CALIF.: SMART ART PRESS, 1995.

RATH, ALAN. *ALAN RATH: ROBOTICS.* WITH ESSAY BY DAVID EBONY. SANTA FE, N.M.: SITE SANTA FE; SANTA MONICA, CALIF.: SMART ART PRESS, 1999.

RATH, ALAN. *ALAN RATH: SCULPTURE.* WITH ESSAY BY DAVID M. RATH. DAVIS: UNIVERSITY OF CALIFORNIA, 1996.

RATH, ALAN. *STEREO.* SANTA MONICA, CALIF.: SMART ART PRESS, 2002.

Family, 1994
SUITCASE, HANDCUFFS, CHAIN, SPEAKERS, ELECTRONICS,
35" X 36" X 68"

Electric Eye, 1996
GLASS, ACRYLIC, ELECTRONICS, CRT 12" X 10" X 10"

The Watcher, 1998
ALUMINUM, ELECTRONICS, TWO CATHODE RAY TUBES, 24" X 42" X 13"

RIGO

Bold and oversized, Rigo's murals in San Francisco appropriate the style of traffic signage and play off the urban landscape. *Sky/Ground* (1998), on a building at the southeast corner of Third and Mission Streets in the South of Market area, is a simple yet powerful statement about the subjugation of nature by urbanization. The words *sky* and *ground* are painted within simple black-and-white arrows—graphically identical to the traffic signage for one-way streets—that point up and down respectively. Bold black-and-white stripes are painted diagonally across two sides of the low-rise building. The mural does not overtly proselytize to the viewer, but as it points at the sky and ground, it provokes consideration of the basic elements of nature that are obscured by urban development.

Rigo's art is a reminder about pertinent issues that are often overlooked in the public realm, from the plight of political prisoners to issues of cultural authenticity. He deliberately employs straightforward, uncomplicated text and a graphic simplicity that speaks to the average person. The bold colors and simple forms of his murals are developed for a specific site, to incorporate the cultural or social values communicated by the architecture. Although he accepts the given conditions of a site as unalterable parameters, chance events may deepen their meaning. Located on a corner in the redeveloped area near the Moscone Convention Center—near the San Francisco Museum of Modern Art, Yerba Buena Gardens, and the future site of the Mexican Museum and the Jewish Museum—*Sky/Ground* is being slowly obscured as an adjacent hotel is constructed, becoming itself a victim of urban growth.

The San Francisco landscape is dotted with Rigo's poignant messages. *Innercity Home* (1995), on the side of a low-income apartment building, brings aspects of city life to the attention of drivers on Highway 101. The mural is painted in the same red, white, and blue colors used on the chevron form of federal interstate highway signs, but the word *Interstate* has been swapped with *Innercity,* and the word *home* replaces what would be a highway number. The mural conceals the entire side of the building on which it is painted, further underscoring its message. Rigo's murals can also be poetically evocative, as in *One Tree* (1995). The text, which functions as title, label, and message, is contained within the graphic arrow of a one-way street sign on the side of a building at Tenth and Bryant Streets, near an on-ramp to Interstate 280. It points to a lone tree, seemingly fragile and misplaced within the concrete and asphalt environment. The oversized

RIGO (B. 1966, MADEIRA ISLAND, PORTUGAL) HAS CHANGED THE NUMERICAL SUFFIX OF HIS LAST NAME EVERY YEAR SINCE 1982. IN HIGH SCHOOL, HE AND OTHERS SIGNED THEIR NAMES TO A CONTROVERSIAL MAGAZINE USING THE FIRST TWO LETTERS OF THEIR FIRST AND LAST NAMES. THUS RICARDO GOUVEIA BECAME RIGO. HE THEN BEGAN INCLUDING THE CURRENT YEAR AS PART OF HIS NEW MONIKER.

IN 1985, RIGO CAME TO THE UNITED STATES FOR AN EXTENDED VISIT WITH COUSINS IN THE SAN JOAQUIN VALLEY OF CALIFORNIA. THE FOLLOWING YEAR, HE ENROLLED AT THE SAN FRANCISCO ART INSTITUTE (BA, 1991) AND HE LATER STUDIED AT STANFORD UNIVERSITY (MFA, 1997). RIGO'S PUBLIC COMMISSIONS INCLUDE MUSEUM PIECES FOR THE M.H. DE YOUNG MEMORIAL MUSEUM IN SAN FRANCISCO (1999), THE BANNER MURALS COMPUTER/PRISONS FOR THE BERKELEY ART MUSEUM AND PACIFIC FILM ARCHIVE AT THE UNIVERSITY OF CALIFORNIA (1999), AND LONGE/PERTO, A SERIES OF STONE MOSAICS ON A WALKWAY IN LISBON, PORTUGAL, AS PART OF EXPO '98. RIGO MAINTAINS HIS STUDIO IN SAN FRANCISCO.

message is momentarily humorous, but the humor is quickly replaced by a deep melancholy brought on by the erasure of the natural environment by unchecked urban growth.

At the San Francisco International Airport, Rigo pays homage to Balmy Alley in the city's Mission District, which is home to many muralists and houses dozens of colorful murals. Made more permanent than his painted works through use of tile, and done in a style traditional to his native Portugal, *Thinking of Balmy Alley* (2000) depicts a teenage boy, with his baseball cap turned backward, sprawled over a canvas as he begins work on a mural. Rigo uses a limited yet bold palette of black, white, yellow, red, orange, and blue, which enhances the graphic quality of the large, twenty-one-foot-by-thirty-two-foot mural.

Rigo has also created works for the gallery and museum environment. Playing off the visual language of popular advertising, he addresses issues of cultural (mis)representation in a series of works depicting the cityscape of Taiwan, such as *Wallpaper, Curtains,* *Antique Chairs, Carpet & Tiles, Sliding Doors, Blinds, Decorations* (1999). In this large bannerlike painting, he employs a simple, striking palette to create an almost clichéd, graphic representation of the fast-changing city. His title refers perhaps to the translation of shop signs in the image or to the ubiquity of commercial goods found in this or any other industrialized city. The paintings in this series each imply a loss of cultural identity, questioning the existence of authenticity in a globalized world by presenting a contrary view of generic, stereotypical city life.

Although Rigo moves fluidly between the public sphere and traditional art spaces, his work resonates most powerfully in the outdoor gallery of the street, with projects that speak to, and for, city residents.

SELECTED READING

GOLONU, BERIN. "RIGO 99: PAULE ANGLIM." FLASH ART 33, NO. 211 (MARCH/APRIL 2000): 115–16.

RUBENSTEIN, RHONDA. "THE BIG PICTURE." ID 48, NO. 1 (JANUARY/FEBRUARY 2001): 92–93.

SCHERR, APOLLINAIRE. "PUBLIC ART—WHO NEEDS IT?" EAST BAY EXPRESS 21, NO. 39, BERKELEY, CALIF. (2 JULY 1999): 8–9.

VAN PROYEN, MARK. "'MUSEUM PIECES' AT THE M.H. DE YOUNG MEMORIAL MUSEUM." ARTWEEK 31, NO. 1 (JANUARY 2000): 18.

Wallpaper, Curtains, Antique Chairs, Carpet & Tiles, Sliding Doors, Blinds, Decorations, 1999
MIXED MEDIA ON CANVAS; 108" X 80"

Innercity Home, 1995, San Francisco

One Tree, 1995
ACRYLIC ON METAL, LIVING TREE;
40" X 100"

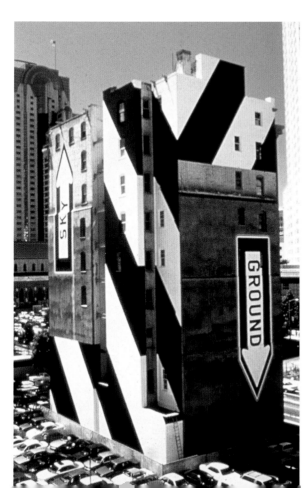

Sky/Ground, 1998
MURAL AT THIRD & MISSION STREETS,
SAN FRANCISCO

RAYMOND SAUNDERS

Over a career that spans four prolific decades, Raymond Saunders has retained improvisation, liveliness, and social relevancy in his art. He has constantly extended his painting, using collage and assemblage, working on a variety of surfaces, including doors, wallboard, paper, and canvas. He combines disciplined drawing with the spontaneity of graffiti-like text, integrates three-dimensional artifacts and objects, and binds everything together with painterly gestures. The whimsy and immediacy of his works are grounded in compelling colors and intriguing compositions.

The multifaceted dimensions in his artworks provide provocative introductions for a viewer into social and political worlds outside of art. Saunders engages strong, politically resonant issues including African American history, and broad universal themes such as racial identity and relations, war, poverty, religion, and family. His paintings include references to specific people, places, and events, and quotations from artists, both historical and contemporary.

The black background Saunders creates for many of his works enlivens his choice of bright, saturated colors. The black, not a neutral ground, binds and activates the different elements. In *Untitled* (1999), a mixed-media work made on a wooden door, colorful flowers seem to float in the spatial depth created by the black ground, from which emanates the delicate chalk line drawing of a woman. Critic Miriam Rosen has described Saunder's use of black as "at once a color, a shape, an outline, a surface, a space, a support, and an anchor."

Recognizable objects, some with personal associations and others acquired on his world travels, are incorporated into the works. In *B. Blue* (1995), Saunders builds the feeling of a child's room by including games and toys—wooden blocks, dominoes, checkers, a puzzle, pastel crayons—along with what appears to be a child's fingerpaint project, pencil drawings of trees, random scribbles, and a list of numbers. While the work may represent Saunders's personal nostalgic remembrances, it is just as likely to evoke memories of childhood for any viewer. Saunders also inserts artworks from other cultures and historical periods into his paintings, such as Hispanic *retablo* paintings on tin, reproductions of Renaissance masters, and Asian calligraphy. Positioning himself within a global artistic community, he pays homage to long artistic traditions by including these works without alteration or manipulation.

RAYMOND SAUNDERS (B. 1934, PITTSBURGH, PENNSYLVANIA) INITIALLY STUDIED ART IN AN INNOVATIVE PITTSBURGH PUBLIC SCHOOL PROGRAM THAT ALLOWED GIFTED STUDENTS TO PURSUE ADVANCED STUDY, THEN ATTENDED THE CARNEGIE INSTITUTE OF TECHNOLOGY IN 1950. FURTHER STUDIES WERE AT THE PENNSYLVANIA ACADEMY OF THE FINE ARTS (1953–57), CONCURRENT WITH THE BARNES FOUNDATION (1953–55) AND THE UNIVERSITY OF PENNSYLVANIA (1954–57). HE GRADUATED FROM THE CARNEGIE INSTITUTE OF TECHNOLOGY (BFA, 1960) AND MOVED TO THE BAY AREA FOR GRADUATE STUDY AT THE CALIFORNIA COLLEGE OF ARTS AND CRAFTS (MFA, 1961). HIS AWARDS INCLUDE A PRIX DE ROME (1964–66) AND FELLOWSHIPS FROM THE JOHN SIMON GUGGENHEIM MEMORIAL FOUNDATION (1976) AND THE NATIONAL ENDOWMENT FOR THE ARTS (1977, 1984). SAUNDERS MAINTAINS STUDIOS IN OAKLAND AND VENICE, CALIFORNIA, IN ADDITION TO PARIS, FRANCE. HE TRAVELS EXTENSIVELY THROUGHOUT THE WORLD IN BETWEEN TEACHING AT THE CALIFORNIA COLLEGE OF ARTS AND CRAFTS.

Drawings, often no more than a chalk outline, and sections of text contribute to the lively spontaneity that characterizes his pieces by providing a delicate counterbalance to bolder forms and blocks of color. Words and phrases written with a whimsical scrawl mimic urban advertising, signage, and graffiti. His texts support the objects or drawings, and ground the larger political and social issues of a work.

Beauty in Darkness (1999) has been so densely filled that it would require hours to completely absorb. On the right side, framed in tin, is a black space filled with classically rendered chalk drawings of female nudes, fragments of reproductions of Renaissance still-life painting, and bright, painted flowers. Attached to the tin frame is the large cutout image of a woman in a red dress, apron, and ruffled sleeves, who presents a collage of printed papers such as comics, Warholian portraits, and advertisements for household products. On the left side of *Beauty in Darkness,* Saunders had scribbled writing among old-time store signs, comic book pages, historic magazine photos of lynchings, postings such as "No Colored thru this door," Mexican folk-art picture frames, and common kitchen items interspersed with painter's tools. The massive assemblage (sixty-nine-and-a-half inches by ninety-three-and-a-half inches) is a condensation and observation of life in 1950s America, with its racial segregation and "Leave It To Beaver" brand of women's domesticity.

Writer Toni Morrison eloquently wrote about Saunders in 1993: Raymond Saunders reconstitutes reality for us and with us. We discover with a shock how much of the world's beauty lies in its detritus. In painting after painting emotion fused by a rapier intelligence forces us to see clearly what we only guess at: the shape of language, the speed of color, the massy weight of space. We look at his pictures and (suddenly or slowly) begin to imagine our own humanity—a kind of trembling tenderness touched with menace, exhilaration, relief, and the outrageous bounty at our disposal.

SELECTED READING

ARMSTRONG, RICHARD. *RAYMOND SAUNDERS, FORUM.* PITTSBURGH, PENN.: CARNEGIE MUSEUM OF ART, 1996.

RAYMOND SAUNDERS: RECENT WORK. WITH TEXT BY W. H. BAILEY; WILLIAM BLOCK, SR.; AND DONALD MILLER. NEW YORK: HUNTER COLLEGE OF THE CITY UNIVERSITY OF NEW YORK, 1998.

RAYMOND SAUNDERS. WITH TEXT BY KENNETH BAKER AND SUSU SCHMIDHEINY. ZURICH, SWITZERLAND: HOLDERBANK FOUNDATION, 1996.

LINHARES, PHILIP. *RAYMOND SAUNDERS: RECENT WORK.* OAKLAND: OAKLAND MUSEUM OF CALIFORNIA, 1995.

SAUNDERS, RAYMOND. *RAYMOND SAUNDERS.* WITH AN INTRODUCTION BY TONI MORRISON. SAN FRANCISCO: STEPHEN WIRTZ GALLERY, 1993.

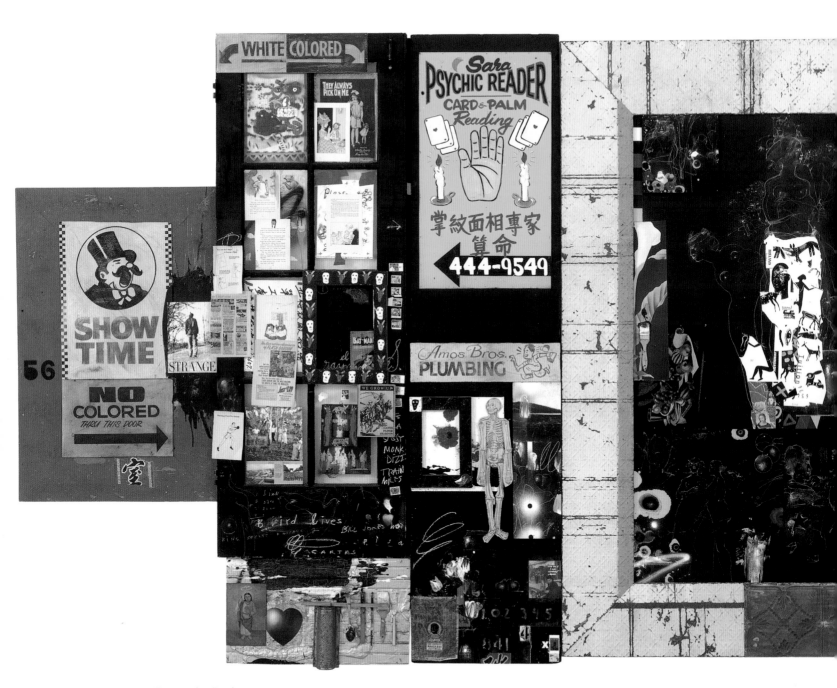

Beauty in Darkness, 1999
MIXED MEDIA COLLAGE, WOOD, METAL; 95" X 176"

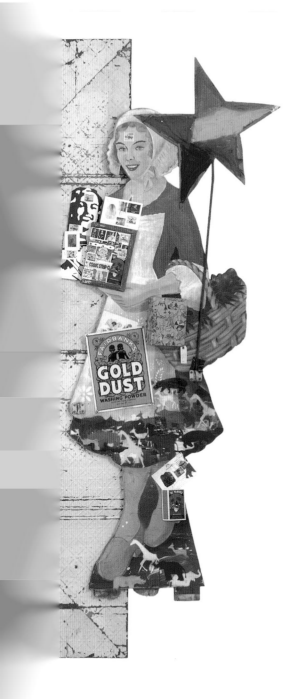

[detail]

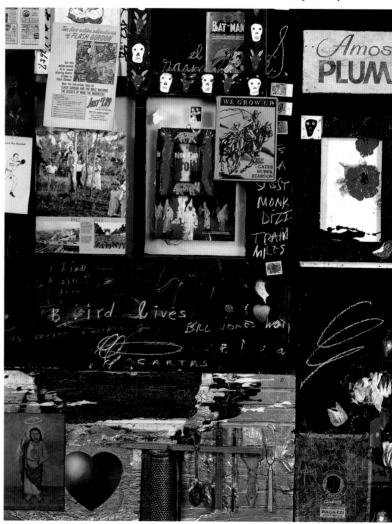

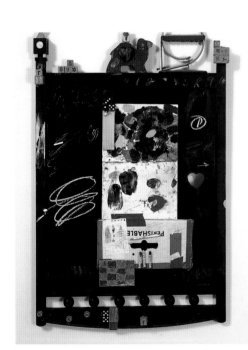

B. Blue, 1995
MIXED MEDIA COLLAGE ON WOOD;
49 1/2" X 31" X 3 1/2"

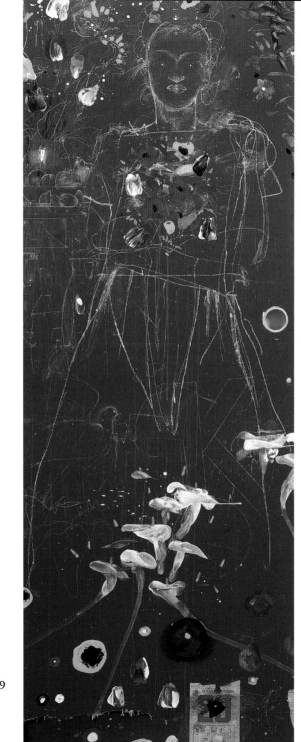

Untitled, 1999
MIXED MEDIA COLLAGE ON DOOR; 77" X 29 3/4"

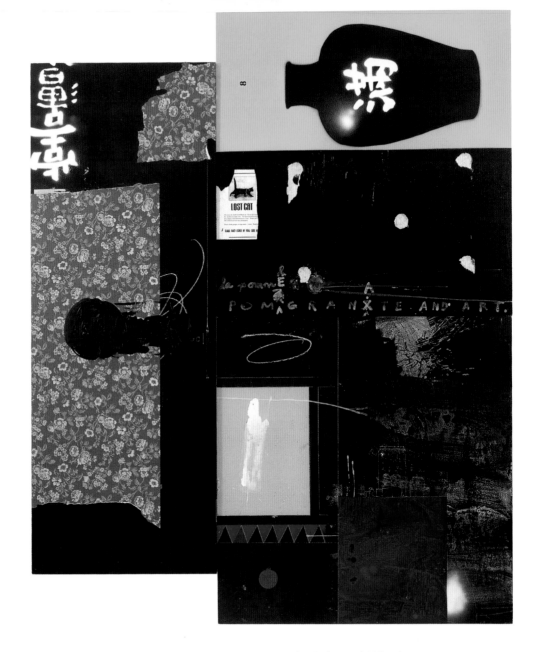

Paris, Asia, and US Mix, 2001
MIXED MEDIA COLLAGE ON BOARD; 96" X 78"

Not Needing to Be Told, 2000
MIXED MEDIA COLLAGE ON DOOR; 80" X 26"

RICHARD SHAW

An incredibly prolific ceramic artist, Richard Shaw is known for a pioneering technical virtuosity and a witty and imaginative investigation of everyday objects. Shaw replicates familiar objects with trompe l'oeil exactitude and places them in unexpected contexts. Works have a compelling sense of beauty and wit through strange, surreal juxtapositions of the mundane. He calls this phenomenon the "magic of other": the wonder that occurs when two objects are coupled to make a third.

Since the 1970s, Shaw has taken a penchant for combining everyday objects and studio clutter in several directions: experimenting with the traditional vessel forms of teapots, jars, cups, and bowls; fashioning assemblages, often situating them on sculpted stacks of books; and composing human-like figures. Although his forms appear to be casually arranged, nothing in his art is accidental. Shaw purposefully relates the objects and carefully conceives his sculptures through preparatory drawings and sketches. *Open Book Jar with Leaf* (1998), as indicated by its title, consists of a seemingly happenstance arrangement of objects—an open, heavy book revealing a leaf pressed between its pages, an eraser with its edges show-ing use, a domino, and a jar of shellac with a peeling label. There is no visible, human presence within the sculpture, yet Shaw creates a clear impression of human use in the type and arrangement of objects. He makes it palpable that someone pressed the leaf between the pages of the book; that someone placed the jar on top of the gathered books; and that someone wore the edges of the eraser with use. It feels as if the items were left sitting in a studio or on a kitchen counter and might shortly be picked up again, used or perused.

Striding (2000) is a faceless, anthropomorphic sculpture with human attributes suggested not only by the objects comprising its body parts, but also by the fact that most are clearly man-made products designed for human use. An upside-down flower vase resembles a neck and head; a Best Foods mayonnaise jar suggests a torso; pencils look like fingers. The figure is depicted in a wide, casual stride, as if jaunting along a city sidewalk, yet it is situated on a thin, flat base with two playing cards lain on top, reminding the viewer of the contrived nature of the sculpture. Shaw's figure is simultaneously anonymous and completely individualistic in the unique composition of ordinary components and suggests the surreal quality of everyday life.

RICHARD SHAW (B. 1941, HOLLYWOOD) WAS ATTRACTED TO CERAMICS AT ORANGE COAST COLLEGE IN COSTA MESA (1961–63). HE STUDIED AT THE SAN FRANCISCO INSTITUTE OF ART (BFA, 1965) AND AT THE UNIVERSITY OF CALIFORNIA AT DAVIS (MFA, 1968). DURING AN EIGHTEEN-MONTH PERIOD IN 1971–73, HE AND ROBERT HUDSON EXPERIMENTED CEASELESSLY WITH PORCELAIN IN A SHARED STUDIO IN STINSON BEACH. A RESULTING EXHIBI-TION, "ROBERT HUDSON/RICHARD SHAW: WORK IN PORCELAIN" AT THE SAN FRANCISCO MUSEUM OF MODERN ART (1973), WAS A PIVOTAL MOMENT IN SHAW'S CAREER. THE COLLABORATION AND MUTUAL EXCHANGE WITH HUDSON HAS FLOURISHED THROUGH THE PRESENT. AMONG SHAW'S MANY AWARDS ARE TWO NATIONAL ENDOWMENT FOR THE ARTS FELLOWSHIPS (1971, 1974). SHAW TAUGHT AT THE SAN FRANCISCO ART INSTITUTE (1966–87) AND SINCE 1987 HAS BEEN ON THE FACULTY OF THE UNIVERSITY OF CALIFORNIA AT BERKELEY. SHAW LIVES AND MAINTAINS A STUDIO IN FAIRFAX.

Shaw exploits the properties of clay—its tactility, proclivity for color nuances, and ability to be endlessly manipulated. He slip casts, hand builds, or throws on the wheel to create primary forms, and then manipulates the surfaces using paints, glazes, underglazes, and decals, to create the illusion of texture and depth. Shaw perfected the ceramic decal, a significant feature in his sculpture, with silkscreen artist Wilson Burrows in 1974. Images are silkscreened onto paper, and when they are dry, a clear coat of enamel is silkscreened over them. When the paper is contacted with water, the images are released and transferred to the ceramic object. Firing burns off the enamel, leaving the images behind. *Two Stories* (2000) is a sculpted two-story house of cards situated on top of a cardboard mailing box; lifelike detail is added to each component, down to the address labels on the box, through a masterful use of decals.

Shaw's virtuoso display of technique invites—almost re-quires—a viewer to closely scrutinize his objects, to want to touch surfaces and verify their reality. He invites the viewer to look further into the work—at the book titles and exposed passages, at the words and images of the decals, at the nature of each individual component, wherein lies subtly clever social and political commentary and personal references—and then step back and appreciate the absurd wit of the entire composition. His stunning technical achievements and sharp for-mal sensibilities allow the humor in the work to emerge. This is the great delight of his art.

SELECTED READING

KUSPIT, DONALD. "HIGH KITSCH: POKING FUN AT THE VESSEL." *AMERICAN CERAMICS* 13, NO. 1 (1998): 12–19.

MILLER, ALICIA. "NEW CERAMIC SCULPTURE: ROBERT HUDSON AND RICHARD SHAW." *SCULPTURE* 18, NO. 9 (NOVEMBER 1999): 60–61.

PORGES, MARIA. "RICHARD SHAW AT BRAUNSTEIN/QUAY." *ART IN AMERICA* 88, NO. 10 (OCTOBER 2000): 178–79.

RICHARD SHAW AND ROBERT HUDSON, WORK IN PORCELAIN. SAN FRANCISCO: SAN FRANCISCO MUSEUM OF MODERN ART, 1973.

ROBERT HUDSON AND RICHARD SHAW: NEW CERAMIC SCULPTURE. ANDOVER, MASS.: ADDISON GALLERY OF AMERICAN ART, PHILLIPS ACADEMY, 1998.

Open Book Jar with Leaf, 1998
PORCELAIN WITH DECAL OVERGLAZE; 11" X 16 1/4" X 10 1/4"

Remembering, 1999
PORCELAIN WITH DECAL OVERGLAZE;
14" X 30" X 10"

Striding, 2000
GLAZED PORCELAIN WITH DECAL
OVERGLAZE, 37¹/₂" X 10" X 19¹/₂"

KATHERINE SHERWOOD

Many artists can **reflect on a moment in time,** perhaps an **event,** something **learned or read,** or a particular work, that unleashed their creativity and catalyzed a new artistic direction. Katherine Sherwood's moment was a massive cerebral hemorrhage in 1997, which paralyzed the right side of her body—a seemingly major devastation for a right-handed painter. After months of extensive rehabilitation and the realization that her right side would remain paralyzed, Sherwood began painting with her left hand, and since has become a self-described "freer, better painter."

Prior to her stroke, Sherwood was a studied, intellectual painter, integrating an unusual combination of signs, symbols, and collaged objects with the application of paint. When closely examined, the forms and figures in her work reveal themselves as something else, such as bingo cards, microscopic or satellite photos, or images of a nuclear explosion, collaged onto the canvas. Through the juxtaposition of disparate images, often with art historical reference, Sherwood sought to convey a social and political commentary beneath the patterns, organic forms, and representational figures.

In paintings from the late 1990s, Sherwood exhibits little trace of this academic layering, revealing instead a more intuitive, gestural direction. Her work is freer and exudes confidence. Yet there are connections between what she describes as the "before" and "after." A persistent interest in symbols is incorporated into her work through the medieval emblems for health, wealth, wisdom, and desire. They are derived from *Lemegeton,* a seventeenth-century sorcery handbook with seals or emblems of various demons that were believed to be drawn by King Solomon, which she used in her painting in the mid-1990s. Prior to the injury, she had worked with images of brain scans (of others), representing the mass of the brain. Now, Sherwood integrates photolithographic images of her own cerebral angiograms, depicting the map of her brain's arterial system, often burying the collaged material under her thick, poured paint. As she states, "The only thing was that my life caught up with my art. . . . I like it happening that way."

Buer II (2001) is a large piece (sixty inches by seventy-two inches) with thick, cracking paint, in various muted, earthy greens and browns and bold yellow and orange. The title and imagery refer to a medieval demon, a healer who was said to teach philosophy, the logic arts, and the virtues of plants and herbs. Overlapping, irregular circles suggest the medieval emblem and partially obscure the photolithographs of angiograms, produced in soft hues of pink and orange. Sherwood traces the exposed portions of the X-rays with a thick

outline of pale green paint. Although the forms are relegated to one portion of the canvas, there remains a sense of balance. She creates an impression that the viewer is seeing only a portion of a much larger system of organic shapes and forms. The curving lines of the angiograms complement the abstracted form of the medieval seals, underscoring the connections she draws between past and present, magic and science, medicine and mysticism, and faith and reason.

For practical reasons, Sherwood no longer paints with oil on canvas, instead using latex and acrylic, which are easier to apply, and she prefers to work on the smooth surfaces of paper, which are then applied to canvas. Her work has become more process-oriented than in the past; in many instances she pours the paint, employing the subsequent thickness and the weathered, cracking appearance as strong textural devices. Her painting presents what writer John Yau has described as "a reality that consists of multi-layered things in a state of constant if largely undetectable change."

Employing a similar palette of pale greens, yellows, browns, and a salient red, in *Sallos II* (2000)—referring to another medieval demon said to instigate love between men and women—Sherwood creates curving tendrils with a poured, gestural application of paint that

KATHERINE SHERWOOD (B. 1952, NEW ORLEANS, LOUISIANA) STUDIED ART HISTORY AT THE UNIVERSITY OF CALIFORNIA AT DAVIS (BA, 1975) AND THEN PAINTING AT THE SAN FRANCISCO ART INSTITUTE (MFA, 1979). SHE TAUGHT FOR FIVE YEARS AT NEW YORK UNIVERSITY IN NEW YORK CITY, THEN RETURNED TO THE BAY AREA IN 1988 AND HAS SINCE TAUGHT AT THE UNIVERSITY OF CALIFORNIA IN BERKELEY. AMONG HER AWARDS ARE A POLLOCK-KRASNER FOUNDATION GRANT (1998) AND A NATIONAL ENDOWMENT FOR THE ARTS FELLOWSHIP (1989). SHERWOOD LIVES IN RODEO.

strikingly mimics the forms of plants. Fractures in the thick paint are reminiscent of dried, cracked mud. Within the organic forms, she integrates imagery of King Solomon's seals—irregular, green, red, and black circles connected with thick, uneven stripes, from which offshoot three thin lines ending in a rectangular block of paint. The paint echoes the collaged, overlapping black-and-white X-ray photolithographs beneath, which appear as little more than abstract, curving lines. The artwork places the particular biology of the artist within the greater system of life, suggests the perpetuating reproductive capabilities of all living things, and brings together the mysticism of a past era with the present age of science and certitude.

SELECTED READING

KATHERINE SHERWOOD. WITH TEXT BY JOHN YAU. SAN FRANCISCO: GALLERY PAULE ANGLIM, 2001.

KATHERINE SHERWOOD: 1999 ADALINE KENT AWARD. SAN FRANCISCO: SAN FRANCISCO ART INSTITUTE, 1999.

READ, MICHAEL. "KATHERINE SHERWOOD AT THE WALTER/MCBEAN GALLERY, SAN FRANCISCO ART INSTITUTE." *ARTWEEK* 30, NO. 7/8 (JULY/AUGUST 1999): 17.

WALDMAN, PETER. "MASTER STROKE: A TRAGEDY TRANSFORMS A RIGHT-HANDED ARTIST INTO A LEFTY—AND A STAR." *WALL STREET JOURNAL,* 12 MAY 2000, A1(W), A1(E).

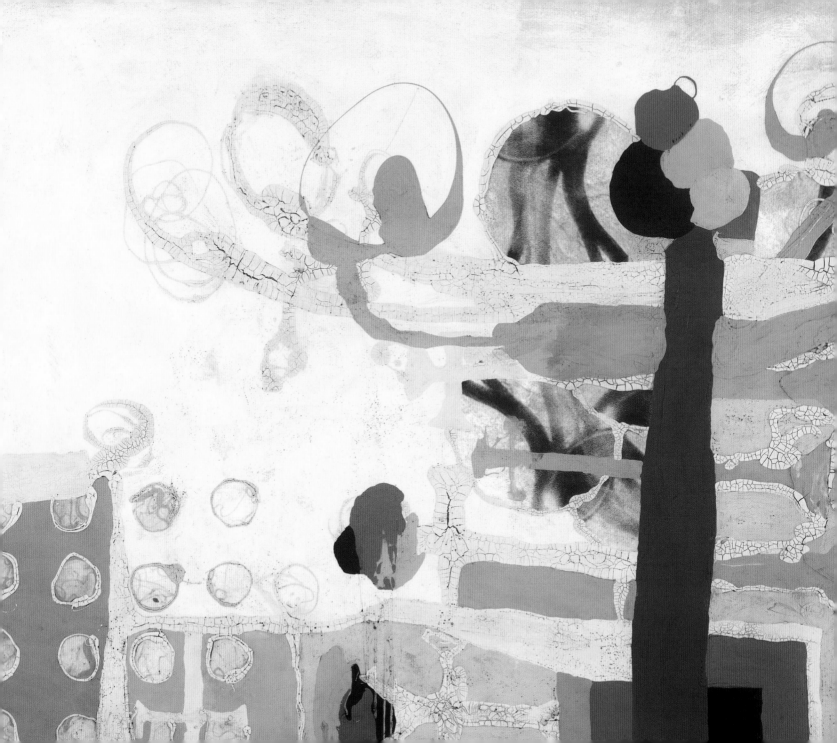

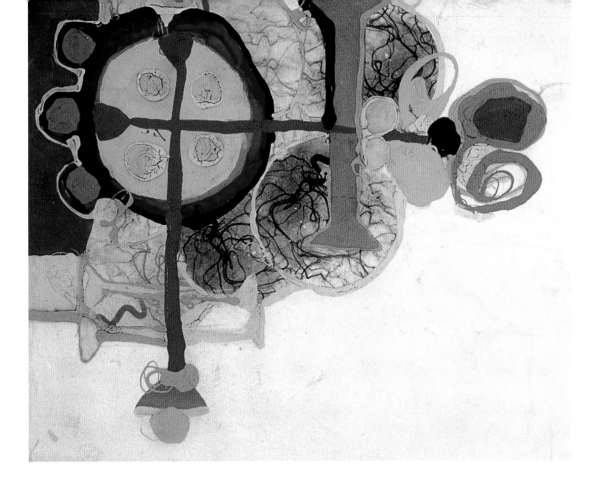

Virtues of Stones and Plants, 2001
MIXED MEDIA ON CANVAS;
84" X 108"

Buer II, 2001
MIXED MEDIA ON CANVAS; 60" X 72"

SILT

The **cinema trio** Silt is motivated by a fascination with the **sculptural qualities** of **film as a material**, the nature of cinema as a **time-based event** in **space**, and the unexpected **paths** that can be **produced** through collabora**tion.** The three artists—Keith Evans, Christian Farrell, Jeff Warrin—began their work in 1990, when the medium of Super-8 film was being replaced by video. Use of a once ubiquitous medium, now eclipsed in the marketplace of popular culture, presented an opportunity for artistic exploration. The individual identities of the three artists are completely submerged into the collaborative identity. No individual credit exists in any of the group's films, installations, and performances, even when only one or two of the three participate.

The creation of *Kuch Nai* (1992) began when one member traveled through India for nine months, shooting Super-8 film and shipping the exposed, undeveloped rolls back to the Bay Area. The other two artists, working alone and in tandem, hand-processed and roughly edited the rolls, but without any notes or script. Imagery was rephotographed with multiple projectors, and the trio later worked together in the final editing and addition of a soundtrack.

Kuch Nai opens with one member's narrative of his travels through India. After several minutes, as he suspects the camera is malfunctioning, his diaristic travelogue is interspersed with the personal narratives of the two who did not take the journey. During the thirty-eight-minute film, the narratives grapple with personal relationships, takes the viewer into a dreamy, otherworldly space, and elicits the conceptual, collaborative space among the trio.

The treatment of the film material itself to achieve unpredictable (and uncontrollable) effects is an ongoing part of Silt's working process. Different lengths of film are buried underground, exposed to bacteria and allowed to mold, to produce colors, patterns, and actual dimensionality in or on the film emulsion. These unusual techniques create images that are substantially thicker than conventionally processed film and vary with somewhat unpredictable results.

The textural and sculptural metamorphosis of the film for *Kemia* (1994) is biologically ongoing. A fourteen-minute visual adventure of abstraction and colors, this Regular 8-mm film is shown through a Super-8 projector placed on its side, which requires one of the artists to operate the projector manually to adjust focus and framing. Every public showing of the film becomes a kind of performance, and this led to their intentional use of projection as part of a screening.

Silt's earlier performances have metamorphosed into more elaborate installations and installation-performances, where environments are used both for cinema projection and cinematic performance events whose subject is cinema and which include viewer interaction as part of the work. For *Lagoon* (1998), made while they were artists in residence at the Headlands Center for the Arts (HCA) in Marin County, a rear projection screen bisected a large pool in a darkened gallery. Behind the screen, images of varied wildlife from a lagoon outside were projected onto the water's surface and in turn reflected up onto the screen. People could walk in front of the screen, their movements passing through the water and disturbing that part of the pool behind

the screen, which then altered the image on the screen. Field recordings made in the Headlands area played from small speakers around the pool. On one side of the gallery, an image of the lagoon was cast upside-down on a three-by-eight-foot screen by a pinhole camera obscura, and on the other side viewers could sight a small bird sanctuary in the lagoon through a telescope.

Kymatic Projections (1998), also made at the HCA, was based on the visual patterns created by different materials when sound vibrations pass through them. Visitors were given flashlights to navigate a darkened gallery that held seven speakers of differing shapes and sizes laid pointing face up. Each speaker membrane had been filled with a different liquid or fine particulate matter such as coyote bones or crab shells ground to a fine powder. Field recordings from the surrounding Headlands area were audibly processed for particular frequencies, which when transmitted through the speakers produced polymorphous patterns in the materials.

Silt literally transformed a gallery into a black box for *Pnumbra* (2000). As participants walked into the empty darkened space, they carried translucent hand-screens—sheets of vellum and tracing paper that served as handheld rear projection screens. Nine projectors on the room's periphery pointed toward slightly different areas of the center. The participants could see different projections, or parts of projections, by moving the hand-screens around the room, but

SILT IS A CINEMA COLLABORATIVE COMPOSED OF KEITH EVANS (B. 1965, COLUMBUS, OHIO), CHRISTIAN FARRELL (B. 1967, SAN LEANDRO, CALIFORNIA) AND JEFF WARRIN (B. 1965, PLAINFIELD, NEW JERSEY). THEY MET DURING AN UNDERGRADUATE EXPERIMENTAL FILM COURSE AT SAN FRANCISCO STATE UNIVERSITY (FARRELL, BA, 1990; EVANS, BA, 1992; WARRIN, BA, 1992). FARRELL ALSO STUDIED PHILOSOPHY AND RELIGION AT THE CALIFORNIA INSTITUTE OF INTEGRAL STUDIES IN SAN FRANCISCO (MA, 1999). THEY LIVE IN THE BAY AREA.

they needed to work collaboratively and put their screens together in order to see or gain a sense of larger images. Nine different cinematic events of varying duration, some overlapping and others separated by periods of darkness, moved viewers around and through the space over the course of an hour.

Esoteric titles for the films and installations such as *Chromatic spectra in aqueous medium, Archaeopteryx dreaming* (1999, 16mm, three minutes), or *The nocturnal movement of solvents and radioactivity, under the direction of black ants and honeybees* (2001) hint at the multidisciplinary and cross-disciplinary investigations that inspire them. The works retain primacy through an eschewal of self-aggrandizement or marketability of the art object experience, and create new visual, aural, spatial, and conceptual interpretations of cinema.

SELECTED READING

CAMPER, FRED. "CRITIC'S CHOICE: *KUCH NAI.*" *CHICAGO READER.* 28 MAY 1993, SEC. 2, P. 4.

GERHARD, SUSAN. "SUPER-8 SPIRITUALITY." *SAN FRANCISCO BAY GUARDIAN,* 13–19 SEPTEMBER 1995, P. 43.

KILCHESTY, ALBERT, ED. *BIG AS LIFE: AN AMERICAN HISTORY OF SUPER-8 FILM.* NEW YORK: MUSEUM OF MODERN ART, 1998.

ORTIZ, SELENA. "SILT SPEAKS." *HEADLANDS CENTER FOR THE ARTS NEWSLETTER* (SUMMER 1998): 2.

RINDER, LAWRENCE, ET AL. *2002 BIENNIAL EXHIBITION.* NEW YORK: WHITNEY MUSEUM OF AMERICAN ART, 2002.

SILT. "SILT . . . ON SEVEN GIANT SEA TURTLES." *CANTRILLS FILMNOTES,* NOS. 79, 80 (NOVEMBER 1995): 67–70.

Lagoon, 1998
INSTALLATION VIEW, HEADLANDS CENTER FOR THE ARTS

Film Extractions, 1997–2001
BIOLOGIC MATERIAL AND 16MM FILM;
DETAILS FROM 16MM ORIGINALS

Kymatic Projections, 1998
INSTALLATION DETAIL, HEADLANDS CENTER FOR THE ARTS

MARY SNOWDEN

The comfort and contentment of domestic life are set at odds in Mary Snowden's paintings and watercolors since the mid-1960s, which characteristically display a skillful and detailed realism, and range from complex, dense still-life studies to works shaped like jigsaw puzzle pieces. She draws subject matter from the circumstances of her life as an artist, balancing work and family, and twists otherwise straightforward depictions of everyday scenes of home life with a use of surreal humor.

Snowden's paintings from the mid-1960s are hard-edge abstract designs based on the diagrams of industrial machines such as engines and earth-moving equipment. This early work was followed by paintings with a softer palette depicting barnyard or farm animals, such as roosters, chickens, and cows shown in a living room or peeking over a kitchen counter. Snowden switched to watercolors and colored pencils in 1975, wanting to work faster and feeling alarmed by the chemical toxicity of oil painting materials with the birth of the first of her three children. She also began basing her work on photographs, an approach that continued into the early 1990s. The subjects of her colored pencil drawings directly resonate with her role as a mother and frequently include her children. During this time, she also painted watercolor still-life studies of domestic objects such as houseplants, pin cushions, kitchenware, and children's toys.

Snowden's arrangements of the early 1990s continue to consist of household objects in domestic settings, but also add images and objects related to art. These still-life studies have a complex interplay of color, patterns, and abstracted space. Various items are spread across the top of a wood chest in *Passages* (1991). On the right, dried pods poke out of an antique ceramic pitcher situated behind a wire basket filled with eggs; in the center, dark plums rest in a white dish by an antique clock; on the left, a yellowish brown pear sits atop an architectural fragment of a Greek pediment. A large print of a colonnade with vaulted arches is hung over the left side of the chest, against a wall of striped wallpaper. Objects both old and new populate the scene, from the fresh fruit and eggs to the antique pitcher and clock, which has digital numbers replacing the traditional face. Browns, blacks, and soft grays repeat throughout the composition, and the lines that define the flat plane of the wallpaper and the space of the wire basket create a mesmerizing and dizzying effect.

Snowden's work changes in the mid-1990s, when she returned to oils and based her paintings on the products, fashions, and images of 1940s and 1950s advertising to satirize a woman's role as homemaker. Rendered as if a hazily recollected scene, her paintings isolate domestic products, such as a close-up view of a hand extending a pot toward a soup bowl in *Tomato Soup* (1994). The bowl, sitting on

a tabletop, is precisely rendered as gleaming porcelain with crisp lines and picture-perfect steam rising from the soup. By contrast, the hand and pot and other elements—tin cup, milk bottle, salt shaker, tomato, sugar, and salt containers on the corner of a nearby table—are crudely rendered, as if incompletely remembered.

Snowden establishes a mood of nostalgia with a palette dominated by browns, grays, and reds, imbuing the paintings with the look of aged magazine reproductions. Everyday objects such as coffee cups, spoons, vacuum cleaners, and kitchen burners appear at times fully rendered and at others as mere outlines. The items may be collaged with unrelated elements such as a disembodied manicured hand, mixtures being poured into mixing bowls, or cartoon characters such as Dagwood or the Morton salt girl. The disparate jumble of elements, their rendering, and their scale suggest a wandering mind and the inconclusive nature of memory.

The piecing together of the past and the fitting of the domestic promise of advertising with the less glamorous reality are laid out by Snowden in paintings of the late 1990s that are approximately four feet square and are shaped and cut like jigsaw puzzle pieces. The lines of four large interlocking jigsaw pieces run through *Lost in Thought* (1998), and the edge of the painting has been irregularly cut to complete the illusion. A 1940s housewife reads a book in a wingback chair, a steaming cup of coffee on the end table beside her. This would be a blissful scene if not for two strange factors. First, the overall painting is rendered to appear faded and flat, except for the steaming cup of

MARY SNOWDEN (B. 1940, PENNSYLVANIA) STUDIED AT BROWN UNIVERSITY IN RHODE ISLAND (BA, 1962) AND THE UNIVERSITY OF CALIFORNIA AT BERKELEY (MA, 1964). SHE HAS TAUGHT AT THE CALIFORNIA COLLEGE OF ARTS AND CRAFTS SINCE 1965 AND LIVES IN BERKELEY.

coffee, which is realistically depicted in vivid color and with full dimensionality. Second, small cartoon elements are scattered throughout the scene: on top of the end table, a man toting a chair on his back; under the table, a policeman and a police car; and a prop plane flying at the woman's head. An image of Little Lulu grabs the woman's shoulder and stretches to shout something in her ear. Little Lulu is not simply a nostalgic detail from comics of the 1940s. She used her feminine skills and intelligence to triumph, and is also noteworthy for being drawn by a woman. Little Lulu's creator controlled the copyright, which was highly unusual for that era, and marketed her character as an advertising mascot for Kleenex, greeting cards, and many other products. Snowden's selection of images reveals that her painting is not about the hallucinatory imaginings of a 1950s housewife gone mad, but about a feminist voice of reason advising her about the future, possibly of the expanded roles for women.

SELECTED READING

BRUNSON, JAMIE. "STILL LIFES IN A PRIVATE WORLD." *ARTWEEK* 26, NO. 9 (2 SEPTEMBER 1995): 3.

CLARK, LUCY. "SYMBOLIC REALITIES." *AMERICAN ARTS QUARTERLY* (SPRING 1992):12–15.

COHN, TERRI. "MARY SNOWDEN AT BRAUNSTEIN/QUAY GALLERY." *ARTWEEK* 26, NO. 7 (JULY 1995): 19–20.

PORGES, MARIA. "SAN FRANCISCO FAX." *ART ISSUES*, NO. 48 (SUMMER 1997): 36–37.

Tomato Soup, 1994–95
OIL, ACRYLIC, AND COLLAGE ON CANVAS; 24" X 36"

Lost in Thought, 1998
ACRYLIC ON WOOD,
43" X 45"

Refrigerator Chase, 2000
ACRYLIC ON PANEL, 48" X 48"

LARRY SULTAN

A fascination with photography as a ubiquitous social phenomenon has been the motivation for Larry Sultan's work over the past three decades. He observes the different purposes of photography, ranging from advertising to ordinary snapshots made for personal purposes, and creates his own photographs and uses found images for exhibitions, books, installations, billboards, and public commissions.

Sultan's early artistic identity was submerged in collaboration with artist Mike Mandel, whom he met in graduate studies at the San Francisco Art Institute. Although still ongoing, their collaborative photographic work was most active from the early 1970s to the mid-1990s, when they produced together two books (*How To Read Music in One Evening,* 1974; *Evidence,* 1977), exhibitions, billboards, and several public commissions. The photographs they used were appropriated from the archives and collections of commercial corporations, educational institutions, government agencies, and advertising. Their examination of photographs and photographic information as vehicles of meaning within American culture led to the creation of unconventional works that subverted or unmasked manipulative, commercial messages, probed the verisimilitude of photography, and tested the intelligence of their audience. The collaborative explorations with Mandel laid the groundwork for Sultan's investigations into the public awareness of private worlds.

Domesticity is a condition that implies comfort and well-being. The familiar and regimented solace peculiar to home is a protective buffer against the uncertainty and vulnerability experienced in the outside world. Sultan has photographically explored the qualities that delimit this idea through various subjects since the early 1980s.

From 1983 to 1992, Sultan worked on a project that began simply as pictures of his parents and resulted in *Pictures from Home.* The book includes Sultan's own text, notes, and photographs; writing by each of his parents; family snapshots, and stills from home movies. It is a moving chronicle in which Sultan recovers the family's history through individual narratives and old pictures and juxtaposes the story with his own text and photographs. The story begins with the idealized vision that characterized American postwar aspirations for family, financial, and corporate success and continued into the Reagan era of the 1980s. But Sultan's assembly of images and stories eventually reveals the inconsistencies of memories, the ways family relationships can change, and shows the different interpretations that can be elicited by a single, seemingly objective photograph.

Sultan reviewed his placement of photographs and photographic information in public spheres through several projects in the 1990s. Among them, through the sponsorship of Public Art Works in San Rafael in 1994, Sultan collaborated with spouse Kelly Sultan on *Have You Seen Me,* consisting of four stories, six drawings, and text by and about immigrant children, which were printed in offset lithography on 1 million milk cartons and 250,000 grocery bags that were distributed by United Markets throughout Northern California. He also

collaborated with Harrell Fletcher and Jon Rubin, during a six-month artists-in-residence at the Stoneridge Shopping Mall in Pleasanton, California. Meeting and talking with the shoppers and residents of the community, they produced larger-than-life-size portraits on banners, video, and text and installed them in the form of a store in the mall in *People in Real Life* (1997).

In 1999, Sultan was commissioned by *Vogue Hommes International* magazine to photograph the thriving pornographic film industry in the San Fernando Valley north of Los Angeles—the same area where he grew up. In an ordinary suburban house, Sultan observed a set crew constructing an interpretation of the *ideal* suburban house, and this prompted his interest in the surroundings and how they reflect the desires, culture, ideas of domesticity—and sexuality. This work interprets the social milieu of pornography within the same setting as the personal experience in *Pictures from Home*. "Once pornography has been in a room," he observed, "it has touched and tainted that room. You look at the most benign things in a more interesting light. So it is another vehicle to deal with the mundane, with the wonderful banalities of domestic life."

The suburban life described by these color photographs of the San Fernando Valley—also known as The Valley and mythologized in the film *Boogie Nights* (1997)—is not as skewed as one might expect. Although San Fernando Valley in this context is snidely referred to as Silicone Valley and the Valley of Sin, a gentleness and quiet familiarity seem to emanate from Sultan's photographs. He generally avoids the

LARRY SULTAN (B. 1946, NEW YORK, NEW YORK) MOVED WITH HIS FAMILY FROM BROOKLYN TO LOS ANGELES IN 1949. SULTAN STUDIED AT THE UNIVERSITY OF CALIFORNIA, LOS ANGELES (BA, 1968), AND THE SAN FRANCISCO ART INSTITUTE (MFA, 1973). HE HAS TAUGHT AT VARIOUS SCHOOLS, INCLUDING THE SAN FRANCISCO ART INSTITUTE, AND SINCE 1989 HAS BEEN ON THE FACULTY AT THE CALIFORNIA COLLEGE OF ARTS AND CRAFTS. AMONG HIS EXTENSIVE LIST OF GRANTS AND AWARDS ARE A JOHN SIMON GUGGENHEIM MEMORIAL FOUNDATION FELLOWSHIP (1983), THREE PHOTOGRAPHY FELLOWSHIPS FROM THE NATIONAL ENDOWMENT FOR THE ARTS (1980, 1986, 1992) AND AN AWARD IN VISUAL ARTS FROM THE FLINTRIDGE FOUNDATION (1999–2000). HE LIVES IN MARIN COUNTY.

lurid or sensational by relegating overt sexual scenes to the background or shadows. Instead, the photographs gravitate toward the strange beauty and ambiguity of narratives that occur on the periphery of any action, and typically the subjects are the sets, cast, or crew. They are hauntingly beautiful scenes that require close scrutiny for full appreciation, and even then are a puzzling plethora of domestic details.

A great deal of tedium is experienced in the making of these photographs, as Sultan waits for often indeterminate human exchanges or a poignant banal moment—in either instance, his photographs are the antithesis of a climax. Sultan's images dispel any of the sensational expectations in shooting pornography, as they also create and propose new understandings for what is encompassed by the idea of "home."

SELECTED READING

DECOSTER, MILES; MARK KLETT, MIKE MANDEL, AND LARRY SULTAN. *HEADLANDS: THE MARIN COAST AT THE GOLDEN GATE.* ALBUQUERQUE: UNIVERSITY OF NEW MEXICO PRESS, 1989.

HERSCHBERGER, MIKE, ET AL. "THE ART OF BOREDOM." *NEW YORK TIMES MAGAZINE,* 9 APRIL 2000: SEC. 6, PP. 74–76.

SULTAN, LARRY. *PICTURES FROM HOME.* NEW YORK: HARRY N. ABRAMS, 1992.

SULTAN, LARRY, AND MIKE MANDEL, WITH AFTERWORD BY ROBERT FORTH. *EVIDENCE.* GREENBRAE AND SANTA CRUZ, CALIF.: CLATWORTHY COLORVUES, 1977.

SULTAN, LARRY, AND MIKE MANDEL. *HOW TO READ MUSIC IN ONE EVENING.* GREENBRAE AND SANTA CRUZ, CALIF.: CLATWORTHY COLORVUES, 1974.

Haskell Avenue, 1998
CHROMOGENIC PRINT; 50" X 60"

My Mother Posing for Me, 1984
CHROMOGENIC PRINT; 30" X 40"

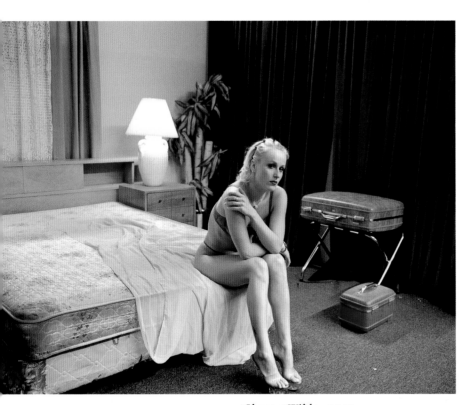

Sharon Wilde, 2001
CHROMOGENIC PRINT; 40" X 50"

Tasha's Third Film, 1999
CHROMOGENIC PRINT; 50" X 50"

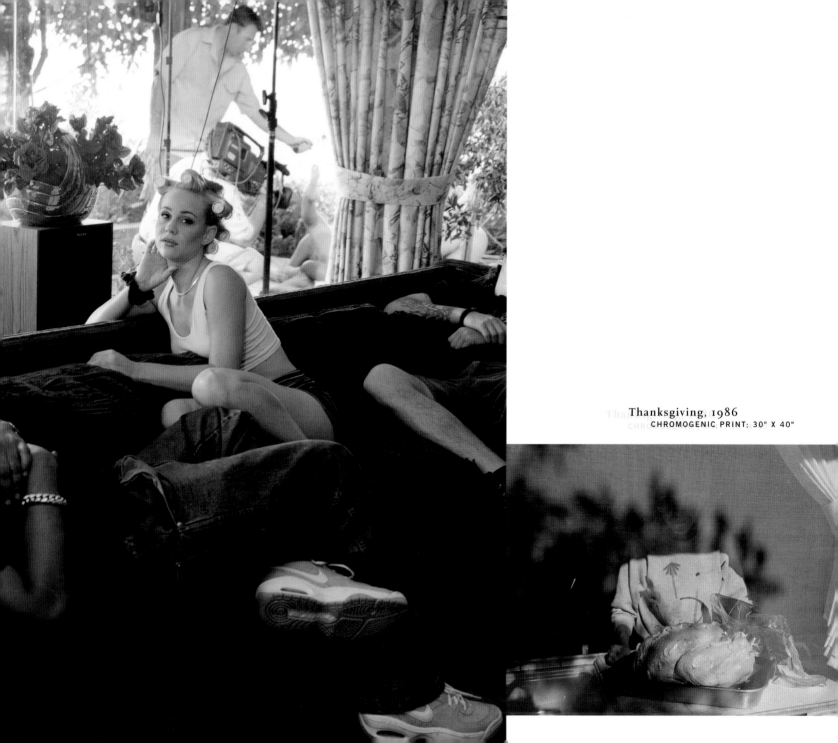

Thanksgiving, 1986
CHROMOGENIC PRINT; 30" X 40"

SURVIVAL RESEARCH LABORATORIES

Survival Research Laboratories (SRL) explores the entwined nature of technology and human existence through what is called "Spectacular Machine Performance." Under the direction of founder Mark Pauline and through the efforts of dozens of volunteer artists and engineers, SRL builds devices that reshape business and military technology for sensational outdoor theatrical performances. Machines that are designed to release the most energy in the shortest amount of time, and weigh as much as several tons, are remotely operated in deafening violent spectacles that provide viewers with visceral experiences of fear and expose them to the inherent dangers of technology.

SRL performances have become increasingly more complex since the late 1970s. Titles of performances typically vacillate between straightforward description such as *Hovercraft Debut Run* (2001) and philosophically or poetically provocative phrases such as *An Infestation of Peculiar Irregularities: Taking Place in a Disintegrating Landscape, Marked by Unresolved Entanglements* (1992) or *Illusions of Shameless Abundance: Degenerating into an uninterrupted sequence of hostile encounters* (1989). Shows are thematically organized, and have targeted consumerism, religion, technology, and of course, war. Much of the machinery, which is equally complex, is U.S. Navy surplus equipment from the 1940s and 1950s that runs on tough, oily drive chains, powered by gas-burning engines ranging from motorcycle to full V8 or lead and acid batteries or compressed air. The devices are aptly named, such as "Flame Hurricane," comprised of five 150-pound-thrust Pulse Jet engines that produce a rapidly rotating column of hot, high-velocity hurricane-like fire; "Hand of God," a giant spring-loaded hand cocked by a hydraulic cylinder with eight tons of pressure; or "Pitching Machine," a device that can launch a six-foot-long two-by-four piece of lumber at a velocity of 120 miles per hour. The heavy-duty hydraulic devices are deliberately engineered to appear unsafe, which enhances the theatrical, sensory performance. The audience at a performance is assaulted with extremely high and low levels of sound that have physical and psychological effects and, along with the sights and strong chemical smells generated by the engines, contribute to a feeling of exhaustion by the conclusion.

SRL has achieved international recognition by staging extremely complicated operations abroad. For example, twenty-eight tons of equipment and machinery packed in forty containers were shipped from the Bay Area to Japan for their first performance there in 1999. The SRL events take place in massive empty warehouses or large outdoor spaces that will accommodate up to five thousand spectators. A long prelude to each performance, of inane and irritating music, creates an emotionally unsettling atmosphere. (G.X. Jupitter-Larsen, founder of the experimental noise group The Haters, frequently collaborates with SRL.) Theatrical props that range from billboard-size, graphically shocking scenes painted on paper or cloth, such as a nude pregnant woman holding a beer and a cigarette, or objects that will be destroyed, such as a stack of fifteen pianos, are interspersed through the space. The equipment is set up in the performance area when the

MARK PAULINE (B. SARASOTA, FLORIDA, 1954) ATTENDED ECKERD COLLEGE IN ST. PETERSBURG, FLORIDA (BA, 1977). PAULINE BRIEFLY WORKED AS A CIVILIAN CONTRACTOR FOR THE U.S. AIR FORCE AND A PIPE WELDER, AND LATER DID FABRICATING, CUSTOM MACHINING, AND PROTOTYPING FOR HIGH-TECHNOLOGY COMPANIES AND LABORATORIES IN THE SAN FRANCISCO AREA. HE FOUNDED SURVIVAL RESEARCH LABORATORIES IN NOVEMBER 1978 (THE NAME WAS LIFTED FROM A *SOLDIER OF FORTUNE* MAGAZINE ADVERTISEMENT), AND THE FIRST PERFORMANCE WAS AT THE SAN FRANCISCO ART INSTITUTE IN 1979. HE MAINTAINS A WAREHOUSE FOR SRL ON THE OUTSKIRTS OF THE MISSION DISTRICT IN SAN FRANCISCO. HE PRESENTLY IS A RESELLER OF EQUIPMENT, AND LIVES AT THE WAREHOUSE.

audience arrives, although SRL staff are usually making adjustments right up to the beginning. SRL-trained technicians linked by headsets operate the performances, which typically run from at least one and a half to three hours, and follow prepared performance sequences.

Pauline has broad engineering and computer knowledge and is the single organizing force behind SRL, even though it is a collaborative. He operates an open workshop that typically may have thirty to fifty people working as apprentices at the warehouse and yard, many with graduate-level engineering education. Another eighty-odd volunteers do the labor required to stage an event. There is evidence of contributions from other individuals in the design of equipment and shows, such as the predominant machine performances from 1982–88 when Pauline worked with artists and engineers Matt Heckert and Eric Werner. Artist Ray Thomas, founder of RTMark, an organization dedicated to the sabotage of corporate products, worked at SRL for a period of time, as did Eric Paulos, a computer science doctorate candidate and founding organizer of the Experimental Interaction Unit, a loose-knit group of artists and computer scientists. Paulos was active at SRL in the early to late 1990s when telerobotic projects were developed such as *Further Exploration in Lethal Experimentation* (Karlsruhe, Germany; 1997) and *Increasing the Latent Period in a System of Remote Destructibility* (Tokyo, Japan; 1997). In both instances, the viewing and operation of potentially lethal equipment was carried out by video and telerobotic hookups through the Internet between San Francisco and remote locations abroad.

The apparently rational nature of engineering is made hideous in the excessive, satiric performances of SRL, and as Pauline says, "The idea is to make people's fear of a technological Armageddon come true in a controlled environment." The noise and fires produced by machines have resulted in police and fire citations, Pauline being jailed, and the organization being banned for periods of time from American cities (San Francisco, Seattle, Phoenix, Austin) and other countries (Japan, Spain), although these developments have not been a deterrent.

SRL performances deliver messages of how art and technology are transitory, or how war is a form of art. "This is what Mark's work is about, what Mark Pauline really understands," author Bruce Sterling observes. "Everything that industrial society would prefer to forget and ignore and neglect takes on a pitiless Frankenstein vitality. It isn't beautiful, it isn't nice, it isn't spiritually elevating. It casts the darkest kind of suspicion on the lives we lead and the twisted ingenuity that supports those lives. And it offers us no answers at all."

SELECTED READING

BURNHAM, LINDA. "REVIEWS, LOS ANGELES, SURVIVAL RESEARCH LABORATORIES." *ARTFORUM* 24 (NOVEMBER 1985): 113.

DERY, MARK. *ESCAPE VELOCITY: CYBERCULTURE AT THE END OF THE CENTURY.* NEW YORK: GROVE PRESS, 1997.

LUCAS, ADAM. "THE ART OF WAR." *WORLD ART* 1 (JANUARY 1995): 66–71.

MRAZ, STEPHEN. "CRASHING AND BURNING." *MACHINE DESIGN* (8 JULY 1999): VOL. 71, NO. 13, 50–60.

PESCOVITZ, DAVID. "BE THERE NOW: TELEPRESENCE ART ONLINE." *FLASH ART* 32, NO. 205 (MARCH/APRIL 1999): 51–52.

STERLING, BRUCE. "IS PHOENIX BURNING." *WIRED* 4, NO. 7 (JULY 1996): 106.

VAN PROYEN, MARK. "HOME IS WHERE THE ROBOT IS: A HOMECOMING FOR SURVIVAL RESEARCH LABORATORIES." *NEW ART EXAMINER* 26, NO. 2 (OCTOBER 1998): 32–35.

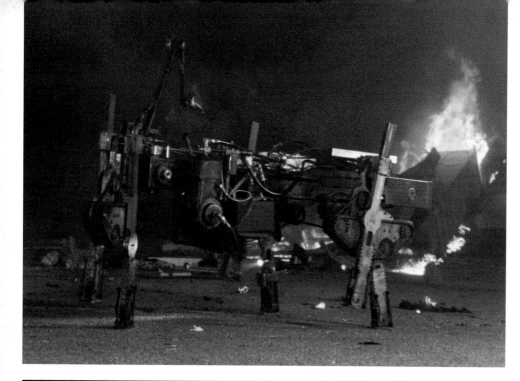
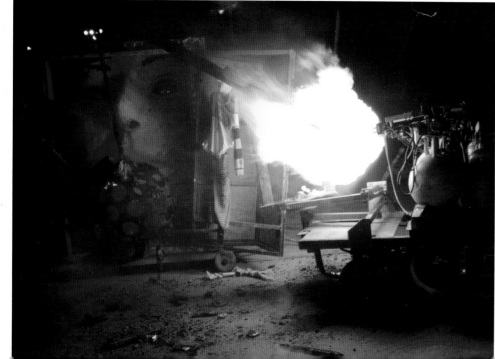

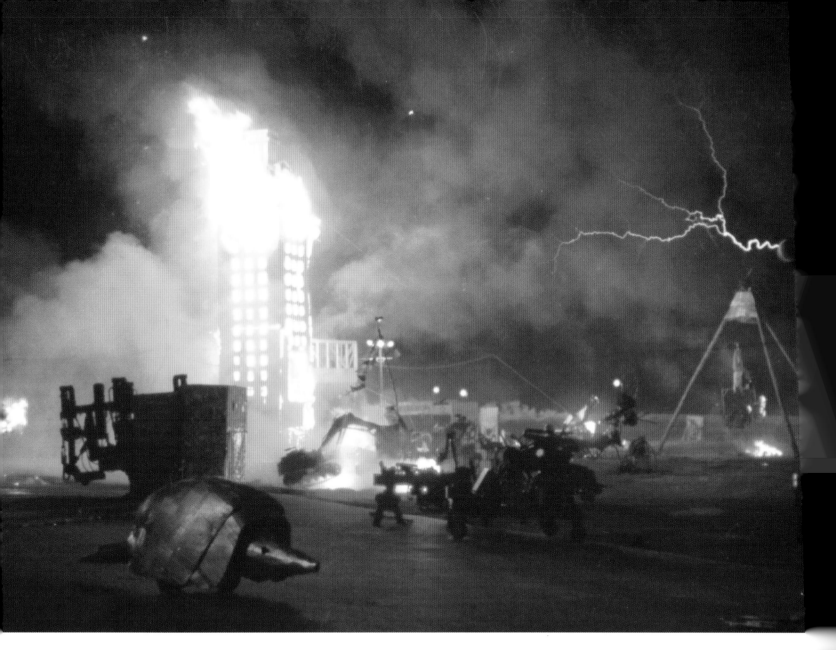

The Unexpected Destruction of Elaborately Engineered Artifacts
Austin, 1997

Guerilla performance in South Park for Web98 conference,
June, 1998

STEPHANIE SYJUCO

Languages, whether verbal, technical, or visual, are comprehensible within communities that use them. Stephanie Syjuco extracts the essential qualities of what defines a code or language in one community and displaces it, mutating the contextual make-up through the images and objects in her art. She works with a range of materials and processes, from yarn crochet to digital manipulation of photographs, and engages such diverse subjects as Gothic architecture, military battle diagrams, and natural ecosystems. Her work is about the relationships among language, image, and object, between visual representation and spatial experience, and the ways those mediations are culturally interpreted or understood.

The conceptual basis for Syjuco's approach was formed early on. Born in the Philippines, she moved with her family to the U.S. in early childhood, and at age ten they lived in Japan for two years. She describes the effects of these disjunctive cultural experiences by observing, "The cultural state of being neither here nor there, of belonging to no distinct, delineated, or defined cultural identity, is a ripe departure for my work. What is at stake for me is how to address the personal in such a way that it explores the pleasures, ironies, and multiplicities of being 'all at once' and yet 'neither.'"

Syjuco explores what constitutes the natural world and artificial interpretations of it, or what is organic and inorganic, in several groups of work. In *Building Materials Series 1: Grove* (1997), two-by-four wood beams loosely piled against a wall form a faux construction site. The disorganization of the mass also echoes the structural disintegration that naturally occurs in a forest, and crocheted doilies masquerading as moss cover the lumber, in various shades of camouflage green. She crocheted white yarn into small coverlets, and then stretched them over various-sized stones for *Sham (Rocks Posing as Snowballs)* (1997). *Tree Growth Rings,* in her installation *Tree Growth Rings* and *Ficus (Paradise Islands)* (1998), consists of small, various-sized rugs of crocheted yarn, with alternating beige and dark brown concentric rings, lying on the floor like thin cross-sections of trees. *Ficus (Paradise Islands)* are framed thirty-by-forty-inch digital photographs, which she made by digitally manipulating Polaroid snapshots of small ornamental ficus plants, transforming them into large growths with perfectly mirrored sides. While sufficiently resembling natural forms so that the growths appear real, their visual perfection is vaguely sinister, suggesting chemical manipulation or genetic mutation. The symmetry of stalks, branches, and green leaves, many of which are muted or blurred, emerging from an orange pot appears as a kind of household Rorschach test.

Abstractions are essentially translations, and the patterned images and abstracted objects that recur throughout Syjuco's works beg psychological interpretation. The amorphous shapes of her ink-on-paper *Weed Drawings* (1997) were made by copying weeds from a child's coloring book, and then mirroring and filling in the shapes. These high-contrast blobs are extended spatially in *Corner Ink Blot* (1997), a grouping of black crocheted yarn shapes (approximately fifty inches square) installed on two walls at the corner of a room. However,

her work is more complex than a Rorschach ink blot test, having the added elements of texture, the visual permeability of the yarn, and flattened or changing perspective.

Using derivative source material seems perfectly natural to Syjuco, as she belongs to a generation that was raised on mediated information and is skeptical of the concept of "the original." Inspired by eighteenth- and nineteenth-century landscape paintings that sought to depict the sublime in nature, she initiated an Internet search for the word *landscape,* and then downloaded the digital files. She manipulated these images into the symmetrical panoramas *Scenics (Streaming)* (2000). Similarly, what appear to be vintage natural-history botanical studies are actually computer cords, cables, and peripheral connections in *Comparative Morphologies* (2001), which are thirty-by-forty-inch Iris prints on Somerset paper.

Syjuco further blurs distinctions between consensus reality and individual imagination using the spatial language of architecture. *Landscape* (1997) is a city of 117 paper buildings that she assembled from prefabricated kits and then covered with a fuzzy green turf. The

STEPHANIE SYJUCO (B. MANILA, PHILIPPINES, 1974) MOVED WITH HER FAMILY TO THE BAY AREA (1977–84), TOKYO, JAPAN (1984–86), AND THEN RETURNED TO SAN FRANCISCO. SHE ATTENDED THE NEW YORK STUDIO PROGRAM OF THE ASSOCIATION OF INDEPENDENT COLLEGE OF ART AND DESIGN IN AFFILIATION WITH PARSONS SCHOOL OF DESIGN (1994) AND THEN TRANSFERRED TO THE SAN FRANCISCO ART INSTITUTE (BFA, 1995). SHE WAS IN RESIDENCE AT THE SKOWHEGAN SCHOOL OF PAINTING AND SCULPTURE, SKOWHEGAN, MAINE (1997), AND THE CENTER FOR METAMEDIA, PLASY, CZECH REPUBLIC (1999). SYJUCO WORKED AS A GRAPHIC DESIGNER FOR FIVE YEARS AT THE EXPLORATORIUM. SHE LIVES IN SAN FRANCISCO.

buildings were selected from different periods of American history. Some are historically specific, such as Thomas Edison's laboratory; others are generic, such as a train station. Syjuco arranged them to create a city defined by different areas such as a downtown, farmland, industrial parks, and suburbs. The green covering obscures architectural details, reduces the individuality of the structures, and physically submerges the whole scenario into a memory.

Combining ideas derived from Gothic buttresses and cheap, contemporary modular furniture, Syjuco assembled foamcore covered with wood-patterned contact paper with Velcro strips to form the odd, but vaguely familiar structure of *Doppelgangers (Gothic Objects)* (2001). A series of nine ascending columns, the highest over ten feet, are interlocked with diagonal supports at the corner of a room. The rectangular columns are individually different in height and ornamental molding, with fanciful spires sprouting from two of them, and plastic potted plants are placed on various surfaces. Still, this postmodern construction appears flimsy despite the "look" of solidity; it is a mix of history and present that is, as she has observed, "all at once, and neither." It is a kind of virtual sculpture, which borrows historical appearance and blends it with the visual language of the present.

SELECTED READING

FRIIS-HANSEN, DANA; ALICE G. GUILLERMO; AND JEFF BAYSA. *AT HOME AND ABROAD: TWENTY CONTEMPORARY FILIPINO ARTISTS.* SAN FRANCISCO: ASIAN ART MUSEUM, 1998.

DE GUZMAN, RENE. *TO BE REAL.* SAN FRANCISCO: CENTER FOR THE ARTS, YERBA BUENA GARDENS, 1997.

KABAT, NORA. *BEYOND BOUNDARIES.* SAN FRANCISCO: ANSEL ADAMS FRIENDS OF PHOTOGRAPHY CENTER, 2000.

KELLEY, JEFF. *CROSSINGS—14 ASIAN AND ASIAN AMERICAN ARTISTS FROM THE BAY AREA.* SAN FRANCISCO: AT KEARNEY, INC., 1998.

KIMBALL, CATHY. *EUREKA AWARDS SHOW.* SAN JOSE, CALIF.: SAN JOSE MUSEUM OF ART, 2000.

YOUNG, DEDE. *STEPHANIE SYJUCO: SET-UPS AND SPOILS.* WILMINGTON: DELAWARE CENTER FOR THE CONTEMPORARY ARTS, 1999.

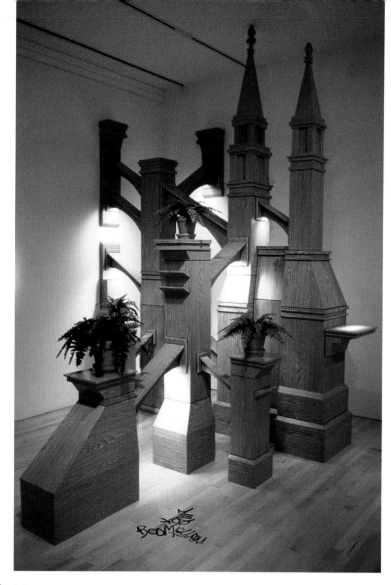

Dopplegangers (Gothic Objects), 2000
FOAMCORE, CONTACT PAPER, VELCRO, ARTIFICIAL PLANTS, FLUORESCENT LIGHTS,
WINDOW TINT VINYL, OVERALL 170" X 150" X 130"

Paradise Island and Tree Growth Rings [installation view], 1998
FRAMED AND DIGITALLY MANIPULATED CIBACHROME PRINTS,
32" X 40", CROCHETED YARN

MARK THOMPSON

MARK THOMPSON

Integral to Mark Thompson's work is his long-standing obsession with the cycles of nature and self-contained ecosystems, exemplified by the honeybee hive. Thompson views the hive as "a remarkable metaphorical window" into the extremely complex systems that exist in human communities and throughout nature—and the interdependence between them. "My work as an artist," he explains, "has grown out of my passion for exploring living systems, both natural ecologies as well as human communities."

This exploration has been influenced by Thompson's experience as a beekeeper, which has so profoundly shaped his life and art that his routine daily activities cannot be clearly separated from much of his art making. The traditional boundaries between performer and performance are reevaluated in Thompson's work, which often confounds the expected distance assumed by artist and viewer alike.

Immersion, a fifty-minute 16mm film created between 1973 and 1976, involved standing on a platform in his grandmother's backyard, placing a queen honeybee onto his head, and remaining motionless until he is covered with a thick mass of honeybees. Using a storyboard and motion picture camera with variable frame speeds, between two and one hundred frames per second, Thompson did the initial filming and then had an assistant shoot the remainder.

Immersion begins with pure blue sky filling the frame and then honeybees flying across it. After a few moments the film speed changes, making the flying honeybees appear as particles or materializing blurred specks that dissolve into lines. The increasing numbers of flying honeybees create an impression of liquidity, and the camera slowly lowers and Thompson's head comes into view with a few bees on his hair, neck, and torso. The film speed again changes, and the bees appear to land more quickly. After several minutes his features are obscured with a mantle of honeybees, and the film ends. On the surface of it, the work is about the sculptural and immaterial relationship between him and the honeybees. But there are formal and almost metaphysical qualities as well: it examines the quality of daylight present, as honeybees use the play of sunlight in their navigation. The physical and psychological space described by thousands of honeybees, interpreted by different rates of time over the length of the film, conveys the honeybees as points in space, and also as vectors in space crossing through time.

In spring 1989, he created *A House Divided,* an installation and performance that addressed the spiritual, symbolic, and physical divisions in Berlin. The exhibition site, Kunstlerhaus Bethanien, bordered the wall in West Berlin and had been a hospital in the late nineteenth century. Over a period of three weeks, Thompson used a nineteenth-century bee-hunting box to catch and track local honeybees within a three-mile-diameter circle, which extended about one mile into East Germany. He experienced a series of warm and intimate interactions with a variety of people, including beekeepers, through this process of catching, feeding, and releasing the honeybees. Thompson met Herr Pickard, a nearby beekeeper with whom he

developed a close relationship. Pickard gave Thompson a small gift of beeswax, which was combined with substantial amounts of other wax purchased from West German beekeepers as well as wax smuggled from East Berlin. Thompson melted the wax; covered the interior of the two arched windows, each five by twelve feet; and coated two metal columns, approximately thirteen feet high, in the former hospital ward.

Thompson then created the *Live-in Hive* for the installation, a glass-walled beehive in which he could insert his head. A swarm of honeybees was transferred from Herr Pickard's backyard hive to the exhibition space. The honeybees came and went through a wire mesh tube inserted into the wall. Thompson then spent two or three hours each morning, before the building was open to the public, with his head inserted into the hive—an extremely dangerous act—meditating on this new wax city being formed by the honeybees, who knew nothing of borders, politics, and the divisions in Berlin.

Individual and group exhibitions are organized in various parts of the building, and visitors move from room to room viewing works, which were minimally described in a catalogue. Viewers entering the room, which was filled with the fragrance of beeswax, had to

MARK THOMPSON (B. 1950, FORT STILL, OKLAHOMA) LIKED TO EXPERIMENT AND INVENT AS A BOY, AND THIS INCLI-NATION INITIALLY LED TO HIS STUDY OF ELECTRICAL ENGINEERING AT VIRGINIA POLYTECHNIC INSTITUTE IN BLACKSBURG (1968–70). HE CHANGED THE DIRECTION OF HIS STUDIES TO ART AND TRANSFERRED TO THE UNIVERSITY OF CALIFORNIA AT BERKELEY (BA, 1972; MA, 1973). THOMPSON'S AWARDS AND HONORS INCLUDE TWO NATIONAL ENDOWMENT FOR THE ARTS FELLOW-SHIPS (1980, 1989), AN AWARD IN THE VISUAL ARTS FELLOWSHIP (1991–92), AND A VISUAL ARTS AWARD FROM THE FLINTRIDGE FOUNDATION (1998). SINCE 1993 HE HAS TAUGHT AT THE CALIFORNIA COLLEGE OF ARTS AND CRAFTS. HE LIVES AND CARES FOR HIS BEES IN ORINDA.

pause until their eyes adjusted to the low-level natural light filtering through the wax-covered windows. The nineteenth-century bee-hunting box was placed on stump a few feet inside the doorway. Viewers would see the wire mesh tube leading from the glass live-in hive, with the head-ring and empty chair underneath it, filled with bees walking and flying in and out, the room bathed in the undulating light suffused through the wax-covered windows. Thompson created a link between the human world and the insect community, the bees functioning as a link between two cities with different political ideologies.

A House Divided was a distillation of Thompson's experiences in Berlin, and stimulated perceptions of beauty and wonderment in the natural world. The work's title, derived from a description of the U.S. Civil War, also encourages considerations about history, human lives, and enduring social relationships

SELECTED READING

BROOKS, LIZ. "SEVEN OBSESSIONS." *WHITECHAPEL ART GALLERY AND PERFORMANCE MAGAZINE* (LONDON) 62 (NOVEMBER 1990): 9–16.

JAPPE, ELIZABETH, ED. "MARK THOMPSON" IN *PERFORMANCE-RITUAL-PROCESS*. NEW YORK AND MUNICH: PESTERL-VERLAG, 1993.

NASH, STEPHEN. *FACING EDEN: ONE HUNDRED YEARS OF LANDSCAPE IN THE BAY AREA*. SAN FRANCISCO: M.H. DE YOUNG MEMORIAL MUSEUM, 1995.

SCHIMMEL, PAUL, AND KRISTINE STILES, ET AL. *OUT OF ACTIONS: BETWEEN PERFORMANCE AND THE OBJECT, 1949–1979*. LOS ANGELES: MUSEUM OF CONTEMPORARY ART, 1998.

SOLNIT, REBECCA. *AS EVE SAID TO THE SERPENT: ON LANDSCAPE, GENDER AND ART*. ATHENS: UNIVERSITY OF GEORGIA PRESS, 2001.

STILES, KRISTINE, AND PETER SELZ, EDS. *THEORIES AND DOCUMENTS OF CONTEMPORARY ART*. BERKELEY AND LOS ANGELES: UNIVERSITY OF CALIFORNIA PRESS, 1996.

THOMPSON, MARK. "LINING THE WILD BEE." IN *FIRE OVER WATER*, EDITED BY REESE WILLIAMS. NEW YORK: TANAM PRESS, 1986.

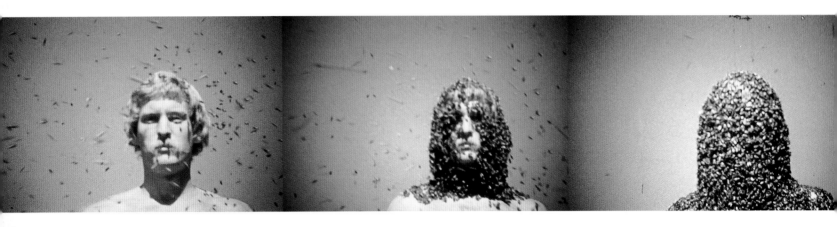

Immersion, 1973–76
PROGRESSIVE STILLS FROM 16MM FILM

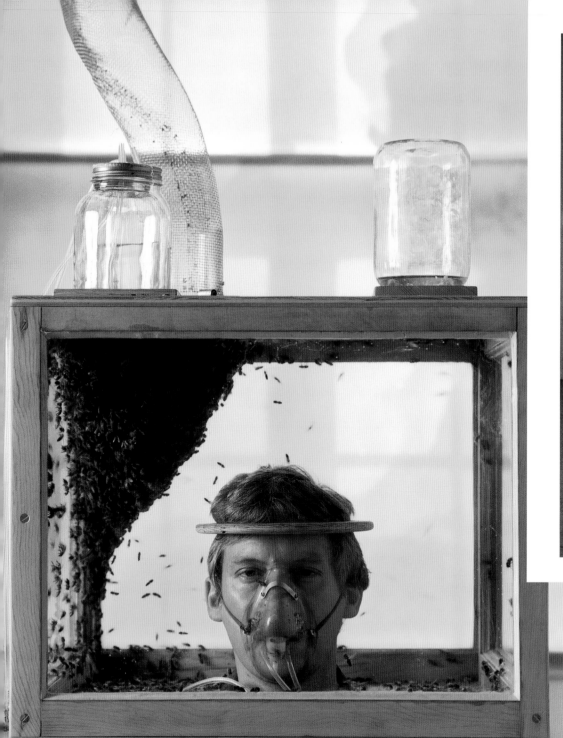

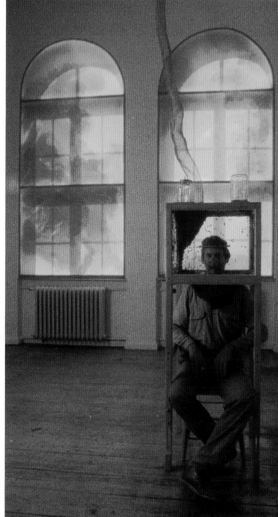

A House Divided, 1989
HEAD INSERTION

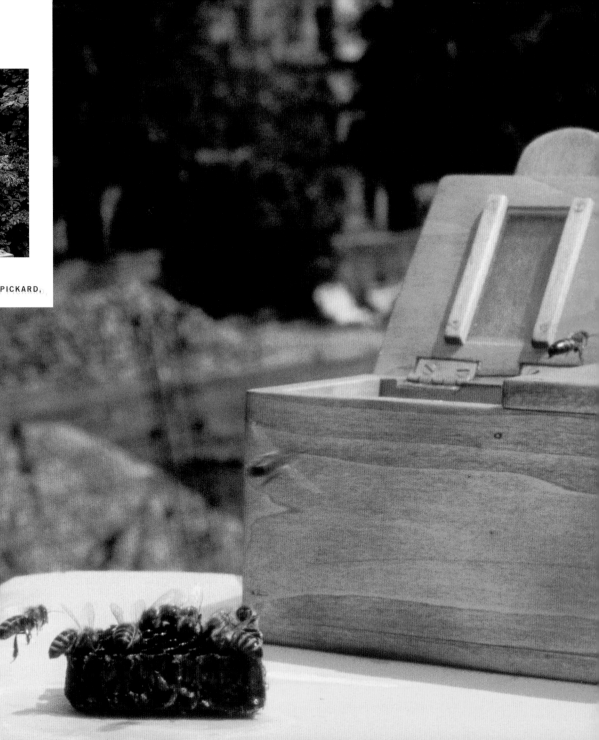

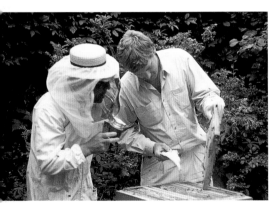

A House Divided, 1989
EXAMINATION OF BEEHIVE WITH HERR PICKARD,
WEST BERLIN BEEKEEPER

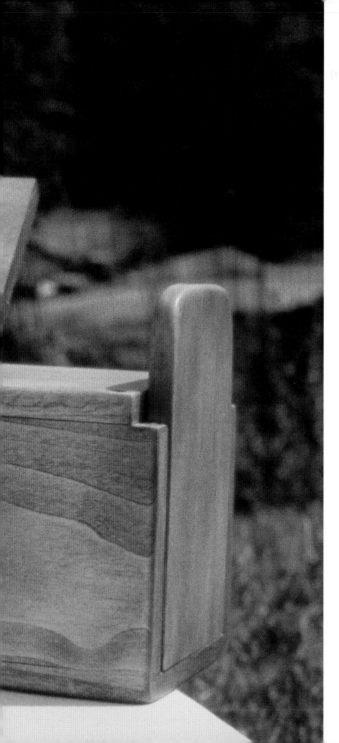

[tracking honeybees, nineteenth-century bee hunting box, West and East Berlin]

[Berlin map with exploration area in yellow]

BERLIN
(WEST)

POTENTIAL FORAGING AREA OF HONEYBEES
IN YELLOW CIRCLE, 5 KM RADIUS

MEREDITH TROMBLE

TROMBLE

Meredith Tromble explores the rich vocabulary of painting and plumbs the depths of color, shape, and texture. Tromble, as an active teacher, writer, and artist, well understands the long history of painting in Western artistic tradition, which she embraces, rather than casts off as something burdensome and weighty.

Before migrating solidly into painting, from the mid-1980s through the mid-1990s, Tromble created large installations of mazes that required a participant to make a series of choices while moving through the structures. Every surface was treated with excruciating detail—painting, manipulating light, sculpting with fabric, and creating small, ceramic sculptures—with the aim of offering participants a timeless, sensory experience of exploration. *Caerdroia* (1992), the Welsh word for ancient outdoor mazes on the British Isles, was installed in a replica ancient temple at the Rosicrucian Egyptian Museum Art Gallery in San Jose. Every inch of the corridors, chambers, and rooms of the twenty-foot-square maze was painted with abstract shapes and unspecified markings in black, brown, white, red, and blue, and niches along the spiral path of the maze were filled with ceramic objects such as cups, bowls, urns, and reliquaries. A black scrim overhead filtered the light, and Tromble had strewn cut hay on the floor. She describes her mazes as "an architectural analog for the interaction between time and will," where viewers are forced to make navigational choices, unaware of what might be encountered. During the seven-year experience of working on *Caerdroia,* Tromble developed an abstract language for her painting. "I had been working figuratively, but I realized that the things I wanted to address with my work required more abstract subjects—that if my work was a sentence, I wanted to talk about the verbs, not the nouns." Within the abstract vocabulary, she gravitated toward the sense of flow and motion evoked by round forms, circles, and curves. She maintained this sensibility after her second maze installation, *Pale Maze* (1994), when she moved abruptly to creating smaller-scale, abstract paintings.

Tromble relishes the immediacy of the process of painting—both the physical and the intellectual aspects. She embraces the intuitive side of painting as an activity and yet relies on studied attention to the progression of each work. She stated, "Each time you touch the paint to canvas, you use different weights, pressure, angles of the arm, motions. And, just like in dance, when you hit it, you feel wrapped in a moment—in life—in a way that's sweet. It's like honey: it makes you want to go back for more."

MEREDITH TROMBLE (B. 1954, HERINGTON, KANSAS) ATTENDED DENVER UNIVERSITY (1972–73), AND THEN MOVED TO CALIFORNIA. SHE STUDIED PAINTING AND ENGLISH AT THE NEW COLLEGE OF CALIFORNIA IN SAN FRANCISCO (BA, 1976) AND LATER ATTENDED MILLS COLLEGE IN OAKLAND (MFA, 1991). TROMBLE PROVIDED THE COMMENTARY "VIEW FROM THE STUDIO" ON THE PUBLIC RADIO PROGRAM "WEST COAST LIVE" (1993–2000), AND FOR TWO YEARS SERVED AS THE SHOW'S ASSOCI-ATE PRODUCER. HER JOURNALISM EXPERIENCE EXTENDS TO PRINT AND ONLINE MAGAZINES. SHE HAS SERVED AS THE EDITOR-IN-CHIEF OF *ARTWEEK* (1996–98), ART EDITOR AND COLUMNIST FOR *LIMN* MAGAZINE (1998–99), AND EDITOR-IN-CHIEF FOR NEXTMONET.COM (1999–2000). SHE IS THE FOUNDING CONTRIBUTOR FOR *STRETCHER*, AN ONLINE MAGAZINE FOCUSED ON BAY AREA ART. ALTHOUGH SHE TOOK A LENGTHY SABBATICAL FROM ACTIVE EXHIBITING WHILE SERVING AS EDITOR-IN-CHIEF OF *ARTWEEK*, SHE BEGAN EXHIBITING AGAIN IN 2000. TROMBLE MAINTAINS A STUDIO AT HUNTERS POINT SHIPYARD IN SAN FRANCISCO.

Lime (2000) consists of various-sized oblong and circular forms that appear weightless and hover in the soft lime-colored background. The emphasized outline of pale blue, rose, and green forms creates a duality: the forms vacillate between appearing as translucent, flat shapes and floating spheres with mass. The small scale of the work (twenty inches by twenty inches) contributes to the hushed impression derived from the soft coloration and buoyancy of the forms. *Untitled* (1999), a mixed-media work on paper, evokes a feeling of suspended time, as if nameless, organic beings have been captured under a microscope in a singular instant. A bright yellow orb ringed with small red spheres appears over the top of a flat beige oblong form within a mottled black background. The yellow and beige structures seem to have an outer layer of fringe, or hair, establishing the impression that they are living, organic beings. Her studies of the circular form evoke a sense of motion, or flow, albeit suspended. Perhaps inspired by the illusion of movement in her paintings, for an exhibition of this series at the Genevieve Gallery in San Francisco in 2000, an acoustic guitarist and a cellist played music composed in response to Tromble's art, a suitable counterpart to the harmonious, quiet nature of her work.

SELECTED READING

DALLE-MOLLE, KATHY. "MEREDITH TROMBLE REALLY KNOWS HOW TO TALK UP ART." *THE NOE VALLEY VOICE* (JULY/AUGUST 1998): 17–18.

REVEAUX, TONY. "THE FOUR-DIMENSIONAL PATH." *VISIONS* (SUMMER 1993): 33.

TROMBLE, MEREDITH. "FOLK, NAIVE, OUTSIDER, AND FUNK." IN *YESTERDAY AND TOMORROW: CALIFORNIA WOMEN ARTISTS*, EDITED BY SYLVIA MOORE. NEW YORK: MIDMARCH PRESS, 1989.

TUCHMAN, LAURA. "A QUESTION WITH A SHROUD WITHIN A MAZE." *SAN JOSE MERCURY NEWS*, 3 DECEMBER 1993, P. 17.

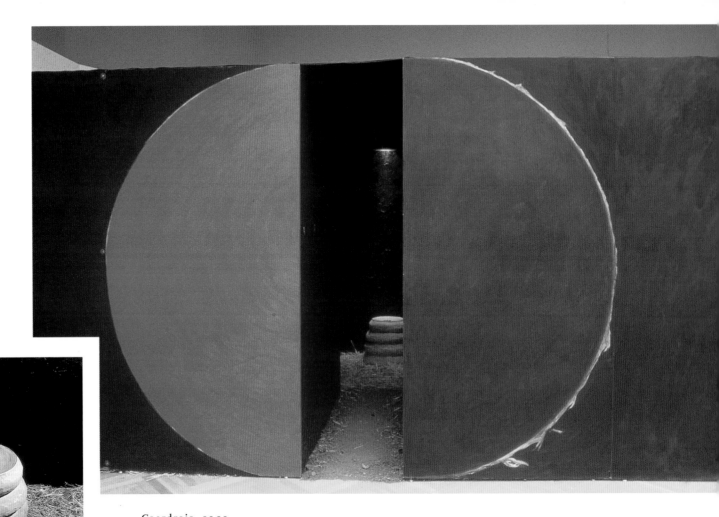

Caerdroia, 1991
INSTALLATION AT THE ROSICRUCIAN EGYPTIAN MUSEUM ART GALLERY, SAN JOSE, CALIFORNIA.
MIXED MEDIA MAZE INSTALLATION; 20' X 20'

[detail]

Lime, 2000
OIL ON CANVAS; 20" X 20"

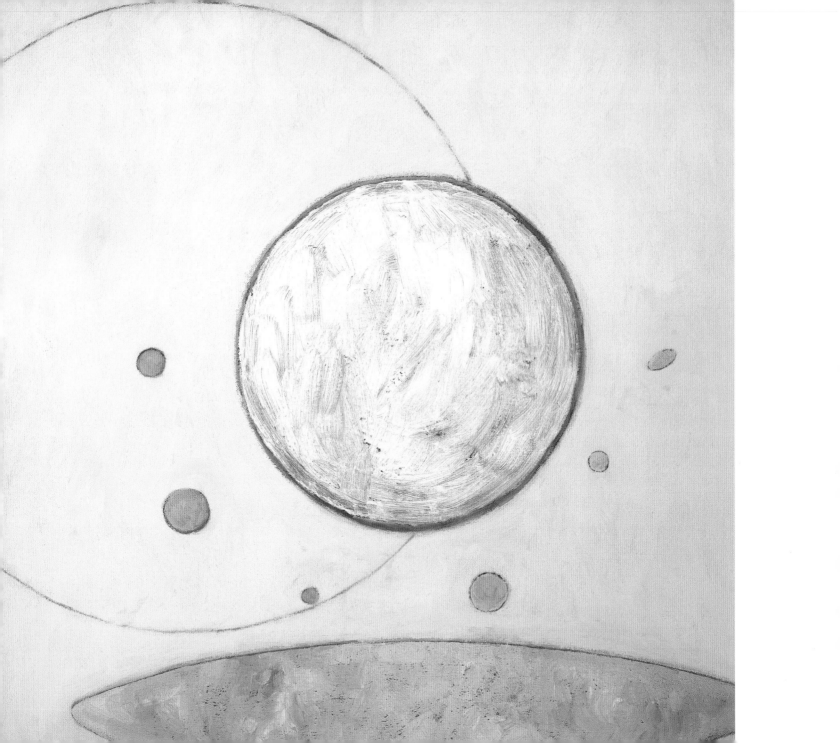

CATHERINE WAGNER

Catherine Wagner makes photographs and then arranges them in installation to reveal connections, suggest deeper meanings, and provoke questions about culture and society. Employing the descriptive capabilities of photography, her different series investigate the educational, recreational, domestic, and scientific institutions and structures that shape our lives.

Wagner's *Moscone Convention Center* (1979–81) is a series of black-and-white photographs that depict the construction of the largest convention center in the Western United States at the time. The photographs individually chart massive pours of concrete, the erection of intricate steel forms from which a plethora of architectural detail emerges, and conclude before the building is finally finished. Her *American Classrooms* (1982–86) are black-and-white interior views of educational laboratories such as elementary and high school classrooms, and trade specialty centers committed to textiles, dog grooming, and acupuncture. She includes both wide overviews of classrooms and the subjects or tools of education, such as a lab tray of frogs awaiting dissection or a portable blackboard.

Her exploration of culture and society is carried from the public sector into personal worlds in *Home & Other Stories* (1989–92) which she arranged in horizontal triptychs that serve as storyboards or narratives. *Home & Other Stories* is about the private accumulation and arrangement of objects, personal pursuits of comfort and how people live; the arrangements of photographs allude to family relationships, emotional solace, and other aspects of domesticity.

People are generally absent in Wagner's photographs, which have explored different types of architectural space—public space that would be defined by the final building in *Moscone Convention Center* (1979–81), temporary public entertainment park in *Louisiana World Exposition* (1981), commonly shared spaces of learning in *American Classrooms* (1982–86), and private domestic space in *Home & Other Stories* (1989–92). People and their activities create society and culture, and the evidence of their activities constitutes the subjects of Wagner's photographs. The Moscone Convention Center will become a convention center, classrooms are sites of past activities and future learning, and homes are places where people cherish nostalgic images and items of the past, occupy in the present, and will retreat to in the future. As she commented in 1983, "I've always photographed places that are in change in terms of the future."

Between 1987 and 1995, Wagner photographed in laboratories across the United States; at first she visited medical research facilities involved in the Genome Project, a concerted effort to map human DNA and identify the building blocks of life. A year spent as artist-in-residence at Washington University in St. Louis provided access to diverse facilities, from earth and planetary science labs to medical research centers. She designed the resulting exhibition of *Art and Science: Investigating Matter,* boldly arranging her large-format,

black-and-white photographs—scaled variously up to five by nine feet—with explanatory text about the scientific processes or research depicted.

Wagner's photographs chart scientific exploration, and propose the laboratory as a museum, a modern-day *Wunderkammer* (chamber of wonders) containing the known and unknowable wonders of the world. A nine-panel typology, an arrangement based on types or categories of life forms—prehistoric sea creatures, plants, and mammals—offers viewers an opportunity to visually compare the different sources of life.

Wagner followed *Art and Science: Investigating Matter* with images made through MRI (Magnetic Resonance Imaging) and SEM (Scanning Electron Microscope) technology (1998–2001), presented in exhibition as *Cross Sections*. Wagner was given access to highly specialized, expensive, state-of-the-art machines that produced images that she then digitally manipulated. The machines allowed her to make visual what the unaided eye cannot otherwise experience, and the photographs peer into various organic forms such as fruits, vegetables,

CATHERINE WAGNER (B. 1953, SAN FRANCISCO) STUDIED ART AT THE SAN FRANCISCO ART INSTITUTE (1971), THE INSTITUTO DEL ARTE, SAN MIGUEL DE ALLENDE, MEXICO (1970–71), THE COLLEGE OF MARIN, KENTFIELD, CALIFORNIA (1972–73), AND FINALLY PHOTOGRAPHY WITH JACK WELPOTT AT SAN FRANCISCO STATE UNIVERSITY (BA, 1975; MFA, 1977). AMONG HER MANY AWARDS AND COMMISSIONS ARE A JOHN SIMON GUGGENHEIM MEMORIAL FOUNDATION FELLOWSHIP (1987), TWO NATIONAL ENDOWMENT FOR THE ARTS PHOTOGRAPHY FELLOWSHIPS (1981, 1990), A VISUAL ARTS FELLOWSHIP FROM THE WEIZMANN INSTITUTE, REHOVOT, ISRAEL (1998), AND A COMMISSION TO PHOTOGRAPH DISNEYLAND FROM THE CANADIAN CENTRE FOR ARCHITECTURE (1998). SHE LIVES IN SAN FRANCISCO, AND SINCE 1979 HAS TAUGHT AT MILLS COLLEGE.

human organs, and single cells. "I am interested in what impact the changes that emerge from contemporary scientific research will have in our culture, socially, spiritually and physically," she stated. "The project revolves around one central question: who are we and who will we become?"

Wagner's images explore the development of life, from tiny cell structures that appear like scenes of deep space to interior views of the human brain. *Pomegranate Wall,* a back-lit image on a curved wall, eight feet high and forty-feet long, holds hundreds of cross-section views of a pomegranate interior. The interior views shimmer from the black background, and form an imposing and slightly hallucinatory pattern. Wagner reminds viewers of the interrelationships in form and function among the structures of life, from a single cell to the cosmos.

SELECTED READING

CHANGING PLACES, PHOTOGRAPHS BY CATHERINE WAGNER. HOUSTON: RICE UNIVERSITY PRESS AND FORISH GALLERY, 1989.

CONKELTON, SHERYL. HOME AND OTHER STORIES, PHOTOGRAPHS BY CATHERINE WAGNER. ALBUQUERQUE: UNIVERSITY OF NEW MEXICO PRESS AND LOS ANGELES: LOS ANGELES COUNTY MUSEUM OF ART, 1993.

TUCKER, ANNE WILKES, WITH AN ESSAY BY WILLIE MORRIS. AMERICAN CLASSROOM, THE PHOTOGRAPHS OF CATHERINE WAGNER. HOUSTON, TEX.: HOUSTON MUSEUM OF FINE ARTS, 1988.

WAGNER, CATHERINE. ART & SCIENCE: INVESTIGATING MATTER, WITH TEXT BY CORNELIA HOMBURG; ESSAYS BY WILLIAM H. GASS AND HELEN LONGINO. TUCSON, ARIZ.: NAZRAELI PRESS AND ST. LOUIS, MO.: WASHINGTON UNIVERSITY GALLERY OF ART, 1996

WAGNER, CATHERINE. CATHERINE WAGNER: CROSS SECTIONS. WITH TEXT BY CORNELIA BUTLER; GLEN HELFAND, AND DAVID PEAT. SAN JOSE, CALIF.: SAN JOSE MUSEUM OF ART AND TUCSON, ARIZ.: TWIN PALMS PRESS, 2001.

WAGNER, CATHERINE. CATHERINE WAGNER, 1976–1986. ESSAY BY MARK JOHNSTONE. TOKYO, JAPAN: GALLERY MIN, 1987.

Pumpkin, 1998
IRIS PRINT; 32" X 44"

Alfred University, Science Classroom,
Alfred, NY, 1987
GELATIN SILVER PRINT; ORIGINAL 20" X 24"

Blastoderm, 1999
IRIS PRINT; ORIGINAL 44" X 32"

Single Cell, 2000
IRIS PRINT, 44" X 32"

Definitely Not Sterile, 1995
GELATIN SILVER PRINT,
40" X 30"

HENRY WESSEL

During the next twenty years, he made black-and-white photographs of vernacular architecture, leisure pastimes in beach communities, and the odd but ordinary ways that humans interact with the landscape in Arizona, Colorado, Nevada, California, and Hawaii. A soft light characterizes these images, ranging from the sunlight diffused by an overcast sky at a Southern California beach to the crystalline illumination that defines an Arizona desert.

In 1990, Wessel began a two-year project photographing the fronts of small single-family homes not far from where he lives in Point Richmond, California. He remembers being a fourteen-year-old in 1956 and seeing the eight-by-ten color glossy photographs of available property displayed in his mother's real estate office. Wessel's *Real Estate Photographs* (previously titled *House Pictures*), his first extended series of color photographs, refer to this practice in concept and appearance. Each of the *Real Estate Photographs* is identified by a five- or six-digit code, mimicking the system used by real estate agents to maintain the secrecy of locations. People are absent, perspective is flattened, and the point of view is centered on the front facade, as Wessel shoots the photographs from an armrest inside his truck. The bright, harsh sunlight of midday further flattens the images, except for a few that display the long shadows and diminished light of late afternoon.

The flattened perspective, conspicuous absence of people, and colors deepened by bright sunlight in Wessel's *Real Estate Photographs* are spiced with humor in either the peculiarities expressed by individual California homeowners or the strange circumstances he finds. In *Real Estate Photograph No. 90602* (1990), the front of a small, boxlike building—stripped of anything that protrudes, windows boarded with plywood shutters—is painted beige, except for the red-painted door frame, windowsills, and front picket fence. A decorative diamond is above one boarded window, and a cooler sits mysteriously by the curb. Regarding the motivations for these photographs, Wessel says, "If I want to clearly describe something in the world, its nature will dictate my process. The idea in the real-estate pictures was to make myself as transparent and neutral as possible. I wanted to see how many different kinds of photographs I could take within that narrow type. I like the edge produced in the contest of making it as clear as possible and still showing as much complexity as possible."

Real Estate Photographs inventory the idiosyncracies of California architecture, which are more apparent in the houses and lots of economically disadvantaged neighborhoods than in wealthy communities, perhaps because these lots and houses are small and the alterations and decorating are makeshift. The small, pale gray shingled house in *Real Estate Photograph No. 908614* appears well kept and has a small strip of cacti planted under a front window. The shock-

HENRY WESSEL (B. 1942, TEANECK, NEW JERSEY) GREW UP ON THE EAST COAST. HE ATTENDED PENNSYLVANIA STATE UNIVERSITY (BA, 1966) AND THE STATE UNIVERSITY OF NEW YORK/VISUAL STUDIES WORKSHOP, BUFFALO (MFA, 1972). WESSEL HAS RECEIVED THREE FELLOWSHIPS FROM THE NATIONAL ENDOWMENT FOR THE ARTS (1976, 1977, 1978) AND TWO FROM THE JOHN SIMON GUGGENHEIM MEMORIAL FOUNDATION (1971, 1979). HE HAS TAUGHT AT VARIOUS INSTITUTIONS AND SINCE 1974 HAS BEEN ON THE FACULTY OF THE SAN FRANCISCO ART INSTITUTE. HE LIVES IN POINT RICHMOND.

ing incongruity about this property is that the front yard is entirely concrete and is neatly painted bright red, as are the walkway and driveway. The treatment suggests a strong controlling owner who desires a low-maintenance yard that will always look well kept.

Long fascinated with the rich subject matter available in Los Angeles, Wessel has shuttled back and forth to Southern California since settling in San Francisco. Houses are the subjects of *Night Walk* (1995–98), a series of black-and-white photographs made at night in a 1940s-era neighborhood in Santa Monica, using available light. The composition of each photograph is different, which emphasizes the individuality of each domicile. When the images are viewed collectively, they convey a feeling of walking through the neighborhood.

Most buildings are lit by the glow of a single light that shines over a front door or a garage or the light that emanates from a window covered by blinds, drapes, or, in one instance, a beautifully sagging sheet. In *No. 14,* a Spanish-style bungalow with a tile roof and an arched doorway devoid of illumination is barely visible through the ambient glow of the city lights. The photographs initially appear to be composed of impenetrable masses of foliage and buildings, differentiated only by their outlines. Then, as viewers become acclimated to the dark tonalities, fascinating details emerge from the shadows: silhouettes of bird-of-paradise plants and Joshua trees, latticework running along fences, a metal security door, rooftop antennas, the conical spray of a lawn sprinkler, a delivered newspaper, the moon.

In the *Night Walk* photographs, visual distractions that would be apparent during the day are submerged in darkness, creating an impression that house and landscape have begun to merge. The stillness captured by Wessel prompts viewers to realize that time has been suspended, drawing them deeper into the nighttime world.

SELECTED READING

GALASSI, PETER. *WALKER EVANS AND COMPANY.* NEW YORK: MUSEUM OF MODERN ART, 2000.

KATZMAN, LOUISE. *PHOTOGRAPHY IN CALIFORNIA: 1945–1980.* NEW YORK: HUDSON HILLS PRESS, IN ASSOCIATION WITH THE SAN FRANCISCO MUSEUM OF MODERN ART, 1984.

SZARKOWSKI, JOHN. *MIRRORS AND WINDOWS: AMERICAN PHOTOGRAPHY SINCE 1960.* NEW YORK: MUSEUM OF MODERN ART, 1978.

WESSEL, HENRY. *HENRY WESSEL.* WITH AN ESSAY BY BILL BERKSON. SAN FRANCISCO: RENA BRANSTEN GALLERY, 2000.

WESSEL, HENRY. *HENRY WESSEL HOUSE PICTURES.* SAN FRANCISCO: FRAENKEL GALLERY, 1992.

WESSEL, HENRY. *HENRY WESSEL— NIGHT WALK.* WITH ESSAYS BY CLAUDINE ISÉ AND DAVID WING. EL CAJON, CALIF.: GROSSMONT COLLEGE, 2000.

Vista Del Mar, 1995
GELATIN SILVER PRINT; 20" X 24"

Night Walk, Los Angeles, No. 28, 1995
GELATIN SILVER PRINT; 24" X 20"

Real Estate Photograph No. 90602, 1990
CHROMOGENIC COLOR PRINT; 26" X 39"

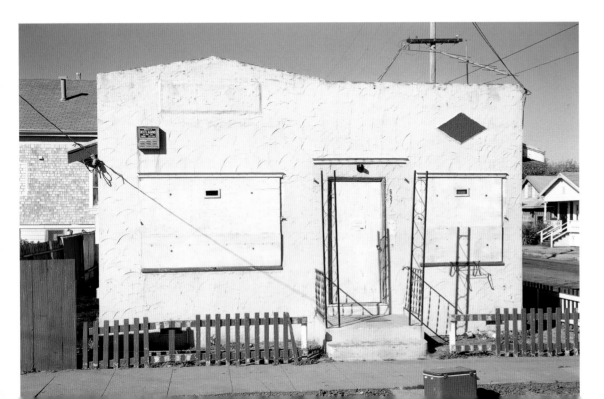

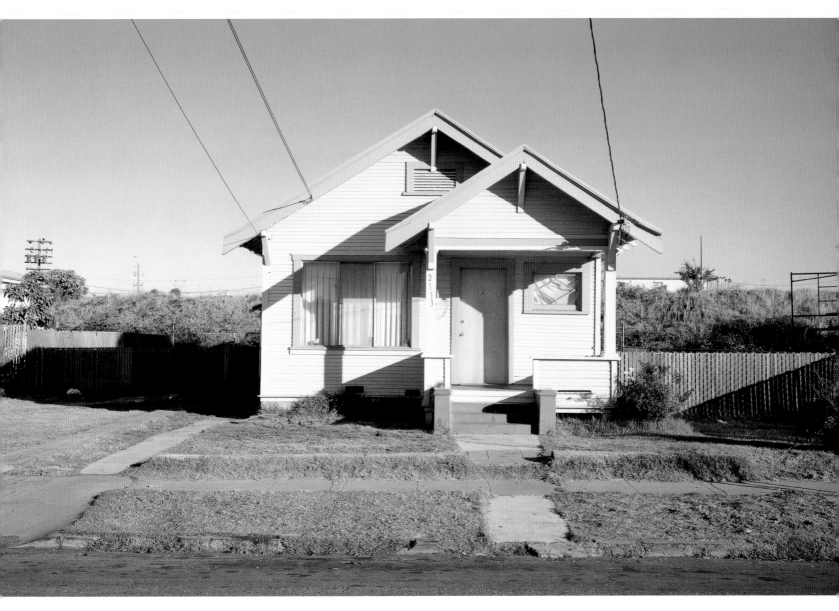

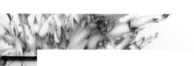 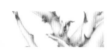

RENE
YUNG

Heterophony is the musical outcome when different voices or instruments play the same song in unison, produced by variations unique to each individual voice or instrument. To the untrained ear, it can sound like cacophony, a marked contrast to the harmonic efforts of Western music. Yet Rene Yung finds a metaphor for unity in heterophony, which is based not on a sense of equivalency, but on a unity that embraces the rich complexity of difference and absolute individuality. For Yung, heterophony is a metaphor for the diasporic voices scattered through a globalized world. Yung explores these voices and multiple perspectives, compelled through her own personal experiences, as an essential theme in her work.

For *Cauldron* (2000), Yung created an installation with wall drawings, framed images, wallpaper texts, and sculpted objects. *Cauldron* grapples with material and spiritual sustenance from the perspective of her native Chinese culture and other immigrants to the West. The cauldron, "in which simmers the multiple narratives of becoming in American culture," as she describes, exemplifies the metaphor of heterophony. Yung used as her primary motifs rice, symbolizing the traditional Chinese form of sustenance and livelihood, and the potato, a European-American staple, transplanted from its origins in pre-Columbian South America, representing the experience of immigration to the United States.

In the installation, Yung repeated the image of a rice bowl in progressively scaled-up charcoal drawings (up to seven feet by nine feet), hung side by side on two adjacent walls papered a vibrant red.

On the wallpaper were black Chinese calligraphy letters from a Confucian text, drawn in evenly spaced columns, addressing the spiritual self and the earning of material sustenance. The other two walls were papered in a blue-and-white pattern reminiscent of porcelain exported to the West from China. The pattern was actually created by Yung from potato prints. Within the pattern was the repeated phrase "You eat potato I eat potahto," from a song lyric by Cole Porter. On one blue-and-white wall, simple black frames alternately contained drawings of different varieties of potatoes and drawings of the potato plant's root system, which were overlaid on pages from a bilingual handbook on the application process for U.S. citizenship. Behind the framed images was a wall-size, magnified, colored pencil drawing of a potato vine. The other, shorter blue-and-white wall contained a single framed sheet of paper embossed with the seal "Certified Naturalized Potato." Throughout the installation, Yung mounted small, sculpted, potato-shaped rice cakes on the walls, each imprinted with a word from the Catholic prayer, "give us this day our daily bread, and forgive us our trespasses." In the center of the gallery were two place settings at a small, white sculpted table, split in two and positioned on either side of a central column in the space.

In *Cauldron,* Yung brought together visual and narrative components into a concordant structure that enabled viewers to follow a clear progression through the physical space of the installation as well as through the content of the art. As she explained, "I am interested in the total textuality of a work, where material, image, spatialization,

sensory and intellectual perception, become elements of a poetics modeled on the way in which the Chinese language combines concise total units of sound and meaning into a fluid whole." After considerable thought, she precisely and obsessively maps out each installation with detailed sketches and descriptions to create a seamless experience for viewers.

Yung's installations are about memory, being, and place. Her artwork is based on her accrued day-to-day experiences—from which she tries to understand her broad relationship to the global context—and makes connections between beauty and aesthetics and the critical or political realities of ordinary life. As she describes, "daily life is continuous navigation between cultural subtexts on different levels—the personal, the socio-political, the economic—shaped by the concrete practicalities of mundane survival, and the mutable longing of memories and dreams . . ." Through her art, Yung attempts to convey the nuances, textures, and minute details of ordinary life, often forgotten and overlooked in multicultural discussion. In *Cauldron,* she examines what such things as songs, prayers, written language, basic foods, and the simple act of sharing a meal at a dinner table can reveal about the experience of "becoming American."

In *Cauldron* as in other installations, Yung employed language —phrases from popular music and Catholic prayers, the full text of a Confucian morality tale—and its interplay with images to create different paths and indicate the multiple viewpoints of immigrants to the United States. She is deeply interested in the communicative and expressive power of language and places particular emphasis on the definitions and implied meanings embedded in language. Carefully selected words and suggestive, resonant phrases (in English and/or Chinese) are powerfully used to enhance the multiple layers of meaning in an installation. Yung demands a certain level of participation from an audience, not simply the rote reading that is required to navigate the space, but the deciphering and interpretation of the interplay of text, objects, and images. Yung's work is far from simple and resolutely challenges a viewer with a complex conceptual framework.

RENE YUNG (B. 1951, HONG KONG) MOVED TO CALIFORNIA AT AGE FOURTEEN. SHE STUDIED PRINTMAKING AT STANFORD UNIVERSITY (BA, 1974) AND OWNS A SUCCESSFUL GRAPHIC DESIGN PRACTICE. SHE IS ALSO ACTIVE IN WRITING AND TEACHING, INCLUDING COMMUNITY-BASED EDUCATION PROGRAMS SUCH AS AN INTERGENERATIONAL PROJECT WITH ELDERLY RESIDENTS IN CHINATOWN AND MIDDLE SCHOOL ESL STUDENTS. YUNG HAS RECEIVED NUMEROUS PRIVATE AND PUBLIC COMMISSIONS, INCLUDING PROJECTS FOR THE SAN FRANCISCO CHINATOWN PUBLIC LIBRARY (1993–96), ON LOK SENIOR HEALTH SERVICES (1996–97), AND THE NEWMAN RESIDENCE LIBRARY (1997), ALL IN SAN FRANCISCO; BROADWAY AUTO ROW IN OAKLAND (1997–98); AND THE DODT RANCH IN YORKVILLE, CALIFORNIA (1999). YUNG LIVES AND MAINTAINS HER STUDIO IN SAN FRANCISCO.

SELECTED READING

BONETTI, DAVID. "A WELCOME COMPLEXITY IN NEW SHOWS." *SAN FRANCISCO EXAMINER,* 13 DECEMBER 1996, SEC. B, P. 2.

"IN VENICE." *ARTWEEK* 26, NO. 9 (SEPTEMBER 1995): 2.

WEBSTER, MARY HULL. "RENE YUNG AT HOSFELT GALLERY." *ARTWEEK* 28, NO. 2 (FEBRUARY 1997): 19–20.

YUNG, RENE. *INTERCESSION.* SAN FRANCISCO: TWOTREE PRESS, 1996.

YUNG, RENE. *THE OPACITY OF DREAMS.* SAN FRANCISCO: TWOTREE PRESS, 1997.

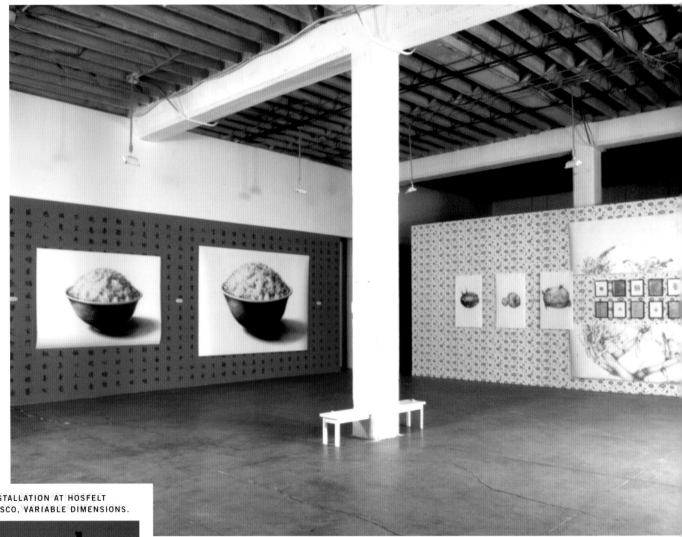

Cauldron, 1999
MIXED MEDIA INSTALLATION AT HOSFELT
GALLERY, SAN FRANCISCO, VARIABLE DIMENSIONS.

[detail: one of fourteen rice bread elements, rice flour, rice;
each approximately 6" x 2³/4" x ¹/4"; wallpaper: acrylic and lacquered ink on silkscreened
vermillion wallpaper, hand-calligraphed text; each panel 27" x 120", 35 total panels]

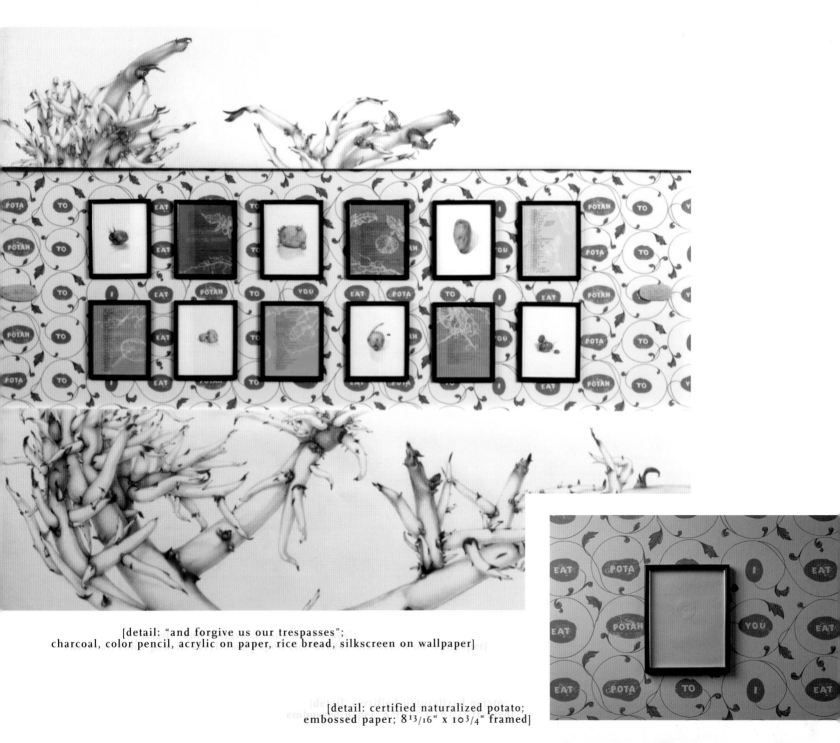

[detail: "and forgive us our trespasses";
charcoal, color pencil, acrylic on paper, rice bread, silkscreen on wallpaper]

[detail: certified naturalized potato;
embossed paper; 8¹³/₁₆" x 10³/₄" framed]

CREDITS